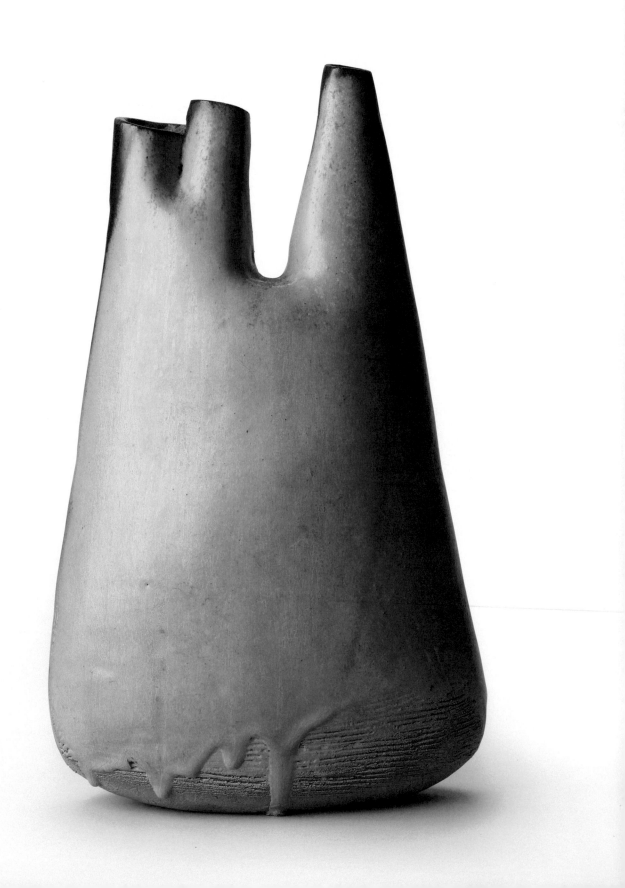

MODERN IN THE MAKING

POST-WAR CRAFT AND DESIGN IN BRITISH COLUMBIA

DAINA AUGAITIS, ALLAN COLLIER AND STEPHANIE REBICK

Vancouver
Artgallery

Figure 1
Vancouver / Berkeley

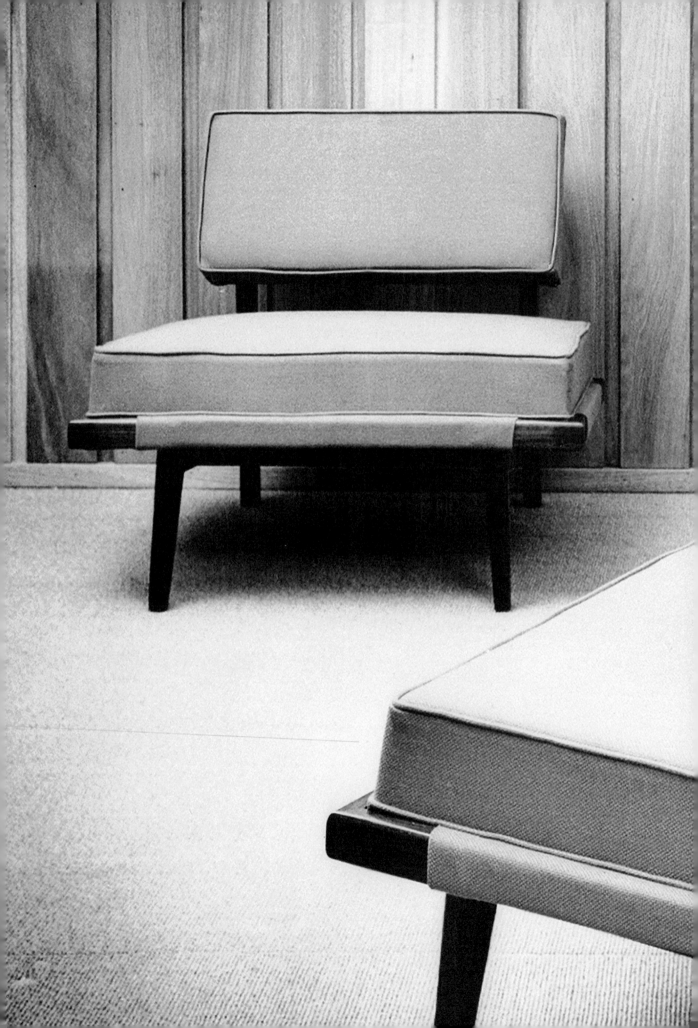

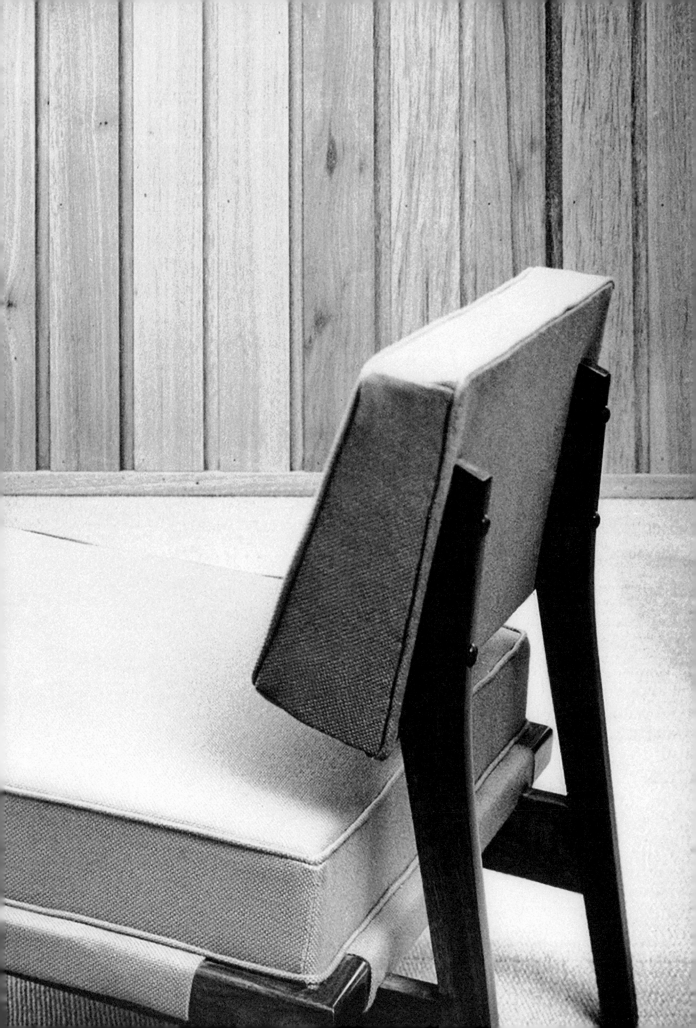

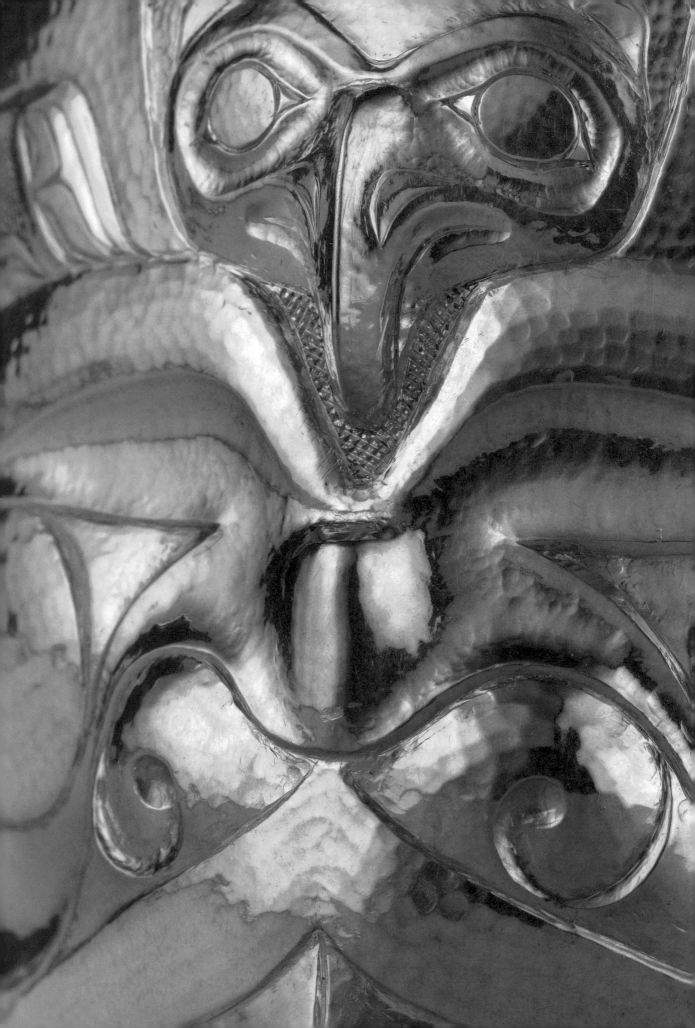

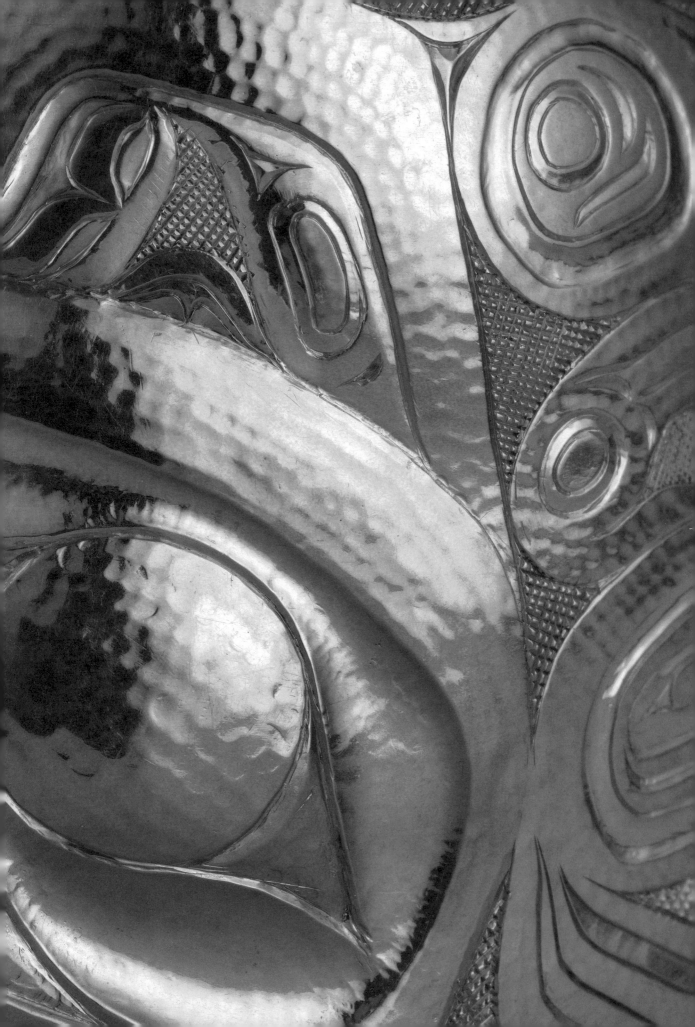

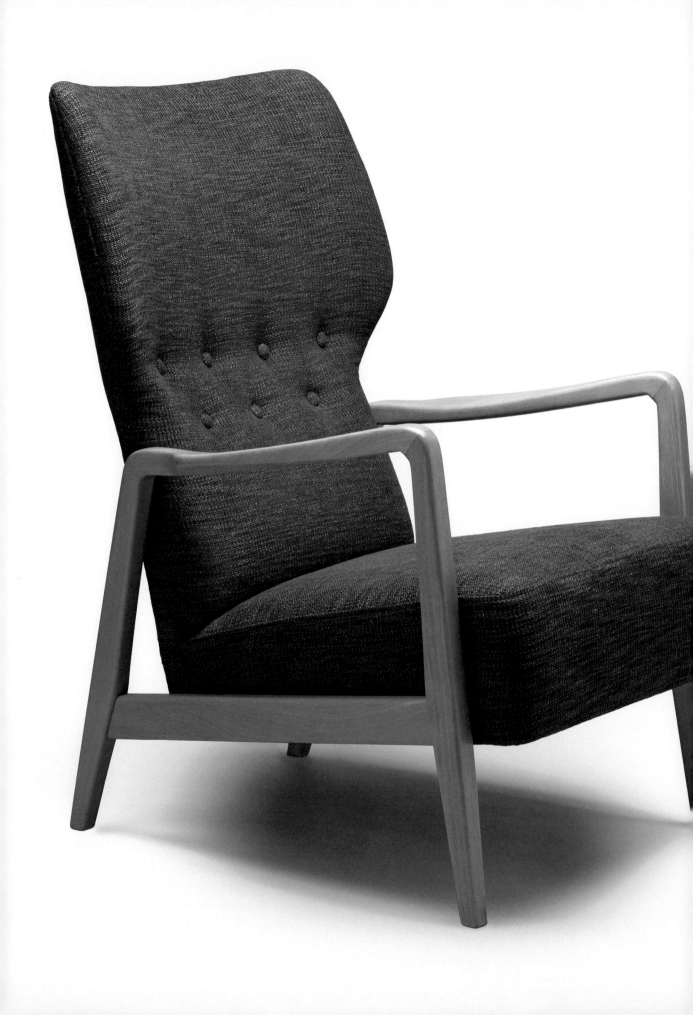

CONTENTS

DIRECTOR'S FOREWORD

Every object has a story. From the formal and material considerations of the maker, to the processes of design and production, to owners' sentimental attachments, the narratives carried by material culture can elicit strong emotional and cerebral reactions. Comprising nearly three hundred works, *Modern in the Making: Post-War Craft and Design in British Columbia* maps the rich and complex histories of a diverse array of objects to uncover why the post-war period engendered such exceptional design and craft practices in the region, as well as to explain their enduring cultural relevance. As part of the Gallery's broader effort to encourage visual literacy—thinking critically about what we encounter in our everyday lives—the exhibition and accompanying publication reveal how material culture can shape our collective and individual experiences.

An exhibition of this scale and ambition is truly a collaborative effort. I am deeply grateful to Allan Collier for his steadfast commitment to unearthing the often obscure stories behind each object in the exhibition and for sharing his exhaustive knowledge of the visual culture of this region. His passion, keen eye and deep reverence for modern craft and design has influenced every aspect of this exhibition and publication. I would also like to acknowledge Stephanie Rebick, Associate Curator, for her deft stewardship and handling of the myriad details that an exhibition of this complexity and size requires. It was a pleasure to work once again with Michael Lis of Goodweather, who provided the exhibition and publication design. I thank Michael for his clear vision, which provided a necessary shape to our narrative. I am also indebted to Michelle McGeough and Michael Prokopow for their astute and insightful contributions to this volume.

The assistance and participation of individuals from all departments of the Gallery was required to realize our objectives. The shipping, conservation and installation of nearly three hundred works is a massive undertaking, and I commend our Registrars Jenny Wilson and Amber McBride for their meticulous care of both the objects and their numerous lenders; Preparators Steve Wood, Glen Flanderka and Dwight Koss for their valuable insights, which helped guide the installation and presentation of the works; and Conservator Tara Fraser, who used every skill in her impressive arsenal to ensure that these objects designed for everyday use were exhibition ready. Photographers Ian Lefebvre, Maegan Hill-Carroll and Trevor Mills (who came out of retirement to assist) did an admirable job producing the seductive imagery you see on these pages.

I extend my deep appreciation to Figure 1 Publishing for their enthusiasm for this project and for producing such an elegant volume. *Modern in the Making* would not have been possible without the generosity of the exhibition's Lead Sponsor, Rogers Communications Inc.; and Supporting Sponsors, Coromandel Prowperties and KIMBO Design; as well as Gallery Board Member Phil Lind and the Poseley Family. I would also like to thank the Jack and Doris Shadbolt Foundation for the Visual Arts; the Richardson Family, the Gallery's Visionary Partner for Scholarship and Publications; and an anonymous donor for generous contributions toward the publication. The exhibition was also enriched by the participation of the more than seventy lenders who parted with their prized possessions for such a lengthy period of time. The dedication and passion of these individuals has contributed enormously to the

Previous spread: Folke Ohlsson for A.P. Madsen Ltd., Vancouver, BC, Easy Chair (Model 32), 1950 (produced 1952), beech wood, upholstery, 98.0 × 65.0 × 74.0 cm, Collection of Allan Collier

Installation view of *Ceramics, Textiles, and Furniture*, exhibition at the Vancouver Art Gallery, BC, September 26 to October 14, 1951

documentation, care and conservation of the material culture of the region. I especially acknowledge John David Lawrence, who opened his home to us multiple times to share his extensive collection of Canadian studio ceramics as well as his exhaustive knowledge of the material, and fashion historian Ivan Sayers, who allowed us to draw from his impressive repository of historical clothing. Finally, and most importantly, I thank the artists, designers and artisans represented in these pages, whose timeless objects continue to inspire and tell stories from a different time.

Daina Augaitis
Interim Director, Vancouver Art Gallery

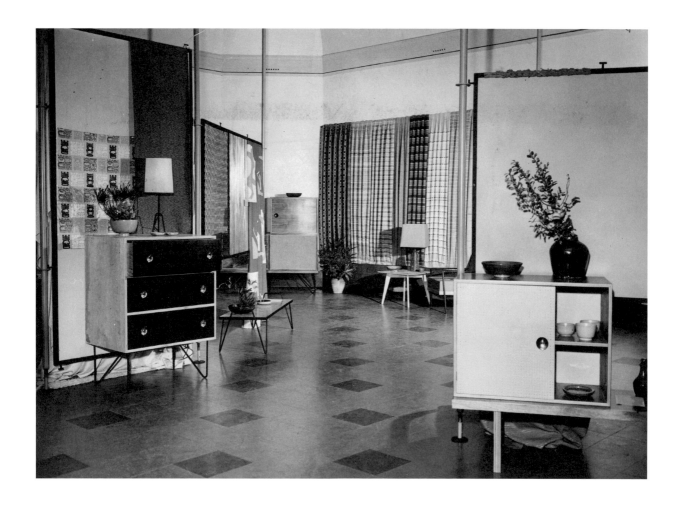

Introduction:
Made in Modern Ways

Daina Augaitis

In many parts of the world, at differing times in the late nineteenth and early twentieth centuries, there arrived a spirit of renewal and reinvigoration. In Europe this groundswell of energy and belief began to dislodge the outdated ideals of a classical order and was deemed to be a "modern" movement. It stemmed from a rejection of the rigid traditions of the past in order to accommodate utopian ideals of progress brought on by industrialization. In this incarnation, modernism took root in the capital cities of Europe at a time when mass migrations of people into urban centres and other sociocultural impacts of the Industrial Revolution were triggering enormous upheaval and alienation. While social and political conditions were difficult, especially for the disenfranchised working classes, in the art world this rupture with the past was liberating and led to enormous innovation, especially in the advancement of abstraction on the one hand and an emphasis on political messaging on the other. By the mid-twentieth century, the modernist belief in limitless social improvement had reached its apex and its universalizing values in turn began to be critiqued by postmodern thinkers. However, modernism's legacies—both productive and damaging—continue to persist around the globe to this day. With the benefit of hindsight, closer examinations of some of the effects of the modern movement, at least in North America, reveal that the utopian goal of modernity to improve society in multiple ways—using innovations in engineering, architecture and technology, for example—was largely a colonial imperative that advanced Western narratives of universal progress while also furthering European cultural dominance over newly acquired territories and people.[1]

In the decades immediately following World War II, thousands of immigrants were drawn to the province of British Columbia, seeking many of the things that still motivate people to move here today: jobs in the resource-based economy, a relatively mild climate and immediately accessible, life-affirming natural surroundings. These immigrants from Europe, the United States and Asia introduced new philosophies and methodologies which added to the end-of-war optimism about the future. This buoyant spirit fostered developments in many sectors, and in the creative field it manifested in a proliferation of art schools, galleries, workshops, exhibitions and other avenues of professionalization. In this corner of the world, it was a time of openness where dialogue and collaboration between artists, architects, designers and makers of all types were cherished, and where celebrations of local artistic achievements were as important as sharing music, images and poetry from other corners of the world. A conscious fusion of art and life gave rise to an overarching effort to elevate domestic spaces, not only by filling them with modern art and well-made functional objects designed for everyday use, but also by incorporating into home decor art that was native to the region. The Potlatch ban to which the Canadian government subjected Indigenous populations beginning in 1885, as well as other repressive forces of cultural assimilation, was officially repealed after WWII, in 1951. The post-war period was thus also a time that First Nations were able to openly reactivate their traditional celebrations after some of the more horrendous burdens of colonization. Alongside continuing the centuries-old tradition of inscribing objects with family histories, Indigenous makers of this region were also savvy to the growing consumerism of the era, making non-ceremonial carvings and weavings embellished

Previous spread: Wayne Ngan in his studio, Hornby Island, BC, 1976

20

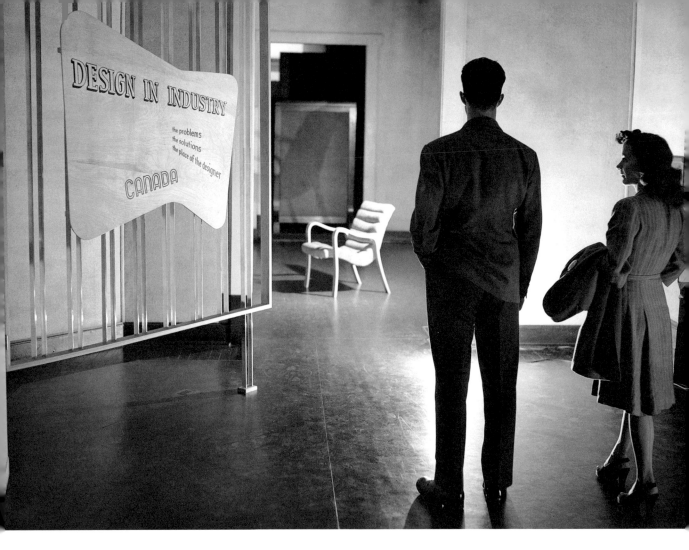

Installation view of *Design in Industry*, exhibition at the National Gallery of Canada, Ottawa, ON, 1946

with Northwest Coast designs for emerging markets in urban centres. Although the layers of cultural knowledge carried by these objects may not have been fully understood by their new owners, many architect-designed, mid-century modern homes displayed prized Indigenous baskets or masks that served to acknowledge the cultural expressions that are deeply imbedded in this land.

While the histories of modern art and architecture as they developed in British Columbia during that robust mid-century period have been widely researched and exhibited,[2] other fields of cultural expression—in the form of the well-designed, the handmade and the skillfully crafted—remain significantly under-documented.[3] Yet this period from 1945 to the early 1970s was especially significant not only because design and craft were deemed to be essential for "living a modern life" (to cite the pioneering modernist architect Le Corbusier's belief in orderly function), but also because in British Columbia these activities were particularly vital to its role as a haven for those seeking a life of creative pursuit. During this time, many local designers were at the forefront of modernism in Canada: they were recognized in significant national exhibitions and publications, and their work was also recruited by the Canadian government to promote a national "design language" predicated on this new functional approach to modern living. This design-based element of national identity was further exported as a signifier of Canada's coming of age at international

biennales, trade shows and embassies. At a meta-level in North America it was also during this period that craft and design, as distinct fields of creativity loosely based around function, began to merge with the world of fine art. This merging of practical design and visual art accelerated as the desire for functional design was supplanted by an excitement for one-of-a-kind aesthetic propositions. Now form, materials and process were the focus of attention, rather than simply utility.

The impetus for *Modern in the Making: Post-War Craft and Design in British Columbia* is to expand the scholarship on this significant subject. This project of research, publishing, interpretation and exhibition involves an enormous gathering of information and objects that have never before been assembled to such an extent. Even so, it tells only one version of the complex story of how design and craft developed in British Columbia; and we hope *Modern in the Making* is one of many to further articulate this field. As curators, we acknowledge that the precedents of British Columbia's modernity were largely developed in Europe and the United States. Notable instances of this cultural flow include the arrival of the "handmade," as popularized by the nineteenth-century Arts and Crafts movement of Great Britain; an intermingling with the edicts of the German Bauhaus, which held that function determines form; the arrival of Scandinavia's uniquely modest utilitarianism and its embrace of natural materials; and an encounter with the enormous influence of American post-war design, which was in the process of expanding the country's dominance. All these movements informed the formal, material and conceptual notions of the modern that flourished in this part of Canada. Indeed, what developed here was a regional inflection of modernity characterized by diversity. This exhibition begins to construct a multifaceted history that was perhaps more significantly affected by local, rather than international, factors such as the availability of specific local materials; the immigration of skilled craftspeople from Europe, Asia and the United States willing to share their distinctive knowledges; the region's geographic isolation, which engendered an independent spirit; the lure of an extravagant natural world, with attendant temptations to live off the land; the presence of Indigenous cultures that were reinvigorated after decades of devastating oppression, and the adaptation of these design traditions to new forms and materials; and a multidisciplinarity that exemplified a bold experimentation even a disregard for the boundaries between art, design, craft and architecture. Comprising almost three hundred works, examines the furniture, ceramics, textiles, fashion and jewellery that defined West Coast modern living in the mid-twentieth century.

This project of foregrounding craft and design from British Columbia arises from an institutional history at the Vancouver Art Gallery that has long considered this field to be an essential component of visual culture. A landmark exhibition at the Gallery in 1949 was *Design for Living*, one of the first exhibitions in Canada to demonstrate how modern furniture (such as DIY chairs), crafts and other household objects complemented the new residential architecture. Organized by Vancouver's Community Arts Council, the widely acclaimed exhibition served as a preview of the modern spirit of craft and design that would come to unfold in British Columbia over the 1950s. Between 1950 and 1980, the Vancouver Art Gallery held numerous design survey exhibitions, including *Ceramics, Textiles, and Furniture* (1951); *Design*

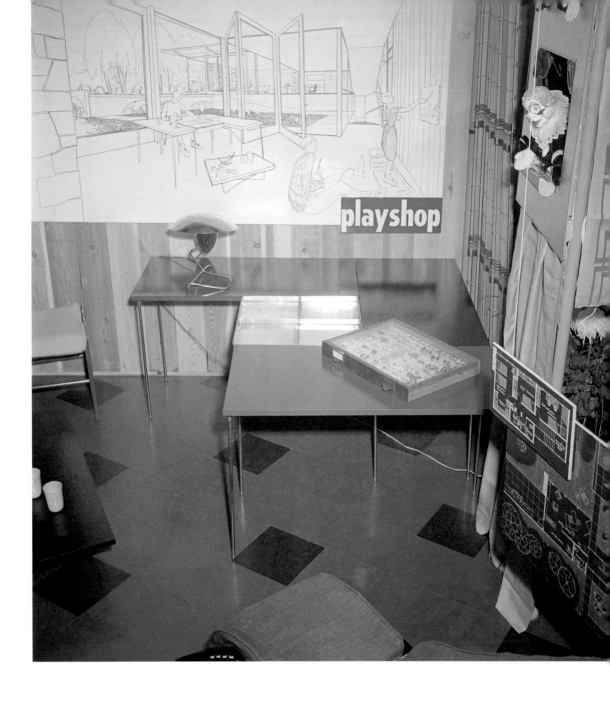

Installation view of the Playshop for the
McTavish Family in *Design for Living*,
exhibition at the Vancouver Art Gallery, BC,
November 8 to November 27, 1949

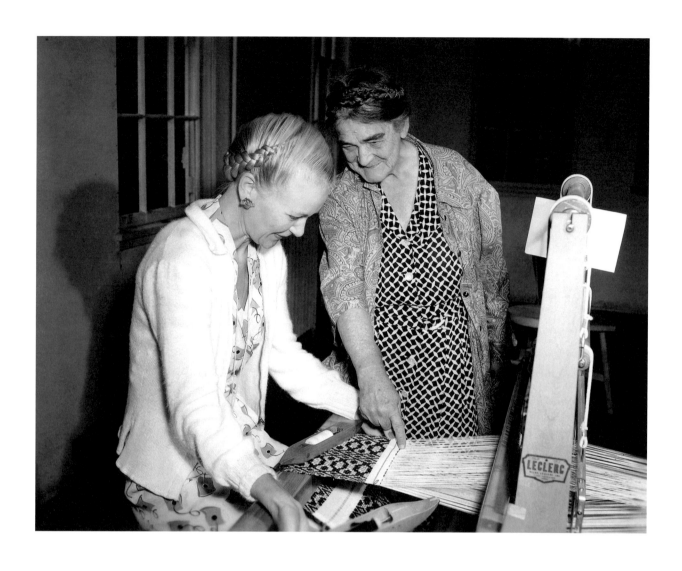

Mary Meigs Atwater provides instruction during a weaving class, Department of Extension, University of British Columbia, Vancouver, BC, 1950

in Scandinavia (1956); *British Columbia Crafts* (1961); *Ceramics '69* (1969); and *28 Years: A Retrospective Exhibit of the UBC School of Architecture* (1974), as well as more than eight solo exhibitions devoted to noted ceramicists and weavers. During this period, the Gallery also hosted a series of annual and biennial exhibitions organized by local craft and pottery guilds. The mounting of so many craft and design exhibitions by the Gallery speaks to the value placed on these activities throughout the BC visual arts community and the public at large. However, by the 1980s, traditional crafts were sidelined as curatorial interests broadened to make way for groundbreaking initiatives in performance, photography, video and multimedia art. In the last decade, the Gallery's exhibition program has been reassessed to once again include visual culture exhibitions that ask broad critical questions related to the possibilities of design or that chart under-recognized typologies.

The *Modern in the Making* exhibition has itself been many years in the making. My co-curator, Allan Collier, has had a lengthy relationship with the Vancouver Art Gallery. He initiated and guest curated *West Coast Modern Furniture, 1945–1960* in 1988; contributed an essay and his expertise to *A Modern Life: Art and Design in British Columbia, 1945–1960*, published in 2004; and allowed loans from his remarkable collection for the Gardiner Museum's touring exhibition *True Nordic: How Scandinavian Design Influenced Design in Canada*, exhibited here in 2016. Indeed, his encyclopedic knowledge of the material culture of the West Coast region is staggering. I first began discussions with Allan in 2007 about the possibility of the Vancouver Art Gallery becoming the eventual home for his furniture collection. I was inspired by his infectious enthusiasm about the post-war period, and together we pondered how to contextualize his collection in ways that would not repeat previous exhibitions[4] that took on a national context or examined the relationship with visual art. Allan and I landed on researching the largely untold post-war narrative of design and craft in British Columbia, a region of Canada that has yet to have scholars and curators bring sufficient attention and documentation to its unique historical development. Over the course of two years, we made countless visits to artists, practitioners, artisans, designers from that era—people who make incredible objects that arise from a variety of craft and design traditions and defy conventional labels—and their children and friends, as many are elderly or have passed away. We talked to curators and historians and had endless meetings to uncover the work of individuals who may have previously been overlooked, allowing us to chart the history that is mapped out in the essays of this book. A significant dimension of this project is to acknowledge that as the first European settlers were landing in British Columbia, there already existed a sophisticated language of design here, as seen in the remarkable objects made by Indigenous Peoples. They remain essential to our perceptions of design development in this region, and by incorporating examples of Indigenous production, this project attempts to level some of the power imbalances that emerged as modernism strained to achieve its utopian goals of progress. We also aimed to tell a broader story by including immigrant artists who had not arrived from Europe or the United States but had Asian ties, and by persevering to find works whose historical value may not have been evident at the time, such as some of the jewellers, and by including weaving objects and other works by women which could only be tracked

through word of mouth. In sum, what we have produced is a messy genealogy made up of the threads, lineages, movements, historical actors and contemporary agents (both familiar and previously unheralded figures) that gave rise to British Columbia's creative expressions during a time when people were embracing new and often radical thinking about post-war domestic life and its materiality. Our historical account of this modern period is timely from two perspectives. The first is that the inter-generational transfer of wealth and possessions occurring today has many people wondering if the objects valued by older generations still have significance. Secondly, from the perspective of today's technological age, we can see that a wave of renewed appreciation for the non-digitized and handmade is rising, not only in contemporary art but in broader expressions of creativity.

Where shall these mid-century design and craft objects live once they have passed out of the hands of their original makers and owners? Many questions about the cultural value and collecting practices of such objects have emerged over the course of this project. They arose from the fact that, as curators, we had the extraordinary privilege of accessing both the riches of public collections and the decades-worth of collecting undertaken by impassioned private individuals whose work remains largely invisible to the public eye. In Vancouver, Victoria, Nanaimo, Surrey and other major centres in British Columbia, some institutional collecting exists, but between these disparate bits it is difficult to piece together a comprehensive whole, especially regarding jewellery or textiles. With the additional involvement and aid of very generous, knowledgeable and committed private collectors, it was possible for us to assemble, from their discerning and extensive collections, the foundation of British Columbia's post-war material history. As many of these collectors ease into their sixth or seventh decade, they are now considering their options: sell the works so that others can collect anew; create not-for-profit foundations that require funds in addition to physical holdings; or donate to a public institution for long-term care but where necessities of storage and curatorial knowledge may be lacking. Surprisingly, the province of British Columbia cannot boast a dedicated design or craft museum. A sense of urgency is mounting as one of the most prolific periods of this province's cultural heritage faces the danger of being unwittingly dispersed, simply because the knowledge of what is valuable as cultural heritage is not widespread nor is there a clear and logical repository for these objects. I encourage collaborative, interinstitutional discussions—that include collectors—about activating new possibilities for housing these collections in perpetuity, to ensure that this important segment of British Columbia's craft and design history is preserved for future generations. This province's post-war creativity stands as an important reminder of the pleasures and responsibilities we can all take in the mindful living of everyday life.

Installation view of *Pottery by Wayne Ngan*, exhibition at the Vancouver Art Gallery, BC, December 2, 1978 to January 7, 1979

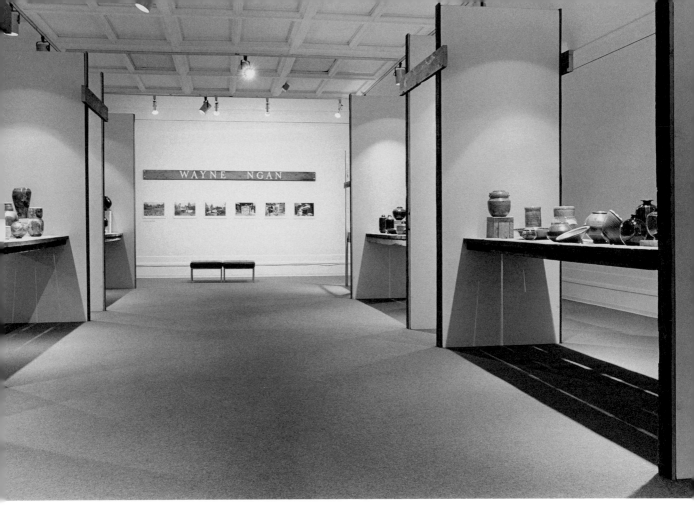

NOTES

1 Michelle McGeough's and Michael J. Prokopow's texts in this volume
expand on the toll of modern development on Indigenous Peoples of the
Northwest Coast.

2 The Vancouver Art Gallery has steadfastly investigated the regional manifes-
tations of modern art, in particular in *Vancouver Art and Artists: 1931–1983*,
published on the occasion of the Gallery's relocation to its current site on
Hornby Street, as well as in numerous other solo and group exhibitions on
this subject. The Charles H. Scott Gallery, Vancouver, also exhibited and
published several books on the mid-century modern architecture of this
region. Likewise notable is the West Vancouver Art Museum's exhibition
program, which frequently focuses on local post-war art and modern design.

3 Some significant exceptions are *Thrown: Influences and Intentions of West
Coast Ceramics*, an exhibition and publication organized by the Morris and
Helen Belkin Art Gallery, Vancouver, in 2004 that examined post-1960s BC
ceramics made in the tradition of the studio pottery movement established
by Bernard Leach and Shoji Hamada; and other smaller ceramics surveys
including Bob Kingsmill's *A Catalogue of British Columbian Potters*, com-
piled in 1977. There is still work to be done on full-fledged historical surveys
of the art and design of various Indigenous nations of the Northwest Coast,
although some examples include *Raven Travelling: Two Centuries of Haida
Art*, Vancouver Art Gallery, 2006; U'mista Cultural Centre; and others.

4 These include the Vancouver Art Gallery's 2004 *A Modern Life: Art and
Design in British Columbia, 1945–1960* where curator Ian Thom merged
craft with visual art, or the Art Gallery of Greater Victoria's 2011 *Modern
Eye: Craft and Design in Canada* that offered a national narrative of Cana-
dian design and craft.

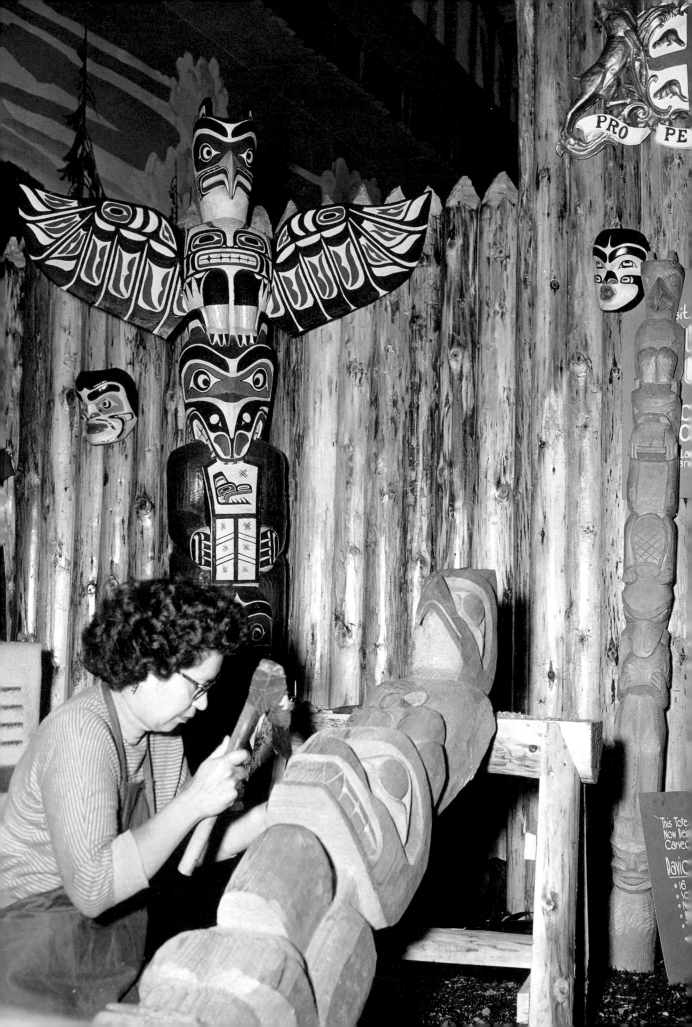

This Tote
Now Bei
Davic
16 <c

From Prohibition to Revitalization: Indigenous Arts and Cultural Production in British Columbia during the 1950s

Michelle McGeough

Beginning in the 1950s, British Columbia's public institutions facilitated a renewed interest in the cultural production of Indigenous Peoples in the Pacific Northwest. This occurred, in large part, due to a shift in federal government policy in the previous decade. In 1946, the Canadian government, under pressure from the newly formed North American Indian Brotherhood, had established a special joint parliamentary committee on "Indian affairs." In consultation with First Nations leaders, the commission began to recast the government policy of the forced assimilation of Indigenous Peoples. Through these consultations, changes were made to the federal Indian Act in 1951. In one such revision, the measure that had made it illegal for British Columbia's First Nations to engage in the Potlatch ceremony was removed.

Canada's desire to project a positive post-war image helped motivate the changes it would implement toward improving its relationship with First Nations people. After all, as a member of the newly formed United Nations in 1945, it had emerged as a major peacemaking player alongside the superpowers of the Western world. However, as Canada put its external affairs in order, it didn't do the same domestically; this lapse was especially evident in its relationship with Indigenous Peoples.

In British Columbia, the repeal of the Potlatch ban was one of many factors that fostered an active and fertile environment for Indigenous cultural and artistic production in the 1950s.[1] With the overturning of that law, cultural objects associated with the ceremony, such as masks, dance curtains and totem poles, were being made once again without fear of confiscation. Although in earlier decades non-Native anthropologists and museum professionals made concerted efforts to actively preserve Canada's Indigenous past, this involved the removal of these forms of cultural objects from active use and their storage in public institutions and, in some instances, private collections. It was also largely non-Native interests, realized through institutional support and gallery exhibitions, that shaped the public's understanding and knowledge of First Nations cultures. Importantly, however, Indigenous artists harnessed this revitalization for their own purposes. For example, the carvers Mungo Martin and Ellen Neel helped secure greater public awareness of the distinctive worldview of the Pacific Northwest First Nations by presenting a Kwakwaka'wakw cosmology in their cultural and artistic production.

Policy changes by the United States Bureau of Indian Affairs also influenced policymakers above the forty-ninth parallel. As early as 1935, under the New Deal brought in by Franklin D. Roosevelt's administration, the United States government passed the Indian Arts and Crafts Act. This act mandated five appointed commissioners "to promote the economic welfare of Indian tribes and the Indian wards of the Government through the development of Indian arts and crafts and the expansion of the market for the products of Indian art and craftsmanship."[2] The Canadian government, too, recognized the potential of Native arts and crafts as a viable strategy to encourage economic development and provide a way for Indigenous Peoples to participate in the market economy. Beginning in the 1940s, private interest groups, aligned by their interest in the welfare of Native Peoples, successfully lobbied the Canadian government to support the production of Native arts and crafts.

Previous spread: Ellen Neel carving a totem pole at the Pacific National Exhibition, Vancouver, BC, 1953

Through the efforts of organizations such as the Society for the Furtherance of BC Indian Arts and Crafts, the production and sale arts and crafts made by Indigenous people "became institutionalized at a federal level in various Department of Indian Affairs (DIA) policies."[3]

The BC-based society, founded in 1940 by Alice Ravenhill, had a board of seven members. Upon incorporation in 1951, the group changed its name to the British Columbia Indian Arts and Welfare Society. The organization had the following objectives:

> …to compile a schedule and pictorial record of authentic specimens of totem poles, pictographs, petroglyphs and other tribal arts and crafts; to compile a bibliography on B.C. Arts and Crafts; to collect new material in the form of drawings, photographs or written records of B.C. Indian Arts and Crafts; to encourage commercial use of these and all other authentic B.C. Indian designs; to gather records of B.C. Native Music; to compile a bibliography of B.C. Native Mythology and Drama; to encourage Pupils of Indian Schools and Tribal Experts in the revival of their latent gifts of Arts, Crafts and Drama, with a view to improve their economic position, to restore their self respect, and to induce more sympathetic relations between them and their fellow Canadians; and to publish leaflets, books and articles in harmony with the work of the Society.[4]

These goals reflected a much larger concern that the government's assimilationist policies—especially the Potlatch ban—had contributed to the perception that First Nations were in decline and that both the "Indians" and their art were on the brink of extinction. This notion was so pervasive that most discussions regarding Indigenous art during this period lamented the loss of Indigenous cultures and their arts. Undeniably, the Potlatch ban had a devastating effect on cultural production. During the sixty-six-year ban, items such as totem poles and masks, presented in the Potlatch ceremony to publicly affirm the rights and privileges held by families and individuals, were seldom produced. Many of the cultural objects that did remain in communities were frequently stolen and sold to private collectors or to institutions in North America and abroad.[5] Especially popular on the international market were the monumental sculptures known as totem poles. Although the collection and preservation of totem poles by non-Indigenous institutions and individuals had begun decades earlier, the 1950s saw an increase of acquisition activity in British Columbia. The province's institutions took a special interest in the poles that still remained in Indigenous communities up and down the Pacific Northwest coast.

Many scholars have offered insights regarding this interest in Indigenous cultural production, explaining that these acts were not solely to preserve and restore Indigenous culture to its past splendour. Rather, the incorporation of Indigenous cultural items into public collections during this era can be considered a form of appropriation in service of the construction of a national mythology regarding Canada's treatment of Indigenous Peoples.[6] As the historian Daniel Francis explains, the promotion

of Indigenous Peoples and their cultures as dead or dying—a practice central to the settler nationalist discourse—enables the birth of the "imaginary Indian": a being wholly constructed by non-Indigenous observers—a uniquely "Canadian" subject.[7] The representation of Indigenous cultures and Peoples as extinct has enabled settler nation-states such as Canada to ignore the ongoing violence of the colonial project. In this country in the 1950s, First Nations people did not have the right to vote and First Nations women still lost their Indian status when they married a non-Native man. While the totem pole as a symbol may have represented the splendour of an Indigenous past, it certainly did not represent the contemporary realities of Indigenous people in the 1950s.

As the turn of the decade, the Royal Commission on National Development in the Arts, Letters and Sciences, often referred to as the Massey Commission after its chair, Vincent Massey, was just gathering momentum. During the course of the two-year inquiry, the commission held 114 public hearings throughout Canada.[8] A report of its findings was published in 1951. Charged with the task of determining the state of Canada's art and cultural affairs, the commission recommended in its report the founding of the National Archives, the Canada Council for the Arts and federal funding for universities and the conservation of Canada's historical past.[9]

As the anthropologist Michael Ames has written, institutions are cultural artifacts of the societies that produce them.[10] An institution, whether a museum or an art gallery, produces and reproduces prevailing notions and their subsequent narratives regarding Indigenous cultures. The notion that Indigenous art had died and was brought back from the brink of destruction has continued to be a commonly held belief, despite evidence to the contrary. In 1935, Reverend George Raley wrote:

> Admitting there have been a large falling off of both men and women engaged in primitive arts and crafts in the past years: admitting the artisan has not been able to secure full time occupation at his craft and that the sale for his merchandise is small compared with what it was up to the time of the depression: there still remains a sufficient number of craftsmen who are producing work of fine quality.[11]

In the 1950s, Indigenous arts and cultural production were presented as being from the past. Consequently, these narratives influenced which artists and projects were supported through commissions and exhibitions in British Columbia's art institutions during this period.

Ellen Neel, West Wind Mask, c. 1946–65, cedar, 27.4 × 18.4 × 10.5 cm, Courtesy of Equinox Gallery

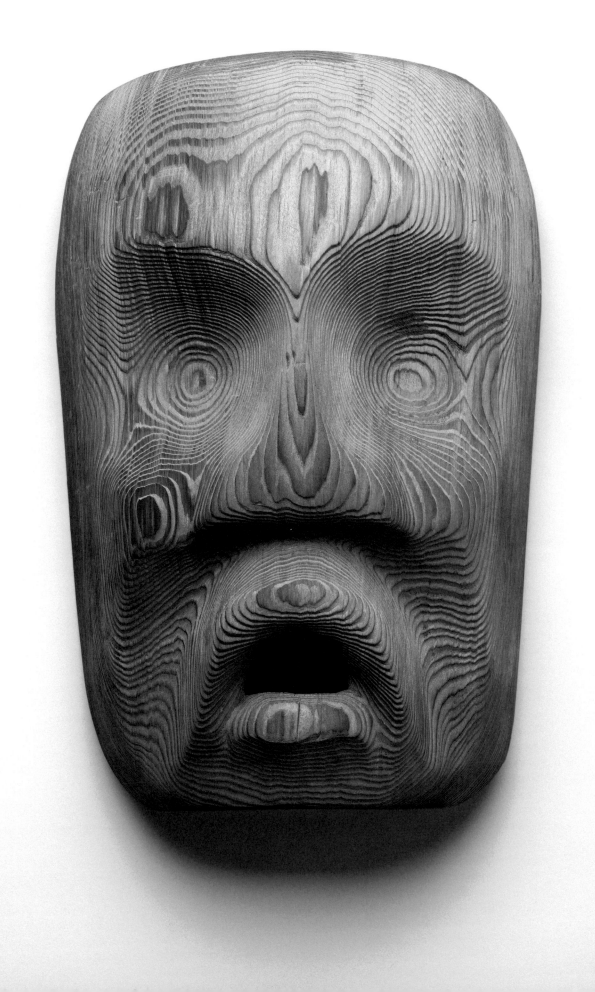

THE TOTEM POLE PRESERVATION PROJECT

The renewed interest that arose in the 1950s around totem poles was multilayered and complex, and the symbolic meaning found in the poles shifted depending on the audience. For the general public, they were associated with tourism, whereas others viewed them as a hallmark of a bygone era. The Totem Pole Preservation Project began in late 1949 under the sponsorship of the University of British Columbia, with initial funding from the Office of the Provost. The project was administered by the university's newly established Department of Anthropology and Museum of Anthropology (MOA), both of which were under the direction of Harry Hawthorn, OC. The intent was to restore the totem poles held in the MOA's collection. Kwakwaka'wakw carvers Mungo Martin and Ellen Neel were commissioned to repair the poles that had been ravaged by time and the coastal elements. Although Neel left within the first few months of the project to pursue other artistic avenues, Martin remained until 1952.

As an invited speaker at the Conference on Native Indian Affairs in 1948, Neel made her vision for Indigenous arts known. Her poignant speech provided insight as to why her participation in the totem pole restoration project was short-lived:

> This point of mine, which I shall endeavor to illustrate, deals with an idea that the Native Art is a dead art and that efforts should be confined to preservation of the old work. To me, this idea is one of the great fallacies where the art of my people is concerned. For if our art is dead, then it is fit only to be mummified packed into mortuary boxes and tucked away into museums. Whereas to me it is a living symbol of the gaiety, the laughter and the love of color of my people, a day to day reminder to us that even we had something of glory and honor before the white man came. And our art must continue to live, for not only is it part and parcel of us, but it can be a powerful factor in combining the best part of Indian culture into the fabric of a truly Canadian art form.[12]

Neel focused her efforts to reframe Indigenous cultural production as alive and thriving on the Totem Arts Shop located in Vancouver's Stanley Park, where she had an open studio and sold miniature totem pole carvings.[13] With the acumen of a seasoned entrepreneur, Neel was a strong advocate for Indigenous arts. Having to support her family, Neel branched out and sought various marketing opportunities, for which she "designed and created items such as table runners, coasters, trays, skirts and designs for Royal Albert China and extended her repertoire to include wearable art such as bags, blouses and skirts."[14] She understood the need to cultivate and educate the consumer to build and sustain a market for her artistic production. The mainstay of her practice was tourist curios and private commissions; her market was not institutions.

In that same 1948 speech, Neel made an impassioned plea: "We the Indian artists must be allowed to use new and modern tools, techniques, and new and modern materials." This statement reveals that, at least for Neel, Indigenous art needed to

Two views of a Totem Pole carved by Ellen Neel that was presented as a gift to an Australian delegation to Canada, 1950

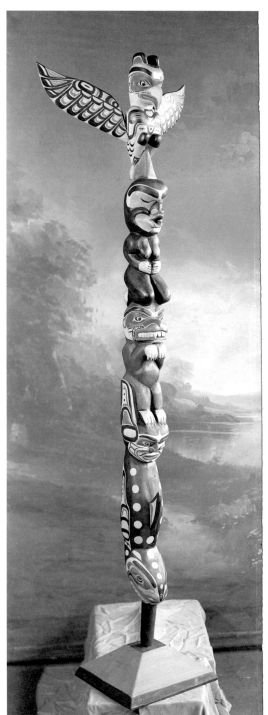 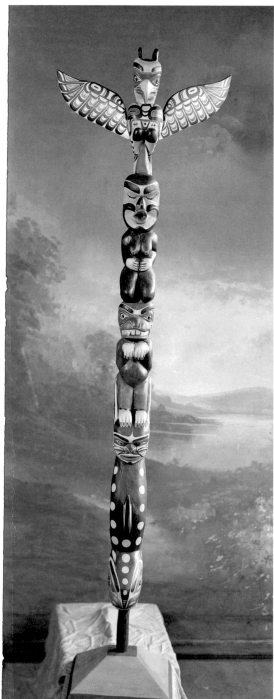

35

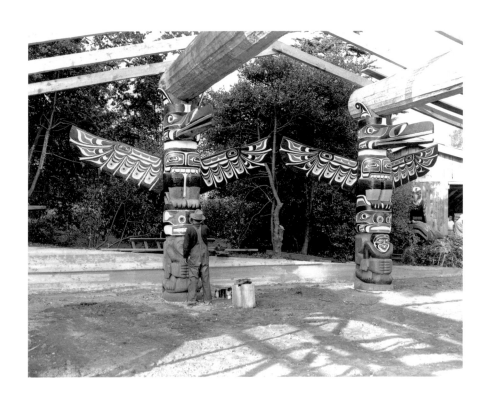

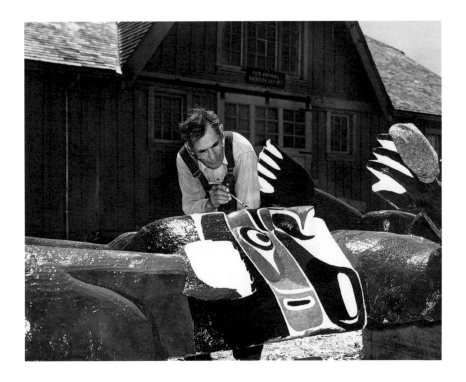

Above: Mungo Martin in Thunderbird Park, Victoria, BC, 1953

Left: Mungo Martin painting a Totem Pole, Vancouver, BC, 1949

come forward into the twentieth century. However, institutions at that time were reluctant to embrace this approach. Instead, British Columbia's public bodies focused on reproducing and restoring monumental carvings and exhibited only historical cultural objects. The irony was that taking these cultural objects from Indigenous communities facilitated the loss of the knowledge embedded in and activated by them. That is, these institutions appeared to extol Indigenous arts and culture using the same objects whose removal undermined the active survival of these very cultures.

Meanwhile, under Mungo Martin's skillful hands and the efforts of his apprentices, the restored poles and two newly commissioned poles were raised and presented in a dedication ceremony in Totem Park at the University of British Columbia in the spring of 1952.

Martin and Neel both played pivotal roles in the promotion of Indigenous arts but in very distinct ways. Through his commissions with the university as well as the Royal British Columbia Museum, Martin made substantial contributions both as a carver and as a cultural consultant. From an outsider's point of view, the pinnacle of Martin's career came in December 1953, when he sponsored the first public Potlatch held since the ban's repeal two years earlier. The opening of the big house Wa'waditla on the grounds of the Royal BC Museum in Victoria, where the Potlatch was held, was a remarkable achievement for its time.[15] Designed by Martin and constructed

Ellen Neel, Postcard, 1960, card, 8.9 × 13.9 cm, Museum of Vancouver, H2008.23.3186

with the help of his son David Martin and son-in-law Henry Hunt, the structure was based on the big house Martin knew as a child in Fort Rupert. The political ramifications of building a Kwakwaka'wakw big house in the Traditional Territory of the Songhees and Xwsepsum Nations does not seem to have been an issue, at least publicly. The presence of the longhouse made a bold statement: it publicly reinforced an Indigenous form of governance and culture. Its close proximity to the provincial legislature not only increased the visibility of Indigenous Peoples in British Columbia's capital but also served as a form of reclamation.

While Martin followed the Protocols of traditional Kwakwaka'wakw carving practices, Neel was more experimental in her artistic output. Her usual commissions, primarily from the private and commercial sectors, offered more creative leeway. For example, while a traditional Kwakwaka'wakw totem pole displays the family crest of the person who commissioned the pole, Neel's work might include symbols that deviate from this practice. A totem pole she carved for the White Spot restaurant, for instance, featured Kwakwaka'wakw elements, but she placed a white rooster—the restaurant chain's mascot—at the pole's crown.

In the years that followed, British Columbia's public institutions would maintain their interest in preserving the past. For example, totem pole restoration projects, funded in part by government sponsorship, continued throughout the decade and into the next. The success of these projects is evidenced by the names of their participants, including Mungo Martin and Bill Reid, who are among Canada's most distinguished Indigenous artists.

The support for Indigenous "arts and crafts" demonstrated by such preservation projects as well as new commercial enterprises was not entirely altruistic, however. Instead, the institutions who backed this work viewed the art and crafts as a viable form of economic development. However, this was a difficult task, as cheaper curios from offshore sources were flooding the market, making the competition very difficult for artists. As an artist and businesswoman, Ellen Neel understood that in order for the arts to thrive, artists' compensation had to be a fair reflection of the cost of the materials used and the labour expended. Being the visionary she was, Neel foresaw that educating both the public and institutions was the lynchpin to developing a successful market for Indigenous art.

The 1950s was a crucial period that defined the future of Indigenous art in British Columbia. However, the notion that these art forms were lost or brought back from the brink of destruction during this time remains questionable. As George Manuel, the Chief of the National Indian Brotherhood, would observe twenty years later:

> The renaissance of today is the fruit of the accumulated labour of our grandfathers. If it appears that we are only awakening and discovering a new strength it is because the current climate of political, social and economic forces is allowing what was always beneath the surface to emerge into the light of the day.
>
> Above all, the appearance that we are only now coming alive is an illusion created by the press and public institutions, who have for so long warped, distorted and falsified the story of our resistance.[16]

NOTES

1 I recognize that there is much debate regarding the application of the term "art" to the objects created for use within an Indigenous context (such as Potlatches). For the purpose of the discussion here, I use the term "cultural production" to identify those objects or entities that were created for cultural purposes such as ceremonies and have been brought into ceremonial life through the processes dictated by community Protocols. I use the term "art" to refer to objects created by Indigenous artists for circulation outside of these original cultural contexts.

2 U.S. Department of the Interior, "Indian Arts and Crafts Act of 1935," https://www.doi.gov/iacb/indian-arts-and-crafts-act-1935.

3 LiLynn Wan, "'A Nation of Artists': Alice Ravenhill and the Society for the Furtherance of British Columbia Indian Arts and Crafts," *BC Studies*, no. 78 (Summer 2013): 52.

4 British Columbia Indian Arts and Welfare Society Fonds, British Columbia Archives, CA BCA accession 2011.118, https://www.memorybc.ca/british-columbia-indian-arts-society-fonds.

5 The market created for Indigenous cultural objects by private collectors and institutions demands resulted in instances where cultural belongings were sold by family or community members who had internalized settler colonial ideas and beliefs regarding Indigenous cultural practices.

6 Marcia Crosby, "Construction of the Imaginary Indian," in *Vancouver Anthology: The Institutional Politics of Art*, ed. Stan Douglas (Vancouver: Talonbooks, 1991); Terry Goldie, *Fear and Temptation: The Image of the Indigene in Canadian, Australian, and New Zealand Literatures* (Montréal: McGill-Queen's University Press, 1993); Nicholas Thomas, *Possessions: Indigenous Art/Colonial Culture* (London: Thames & Hudson, 1999); and Carmen Robertson, *Mythologizing Norval Morrisseau: Art and the Colonial Narrative in the Canadian Media* (Winnipeg: University of Manitoba Press, 2016).

7 Daniel Francis, *The Imaginary Indian: The Image of the Indian in Canadian Culture* (Vancouver: Arsenal Pulp Press, 1992), 223.

8 *Report: The Royal Commission on National Development in Arts, Letters and Sciences, 1949–1951,* Library and Archives Canada, 1951, https://www.collectionscanada.gc.ca/massey/index-e.html.

9 *Royal Commission Report*.

10 Michael M. Ames, *Cannibal Tours and Glass Boxes: The Anthropology of Museums* (Vancouver: UBC Press, 1993).

11 G.H. Raley, "Important Considerations Involved in the Treatise on Canadian Indian Art and Industries,"1935, Raley Papers, H/D/R13-3(11), Unpublished BC Archives, Victoria.

12 Ellen Neel, "Speech Presented at the Conference on Native Indian Affairs," 1948, box 2 2-4, Harry Hawthorn fonds, University of British Columbia Archives, Vancouver.

13 Robert Amos, "A Lifetime of Visionary Totem-Pole Art," *Times Colonist*, February 5, 2017, https://www.timescolonist.com/islander/robert-amos-a-lifetime-of-visionary-totem-pole-art-1.9714269.

14 Carol Butler-Palmer, "Ellen Neel: The First Woman Totem Pole Carver," brochure (Victoria: Legacy Gallery, University of Victoria, 2017).

15 The importance of this event was later recognized and remarked upon by the local press; see Kevin Griffin, "Art from the Archive: Mungo Martin lying in state in Wa'waditla, *Vancouver Sun*, October 15, 2015.

16 George Manuel, *The Fourth World: An Indian Reality* (Don Mills, ON: Collier-Macmillan, 1974), 69–70.

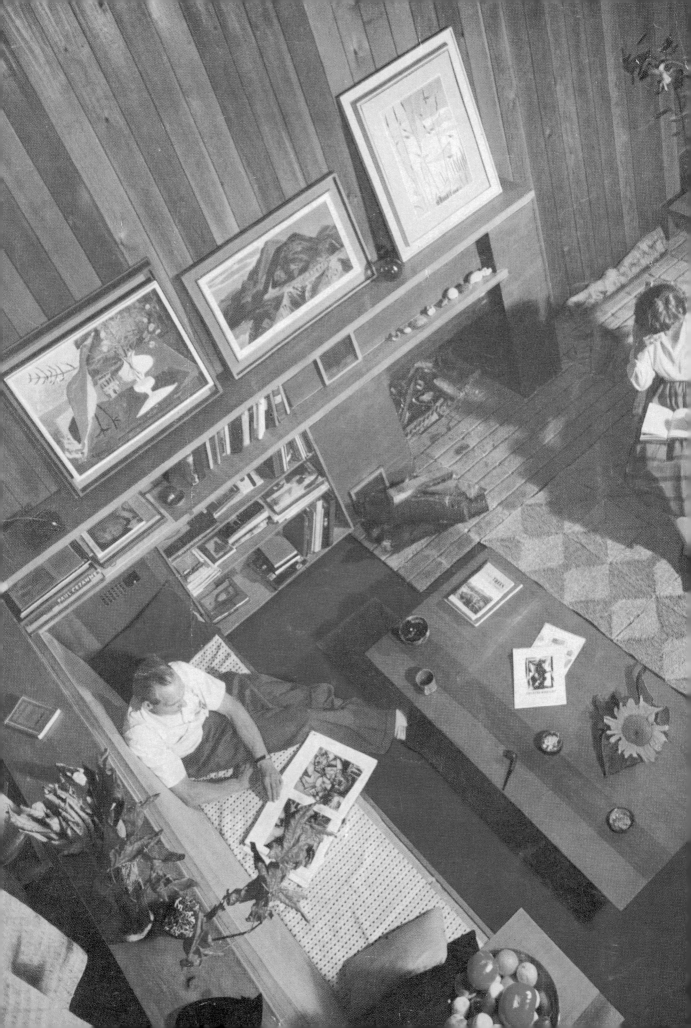

"To Have a New World"; or, Contingent Modernisms, Colonialisms and Rethinking the Histories of Design and Culture in British Columbia[1]

Michael J. Prokopow

|

> By posing fundamental questions such as "For whom are histories of design written?", "Whose interests do they serve?", design history also fulfils a critical role in respect to the discourse of design.[2] —John A. Walker

The town of Haney, British Columbia, laid out in the nineteenth century on the ancestral and unceded lands of the Katzie First Nation, might not seem a likely place by which to consider the ideological and aesthetic implications of the modernization of the province. Indeed, numerous other places and sites could serve as points of entry into a discussion about the intellectual mechanisms and ethics of what can be called "the modernist project" in British Columbia in the twentieth century. And yet, the fact that the hamlet of Haney was the home and workplace of the well-known potter Ruth Meechan makes it useful in thinking about the transformation of Indigenous homelands into sites of technological, social, aesthetic and material change in the province, particularly in the decades between 1920 and 1970.

Situated just over a kilometre from the northern bank of the Fraser River, some fifty kilometres upstream from the Pacific Ocean, and named after the "early pioneer" Thomas Haney, who was an Ontario-born brickmaker, Haney's historical development—like so many settler places in the colonial and provincial history of British Columbia—is at once commonplace and particular.[3] With the Hudson's Bay Company's economic exploitation and settlement of the Fraser Valley in the 1840s; to the signing of the first treaties that resulted in the cession of title a decade later; through the expansion of the lumber trade in the late 1850s and the commencement in 1858 of the state-building and cartographic activities of the Royal Engineers; from the laying out of the first reserves on the mainland under the policies of Governor James Douglas in 1850; onward through the arrival of a second wave of immigrants to the province in the 1870s and 1880s; and finally to the rapid and significant industrialization and population growth in the Lower Mainland between 1900 and 1940, so the history of Haney, while distinct, represents the broad, often blunt, forces of colonial and modern change in the province, meaning westernization.[4]

That Haney was home to Meechan and her studio sometime after 1950 is significant because of what it reveals about how modernization was negotiated in the province. It serves as a starting point from which to trace the ideological and personal strategies employed to advance the idea of "progress" that defines the modern period. Meechan's activities as a ceramicist, including her long-standing involvement with the BC Potters Guild, are striking in their seeming contrasts: she explored the aesthetics of the modernist movement, and she made well known her interests in the cultural forms of the Indigenous Peoples of the Pacific Northwest.[5]

Raised in Saskatchewan, Meechan moved to British Columbia in the early 1940s to study art and graphic design. Socially minded, politically active and interested in the arts, she sketched, painted and worked in textiles before, in the early 1950s, turning her creative abilities to ceramics, taking night classes with Reg Dixon at the Vancouver School of Art. Her studio work—functional, modern and stylistically indebted to British, Scandinavian and Californian precedents—was sold in specialty shops and profiled in the popular press, including the Vancouver-based *Western Homes and Living*.[6]

Previous spread: Interior view of Molly and Bruno Bobak's House, North Vancouver, BC, published in *Western Homes and Living*, November 1951

Right: Ruth Meechan, Dish, 1970, ceramic, 3.0 × 21.9 (diameter) cm, Collection of John David Lawrence

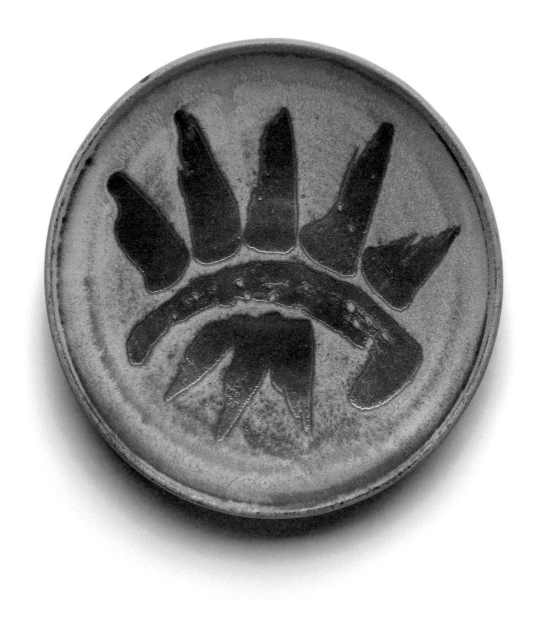

However, and significantly, in addition to Meechan's studio practice and her public dedication to the promotion of contemporary ceramic arts in the province, she sought economic gain by producing a line of mould-made tourist wares decorated with bas-relief motifs taken from the design traditions of the Haida, Tsimshian and other West Coast First Nations (allegedly the result of a class assignment). These ceramic works—essentially ethnographically-inspired pieces for tourists and decorative accessories for middle-class homes—were hugely successful and, in many ways, are what made Meechan's name as an artist. Generally small in size and square, ovoid, triangular and occasionally elongated in shape, the dishes were most often glazed dark beige and brown in colour. Their backs were marked with an underlined "R" over an "M" and the sentence "HANDMADE OF B.C. CLAY."[7]

The significance of Meechan's Indigenous-inspired and other problematically decorated dishes, made as a settler on the Traditional Territory of another nation, the Katzie, lies in the fact that her assured, seemingly unapologetic appropriation of Indigenous motifs captures one of the more complex aspects of the dominating sensibility of aesthetic and ideological modernism in the province. The relationship between the logic of settler dominion, ideas of progress and its material articulation through modernism—which can be defined broadly as the transformation of social existence through design—at the expense of Indigenous Peoples was rarely interrogated at the time. If colonialism was tied to ideas of implementing "correctness" and "civilization," then modernity—despite being hailed as universalizing and beneficial for all—in fact represented a particularized expression of long-held ideas about hierarchies of cultures and their agents. As such, Meechan's dishes need to be understood as an homage to the idea of the "primitive" or "tribal," as situated within western thought systems about superiority and progress and as such representative of the widespread modernist action of sampling non-western cultures at will to affirm ideas about the right to power.

On the fascination of early twentieth-century Europeans with the arts of Africa and elsewhere, the contemporary multimedia artist Susan Hiller insightfully notes that

> In borrowing or appropriating visual ideas…found in the class of foreign objects that came to be labelled "primitive art," and by articulating their own fantasies about the meaning of the objects and the people who created the artists have been party to the erasure of the self-representations of colonized peoples in favor of a western representation of their realities.[8]

Hiller also notes the interest in the material culture of colonized societies—a topic well interrogated by scholars of twentieth-century art and design—is an important dimension of the ideological operations of modernity. It is as if the acknowledgement by western artists of the societies that are being colonized and marginalized is intended to serve as some sort of elegiac counterpoint to the at once hegemonic and progressive ideas that modernism strove to propound and make tangible.

Ruth Meechan, Three Dishes, c. 1955–63, ceramic, a: 2.4 × 11.0 × 11.0 cm, b: 2.1 × 8.4 × 14.4 cm, c: 2.2 × 10.9 × 28.4 cm, Collection of John David Lawrence

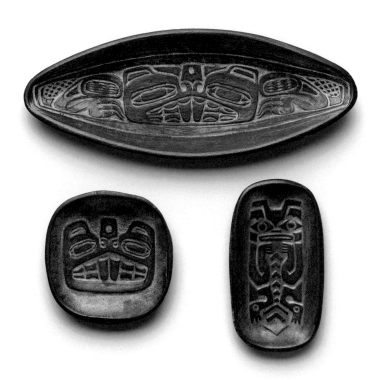

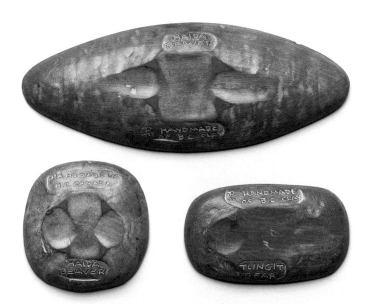

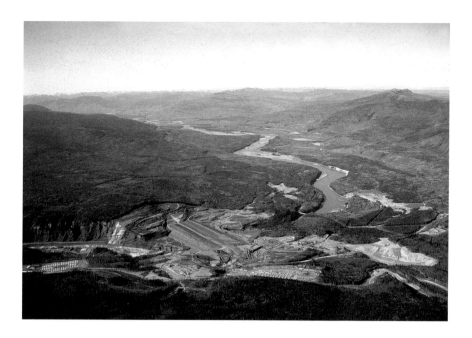

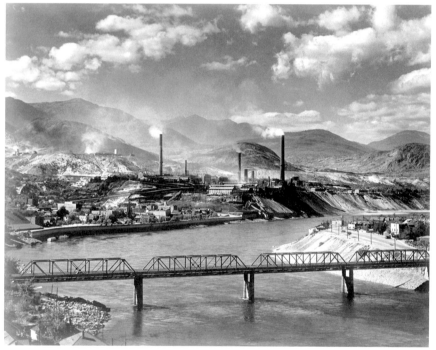

If modernization—namely the application of ideological thinking, technological capacity and agendas of societal betterment in the name of "progress"—is a collective (western) project of enduring transformation, then Meechan's Indigenous-style dishes bring into sharp focus the means by which British Columbia was made modern. Forced dislocation and migration, the criminalization of social rituals, economic marginalization, the theft of cultural property, the kidnapping of children and their incarceration and indoctrination in residential schools, the ostracism and open vilification of Indigenous Peoples, and the settler appropriation of sacred forms were vital to the consolidated work of white settlement and settler definitions of progress

Aerial view of Bennet Dam, Hudson's Hope, BC, 1966

Cominco Smelter, Columbia River, Trail, BC, 1943

and undeniably contributed to what has been identified as cultural genocide.[9] Meechan's factory productions were intended to be understood in a specific way and to be owned by people who willingly, if unwittingly, participated in the settler culture of appropriation and cultural commodification. The dishes, meant merely to be amusing knick-knacks tied to a place and its colonial history, in fact operate as tangible manifestations of hegemonic power and the ownership of history.

Indeed, the settler use of Indigenous objects and images in the modernist period in the province requires in-depth examination.[10] In British Columbia, the use of Indigenous forms as decoration was extensive (whether authentic items or "Indigenous-looking" objects made by settlers), and this tendency is centrally important to the visual and aesthetic operations of modernism. Accordingly, the fact that Indigenous forms are inextricably bound up in the design history of the province can be understood in two ways.

First, cultural appropriation and cultural commodification were part of larger western interests in the "exotic" and a need on the part of settler societies to "other" Indigenous Peoples in order to legitimate the imposition of exploitative systems of power—manifested in a range of attitudes and behaviours—that serve colonizers, and other imperial and state agents.[11]

In British Columbia, as in the case with so many post-colonial jurisdictions, the work of modernizing infrastructure, changing social practices and producing new machines and new tools for everyday life—whether works of architecture, art, industrial design or craft and whether utilitarian or decorative—could only be achieved through the consolidation of systems of control over a place's land and resources and over its Indigenous Peoples. As in the rest of Canada, the creation of reservations in British Columbia and other control structures enacted when the province entered Confederation in 1871 would prove essential to implementing the technological and social changes understood and promoted as modernity. The construction of hydroelectric dams, highways, bridges, tunnels, steel-framed and glass buildings and other towering structures, the proliferation of middle-class suburbs with their cookie-cutter bungalows and low-slung ranch houses, and the reshaping of domestic furnishings with an emphasis on new materials and new forms were part and parcel of the novel thinking that fueled and defined modernization. Indeed, that these infrastructural achievements were captured in valorizing photographs then mass-produced as postcards in the 1950s, 60s and 70s says much about the confidence in material progress that prevailed in the province.

In other words, the process of modernization—and of what functioned as the modern movement in British Columbia, where environments, buildings, furniture and a wide range of domestic goods were designed in the defining aesthetics of the moment—was enabled by earlier established settler rules of property, modes of governance and ideas about the benefits to society of unprecedented and beneficial change.

For to be "modern" was to be current and up to date. It was to embrace an optimism about the future and it represented "the cultural condition in which the seemingly absolute necessity of innovation becomes a primary fact of life, work and thought."[12]

Defined as much by the determined shedding of provincialism in all its forms as by the willing adoption of the belief that progress was a unifying, universalizing and beneficial force, modernization—and ideas about modernity—accelerated the pace of experimentation and sowed a widespread faith in the "correctness" of new forms of being and thinking. Sprawling, complicated, inconsistent and ultimately unrelenting, modernization was an all-encompassing phenomenon that remade and configured infrastructure, social relations and the sensibilities of culture and aesthetics.[13]

However, with its incessant mantra of "progress" at the cost of all else, modernity was always a project inherently contingent on the coercive management, marginalization and removal of Indigenous Peoples. The European and settler ideologies and strategies that facilitated and regulated colonial activity and nation-building were predicated on assumptions about the inherent characterological and ethical inequities between peoples (or between the colonizing and the colonized or the subjugating and the subjugated). This system of white supremacist thinking, in turn, served to justify and legitimate the systemically racist and violent actions of settlers and the institutions of settler governance. In this way, Meechan's twinned studio and commercial practices in Haney were emblematic of the negotiations—ideological and ethical—essential to the workings of modernization: the embracing

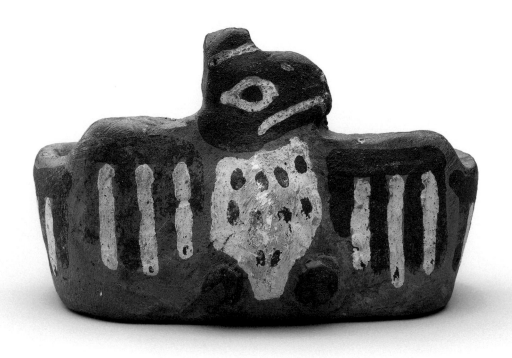

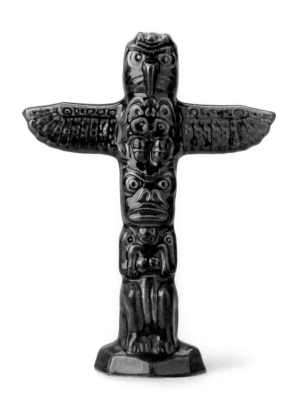

of new forms—with her studio ceramics representing progress—and the settler commodification of Indigenous cultures (perceived as disappearing or disappeared) functioning as mnemonic and perhaps even sentimental signposts to the march of change. It is not difficult to imagine one of Meechan's little dishes sitting on a wooden coffee table in the living room of some wood-and-glass modernist house with views to the ocean. The incorporation of such bowls and plates, with their settler versions of Indigenous visual culture, into the modern sphere is of particular concern. They might well have functioned as a type of cultural counterpoint to modernism's dictates. At the same time, they were considered thoroughly modern, as many tastemakers of the time advocated for the inclusion of such craft objects and what can be called the material arts of non-western cultures in the modern interior.[14] In modernizing British Columbia, flatweave carpets, handmade ceramics and ethnographic objects served supporting roles in the contemporary aesthetics of the domestic realm, at once nodding to the past and pointing to the future.[15]

The inclusion, therefore, of handmade Indigenous-motif dishes such as Meechan's in a modern interior should be read as an exercise as much in temporal balancing—an acknowledgement of the continuity of traditional cultural forms serving as a bulwark against the ever-changing and fugitive character of modern things—as a type of material vigil for what were regarded as lost or fading cultures. The ownership of Meechan's dishes by settlers—or, for that matter, the possession of ceramic totem poles by Herta Gerz or her biomorphic dishes with their depictions of Indigenous motifs,[16] of the dishes of David Lambert with their images taken from coastal cultures[17] or, even, the hand-formed pots made a generation earlier in the 1930s by Emily Carr,[18] with their painted interpretations of the clan forms of the Haida and Salish peoples—existed as presumptively benign, although never fully understood, declarations about the

Left: Emily Carr, *Untitled*, 1924–30, clay, paint, 7.5 × 11.2 × 5.5 cm, Collection of the Vancouver Art Gallery, Bequest of Alice Carr, VAG 51.27.24

Above: Herta Gerz, Totem Pole, c. late 1950s–early 1960s, ceramic, 15.0 × 14.8 × 5.5 cm, Collection of John David Lawrence

economic and cultural realities of modernization and history. In so many ways, the presence of Indigenous forms in the sites of modernity functioned as elegies for absent peoples.[19]

These sentiments and ideas had been in circulation for some time when Meechan made her pots. In 1947, Vancouver author, jeweller and curator Doris Shadbolt published a much-discussed article in *Canadian Art* in which she considered the question of contemporary society's relation to "Primitive Art."[20] Holding that the modernist and modernizing impulses of the twentieth century—socially beneficial but entirely demanding in her opinion—had resulted in "increasing enthusiasm and sympathy, on the part of the civilized world, for the art of primitive peoples,"[21] Shadbolt suggested that Indigenous forms provided a type of comfort or succour to modern people, who viewed "the primitive state" with a "romantic nostalgia," and offered "the release we crave" from the demands of modern life.[22] The "release" about which Shadbolt wrote represented her acknowledgement of the tensions that defined participation in the processes of change that unavoidably accompanied modernization or what has been likened to a type of homesickness and a longing for a simpler life. One manifestation of the anxieties or thoughts occasioned by the rapidity of change that defined modern life was the sentimentalizing of Indigenous life or a type of transference of longing for a long-lost past.[23] Shadbolt's thinking was in keeping with a long-standing tradition in western thought from the seventeenth century onwards that cultivated the idea of the "noble savage" where Indigenous peoples were viewed as innately good and not marred by the complexities of what was regarded as civilized society.[24]

But Shadbolt, while a maker of abstract, often talisman-like wearable objects, and whose husband, Jack Shadbolt, made numerous quasi-abstract paintings that drew heavily on Tlingit, Kwakiutl and Haida imagery, was no apologist for modernization's aesthetic explorations.[25] In her article, she simply sought to explain the persistent interest in what she labelled the "primitive" in the changing material world she inhabited.

This is also the argument the historian James Clifford powerfully makes in his discussion of the implications of the institutional collecting of "art and culture." Here "art" refers to aesthetic objects produced in a western tradition, and "culture" refers to the material culture of non-western societies. Clifford suggests that the mixing of objects from the two categories creates "chronotopes": sites where appropriated forms are brought together and recontextualized, resulting in a type of temporal disruption.[26] While Clifford's argument focuses on the activities of museums in Britain, France and in other parts of western Europe, he extends its implications to the post-colonial western world, where "the value of exotic objects…was in their ability to testify to the concrete reality of human Culture, a common past confirming Europe's triumphant present." Clifford goes on to explain that, while the meanings accorded to non-western cultural objects changed throughout the twentieth century, there remain persistent ontological and epistemological notions about the differences between "western things" and "things made by cultures encountered by western peoples."[27]

Perhaps not surprisingly, even the most cursory survey of issues of British Columbia's *Western Homes and Living* magazine from after 1950 shows the extent to which advertisers used decontextualized images of Indigenous expressive culture to promote

Doris Shadbolt, Human-Form Pendant, 1955, silver, 5.0 × 4.1 × 0.8 cm, Collection of Alice Philips

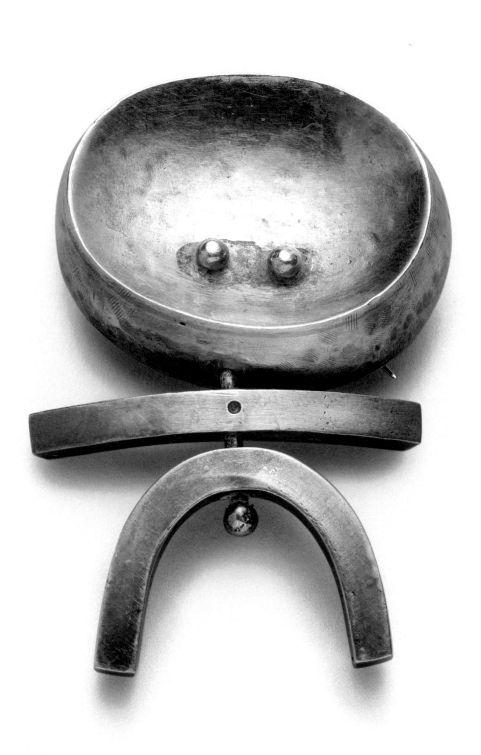

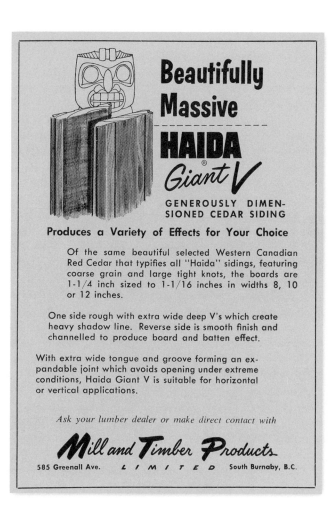

modern conveniences and contemporary living. The Hudson's Bay Company (HBC), for example (and seemingly without irony), ran a series of advertisements for assorted liquors that paired images of masks and carved objects with catchy taglines like: "Really worthwhile things…like this Kwakiutl Indian Housepost aren't made over-night. That's why our Hudson's Bay Rum still ages for years at London Docks, famous for maturing rum of unusually fine flavor and smoothness." Another HBC liquor ad, also featuring a "Kwakuitl Indian Mask" informed potential customers how, "Like this Indian wooden image, Hudson's Bay Rye Whiskey has a character all its own." And only a month later, the HBC explained how because its customers "admire something just a little bit different," so the firm's distinctive, premium aged scotch was the right choice for the discerning palette.[28] Here, the exotic appeal of lost cultures served as a suitable foil to the social currency of the popular mid-century cocktail hour, all promoted by the company that first settled Vancouver Island and the BC mainland in the mid-nineteenth century.

And the HBC was not alone in its use of Indigenous imagery to promote contem-porary modern life. The Mill and Timber Products company of South Burnaby used engraved images of family poles and masks to alert architects and consumers of the exemplary quality and contemporary character of their wares.[29] Carol Candles

Mill and Timber Products, Ltd., Advertise-ment, published in *Western Homes and Living*, November 1955, p. 58, Collection of the West Vancouver Art Museum

Carol Candles, Advertisement, published in *Western Homes and Living*, July 1957 (detail), p. 52, Collection of the West Vancouver Art Museum

of Vancouver touted its line of "Totem Pole candles," described as "typically British Columbian in theme and extremely decorative."[30] Moreover, as the advertisement explained, the candles would be "intriguing as gifts" or serve as "effective motifs in the home." Trudy Cox's Gift Shop, likewise advertising in the "Shopper's Bazaar" section of *Western Homes and Living* highlighted the store's range of decorative items "created by BC artists" and "best described," the ad copy explained, "as conversation pieces" whose "inspiration came from the colorful legends of our coast Indians." Craftsmen Designs offered for sale "authentic" models of "Indian Stone Sculptures from the Vancouver Museum"[31] and decidedly romanticized and infantilizing portraits of "Indian Children" were offered by the gift retailer Oxborough. "Wouldn't you love to have this appealing little child in your home?" the advertisement asked, noting that not everyone would be so fortunate as to own the set of four in "full colour." Indeed, the company emphasized how such "an Indian child portrait" would be "Ideal for your children's bedrooms where it will add a further precious memory of childhood to be cherished in future years."[32]

In instance after instance, modern life—design and domesticity alike—were promoted and validated with the aid of Indigenous cultures. In these lights, the pressing question becomes not why the agents of modernity in British Columbia looked to Indigenous cultures for imagery but rather to what lengths settlers could go in using—deforming, commodifying—ancestral forms for the promotion of modern design and crafting contemporary vernacular domestic life. The July 1957 issue of *Western Homes and Living*, for example, the celebrated "the ingenious use of a [Haida] totem pole in the garden of the Walter Koerner home in Vancouver," which managed to "cleverly" disguise an "unsightly" telephone pole.[33] Here, the conundrum of what to do with a beneficial but aesthetically problematic electrical infrastructure was answered by debasing an Indigenous object through decorative fetishism. Other articles in the magazine similarly profiled how Indigenous objects were put to practical and aesthetic uses by settlers. A "modern Shaughnessy garden", as the magazine chirped, was decorated with the "top of a Haida totem pole found rotting on the ground in the Queen Charlotte Islands." Now, the article noted, "The Ancient cedar carving is at home among native plants against an evergreen hedge background." That a Haida pole was removed from its resting place in the forests of Haida Gwaii was not considered problematic nor, for that matter, was its placement on unceded Musqueam land because either there was a lack of awareness of the political autonomy of Indigenous nations and a sensitivity to the cultural differences between them or simply because there was little interest in such matters.[34]

Indeed, the persistent commodification of Indigenous cultural objects was but one dimension of the ideological operations of colonialism and dominion that could range widely from violence and disdain to paternalism and bemused appropriation. For notwithstanding Doris Shadbolt's discussion of the character and implications of "the primitive" and her confessed longing for a break from the pressures of modernization, the fact remains that for most settlers the use of the expressive culture of coastal Indigenous Peoples in the negotiation of modernity was rarely the subject of serious reflection. How else to explain a basement renovation in the Sentinel Hill neighbourhood of West Vancouver that featured an "underlying Indian motif"? A consequence

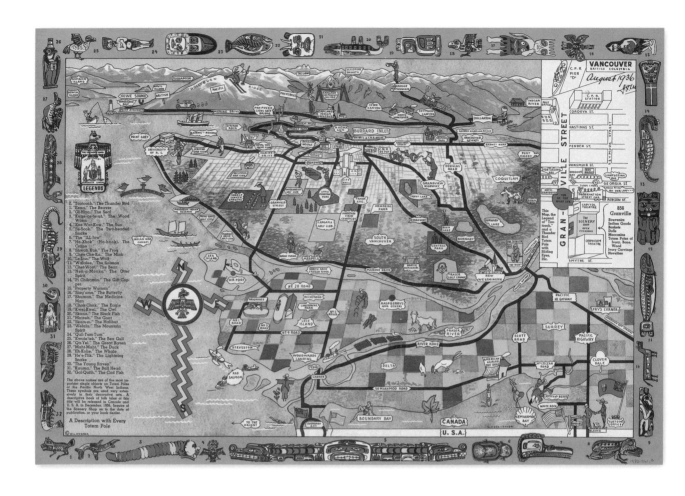

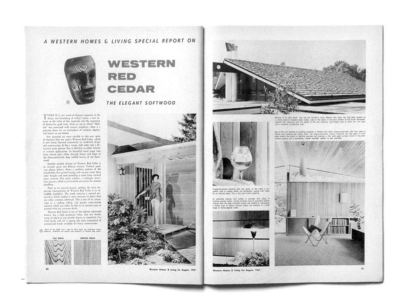

Above: Tourist map of Greater Vancouver, c. 1936

Left: *Western Homes and Living*, August 1961 (interior spread), pp. 20–21, magazine, 35.6 x 25.4 cm, Courtesy of the Vancouver Art Gallery Library

of what was described as the family's "interest in Haida designs"—with "interest" being a genial term that effectively avoided the need to explain in more specific ways the character of the attraction—the basement featured "giant photostats made of the Haida emblems" placed over the fireplace and behind the bar. The resulting aesthetic of the transformed room was one of "rustic charm."[35]

But much more than exercises in what was often discussed in terms of aesthetic complementarity, the uses in modernist settings of Indigenous cultural objects (and settler-made Indigenous-style objects for that matter) served to legitimate settler power. Colonialist curiosity about—and, in certain, rare situations, seemingly informed admiration for—Indigenous expressive culture has always been part of larger systems of control and superiority. While the linking of colonialism and imperialism in British Columbia, the history of modern design in the province and the appropriation of Indigenous motifs by settler makers may seem unexpected (at least to some), these phenomena are indeed connected and need to be considered as such in any study of history. The narrative of the history of material modernity in British Columbia—including the careers and accomplishments of the province's designers and makers, the tangible realities of the new forms in architecture, furniture and household items and the attitudes and sensibilities of the agents of ideological and aesthetic modernism, that is, the consumers—needs to be remade.

Put another way, the history of modern design in the province is not separable from the systems of control that settler society exacted on Indigenous Peoples. Modernism's rationales, ideological underpinnings and stylistic and decorative contours and the means by which these systems were represented by designers, artisans and home-makers are inextricably connected. The project and consequences of modernization, therefore, are about a shared settler complicity in colonialism and its operations. While this is not to say that the work of settler designers does not merit scholarly attention—such work should be assessed critically—it is to say that the old models of such inquiry and historical analysis are no longer acceptable. And while it may be that the rejection of the long-established models of history-making will be understood as a direct consequence of postmodernity's discrediting of "grand narratives and its call for multiples interpretive modes," it is also the case that to use pre-existing or modernist models of historical interpretation to advance new narratives will only reinscribe the systems of power that need to be dismantled. Whatever the case, the fact remains that any understanding of modern design in British Columbia—and modern life, for that matter—needs to acknowledge the means by which the project of modernization was advanced and legitimated.

Consideration, therefore, must be given to working toward a new model for the interpretation of history that takes into account the legacies of colonialism and that does not take for granted the legitimacy of a devastating phase of national history, the legacies of which are many, complex and ongoing. The telling of the history of modern design in British Columbia—design that represented both emulative and original exercises in creativity and material transformation—must be held accountable in the larger critical assessment of provincial history and the history of western colonial activity in North America.

> Throughout the 20th century, design has existed as a major feature of culture and everyday life. Its compass is vast and includes three dimensional objects, graphic communications and integrated systems of information technology to urban environments. Defined in its most global sense as the conception of all man-made products, design can be seen fundamentally as an instrument for improving the quality of life.[36] —Charlotte and Peter Fiell

Standard histories of the modernist movement in North America usually begin by describing the changes in thinking that occurred in early twentieth-century Europe, and specifically the establishment of the Deutscher Werkbund in Germany in 1907, the emergence of the De Stijl movement in the Netherlands in 1914 and the founding of the Bauhaus art school in Weimar, Germany, in 1919 by architect Walter Gropius. These are the historical foundations pointed to whether one is tracing developments in architecture, outlining the changing approaches to the making of art or, more particularly, accounting for advancements in the design of utilitarian and decorative arts. Adjacent accomplishments in France in the early 1920s (Le Corbusier's writings and work) are similarly factored into the timeline, as are investigations into materiality and new forms in the Nordic countries in the 1920s and 30s.[37] Likewise, such narratives cannot leave out the exhibition *Modern Architecture: International Exhibition,* which opened at the Museum of Modern Art in New York City in 1932. Curated by Philip Johnson and Henry-Russell Hitchcock, the exhibition contributed to western consciousness the potent, universalizing name of the International Style to describe developments in design. This landmark exhibition established the primacy of new modernist typologies in building and design and constituted the beginnings of a particular type of narrative in the history of the same.

That the flurry of reformist and modernist activity in the first decades of the twentieth century would meet the consequences of the growing political success of the National Socialists in the 1920s and 1930s, including the closure in 1936 of the Bauhaus (by then based in Berlin), only adds to the ostensible power of the story.

In the case of the history and legacy of the Bauhaus, the hostility that the school experienced across its relatively short existence—embodied broadly in the suppression by the Nazis of avant-garde cultural forms in Germany was subsequently enshrined as the centrepiece of the narrative of modern design broadly and provided the seed of what can be called its destiny: the innovative, progressive thinking about design—about making and form—that survived the viciously backwards-looking tendencies of fascism would rightly go on to thrive in a post-war world. As Guy Julier aptly notes, "the representation of design has been dominated by the achievements of individuals in the first place; second by the aesthetics and ideology of modernism; and third, via specific objects of a certain type."[38]

That leading designers, architects and urban planners—the authors of ideas and the makers of things—had to flee Europe is likewise key in the telling of the story of modernist design thinking and design experimentation in the decades from 1919 until well into the decades after 1940. Gropius took up the directorship of the

B.C. Binning mural and mobile, CKWX
Radio Station, Vancouver, BC, c. 1956

Harvard Graduate School of Design in Cambridge, Massachusetts, in 1936, and his fellow Bauhaus architect Ludwig Mies van der Rohe joined the Illinois Institute of Technology in Chicago in the same year.[39] Numerous other leading designers and thinkers likewise took up positions at assorted educational institutions. Thus the transfer from Europe to North America of the mission of modern design—its colonizing mission in so many ways—was accomplished, and decidedly not without consequence.[40]

This emigration of thinkers to North America, with their ideas about the transformative role of design, influenced a generation of makers and educators, including many in British Columbia.[41] As BC-born and raised architect Arthur Erickson once noted, in reflecting on his education and subsequent career as one of the great champions of modernist design in the province and elsewhere: "Mies van de Rohe, Walter Gropius and Marcel Breuer were the masters to be emulated."[42] BC designers and makers looked dutifully and gratefully to European and American precedents for their own creative work, embracing unequivocally modernist thinking. The flow of information about current trends and achievements through academic and professional publications was constant, and, with the movement of people to and through Vancouver, the adoption of modernist aesthetics and thinking commenced with assured optimism in certain progressive cultural spheres.[43]

In turn, the documentation of contemporary design—buildings, interiors and objects—by such gifted photographers as Selwyn Pullan and Graham Warrington meant that the post-war public was able to see the many tangible expressions of modernist design in British Columbia. With often worshipful photographs of post-and-beam and glass houses in West Vancouver, Victoria and elsewhere, the profiles of new furniture designs and architectural projects for publications such as *Canadian Homes and Gardens* and its provincial, ever-modern-movement-favouring equivalent, *Western Homes and Living*, turned British Columbia's forays into modernism into a visual exercise. The lush images of the interiors and their furnishings—the colours and textures of the upholstery, the shapes of table legs, the art on the walls (so often abstract), not to mention the carefully presented objets d'art, those pieces of aesthetic and cultural interest that enhanced a room—served to advance a belief system defined by optimism and the idea of an attainable utopia, but a utopia dependent on the systematic regulation and removal of Indigenous Peoples.

That both magazines profiled developments in the most westerly of provinces is worth noting. The magazines' editors undertook a demonstrated effort to promote new contemporary modes of living in the province as part of a larger modernist project that ran down the Pacific Coast to the border of Mexico. British Columbia was portrayed as a northern extension of the western, coastal United States—ocean facing, possessed of a temperate climate, socially progressive and often at the forefront of aesthetic experimentation—thereby explaining its self-styled cultural tone. While influenced by European thinking and the trends of New York City and Chicago, the design culture of the province was most often compared to that of Southern California. The modernist experiments that defined the state were legendary, especially the work of Cranbrook Academy of Art–trained designers Ray Eames and

Charles Eames, who arrived in Los Angeles in 1943 and then established their eponymous studio in Santa Monica.[44] For many advocates of modernism in the province, there was an obvious logic in the idea of British Columbia sharing contemporary material and aesthetic sensibilities with California, Oregon and Washington.[45]

Indeed, *Western Homes and Living*, while interested in surveying contemporary trends in the province itself, often focused on developments in the extended West Coast region.[46] For as the editors well knew—as did the architects, designers and curators who were the predominant readers of the magazine—central to the success of modernist movement in British Columbia was convincing people about the value of new design, which they accomplished by linking the province's achievements with those of its bigger, more impressive cousins to the south. It was, as the BC architect Ned Pratt explained, through such "untiring efforts" to promote modernism's exciting unfamiliarity and transformative promise that he and other architects introduced prospective clients to what he called the "contemporary frame of mind."[47]

It was not only the design press that took up the work of championing change in the province.[48] Any number of prominent individuals (not to mention institutions), who, with the aid of efforts at the national level, became vocal advocates for new thinking around contemporary life. In 1946, for example, the artist B.C. Binning arranged a visit to Vancouver by the Austrian-born, Los Angeles-based architect Richard Neutra. This widely publicized visit—with Neutra's two lectures providing "the most lasting stimulus"—was characteristic of the particular type of enthusiasm for modernism that existed in the period immediately after the Second World War.[49]

Installation view of *Modern Architecture: International Exhibition*, exhibition at the Museum of Modern Art, New York, February 9 to March 23, 1932

Binning, for his own part, was a central figure in the development of modernist thinking and design in the province.[50] An artist, designer and educator, he and his wife, Jessie, were well liked and influential in Vancouver and counted among their friends, artists and thinkers such as Lawren and Bessie Harris, Bruno and Molly Lamb Bobak and Gordon and Marion Smith. Binning's activist sensibilities around the transformative promise of modernism were evident in his designs for his house, his art practice and his work as a public intellectual, as well as in his co-founding in 1944 of the Art in Living Group, a progressive, engaged organization dedicated to investigating the prevailing conditions of modern life and taking action through public meetings and events.[51] "We do not wish for a new world," states the group's manifesto (published, it is worth noting, in *Canadian Art* in 1947). "Instead, we are firmly determined to have a new world."[52]

Such visionary goals had any number of advocates. In 1949, for example, the Community Arts Council, a non-aligned organization in the city that championed the arts and with which Binning had ties, demonstrated its engagement with issues of social change and modernization by mounting the exhibition *Design for Living* at the Vancouver Art Gallery. Extensively discussed in the local press—garnering mostly praise—the exhibition was a hugely popular event and boasted record attendance numbers for the gallery.[53] Anchored, literally and figuratively, on the domestic worlds of four fictional families living in Greater Vancouver, *Design for Living* aimed both to consider the "possibilities of the Artist making his voice heard and his ideas felt in the realm of architecture" and to present to the public the benefits of modern living, namely in the form of new houses, new furniture and new ideas as presented through the four tableaux.[54] Each installation was affirmational, offering four case studies of the conditions and possibilities of modern life.[55]

Upon entering the exhibition, visitors filed past the staged living rooms of the Peridots of West Point Grey (a history professor husband and a weaver wife with two children); the McTavishes of Grandview (a youth counsellor, a homemaker and three active, artistic children); the Rathburns of Dunbar (a homemaker wife with an interest in "collective living" and a structural engineer husband with an amateur interest in geology and two children); and the Saterians of West Vancouver (a "manager" and a musician), described as "sophisticated young people" with future plans to start a family. Each family's personal details were displayed on large panels alongside the architectural plans of the house and line drawings of the rooms. It was hoped that viewers who spent time poring over these details would come to appreciate the possibilities of modern design and contemporary aesthetics in their own lives. All the families expressed their collective and individual sensibilities in their homes, and visitors were meant to understand how modern design could aid in the presentation of the self, or what the exhibition's organizers deemed "the scope for creative home-making."[56] As the introduction to the accompanying publication boldly asked: "DOES YOUR HOUSE FIT YOU?"

The fact that the families were white and middle class, engaged in professions central to the progressive mission of the modernist project in the province makes perfect

ideological and cultural sense. Education, engineering, mining, the arts, community involvement, along with an open appreciation for modern things and cultural objects, were the hallmarks of the materialist and progressive sensibility in British Columbia from 1945 onwards. The families of *Design for Living* were clearly avatars for people like B.C. Binning and his Art in Living Group colleagues and their wider circle of associates and friends.[57] As the promotional materials noted, the exhibition was only possible with the assistance of numerous designers and craftspeople, the labours of which were to be seen in the conceptualization of the project and what functioned as its props, and the implications of which were likely not lost on the thousands of eager visitors to the exhibition.

The Peridots lived in post-and-beam house designed by the real-life firm of Sharp and Thompson, Berwick, Pratt that featured an open-plan living room furnished with a sofa bed and a webbed wooden reading chair by Vancouver designer Robert Calvert. The McTavishes' large, two-storey house was defined by a much-needed "Playshop" (or family room) featuring lightweight wood-and-metal tables that could be reconfigured at will. In pride of place was designer Murray Dunne's decidedly lavish biomorphic copper lamp with a bent-wire base. The Rathburns' living room had, among other things, pottery by Hilda Ross, a large jute rug woven by Esme Davis, and a wooden armchair, wooden coffee table, Eames-like three-tiered storage

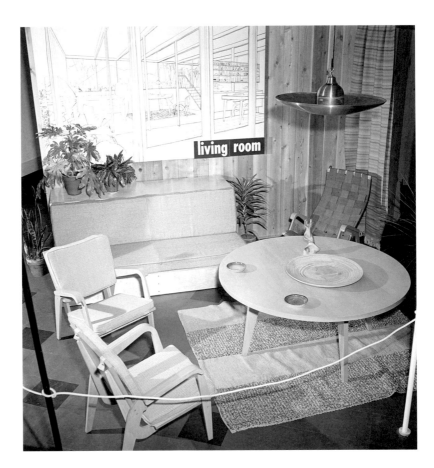

Installation view of the Living Room for the Peridot Family in *Design for Living*, exhibition at the Vancouver Art Gallery, BC, November 8 to November 27, 1949

unit with panels and metal standing lamp all designed by Catherine Wisnicki, with the panels, it is important to note, having been woven out of cedar by Indigenous maker, Mrs. Jim Joe. The Sarterians—whose grand piano anchored their two-level open-plan house by the architectural firm of Gardiner and Thornton—married charming French Provincial chairs with a sectional dining table by Murray Dunne and a sideboard by their architects. The living room also boasted a gently curving lounge chair by Dunne. Made of wood lattice, steel rod and leather, it was positioned near the fireplace.

The curators of *Design for Living* went to great lengths to construct the personalities of the families in ways that both reflected certain identifiable characteristics of Vancouver's demography and that simultaneously acknowledged and demonstrated the beneficial conditions of modern life. In doing so, the curators necessarily employed the modernist tactic of using Indigeneity as a counterpoint in driving home modernism's narrative of progress. For although the temporal balancing act played out through modernity's appropriation of craft practices could be witnessed in many facets of the exhibition—Mrs. Peridot's home loom, for example, and the evidence of craftspeople's labour to build the tableaux themselves—it was the character of Mrs. Rathburn that most significantly encapsulated the aesthetic and cultural complexities that scaffolded modern life in British Columbia at the time. In addition to liking houseplants (with their attendant implications of nature being tamed), Mrs. Rathburn was extremely proud of the fact she owned Emily Carr's work *Strangled by Growth* (1931),[58] which portrays an ancient carved family pole being overtaken by vegetation, as well as of her collection of "Indian crafts," the display of which, as the exhibition catalogue made a point of noting, "was important to her." In the simple act of fleshing out some details about the character of an imaginary person in an exhibition about the social promise of new design in Vancouver, the organizers of *Design for Living* not only made tangible their thinking about the possibilities of modern life but revealed the inseparable connections between the fetishizing affinities of modernist aesthetics and contemporary living and the brutal realities of colonialism and settler history in the province.[59]

While it has been suggested that the presence of Indigenous objects in the Rathburn tableau was representative of a growing appreciation by settlers of the significance of the expressive culture of coastal First Nations, arguably, Mrs. Rathburn's appreciation is no more than the same cultural paternalism eventually embodied by Ruth Meechan's Haida-inspired tourist wares. In these fictional and actual instances, modernism deemed the mixing of ethnographic objects and new designs both necessary and appropriate. Mrs. Rathburn's imaginary life was constructed to advance the operations of modernism in keeping with the requisite othering of Indigenous Peoples and non-Western cultures during the period. And by framing this character's possessions and collecting—arguably reflective of the exhibition organizers' own lifestyles—as "progressive," so the colonialist realities of modernization were justified and disseminated.[60]

III

Decoloniality is about shattering the familiar.
　　—Danah Abdulla[61]

Writing in 2015, design historian and critic Tony Fry suggested that "design history is dominantly disarticulated from those 'questions of history' that have preoccupied historical studies."[62] What Fry means is that the study of design often focuses on authorship, biography and issues of aesthetic achievement—a significant problem at the core of what is called "design history." While this is not to say that focusing on the work of specific individuals or objects does not have critical value, it is to suggest that too often larger historical issues are overlooked or sidelined by such an approach. This criticism echoes in significant ways the argument advanced by the art historian John A. Walker some twenty-five years earlier in 1989, that there is an important critical difference between "design history" and the "history of design." Most significantly, the latter affords opportunities to consider the circumstances within which designers create.[63]

The work of designers in British Columbia, usually born out of precedent-setting developments from outside the province, is a narrative of creative and manufacturing achievement that has rarely, if ever, been required to consider a different conceptual approach to the telling of the story of material modernism after 1920. The histories of design in British Columbia—critically insightful and valuable contributions to knowledge that they are—have never needed to take into account the larger historical circumstances of the province. But as Fry argues, the writing of history always involves defining the parameters of inquiry and putting forth an argument that is never without a set of critical goals.[64]

The logic of the critical narratives of design history in British Columbia (and in the rest of Canada, for that matter) has long existed within a paradigm that has rarely been challenged, because of the presumptive "rightness" of the phenomena it describes. As Jean-François Lyotard notes in his 1979 work *The Postmodern Condition*, the writing of western history since the Enlightenment has been defined by grand or master narratives because institutional and ideological interests—the interests of hegemony—are best served by such an approach.[65] The explanations of events, actions and consequences are thus manifestations of the very systems of power being described.

Design history in North America is generally understood as being about European settlement and the forward march of democratic and material life. Certainly this is the case for the history of modern design in British Columbia. A valorizing rhetoric often permeates the description of new pieces of furniture, the application of novel technologies and the beneficial consequences of modern ways of thinking about the domestic sphere. Rarely do histories of modernism—of modern design—offer something other than a celebratory narrative of progress.[66] Historian Arthur J. Pulos, although framing the study of design in the context of the history of the United

States (the history of which he regards as exceptional), makes an argument that can be applied to other North American societies born of colonial thinking, action and change. At the core of his thinking is a belief in the significance of creativity—of design—in the making of society. "Design is the indispensable leavening of the American way of life," he explains, continuing:

> It emerged with the need for the colonists to transform the wilderness into a secure haven and expand as a natural component of the industrial revolution in the New World. The United States was in all likelihood the first nation to be designed—to come into being as a deliberate consequence of the actions of men who recognized a problem and resolved it with the greatest benefit to the whole. America did not just happen: It was designed.[67]

Beyond Pulos' rhetorical and ideological (and hubristic) flourish in the service of narrating a specific national history, his framing of design history as inextricable from state-building, or in the case of British Columbia, province-building, is in keeping with the long-held, self-fulfilling logic of modernization—a logic wholly indifferent to the human and environmental consequences of the project it championed. As a multifaceted, global phenomenon inseparable from colonialism and state ideas of power and progress, modernity depended on ideas about dominion, on the marshalling of natural resources and on those resources' transformation, through need, ingenuity and creativity, into goods. Ruth Meechan's mass-produced clay dishes and the *Design for Living* exhibition and the modernist sensibilities they espoused are representative of the ways that technological, ideological and aesthetic change functioned in British Columbia, namely as an instrumentalizing system dependent on the unquestioned, presumptively shared goals of "progress" and "well-being" for white settler citizens, and on the racist, policy-driven maltreatment of Indigenous Peoples.

Changing the prevailing approaches to the history of modern design in British Columbia is a necessary task. Doing so will allow the histories of the province— Indigenous and settler—to be told in ways that seek to dismantle bias and the privileging of ideas about cultural superiority. Put simply, the history of modern design in the province needs to be decolonized and the old narratives of social and material progress put to rest. This does not mean that the work and accomplishments of modernist designers cannot be considered and perhaps even praised. But the critical assessment of material change—of modernist design—must begin to take into account the means by which such change and design achievements were made possible.

History is always about the study of the relationships between cause and effect, about agency and about ideas, values, and systems of thought and action that explain how and why things happened. In this light, there is immense value in turning to Haida thinking about the connectedness of and inseparability of all things in the world. As curator Nika Collison of the Ts'aahl Eagle Clan of Haida Gwaii explains,

"Everything depends on everything else." This thinking at the core of Haida cosmology can powerfully inform historians, settler and Indigenous alike, who seek to change approaches to the study of history in British Columbia, Canada and beyond. In British Columbia, the process of modernization, part of the continuum of colonial settlement, was profoundly destructive to Indigenous cultures and Indigenous lands. Future histories of modernity—of modern design, of technological change, of aesthetics and of thinking—must take into account the intricate connections between actions and consequences that define the unfolding of life and which shaped the histories of British Columbia and its people. This is a task that requires changes to the ways that the past is viewed and remembered.[68]

NOTES

1 The author would like to thank Professor Eugenia Kissen for her wise counsel in the preparation of this essay. The author would also like to acknowledge the generous assistance of the following people: Stephanie Rebick, Daina Augaitis and Jane Devine Mejia of the Vancouver Art Gallery; Allan Collier; Duncan Farnan; John David Lawrence; Dr. Rachel Gotlieb; Dr. Jill Baird of the Museum of Anthropology at the University of British Columbia; and Krisztina Laszlo and her colleagues at the Rare Books and Special Collections at the University of British Columbia.

2 John A. Walker, *Design History and the History of Design* (London: Pluto, 1989), 20.

3 Haney was eventually subsumed by the town of Maple Ridge during the rapid post-Second World War suburbanization of the Lower Mainland of British Columbia. To gain a sense of the traditional narrative modes for the economic and political history of the province, see Margaret Ormsby, *British Columbia: A History* (Toronto: Macmillan of Canada, 1958). For a different account, see Wilson Duff, *The Indian History of British Columbia: The Impact of the White Man* (Victoria: Royal British Columbia Museum, 1969).

4 This rapid growth also saw communities, including Maple Ridge, incorporated into the social and cultural ambit of Greater (now Metro) Vancouver.

5 "Ruth Meechan 'Bio'," undated typescript, provided to the author by Allan Collier.

6 See Ruth Meechan, "Shopper's Bazaar," *Western Homes and Living*, November 1956, 63. Meechan makes pottery, the advertisement reads, "that is truly British Columbia crafted...artisanally designed and skillfully created...from clay dug in Burnaby, Seymour Creek and other local spots." "These lively items," the advert advises, "would be an addition to the décor of any home." "Sold at R.M. Potteries. 3856 East Hastings street. North Burnaby."

7 One exception to the typically four- to six-inch-sized pieces is a horizontally oriented dish with an image of a "Haida Sea Monster" that measures three inches at its widest point and nine inches from end to end.

8 Susan Hiller, "Editor's Foreword," in *The Myth of Primitivism: Perspectives on Art*, ed. Susan Hiller (London: Routledge, 1991), 2.

9 In the introduction to the final report of the Truth and Reconciliation Commission of Canada, the commission offers the following summary of the legacies of colonialism and statism on Indigenous Peoples: "For over a century, the central goals of Canada's Aboriginal policy were to eliminate Aboriginal governments; ignore Aboriginal rights; terminate the Treaties; and, through a process of assimilation, cause Aboriginal peoples to cease to exist as distinct legal, social, cultural, religious, and racial entities in Canada. The establishment and operation of residential schools were a central element of this policy, which can best be described as 'cultural genocide.'" See Truth and Reconciliation Commission of Canada, *Honouring the Truth, Reconciling for the Future: Summary of the Final Report of the Truth and Reconciliation Commission of Canada* (Ottawa: Library and Archives Canada, 2015), 11.

10 Like the other settler artisans and artists in the province who looked to the expressive culture of Indigenous Peoples for both inspiration and monetary gain, Meechan's decision to appropriate sacred, cosmological images of family and clan as decorations for her mass-produced work raises both general questions about the aesthetic operations of what functioned as material and aesthetic modernization in British Columbia—what can be understood as the history of modern design in the province—and specific ones about how the standing histories of modernism in the province can be revised and reframed.

11 See, for example, Jean-François Staszak, "Other/Otherness," in *International Encyclopedia of Human Geography*, 12 vols., ed. Rob Kitchin and Nigel Thrift (Oxford: Elsevier Science, 2009).

12 Jane Turner, ed., *The Dictionary of Art*, vol. 21 (London: Macmillan, 1996), 777.

13 In British Columbia, the encompassing project of changing material and mental life was predicated on the operations of British imperialism and the subsequent post-colonial statist agendas of the provincial and federal governments. In British Columbia, as in all locales, places and jurisdictions of North America and the colonized world, the project of modernity, with its belief in the ostensibly shared promise of material and progress, was only possible through the negation or repression of existing cultural forms, both Indigenous and historical. This point has been effectively argued by Theodor Adorno and Max Horkheimer in their *Dialectic of Enlightenment*, a careful and thorough work of social criticism concerned with the failure of the Enlightenment and capitalist development in the West. See Theodor Adorno and Max Horkheimer, *Dialectic of Enlightenment* (1944; London: Verso Classics, 1997), 3–41.

14 James Clifford, "On Collecting Art and Culture," in *The Predicament of Culture: Twentieth-Century Ethnography, Literature, and Art* (Cambridge, MA: Harvard University Press, 1988), 215–51.

15 See, for example, the revealing cover of *Western Homes and Living* for March 1951. The photograph shows a modern living room with a dominating stone fireplace and a kilim carpet on the floor. On one table near the sofa is a woven cedar basket from a Coast Salish Nation. On another table is another basket, likely also Coast Salish, in which yellow and red chrysanthemums have been placed. In the corner of the room are birch tree trunks that appear to have been anchored to the floor and affixed to the ceiling.

16 Born in Hanau, Germany, potter Herta Gerz ran her own ceramics factory in Gelnhausen between 1946 and 1951. She and her husband immigrated to Canada in 1952. Settling in Vancouver, she opened a small commercial studio that produced both abstract wares and wares with Indigenous motifs. The latter body of work—tableware and decorative items—were marketed under the label "West Coast Indian Design."

17 "For the modern West Coast home—authentic West Coast Indian designs on plates, dishes and decorative pottery," reads an advertisement for the work of David Lambert in *Western Homes and Living*. It is worth noting what Lambert said about how he came to his work as a potter using Indigenous forms as decoration: "We were in a new country and doing a new thing in that country. But what were we doing, all that we had done was to import all the old methods of doing pottery and what we were making and selling could be made and sold in any country in the world by thousands of potters... We went to the Indian people themselves (a very rare thing I found) and they were most helpful and kind, terrifically interested... Many people came to tell us of things that had happened in their childhood and to show us designs used on everyday objects. They took my breath away. The understanding of shapes, line, use of colour, symbolism, showed much more than we had thought... After five years of real hard work we decided to do something with it and see what we could do." "David Lambert," wall panel, Museum of Anthropology, University of British Columbia, Vancouver.

18 It was one of Carr's tenants in Victoria, the Banff tourist shop owner Kate Mather, who suggested that the artist decorate her small hand-built pots with Indigenous motifs. Carr did so and improved her monthly finances considerably. "I ornamented my pottery with Indian designs," she writes in her autobiography *Growing Pains*, as "that was why the tourists bought it." However, she recognized the inherent problem with her decision. "I hated myself for prostituting Indian art" she writes. "Our Indians did not 'pot,' their designs were not meant to decorate clay—but I did keep the Indian designs pure," she continues, as if her fidelity to the rendering of Indigenous forms mitigated her acts of cultural appropriation. Emily Carr, *Growing Pains* (Toronto: Hancock House, 1946), 3.

19 In the early 1970s, Island Cabin Crafts based in Ganges, on Salt Spring Island, BC, produced modernist red burlap wall hangings with black printed and highly stylized Indigenous, and specifically Innu, images.

Titled *Canadian Arctic Primitives*, the hand-screenprinted, narrow tex-
tiles had a small text panel affixed to their backs. It reads: "In the barren
Canadian Arctic, with its dark winters and short hot summers, Eskimoes
[sic], Indians birds and animals pit their strengths against Mother Nature.
In the unending struggle for existence there are lighter moments when
caribou race across the frozen tundra, seals poke their heads through the
ice and dog teams [sic] race with loaded sleds. The challenges and joys of
the Arctic are shown here in these Canadian primitive designs." The work
is signed "Studio at Island Cabin Craft Box 1057 Ganges, BC, Canada."
Numerous settler artists working in clay, as well as other media, used
Indigenous motifs in their work. For a discussion of this complicated,
problematic issue, see Ruth Phillips, "'New Yet Old': Aboriginality and
Appropriation in Canadian Ceramics," in *On the Table: 100 Years of Func-
tional Ceramics*, ed. Rosemary Shipton, exhibition catalogue (Toronto:
Gardiner Museum, 2007), 64–67.

20 Doris Shadbolt, "Our Relation to the Primitive," *Canadian Art*, October–
November 1947), 14–16.

21 Shadbolt, "Our Relation to the Primitive."

22 Shadbolt's argument about the challenges of coping with rapid change
is not so different from Karl Marx's argument in *Das Kapital* about the
fugitive character of modernity and its material manifestations. See also
Karl Marx, "Bourgeois and Proletarian," chapter 1 of *The Communist
Manifesto* (1848).

23 For a discussion of this phenomenon of homesickness, see David J.
Rosner, "Anti-modernism and Discourses of Melancholy," *E-rea* 4, no.
1 (2006): https://doi.org/10.4000/erea.596. Rosner considers the anti-
modernist and Romantic thinking of Martin Heidegger, one of the most
important theorists of technology and technological modernity.

24 For a discussion of the idea of the "noble savage," see Anthon Pagden, *The
Fall of Natural Man: The American Indian and the Origins of Comparative
Ethnology* (Cambridge: Cambridge University Press, 1982).

25 See Marjorie M. Halpin and Jack Shadbolt, introduction to *Jack Shadbolt
and the Coastal Indian Image* (Vancouver: University of British Columbia,
Museum of Anthropology, 1986).

26 Clifford, "On Collecting Art and Culture," 236.

27 Clifford, "On Collecting Art and Culture," 228. In similar ways, the
cultural theorist Bill Brown suggests that "artifacts from 'other' cultures
became integral to the Western aesthetic imagination and its under-
standing of the aesthetic [of non-Western cultures] tout court." Bill Brown,
"Objects, Others and Us: The Refabrication of Things," *Critical Inquiry*
36, no. 2 (Winter 2010): 184.

28 The HBC advertisements were located in the "Shopper's Bazaar" section
of *Western Homes and Living*. See *Western Homes and Living*, May 1955,
70; October 1955, 73; and November 1955, 42.

29 *Western Homes and Living*, April 1955, 39. The product, available in a
variety of finishes, was memorably marketed under the name "Dyed-in-
the-Wood HAIDA Cabotized Pre-stained Cedar Siding."

30 *Western Homes and Living*, July 1957, 52.

31 *Western Homes and Living*, December–January, 1956–57, 64; *Western
Homes and Living*, March 1957, 58. See also a discussion of making a "totem
plaque" for the front of a lamp, in "Here's How You Can Make Copper
Paintings," *Western Homes and Living*, March 1957, 58.

32 *Western Homes and Living*, March 1962, 49, and *Western Homes and
Living*, March 1961, 42. And, for the smokers in the crowd (perhaps the
parents of children with portrait-enriched rooms), there was a cigarette
lighter in the shape of a stylized, "distinctively accented," burnished-copper
Haida owl that was both "attractive and easily operated" and "typically
British Columbian in motif." *Western Homes and Living*, March 1957, 58.

33 *Western Homes and Living*, July 1957, 42. Walter Koerner was a well-
known businessman and philanthropist in Vancouver. He was born in
Moravia and immigrated to Canada in 1931. In 1939, he and his two

brothers founded the Alaska Pine and Cellulose Company. It is worth
noting that Koerner was an avid collector of Indigenous objects and that
in 1974 he and his wife commissioned the artist Bill Reid to carve a bear
as an outdoor sculpture. The bear proved too large for the garden, and it
along with the Koerner's extensive collections were donated to the Museum
of Anthropology at the University of British Columbia in 1975. The bear
and the Koerner collection are prominently displayed in Arthur Erickson's
remarkable 1974 concrete-and-glass building, the form of which draws on
the architectural precedents of coastal Indigenous Peoples.

34 For a discussion of the evolved thinking around the preservation of
family poles, see Charles S. Rhyne, "Changing Approaches to the Con-
servation of Northwest Coast Totem Poles," *Tradition and Innovation:
Advances in Conservation, Contributions to the Melbourne Congress, 10–14
October 2000* (London: International Institute for Conservation of Historic
and Artistic Works, 2000), 155–60.

35 See *Western Homes and Living*, April 1960, 36; "Basement Remodeling,"
Western Homes and Living, March 1960, 14. The renovation was carried out
by architect Fred Hollingsworth. The article made a point of the innovative
character of the Williams' transformed family room: "If you have always
thought that basement recreation room was somewhat bar-like with little
or no furniture, a quaintly humorous décor, and no attraction whatever
when empty," the writer explains, "you certainly haven't seen what Warner
and Jean Williams have done to the basement of their Sentinel Hill home."

36 Charlotte Fiell and Peter Fiell, *Design of the 20th Century* (Cologne:
Benedikt Taschen Verlag, 1999), 6.

37 For a discussion of developments in modern architecture after 1920,
see, for example, the following classic texts: William J.R. Curtis, *Modern
Architecture since 1900* (London: Phaidon, 1982); Kenneth Frampton,
Modern Architecture: A Critical History (London: Thames & Hudson, 1980).

38 Guy Julier, *The Culture of Design*, 3rd ed. (Los Angeles: Sage, 2014), 56.

39 The Illinois Institute of Technology would go on to earn the moniker
"the New Bauhaus." For a discussion of the legacies of the Bauhaus after
1936, see Achim Borchardt-Hume, ed., *Albers and Moholy-Nagy: From
the Bauhaus to the New World* (London: Tate Publishing; New Haven,
CT: Yale University Press, 2006). See also Laura Forlano, Molly Wright
Steenson and Mike Ananny, eds., *Bauhaus Futures* (Cambridge, MA:
MIT Press, 2019); Katerina Rüedl, *Bauhaus Dream-House: Modernity and
Globalization* (London: Routledge, 2010).

40 The transformational consequence of emigration to the history of
modern design in North America cannot be underestimated. Think, for
example, of Finnish-born architect Eliel Saarinen taking up the helm of
the Cranbrook Academy of Art in suburban Detroit in 1932. Under his
leadership, the school became an important centre of design. Florence
Knoll (née Schust) spent formative time there, as did Ray Eames (née
Kaiser) and Charles Eames (who married in 1940). Eero Saarinen, Harry
Bertoia and many other designers and studio makers also trained there
and went on to have significant and influential careers. In similar ways,
the movement of Bauhaus faculty to institutions in the United States
in the 1930s had a profound effect on design education for decades to
follow. Josef and Anni Albers, both Bauhaus masters, moved to North
Carolina; they had been invited by the architect Philip Johnson to take up
teaching positions at Black Mountain College. Walter Gropius, the first
director of the Bauhaus when the school opened in Weimar in 1919, took
up in 1937 the directorship of the Harvard Graduate School of Design in
Massachusetts, where he trained generations of architects, many of whom
also had teaching careers. The brilliant Marcel Breuer, first a student
in Weimar and then a master teacher in Dessau, likewise took up an
appointment at Harvard in 1937, having for several years lived in London
designing furniture for the Isokon Company. Similarly, the photographer
László Moholy-Nagy established the Bauhaus-modelled curriculum at
the Illinois Institute of Technology, and the school's director, Ludwig

Mies van der Rohe, established the critical and determined sensibilities of modernist design thinking that had defined the last iteration of the Bauhaus in Berlin until its closure.

41 See Jarrell C. Jackman, *The Muses Flee Hitler: Cultural Transfer and Adaptation, 1930–1945* (Washington, DC: Smithsonian Institution Press, 1983). One only has to consider the architect Arthur Erickson's reflections on his time as a student at Montréal's McGill University in the early 1950s to get a sense of how the radical thinking of Gropius, Mies van der Rohe and company came to dominate design thinking in North America in the decades after the Second World War. As Erickson recounted, the long-established Beaux-Arts curriculum—"the trammels," in Erickson's words—had been cast off and the school had become "fanatically Bauhaus," with Gordon Webber, "a man of compelling presence" who taught the basic first-year course, being a "disciple of Moholy-Nagy and György Kepes of the re-established Bauhaus in the Chicago School of Design." See Arthur Erickson, *The Architecture of Arthur Erickson* (Vancouver: Douglas & McIntyre, 1988), 18.

42 Erickson, *The Architecture of Arthur Erickson*, 18.

43 The legacies of the transposed thinking of the Bauhaus were considerable in Vancouver. In 1955, the esteemed educator and cultural critic Abraham Rogatnick (Harvard, class of 1952) was invited by his classmate Geoffrey Massey (class of 1948) to visit Vancouver. Rogatnick had studied under Walter Gropius and graduated in 1952 with two degrees. After his visit, Rogatnick and his partner decided in 1956 to move to Vancouver. In 1959, Rogatnick took up a teaching position at the School of Architecture at the University of British Columbia. Notably, Rogatnick, upon arriving in the city, opened the New Design Gallery in partnership with Alvin Balkind. It was the first commercial gallery to promote contemporary art and represented a number of prominent artists, including Jack Shadbolt. Other Harvard-trained students who came to Vancouver included architect Peter Oberlander and landscape architect Cornelia Hahn Oberlander. See "Peter Oberlander," interview by Jim Donaldson, February 19, 1998, Peter Guo-hua Fu School of Architecture, McGill University, https://www.mcgill.ca/architecture/people-0/aluminterviews/oberlander.

44 For a discussion of the careers of Ray and Charles Eames, see Pat Kirkham, *Charles and Ray Eames: Designers of the Twentieth Century* (Cambridge, MA: MIT Press, 1998), 9–60.

45 The abbreviation "B.C." for British Columbia, was, in the 1950s and 60s often half-jokingly and half-seriously said to mean "British California" because of the projected and claimed similarities in modes of life between the two places.

46 In an article in the August–September 1950 issue of *Western Homes and Living* that profiles the architectural history of British Columbia and lays out for readers the goals of the newly launched publication, the editors went to considerable lengths to tie developments in domestic modernist architecture in California to developments in British Columbia, or what was broadly called the "Pacific Coast," noting how "some say 'modern', some say 'contemporary' and a few severe critics say 'chicken houses.'" "Architecture textbooks," the authors continue, "acknowledge the style and class it as a regional development of the Pacific Coast." In the section titled "Shopper's Bazaar," the compendium for the promotion of new consumer wares, an advertisement for the "contemporary design stoneware" produced by the Heath Company of Sausalito, California, figured prominently on the first page of the two-page spread. The stoneware, with its organic form and monochromatic glaze, was, as the magazine noted in promoting its suitability for modern interiors, "Chosen by architects and exhibited in many museums." *Western Homes and Living*, August–September 1950, 33, 54.

47 See C.E. Ned Pratt, "Contemporary Domestic Architecture in British Columbia," in *The West Coast Modern House: Vancouver Residential Architecture*, ed. Greg Bellerby (Vancouver: Figure 1, 2014), 11.

48 Donald Buchanan, a curator at the National Gallery of Canada in Ottawa, used his position at the institution to raise awareness about the importance of design both to the post-war national economy and to national identity (both of which he and others regarded as vulnerable). Writing regularly in the pages of *Canadian Art* in the late 1940s and early 50s, Buchanan argued in favour of designers finding a visual vocabulary fitting of national conditions, and his profiles of new design from across the country, including objects from British Columbia, were highly influential. The province, as Buchanan saw it, had a particularly important role to play in the remaking of material life. For a discussion of the social and cultural implications of the modern movement in Canada, see Joy Parr, *Domestic Goods: The Material, the Moral, and the Economic in the Postwar Years* (Toronto: University of Toronto Press, 1999).

49 Fred Amess, "The Art in Living Group," *Canadian Art*, October–November 1947, 52.

50 Binning first taught at the Vancouver School of Art and later at the University of British Columbia. See Abraham Rogatnick, "A Passion for the Contemporary," in *B.C. Binning*, ed. Abraham Rogatnick, Ian M. Thom and Adele Weder (Vancouver: Douglas & McIntyre, 2006), 1–40.

51 The art historian Scott Watson discusses this in "Art in the Fifties: Design, Leisure and Painting the Age of Anxiety," in *Vancouver Art and Artists, 1931–1983* (Vancouver: Vancouver Art Gallery, 1983).

52 Fred Amess, "The Art in Living Group," cited in Scott Watson, "Art in the Fifties," 52. As Watson notes, Amess was a conservative individual and his advocacy of modernism in the making of a new world was about the role of design in a world economy and its contributions to what Watson calls "bourgeois democracy."

53 The histories of the Art in Living Group and the Labour Arts Guild (both founded in 1944 and with slightly different ideological approaches around the question of achieving desired change) and the Community Arts Council (founded in 1946 for the promotion of the arts), are entwined in this period, insofar as each organization used the tactics of public events and exhibitions to advance their respective agendas of urban redevelopment, public education on the power of good design and other progressive causes, and the broad support for the arts. For a detailed discussion of the activities of these groups, see Watson, "Art in the Fifties." In reflecting on the work of the Art in Living Group and the opening of the exhibition, Amess noted, "the gallery had a record attendance" ("The Art in Living Group," 13). It is worth noting that the exhibition has long been seen as a significant event in the telling of the history of modern design in British Columbia. See, for example, Alan C. Elder, "The Artist, the Designer and the Manufacturer: Representing Disciplines in *Design for Living*," in *A Modern Life: Art and Design in British Columbia, 1945–1960*, (Vancouver: Vancouver Art Gallery and Arsenal Pulp Press, 2004), 45–55.

54 Amess, "The Art in Living Group," 13.

55 Not all reviews of the exhibition were enthusiastic. Some were sharply critical of the undertaking and emphasized that the entire premise was elitist. Jack Scott, the contributing author of the column "Our Town" in the *Vancouver News-Herald*, offered a scathing critique of the elitist character of the project: "If the nominations are still open for the most futile contribution to Canadian life in 1949, I wish to submit the Vancouver Community Arts' '*Design for Living*' currently on view in these parts." He goes on: "In the day of the basement suite, the attic apartment, the box-like housing development: in the day of the Great, Unwashed Homeless, this Community Arts Council has decided to strike a fierce blow at the problem of housing and gracious living. In their exhibit now on display they prove conclusively that you, too, can live splendidly if you have enough money." Jack Scott, "Wasted Effort," *Vancouver News-Herald*, November 18, 1949, Newspaper Clipping Binder, Vancouver Art Gallery Library.

56 See *Design for Living*, exhibition catalogue (Vancouver: Vancouver Community Arts Council, 1949).

57 Indeed, the blurring of the lines between fictional and actual worlds, while subtle, was nonetheless telling. The Sarterians owned a nautical picture—*Gay Regatta*—by B.C. Binning. Similarly, the fact that Mrs. Peridot was a weaver who made flax cloth on her home loom was an effective reference not only to the importance of craft in modernity but also to the fact that accomplished women who held the role of homemaker within the patriarchal system that defined domesticity in the post-war years were able to find useful and productive outlets for their creativity.

58 In 1949, Carr's work was in the permanent collection of the Vancouver Art Gallery. It remains part of the institution's holdings.

59 See Rhodri Liscombe, *The New Spirit: Modern Architecture in Vancouver, 1938–1963* (Montréal: Canadian Centre for Architecture, 1997), 123–27.

60 Notably, in the history of modernity in the realms of art and design, there always existed an interest in non-Western cultures. Pablo Picasso's proto-Cubist painting of four sex workers whose faces are covered by African masks is one of the most discussed examples of the relationship between the "primitive" and the "civilized." Similarly, much has rightly been made of the "African" chair that Marcel Breuer created with the weaver Gunta Stölzl while students at the Bauhaus, pointing out that, in the midst of the school's rigorous modernist curriculum, Breuer and Stölzl envisioned and fabricated an exoticized chair or throne. See Christian Wolsdorff, "Der Afrikanische Stuhl" [The African Chair], *Museums Journal*, no. 3, (2004): 40. See also, among other texts, Sally Price, "Objets d'art and Ethnographic Artifacts," in *Primitive Art in Civilized Places* (Chicago: University of Chicago Press, 1983), 82–99.

61 Danah Abdulla, "What Does It Mean to Decolonize Design? Dismantling Design History 101," *AIGA Eye on Design*, June 20, 2019, https://eyeondesign.aiga.org/what-does-it-mean-to-decolonize-design.

62 Tony Fry, "On Design and History," in *Design and the Question of History*, by Tony Fry, Clive Dilnot and Susan C. Stewart (London, Bloomsbury Academic, 2015), 4.

63 John A. Walker, *Design History and the History of Design* (London: Pluto, 1989).

64 Tony Fry, "Whether Design / Whether History," in *Design and the Question of History*, 97–98.

65 See Jean-François Lyotard, *The Postmodern Condition: A Report on Knowledge*, trans. Geoff Bennington and Brian Massumi (Manchester: Manchester University Press, 1984).

66 See Rachel Gotlieb and Cora Golden, *Design in Canada: Fifty Years from Teakettles to Task Chairs* (Toronto: Alfred A. Knopf Canada, 2001); Virginia Wright, *Modern Furniture in Canada* (Toronto: University of Toronto Press, 1997).

67 Arthur J. Pulos, *American Design Ethic: A History of Industrial Design* (Cambridge, MA: MIT Press, 1983), 1.

68 For a discussion of the critical strategies for the reconfiguration of settler thinking, see Corey Snelgrove, Rita Kaur Dhamoon and Jeff Corntassel, "Unsettling Settler Colonialism: The Discourse and Politics of Settlers, and Solidarity with Indigenous Nations," *Decolonization: Indigeneity, Education & Society* 3, no. 2 (2014): 1–32.

Modern in the Making:
Post-War Craft and Design in British Columbia

Allan Collier
with contributions from Jenn Jackson and Stephanie Rebick

Previous spread: Robert Weghsteen pottery and wall installation, c. 1960s

Above: Installation view of *2nd Biennial Crafts Exhibition*, exhibition at the Vancouver Art Gallery, BC, April 28 to May 24, 1959

Left: View of Earle A. Morrison Designs Inc., Fire Tender, c. 1954

INTRODUCTION

In the three decades following World War II, thousands of people moved to British Columbia seeking the benefits of its resource-based economy, mild climate, natural amenities and inventive spirit. Modernist ideas, with origins in the industrialized countries of Europe, began to permeate the visual art, design and craft communities in the province. These ideas found fertile ground in the buoyant economy of post-war British Columbia, as its population turned its back on the deprivation of the Great Depression and WWII and embraced a promising future based on new technologies and a suburban lifestyle. New forms of residential architecture emerged that stimulated a demand for new kinds of furniture and other accents for the home. Many individuals sought creative expression in crafts such as pottery and weaving. Increasingly, fine craft came to be judged by modernist principles—which stressed simple form and appropriate use of materials—that were applied across all design disciplines. This period also witnessed new ways of making things based on wartime technologies, new uses for traditional materials and adaptations of existing methods to fit contemporary forms of expression.

However, modernism in British Columbia was not homogeneous. Many of the current ideas in art, design and architecture of the period originated from the United States via the media or directly from the many individuals who studied there. Modern ideas were also brought to the province after WWII by immigrants from Europe and elsewhere who had rigorous training in the arts and crafts and offered unique, new modes of artistic expression. As in many other parts of the world, local craft artists were inspired by the traditional designs, motifs and production methods of other cultures, including those of local First Nations whose art forms were rejuvenated during this time. Geographic isolation and freedom from tradition engendered a sense of independence and a willingness to experiment that further defined the diversity of craft and design practice in British Columbia. The diverse objects in this exhibition reveal the many dimensions of material expression that came to define the province's post-war cultural identity.

What follows is a chronological survey of this pivotal period between 1945 and 1975, when makers in British Columbia were at the forefront of modernity in Canada. From the work produced in the transitional period immediately following WWII, to the functional, domestic objects favoured in the 1950s, to the increasingly expressive and idiosyncratic forms of the 1960s and 70s, this period witnessed a surge of creativity and innovation that transformed the culture of British Columbia—the reverberations of which continue to be felt today.

MODERN INFLUENCES

The foundation of modernism was established outside British Columbia. The roots of modern craft and design can be traced back to Britain in the mid-nineteenth century. At that time, design reformers such as William Morris attributed the declining design standards they saw around them to the widespread use of machinery in industry. Morris also believed that factory work—in addition to destroying handcraft skills—robbed individuals of their independence and self-worth. In response, Morris and others in the Arts and Crafts movement turned their backs on industrial production and formed craft guilds that made goods by hand, expressed in simple form and using traditional materials and methods. They wanted to restore respect for simple form and decoration, for the nature of materials and traditional processes and for the honest use of materials, all of which became fundamental craft and design values in the twentieth century. Through their work, they established a special status for the handcrafted object within modern industrial society that endures today.

Morris' refusal to adopt machine production in his craft enterprises resulted in products that were too expensive for the average person, so his approach did little to resolve the place of the machine in mass production. That task was left to design reformers working in Germany before World War I and to other designers, such as the American architect Frank Lloyd Wright, who embraced the idea of machine production as a way of reducing costs. Effective use of machinery dictated the removal of extraneous detailing, resulting in simplified forms and a new appreciation of the decorative qualities of the materials themselves.

Many consider the Bauhaus to be the birthplace of modern industrial design. Unlike the Arts and Crafts movement, the Bauhaus embraced machine production and the simple, undecorated forms that flowed from it. Founded in Weimar, Germany, by the architect Walter Gropius in 1919, the school is best known today

Arts and Crafts interior, Ernest William Gimson's house, Sapperton, Gloucestershire, c. 1902–03

for the revolutionary functionalist products made of unconventional materials and geometric forms that its students and faculty designed in the 1920s. It is also known for its pioneering advocacy of the use of handcraft within industry as a means of exploring new ideas and developing prototypes for production. That basic model would be adopted by the Scandinavian countries after WWII, establishing them as leaders of modern design right up until the 1970s. Attempts in Canada to develop an industrial design profession in the 1940s and 50s also took cues from the Bauhaus model and were partially adopted in Eastern Canada. Because of small local markets and limited manufacturing capabilities, industrial design didn't materialize in British Columbia in any significant way, except during the early 1950s, as well as a recent upturn in the first decades of the twenty-first century.

The most significant impact of the Bauhaus remains the widespread public acceptance of simple form and the use of non-traditional materials it engendered. Bauhaus thinking precipitated other design movements such as Machine Art and Streamline Moderne that surfaced in the United States in the 1930s. In the post-war period, America would become a dominant force in world design through the Good Design movement, which championed the innovative use of materials and technologies in the production of simple, functional products.

These international movements were all-important precedents that informed the formal, material and conceptual notions of modernity that would come to flourish in British Columbia during the post-war period.

Below left: Ceramics by Otto Lindig (coffee pot and cup), Theodor Bogler (teapot), Marguerite Friedlaender (mugs) in Lucia Moholy, *Ceramic Coffee Pot and Cup, Combination Teapot, and Mugs (1923)*, 1924–26

Below right: Lucia Moholy, *Bauhaus Masters' Housing, Dessau, 1925–1926: Lucia Moholy and László Moholy-Nagy's Living Room*, c. 1925

CRAFT AND INDUSTRIAL DESIGN

With industry's widespread adoption of machine production rather than handcraft, a new professional called the "industrial designer" emerged, whose main responsibilities lay in the design of objects rather than hands-on production, which was left up to workers and machinery.

For the purposes of the *Modern in the Making* exhibition, "craft" refers to items made by hand or by machine, individually or in series, where the maker controls the process from design to completed object in the spirit of the Arts and Crafts movement. "Industrial design" refers to the process of planning an object for industrial production, involving a comprehensive understanding of aesthetics, materials, production methods and marketing. The designer plays little or no part in production, apart from making a prototype. Despite their differing approaches to production, craft and industrial design are intrinsically linked. High-quality craft must be well designed and industrial design items well crafted in order to succeed in the marketplace. Today, distinctions between craft and industrial design have become less significant, with all artistic production assumed under the rubric of "visual and material culture."

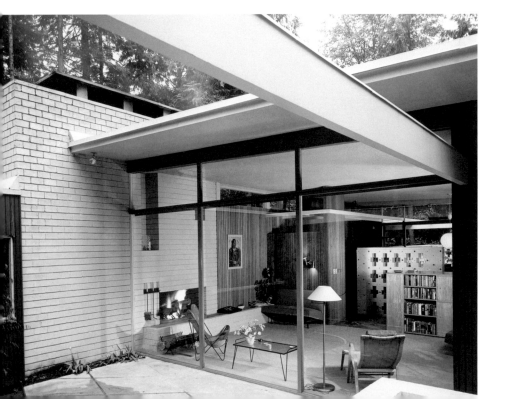

Douglas Simpson House II (Douglas Simpson, architect, built 1953), West Vancouver, BC, c. 1953

POST-WAR RECONSTRUCTION (1945–49)

At the end of WWII, Canadians returned to peacetime full of expectations for a better life. Dreams of new housing with modern conveniences would not be realized, however, until after the reconstruction effort came to an end in the late 1940s. Reconstruction—when material shortages were endemic and efforts were directed at converting wartime industries to consumer goods production—was a transitional period, with manufacturers continuing to produce designs that were popular before the war. Although the post-war housing boom stimulated demand for domestic furnishings and other consumer goods, designers had neither the incentive nor the opportunity to innovate. This dearth of creativity would not last, however. Artists and designers soon assumed an active role in defining and promoting modern ideas about domestic living, both independently and in alliance with government initiatives.

THE ART IN LIVING GROUP

In the mid-1940s, artists across the country expressed an interest in playing an active role in post-war redevelopment. In Vancouver, the Art in Living Group, formed in 1944 under the leadership of Fred Amess, organized four exhibitions at the Vancouver Art Gallery between 1944 and 1946 to inform the public of new developments in art, architecture and urban planning. The first of these exhibitions showcased examples of international modern architecture and the use of art in the home, including a modern living room with locally made hand-screened curtains. The second explored school design through the work of English architect Oliver Hill, and the third featured a plan for a high-density community in East Vancouver. The final exhibition stressed the place of architecture in everyday life and "showed possibilities and examples of more satisfactory forms and methods of living."[1] In connection with these exhibitions, the visionary California-based architect Richard Neutra delivered a series of lectures on global reconstruction and home planning in the spring of 1946 that would prove influential to a number of emerging local architects, including Arthur Erickson and Ron Thom. The Art in Living Group's promotion of contemporary ideas in domestic interiors and architecture would find fuller expression a few years later in the landmark *Design for Living* exhibition of 1949.

Installation view of *Art in Living*, exhibition at the Vancouver Art Gallery, BC, 1945

Installation view of scale model for proposed community centre in *Art in Living*, exhibition at the Vancouver Art Gallery, BC, 1945

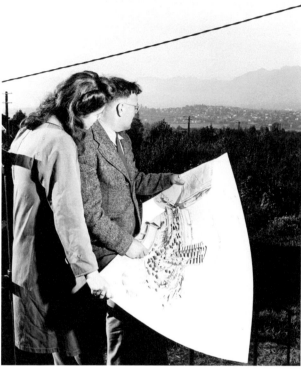

PROMOTING CRAFT AND DESIGN IN CANADA (1946–LATE 1960S)

During the post-war period, the federal government acknowledged the critical importance of good modern design in the development of Canada's domestic and foreign markets and in the promotion of a Canadian identity internationally. From 1946 to the late 1960s, it funded programs through the National Gallery of Canada (NGC) in Ottawa that highlighted Canadian design and craft at home and abroad.

In the fall of 1946, the NGC organized the exhibition *Design in Industry*, a survey of current Canadian-designed products that toured across the country. The exhibition was held at the Vancouver Art Gallery in 1947 and included moulded-plywood furniture produced by Mouldcraft Plywoods of North Vancouver. The exhibition's curator, Donald W. Buchanan, defined Canadian design as follows:

> Good design in manufactured goods, as we understand it today, means a combination of simplicity, fine proportion and functional utility. It is not a question of ornamentation, but of the design of ordinary objects for everyday living. Grace of line and clarity of form are allied to fitness of purpose.[2]

Subsequent initiatives included the creation of the Design Index (1947)—a publicly accessible database of well-designed products—and the National Industrial Design Committee (NIDC, 1948). This group administered the Design Index, the Design Merit Awards program (1953) and design scholarships and competitions. It also produced touring exhibitions (starting in 1949) and established the Design Centre

Above left: Members of the Art in Living Group, Vancouver, BC, 1945

Above right: Fred Amess, leader of the Art in Living Group, discusses a proposed community centre with his assistant, Vancouver, BC, 1945

in Ottawa (1953).[3] These programs, along with national presentations at the Milan Triennial—an international exhibition of architecture and industrial design—in 1954, 1957 and 1964, increased the profile of BC furniture designers such as Earle Morrison, Robin Bush and Peter Cotton.

Federal government funding also extended to support fine craft at national exhibitions, such as *First Canadian Fine Crafts* (NGC, 1957), *Canadian Fine Crafts 1966–67* (NGC, 1966) and *Canadian Fine Crafts* at Expo 67 in Montréal, and enabled the Department of External Affairs to purchase fine craft for display in Canadian embassies and international exhibitions. Many BC craftspeople benefited from these exhibitions, which exposed their work to a much larger market.

Right: Installation views of *Design in Industry*, exhibition at the National Gallery of Canada, Ottawa, ON, 1946

Below: Installation view of the Canadian display at the Milan Triennial X, Italy, 1954

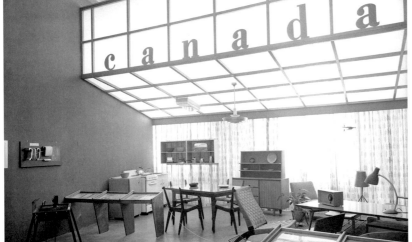

Above: Exterior view of the Design Centre, Ottawa, ON, c. 1950s

Columbia Furniture, Vancouver, BC, End
Table, c. 1947, moulded-plywood legs,
veneered-plywood top, 41.0 × 48.0 × 78.5
cm, Collection of Allan Collier

Hammond Furniture, Vancouver, BC, Chest
of Drawers, c. late 1940s, wood, wood
veneer, 117.0 × 76.0 × 48.0 cm, Collection
of Allan Collier

80

CRAFT AND DESIGN IN THE LATE 1940S

Under pressure to satisfy the huge demand for household goods, many BC manufacturers continued to produce designs that were popular before the war. Common in homes of the late 1940s and early 50s were Bauhaus-inspired cantilevered metal chairs, like those produced by Cyril G. Burch Ltd., and Waterfall Modern furniture made by companies like Hammond Furniture and based on Streamline and Moderne designs of the 1930s and 40s.

Also common in the late 1940s and early 50s were chairs and tables made of moulded plywood, reminiscent of furniture designed by Alvar Aalto in the 1930s. These were made locally by companies such as Mouldcraft Plywoods, who applied plywood-forming technology used in the wartime aircraft industry to furniture making. As such, this type of furniture is considered a prime example of wartime to peacetime conversion.

The softly curving, organic appearance of Mouldcraft furniture offered an alternative to the heavy, upholstered furniture still popular at the time. Mouldcraft furniture was highly regarded in architectural circles—perhaps because of its connection to the revered Aalto. It was often illustrated in journal articles about houses designed by John Porter and Douglas Simpson, and Fred Hollingsworth also included some pieces in his Sky Bungalow display home of 1949, which was built in a downtown Vancouver parking lot and accessible to the public.[4] Despite the publicity, demand for Mouldcraft furniture was limited, which made large-scale mass production impossible, resulting in furniture that was just too expensive for the average consumer. Production difficulties, along with a shift in public taste to more lightweight furniture by the 1950s, forced the company to cease operations in 1950.[5]

Prior to about 1945, studio ceramics involving the potter's wheel was almost non-existent in British Columbia. From 1927 to 1952, the Vancouver School of Art instead taught pottery making using the coil method, and from about 1947 to 1950, a small company called Ravine Pottery made hand-formed pottery in New Westminster. The few exceptions to the rule could be seen in Summerland and Victoria (starting in 1923) as well as in Vernon, where Axel Ebring used skills learned during childhood in Sweden to produce unpretentious country pottery that he sold to the many tourists who visited at his workshop. Marian McCrea McClain, better known in the 1950s as a fabric designer, was also an accomplished potter who learned to use the wheel at the Camberwell School of Arts and Crafts in Britain as well as with F. Carlton Ball in California in the mid-1940s. Self-taught potter David Lambert likewise used the potter's wheel at his craft production studio in 1945, where he also sold the area's first ceramics supplies.

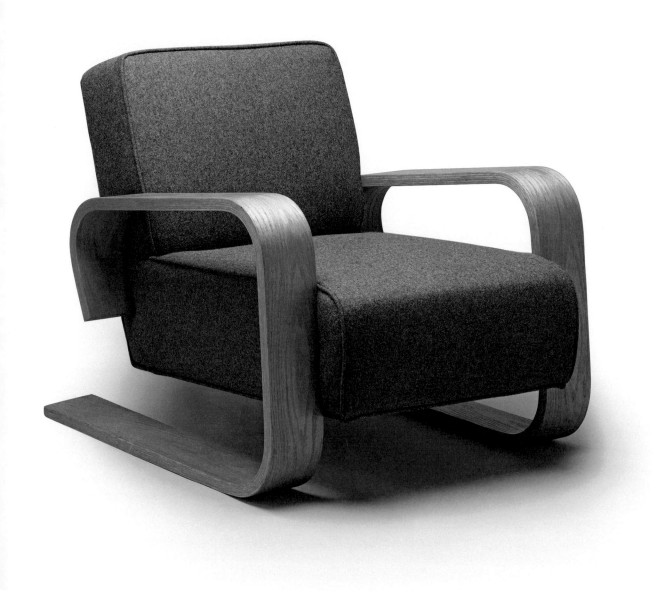

Mouldcraft Plywoods, North Vancouver,
BC, Armchair, 1946, moulded-plywood,
upholstery, foam, 74.5 × 78.0 × 102.0 cm,
Collection of Dwight Koss

Mouldcraft Plywoods, North Vancouver, BC, Chair with Tufted Upholstery, 1946, moulded-plywood, upholstery, 85.0 x 65.0 x 61.0 cm, Collection of Allan Collier

83

Vancouver's fashion industry grew exponentially after WWII and was shaped by the city's geographic context and surrounding landscape. The need for outerwear appropriate for the West Coast weather informed clothing trends, producing an industry predominantly focused on activewear. The fashion community was diverse, ranging from dressmakers with a few assistants who made special commissions, to large firms with hundreds of employees. One success story was Rose Marie Reid, a young housewife who began making innovative swimwear on a small sewing machine in her kitchen. Rather than using traditional wool or cotton materials, she developed inventive designs with quick-drying synthetic fabrics that retained their shape when wet.[6] Established in 1938, her company, Reid's Holiday Togs Ltd. (later Rose Marie Ltd.), found international success in the decades to follow, opening factories in California, Montréal, New Zealand and Brazil.[7]

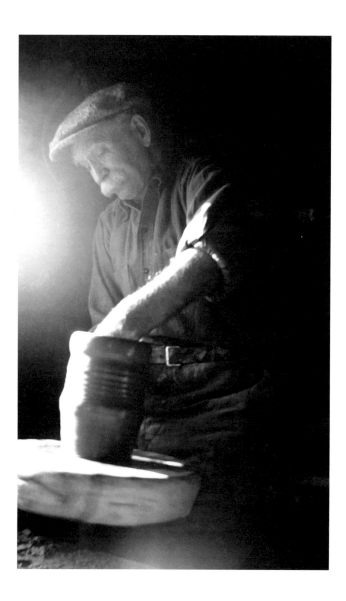

Axel Ebring working in his studio, Vernon, BC, c. 1943

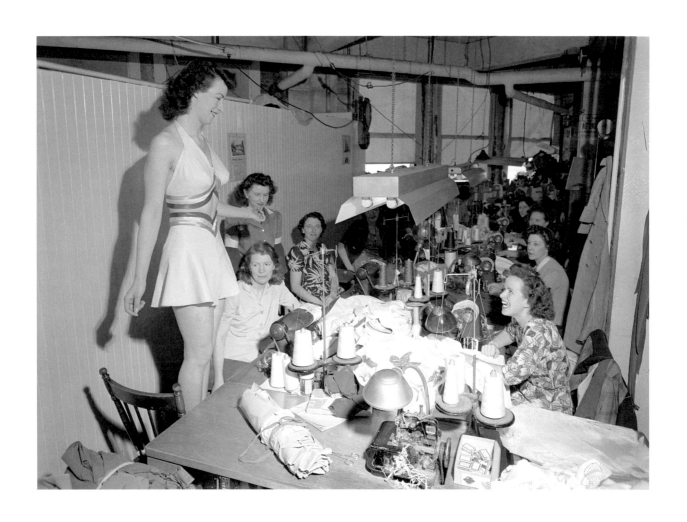

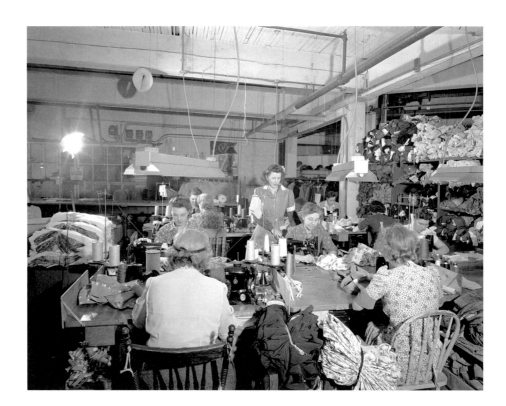

Views of the Reid's Holiday Togs Ltd.
Factory, Vancouver, BC, 1945

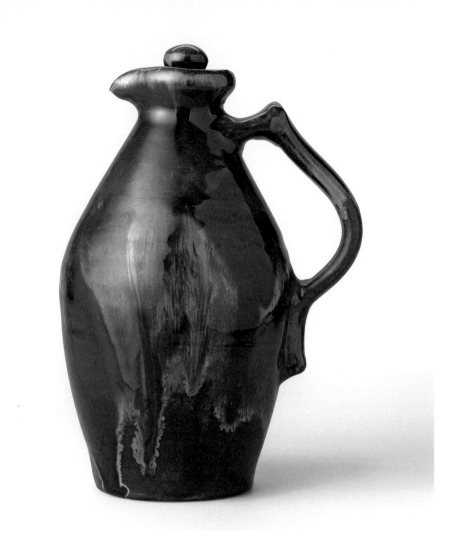

Axel Ebring, Pitcher, c. 1940s (full view
and detail), ceramic, 20.8 × 15.0 × 11.8 cm,
Collection of John David Lawrence

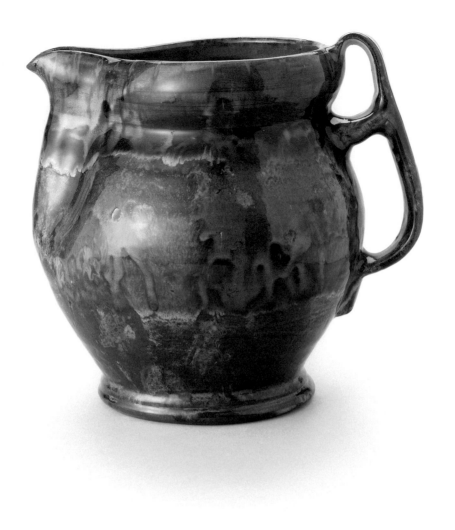

Axel Ebring, Pitcher, c. 1940s, ceramic, 18.0
× 19.5 × 15.3 cm, Collection of John David
Lawrence

Axel Ebring, Flower Pot, c. 1940s, ceramic,
18.6 × 18.6 (diameter) cm, Collection of
John David Lawrence

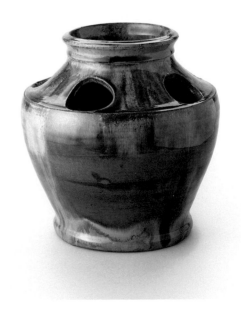

Ravine Pottery, New Westminster, BC,
Tumbler, c. 1948, ceramic, 11.5 × 7.0 cm,
Collection of Allan Collier

Ravine Pottery, New Westminster, BC,
Pitcher, c. 1948, ceramic, 16.3 × 20.7 × 16.7
cm, Collection of Allan Collier

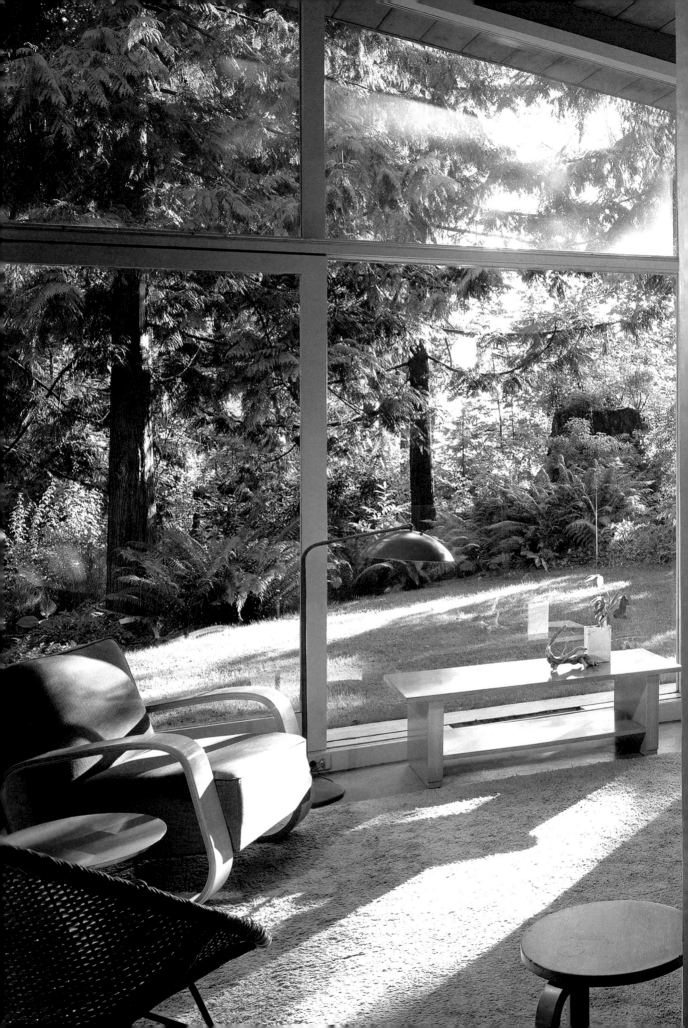

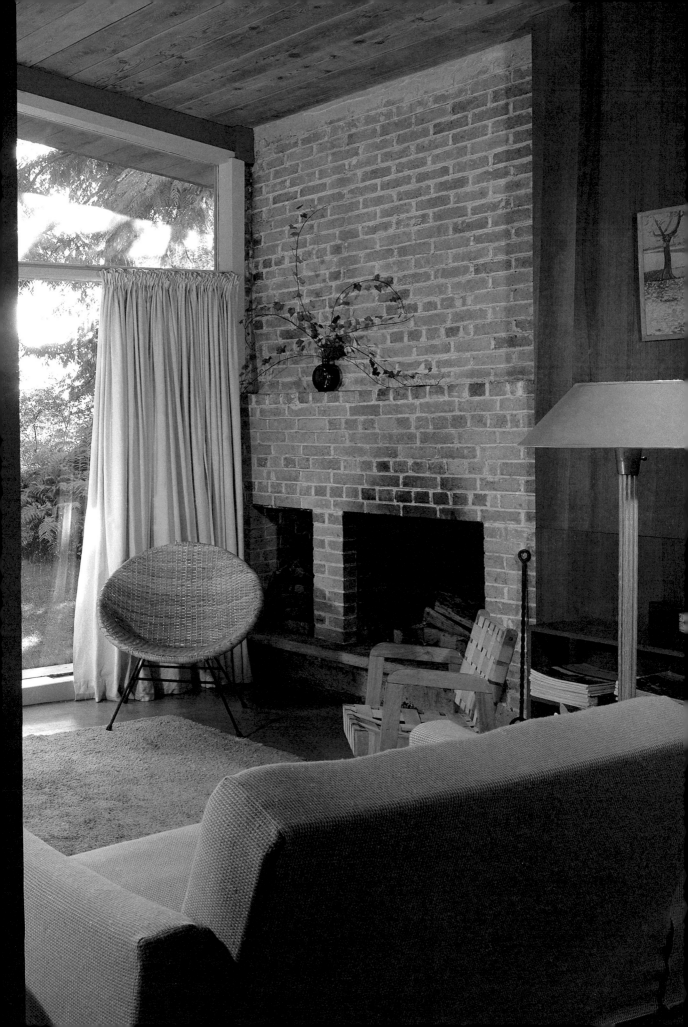

THE FOUNDATION YEARS (1949–59)

As the 1940s neared conclusion and the rations and shortages of wartime became a distant memory, British Columbia underwent a period of significant growth and change. Vancouver and Victoria attracted a wave of immigrants interested in establishing careers in design and the arts who greatly contributed to the increased professionalization of design and craft. The population boom required new housing, furniture and a vast array of consumer goods unavailable during the war. During this period, local architects designed some of the most significant modernist houses in Canada. Rejecting the rigid layouts of traditional residential architecture, home-owners embraced the new modern style characterized by open-plan interiors, natural light and easy access to the outdoors. They animated their new domestic spaces with simple, functional furniture and handcrafted textiles, ceramics and weavings that added warmth, texture and colour to their otherwise plain-surfaced interiors.

After the war, interest in crafts, particularly pottery and weaving, became wide-spread. Crafts were considered fulfilling leisure-time activities that combined self-expression with making useful items for the home. Individuals attracted to crafts saw the handmade object as a response to the ubiquity of machine-made goods that lacked any intimate quality. This longing for a direct relationship between maker, material and product was the same impetus that drove William Morris and others to reject machine-made products about a century earlier. Morris likewise advocated for the honest use of materials, an ethos that proved influential in the resurgence of craft activities in North America in the post-war period.

Internationally, design was very much in the air in the early 1950s. The Museum of Modern Art (MoMA) in New York held its annual *Good Design* exhibition between 1950 and 1955, and in the United Kingdom, modern design took centre stage at the Festival of Britain in 1951. In 1950, Edgar Kaufmann Jr., the director of the Industrial Design Department at MoMA, published the "Twelve Precepts of Modern Design." These were a set of guidelines that stressed the core values of the Bauhaus and the Arts and Crafts movement and were intended to shape public understanding of post-war modernism and guide consumers to well-designed products.[8]

An infrastructure to define, support and promote modern design ideas in British Columbia was also established during this period. Like elsewhere in Canada in the early 1950s, BC residents often saw progressive new design ideas in public art galleries. Between 1949 and 1953, the Vancouver Art Gallery alone held six design exhibitions, three organized locally and three on loan from the NGC and the NIDC. In Vancouver, the newly established School of Architecture at the University of British Columbia (UBC) encouraged an interest in studying modern design, introducing industrial design courses into its curriculum in 1947.

Public interest in craft as a leisure activity resulted in the expansion of pottery, weaving and jewellery-making courses at the UBC Extension Department between 1945 and the late 50s. The Federation of Canadian Artists (est. 1941) and the BC Potters Guild (est. 1955) organized the annual BC Potters exhibitions starting in 1949 and continuing until the early 1960s.

Previous spread: Interior of Porter Residence (John C. Porter, architect, built 1948–49), West Vancouver, BC, 1955

In 1947, the Fashion Manufacturers Association (a.k.a. the BC Needle Trades) collaborated with the Alpha Omicron Pi sorority to develop annual fashion shows and design competitions, which highlighted the work of designers such as Martha Wiens and others.[9] Showcasing BC designs bolstered the careers of local designers and presented the general public with an opportunity to see original, locally made collections. These events were hosted at hotels, department stores, cabarets, theatres, galleries and even at the Pacific National Exhibition grounds. Their audiences ranged from intimate groups to thousands of viewers.[10]

Stores and galleries selling locally made craft and design appeared in Vancouver and Victoria in the early and mid-1950s. Among these were the Quest in Victoria and Mollie Carter Contemporary Design, Charlotte Kennedy Interiors and the New Design Gallery in Vancouver. Starting in August 1950, developments in local architecture, art, design, fashion and craft were reported monthly in *Western Homes and Living*, British Columbia's first home magazine.[11]

Frederic Lasserre and Peter Cotton examining a thesis model, University of British Columbia, Vancouver, BC, 1952

THE *DESIGN FOR LIVING* EXHIBITION

The landmark *Design for Living* exhibition, held at the Vancouver Art Gallery in 1949, served as an important preview of new developments in modern architecture, craft and design and how they might unfold in the province during the 1950s. The exhibition, which posed the question DOES YOUR HOUSE FIT YOU?, was one of the first in Canada to demonstrate how modern residential architecture and functional household goods could best satisfy the needs of post-war living. *Design for Living* presented architectural plans for four imaginary families with distinct needs, complete with four room settings filled with well-designed modern furniture, carpets, lighting, woven items and other craft objects made by local artisans and manufacturers. These items were chosen to illustrate how good design served the specific needs of each family and fit the aesthetics of contemporary architecture. A few of the architects who prepared the drawings for the four houses also designed and made some of the exhibited furniture. Robert Calvert's plans for a reading chair were made available to the public. It could be built inexpensively from a two-foot by four-foot plywood panel using an electric jigsaw and finished off with some upholstery webbing, providing a stylish do-it-yourself alternative to the expensive imports not yet widely available in stores.[12]

The ceramics exhibited in *Design for Living* mostly came from the Art-Craft Workshops, a group of mainly amateur potters who worked in the newly opened Art Centre Workshop (1948) in the basement of UBC's main library. Indicative of public interest in First Nations craft, *Design for Living* also included furniture with woven panels made by the Coast Salish weaver Mrs. Jim Joe, as well as baskets and other objects by Indigenous makers loaned by UBC's Museum of Anthropology. The Community Arts Council of Vancouver, which organized the exhibition, also wished to promote handcraft as a way of generating designs for factory production. The exhibition was hugely popular, but nonetheless received criticism for focusing on the needs of the upper-middle class.

Design for Living, 1949 (interior spread), softcover book, 21.5 × 19.5 cm, Courtesy of the Vancouver Art Gallery Library

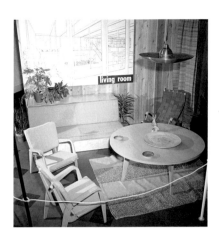
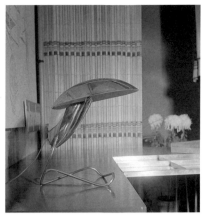
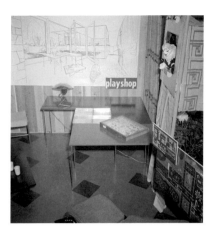
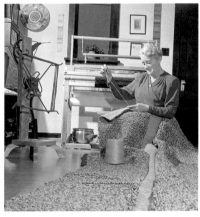

Top left to bottom right:

Installation view of the Living Room for the Peridot Family in *Design for Living*, exhibition at the Vancouver Art Gallery, BC, November 8 to November 27, 1949

Installation view of Murray Dunne, Electric Lamp in *Design for Living*, exhibition at the Vancouver Art Gallery, BC, November 8 to November 27, 1949

Installation view of the Playshop for the McTavish Family in *Design for Living*, exhibition at the Vancouver Art Gallery, BC, November 8 to November 27, 1949

Margery Thorne working on a jute rug on her home loom for display in *Design for Living*, exhibition at the Vancouver Art Gallery, BC, November 8 to November 27, 1949

Mollie Carter working on ceramics for display in *Design for Living*, exhibition at the Vancouver Art Gallery, BC, November 8 to November 27, 1949

Robert Calvert working on a reading chair for display in *Design for Living*, exhibition at the Vancouver Art Gallery, BC, November 8 to November 27, 1949

Installation view of Duncan S. McNab, Garden Chair in *Design for Living*, exhibition at the Vancouver Art Gallery, BC, November 8 to November 27, 1949

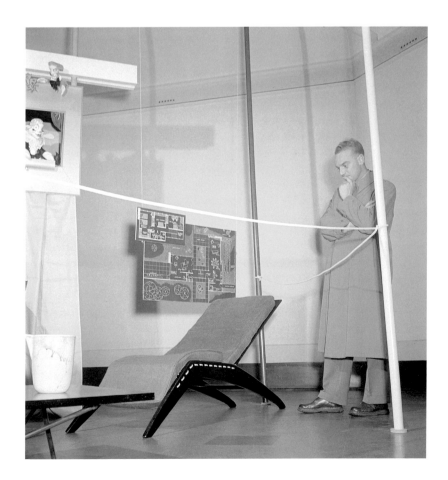

95

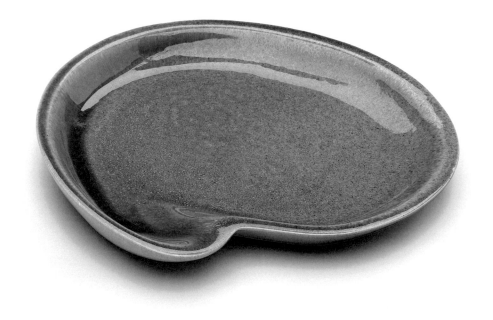

Robert Calvert, Reading Chair (Replica),
1949/2004, plywood, maple, upholstery
webbing, 93.0 × 67.5 × 86.5 cm, Collection
of Allan Collier

Gertrude Weir, Plate, c. 1949, ceramic, 3.0
× 25.7 × 22.6 cm, Collection of Allan Collier

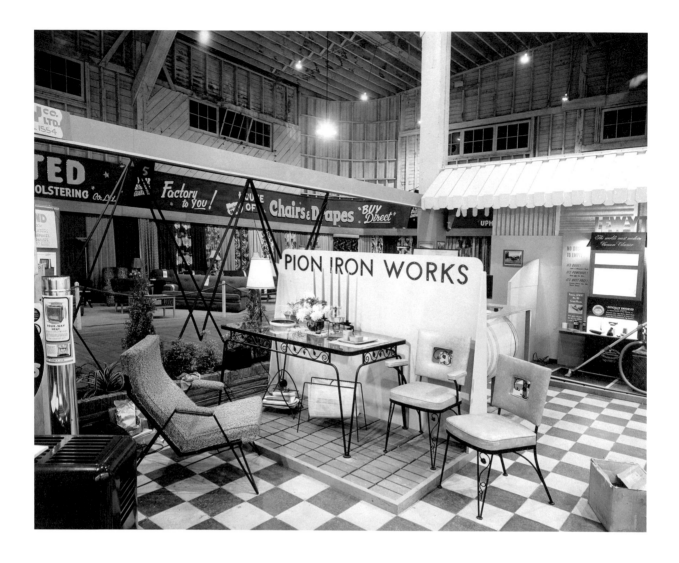

Pion Iron Works display at the Pacific
National Exhibition, Vancouver, BC, 1953

Peter Cotton for Perpetua Furniture,
Vancouver, BC, Glass-Topped Coffee Table,
1950

FURNITURE DESIGN IN THE 1950S

British Columbia's first locally designed modernist furniture appeared on the scene around 1949. Designed by Peter Cotton, Alfred Staples, Earle Morrison and Robin Bush and mostly made of steel rod and angle iron, these minimalist, visually light-weight pieces of furniture helped create a sense of space in the smaller homes of the day. The designs, which featured imaginative uses of industrial materials, were among the most innovative produced in Canada at the time.

Peter Cotton started designing steel-rod and angle-iron furniture in 1948 while a student at UBC's School of Architecture. He credited his architectural training—specifically his knowledge of materials—with steering him toward designs using iron rod, which he considered stronger, more elegant and less expensive than traditional wood construction. Cotton felt that much of the furniture available in shops at the time was "self-consciously styled with clumsy heavy-handed moderne mannerisms" and "too gross and lumpy to look well in small-scaled and finely detailed modern houses."[13]

In January 1952, Cotton, along with interior designer Alfred Staples, opened Perpetua Furniture, a retail shop and interior design office.[14] His furniture designs were mostly manufactured by the nearby Pion Ornamental Iron, run by Carl Ostermeier.[15] Cotton's work was well received critically and exhibited nationally—in Canadian *Design for Living* (NGC, 1953) and at the Design Centre in Ottawa—as well as published in *Canadian Homes and Gardens*, *Western Homes and Living* and national and local newspapers.[16] One of the few BC designers to receive international recognition, he had his metal coffee table with a wired safety-glass top reproduced in the September 1952 issue of the Italian magazine *Domus*, and his tripod lamp was featured at the 1954 Milan Triennial.

Also producing furniture in metal were Victoria designers Earle Morrison and Robin Bush. In the late 1930s and early 40s, Morrison studied aeronautical engineering at the California Institute of Technology and worked briefly for Hughes Aircraft in Los Angeles, where he became familiar with wood-moulding techniques. In 1948, he established a woodworking business, which eventually grew to become E.A. Morrison Ltd., a firm specializing in the design and manufacture of contemporary furniture. Morrison started his modern design venture, he said, because he wanted to create an alternative to the Waterfall Modern style that dominated the market after WWII. At that time, it "just wasn't possible to purchase furniture with good scale, clean detail, and manufactured with materials (hardwood and metals) designed to show the material's natural beauty."[17]

Around 1950, Morrison began working with designer Robin Bush, and the pair formed the marketing company Morrison-Bush Associates around 1952.[18] The Morrison-Bush collaboration, which also involved designer John Grinnell, produced a series of tables, cabinets, upholstered chairs and settees, all supported on iron-rod legs that made the furniture appear as if it were floating.[19] Several of their pieces were listed in the Design Index, received NIDC Design Awards and were reproduced in national and international publications such as *Decorative Art*. A wooden dining table and rush-seat chair were exhibited at the Milan Triennial in 1954.

In 1953, Bush moved to Vancouver and renamed the company Robin Bush Associates (1954), with Morrison and Grinnell remaining as design associates. Morrison stayed in Victoria to run a design company called Designs Incorporated— where he developed furniture items and a cast-aluminum fire tender that was exhibited in the NGC's *Good Design in Aluminum* exhibition of 1955—but eventually followed Bush to Vancouver in 1956. With tastes trending to Scandinavian and the market for steel-rod residential furniture almost saturated, Bush shifted focus to the more lucrative institutional field. In the mid-1950s, he designed the Hotel/ Motel Group chair and desk in angle iron (1954) as well as the colourful Prismasteel modular office-furniture system (c. 1957), which was widely publicized in art and architectural magazines. Bush's furniture for a worker housing development in Kitimat was represented at the Milan Triennial in 1957.

One other Vancouver company designed and manufactured noteworthy modernist furniture in the early 1950s. This was the upholstery company Strahan and Sturhan, which produced a lounge chair based on Eero Saarinen's Grasshopper chair. By using a steel-rod structure instead of moulded plywood, the company succeeded in creating a local version that is, arguably, more elegant than the original.

Furniture made of plywood entered people's homes in the 1950s. Across North America, hobbyists made simple plywood furniture from plans available from magazines like *Popular Mechanics*, which catered to individuals seeking ways to save money by building things themselves. In this category were the modern lounge chairs and other furniture pieces designed by Vancouver architects Robert Calvert and Duncan McNab that appeared in the 1949 *Design for Living* exhibition. Calvert's pieces could be made from plans available from the architectural firm Sharp and Thompson, Berwick, Pratt and from the lumber company BC Forest Products. McNab's chair was similarly easy to make from plywood cut with a jigsaw and upholstered with sash cord and foam rubber. Around 1953, the architect Fred Hollingsworth also designed a plywood chair—inspired by Richard Neutra's Boomerang chair of 1942—that he specified for the Hill and Johnson residences. Eager to increase sales, BC Forest Products published plans for furniture using Shadow Wood, a new textured panelling that came on the market in the 1950s.

The appearance in the early 1950s of this unique body of furniture points to the success local designers achieved in producing modern designs made from industrial materials for national markets and in establishing a nascent design community in British Columbia's increasingly cosmopolitan urban centres of Vancouver and Victoria.

Earle A. Morrison and Robin Bush for
Earle A. Morrison Ltd., Victoria, BC, Buffet
and Wall-Mounted China Cabinet, 1953,
published in the Design Index, 1953

Robin Bush for Canadian Office and School
Furniture Ltd., Preston, ON, Prismasteel
Office Furniture System, published in
Canadian Art, Spring 1959, p. 121, Courtesy
of the Vancouver Art Gallery Library

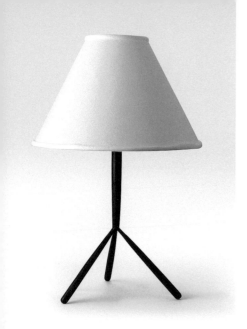

Peter Cotton for Perpetua Furniture,
Vancouver, BC, Tripod Lamp, 1950, steel,
brass, textile, 65.5 × 44.5 (diameter) cm,
Collection of Chris Small

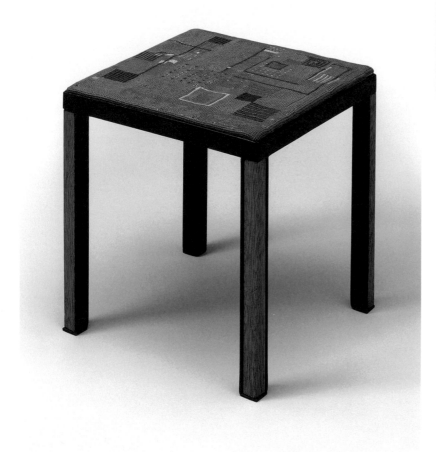

Peter Cotton for Pion Ornamental Iron Co.
Ltd., Vancouver, BC, Delahaye Series Stool
with Embroidery, c. 1954 (full view and
detail), angle iron, plywood, wood, needle-
point, 33.7 × 29.8 × 29.8 cm, Collection of
Allan Collier

Peter Cotton for Perpetua Furniture, Vancouver, BC, Glass-Topped Coffee Table, 1950, steel rod, glass, 40.0 × 150.0 × 45.5 cm, Collection of Chris Small

Peter Cotton for Perpetua Furniture, Vancouver, BC, Armchair A3MKII, 1953, steel rod, plywood, teak, upholstery, 77.0 × 67.0 × 53.0 cm, Collection of Allan Collier

Overleaf: Morrison-Bush furniture in the living room of the Mario Prizek Residence, Vancouver, BC, published in *Decorative Art: The Studio Yearbook, 1954–55*, 1955

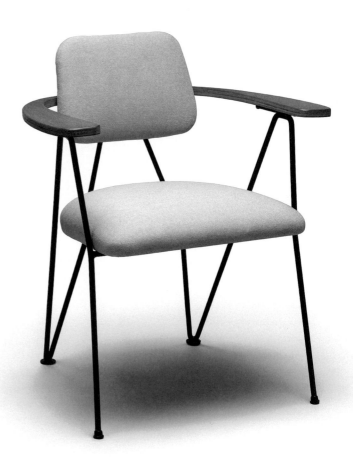

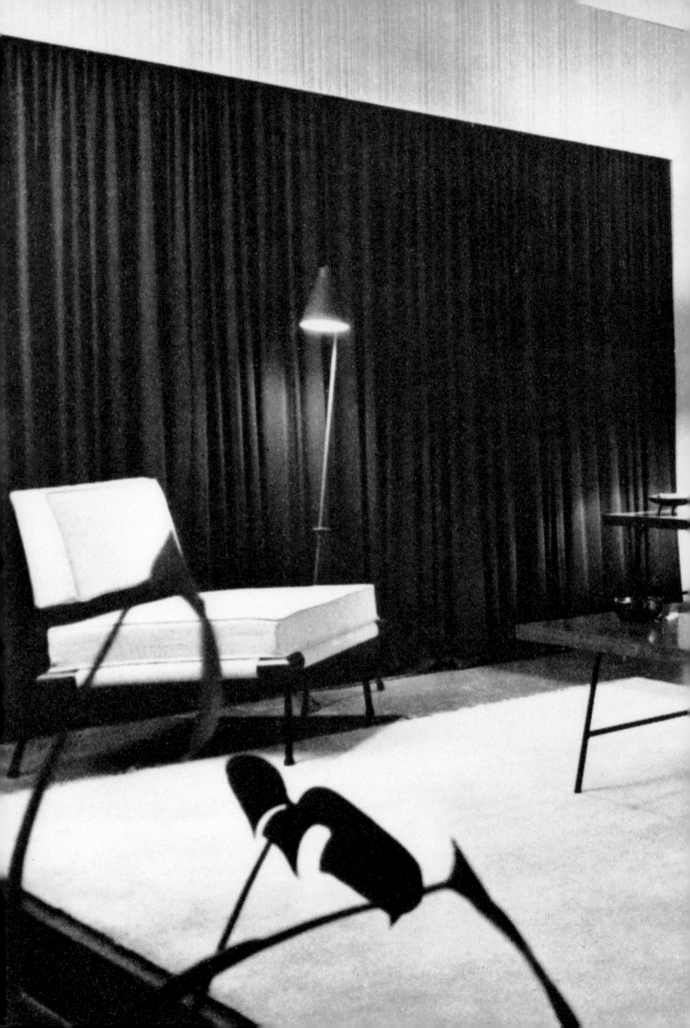

Right: Robin Bush for Robin Bush Associates, Vancouver, BC, Desk #55 (from Hotel/Motel Group), 1955, angle iron, painted plywood, plastic laminate, 74.3 × 119.5 × 50.8 cm, Collection of the Vancouver Art Gallery, Gift from the Collection of Allan Collier, VAG 2019.15.3

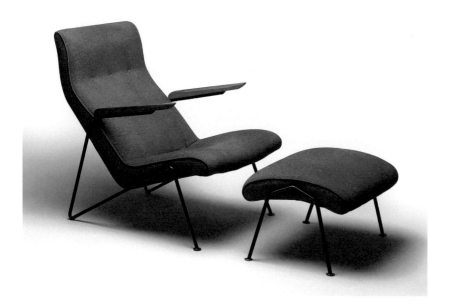

Above left: Attributed to Herbert Sturhahn for Strahan and Sturhan Upholsterers, Vancouver, BC, Contour Chair with Foot Stool, c. 1953, steel rod, upholstery, wood, chair: 83.0 × 67.0 × 79.0 cm, stool: 36.0 × 58.0 × 47.0 cm, Collection of Allan Collier

Above right: Earle A. Morrison and Robin Bush for Morrison-Bush Associates, Victoria, BC, Armchair (#1), 1952, chromed steel, upholstery, 72.0 × 62.0 × 54.0 cm, Collection of Allan Collier

Left: Earle A. Morrison and Robin Bush for Earle A. Morrison Ltd., Victoria, BC, Desk, c. 1952, walnut-veneered plywood, steel rod, 75.5 × 122 × 58.5 cm, Collection of Allan Collier

106

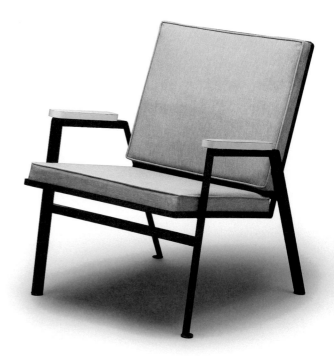

Top left: Earle A. Morrison Designs Inc., Victoria, BC, Fire Tender, 1954, cast aluminum with wooden handle, 99.1 × 12 × 7.6 cm, Collection of Allan Collier

Above: Earle A. Morrison and Robin Bush for Earle A. Morrison Ltd., Victoria, BC, Side Chair (#118), c. 1951, steel rod, plywood, upholstery, 82.0 × 52.0 × 60.0 cm, Collection of Allan Collier

Top right: Robin Bush for Robin Bush Associates, Vancouver, BC, Easy Chair #58 (from Hotel/Motel Group), 1954, angle iron, plywood, plastic laminate, vinyl, 82.0 × 76.0 × 66.0 cm, Collection of the Vancouver Art Gallery, Gift from the Collection of Allan Collier, VAG 2019.15.2

Right: Earle A. Morrison and Robin Bush for Earle A. Morrison Ltd., Victoria, BC, Airfoam Lounge Chair (#141), 1951, steel rod, plywood, walnut, upholstery, 71.7 × 76.2 × 73.0 cm, Collection of Allan Collier

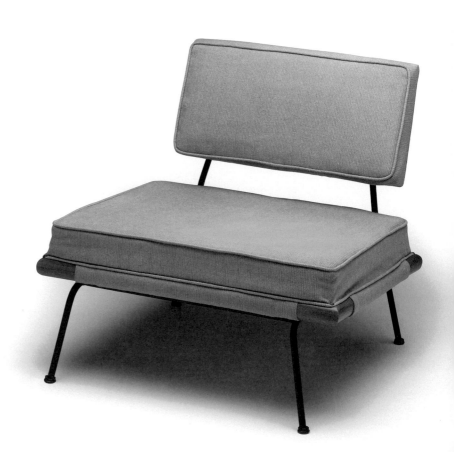

Top: Canadian Forest Products Ltd. display at the Pacific National Exhibition, Vancouver, BC, 1951

Bottom: Interior of Hill House (Fred Hollingsworth, architect, built 1952), North Vancouver, BC, published in *Western Homes and Living*, March 1955

Canadian Forest Products Ltd., Pacific Veneer and Plywood Division, Modern Shadow Wood Desk, c. early 1950s, brochure, open: 27.9 × 43.2 cm, Collection of Allan Collier

Fred Hollingsworth, Plywood Chair (Replica), c. 1951/2018, plywood, upholstery, foam, 71.0 × 71.0 × 61.0 cm, Collection of Allan Collier

Unknown (from plans published by Cana-
dian Forest Products Ltd., Pacific Veneer
and Plywood Division), Modern Shadow
Wood Desk, c. early 1950s, Shadow Wood
plywood, plywood, solid wood, 80.8 × 163.3
× 62.7 cm, Collection of Allan Collier

TEXTILES IN THE 1950S

With the founding of guilds in the mid-1930s, the weaving community in the province was relatively well established by the 1950s. Marjorie Hill and Honey Hooser both exhibited their work in the *First Canadian Fine Crafts* exhibition (NGC, 1957), with the latter also exhibiting at the Brussels World's Fair in 1958. Weavers produced practical and visually appealing domestic items such as placemats, blankets, towels and rugs, sometimes with applied geometric decoration and using local wools and natural dyes. Their formal and material approaches communicated the prevailing ideas about the importance of well-designed handcrafted objects in the modern domestic environment.

Fabric design was taught at the Vancouver School of Art (VSA) from the 1930s to the 50s, but very few graduates succeeded in having their designs produced commercially. One who did was Marian McCrea McClain, a potter and fabric designer who established a fabric design business in the late 1940s using the trade name Marian. Initially she produced hand-silkscreened drapery material and placemats, which she exhibited at the Vancouver Art Gallery in 1948.[20] One of these designs, entitled Persian, was mass produced by George Hees Ltd. in 1950 and renamed Enchantment as part of the company's Homemaker series.[21] Throughout the 1950s, McCrea McClain sold six designs a year to F.W. Fewks in Montréal and Riverdale in New York.[22]

Another VSA graduate, Chuck Yip, also designed fabric for production in the 1950s. One of his designs, Fantasia, won third prize in the 1950 International Fabric Design Competition, sponsored by the Colonial Drapery and Curtain Corporation of New York. The design, with its bold colours and stylized depiction of nature, was subsequently produced by the firm Town and Country and specified for a model home in Toronto called the Trend House, which opened to the public in 1952.[23]

Honey Hooser, Woven Mat (with Pink Flower Pattern), c. 1950s, wool, 31.0 × 38.7 cm, City of Surrey Heritage Services

Honey Hooser, Placemat (Multicolour-
Thread Flower Pattern), c. 1950s, wool, 27.0
× 39.2 cm, City of Surrey Heritage Services

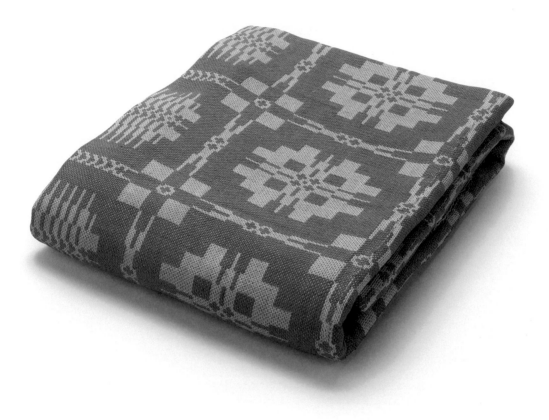

Marjorie Hill, Coverlet Woven in a Summer and Winter Pattern, c. 1947 (details), cotton warp, cotton weft in two weights, 252.6 × 189.7 cm, Victoria Handweavers and Spinners Guild Permanent Collection

Chuck Yip for A Chuck Yip – Town and
Country Fabric, Fantasia Fabric (Sample),
1950, textile, 92.0 × 29.3 cm, Collection of
Roger Yip

POTTERY IN THE 1950S

In 1953, BC potters won half the awards at the Canadian Handicrafts Guild pottery exhibition in Montréal. Over a period of about five years, pottery in the province had risen from obscurity to national prominence.

The emergence of pottery in British Columbia can be attributed largely to the rapid expansion of training programs and exhibition opportunities for local potters, which began in the late 1940s. Seeing a growing need for pottery instruction in Vancouver, VSA graduate Mollie Carter, assisted by Hilda Ross, established the first community pottery classes at the Gordon Neighbourhood House in the city's West End in the fall of 1947 and also at the Art Centre Workshop in the basement of the UBC library in January 1949. In 1952, the UBC classes moved into modernized facilities in a repurposed army hut called the Acadia Ceramic workshop, better known later as the Ceramic Hut.

In 1951 and 1952, the UBC Extension Department, which offered continuing education classes, hired the California modernist potter Edith Heath to teach its first two summer workshops, which would continue until the mid-1960s. The California influence in British Columbia grew when the Extension Department hired modernist potter Rex Mason as its resident instructor. During his time at UBC (1952–56), Mason mentored a circle of potters including Hilda Ross, Olea Davis, Thomas Kakinuma, Dexter Pettigrew, Gordon Stewart and Sasha Makovkin and encouraged them to develop and to exhibit their work outside the province.[24] F. Carlton Ball, Mason's own teacher in California in the 1940s, also held workshops at UBC throughout the 50s.[25] In 1952, the VSA, which up until then had taught only hand-built pottery using the coil method, installed new kilns and electric potters' wheels and hired the instructors David Lambert and Reg Dixon to bring its program more in line with pottery practice of the period. This modernization effort would come to fruition in the late 1950s and early 60s, when prominent potters such as Wayne Ngan, Glenn Lewis, Mick Henry and Ian Steele began to graduate.

Local annual pottery exhibitions started in April 1949 at the Art Centre Gallery (later the UBC Fine Arts Gallery), located in the basement of the UBC library. The first six were organized by the Federation of Canadian Artists between 1949 and 1954, after which the newly formed BC Potters Guild took over until the early 1960s. These groups frequently appointed judges from the United States, among them Hal Riegger from California (1952) and Betty Feves from Oregon (1958).

The development of pottery in the region was also impacted by well-trained ceramic artists who immigrated to British Columbia during the 1950s. One of the few experienced potters working in Vancouver in the early 50s was Zoltan Kiss, a Hungarian-trained architect who came to Vancouver in 1950 after spending about four years working as a building designer and potter at Knabstrup Keramik in Denmark. While there, he acquired Scandinavian design sensibilities, which are revealed in his well-proportioned forms, tactile surfaces and subtle glaze treatments. Kiss established a home-based studio in West Vancouver in the mid-1950s and was a frequent exhibitor and award winner in local and national exhibitions.

Thomas Kakinuma at the University of British Columbia, Vancouver, BC, 1958

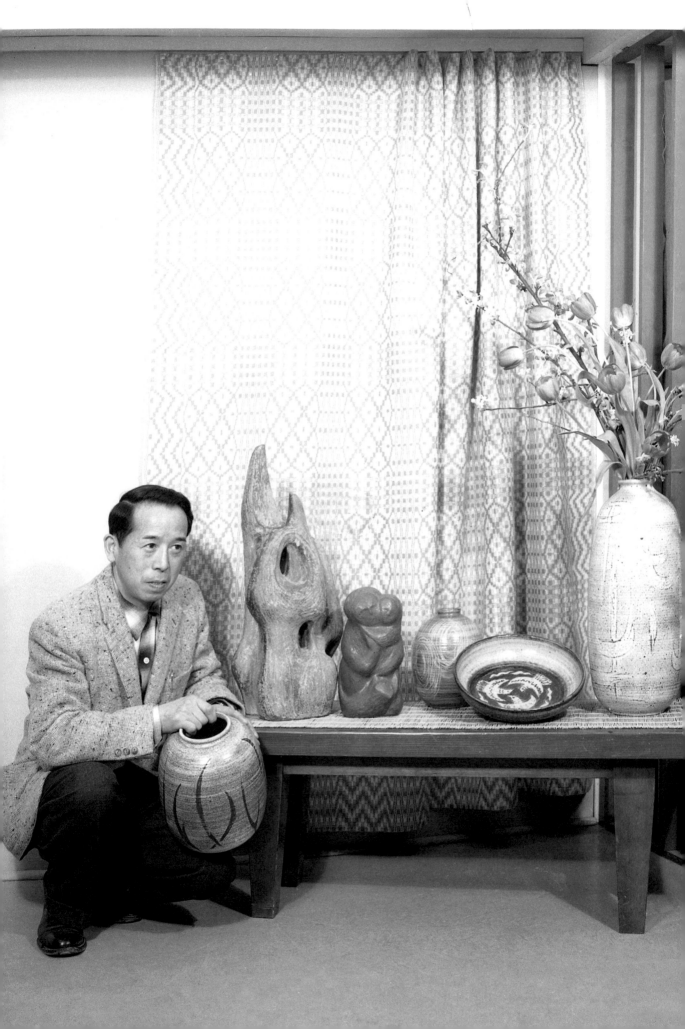

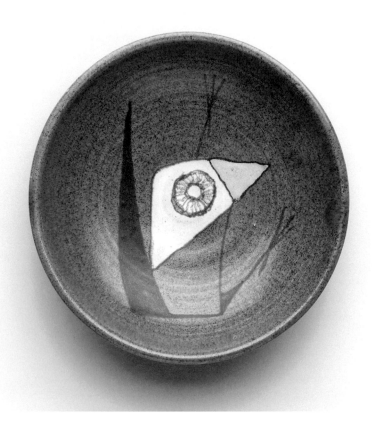

Top: Rex Mason, Jar, 1954 (full view and detail), ceramic, 35.0 × 15.9 (diameter) cm, Collection of the Vancouver Art Gallery, Vancouver Art Gallery Women's Auxiliary Purchase Fund, VAG 54.15

Bottom: Robert Weghsteen, Plate with Bird, c. late 1950s–early 1960s, ceramic, 3.4 × 14.5 cm, Courtesy of Joanne Weghsteen

Top left: Herta Gerz for BC Ceramics Ltd.,
Vancouver, BC, Plate (#7088 Flamenco
Décor), c. 1960, ceramic, 4.0 × 21.8 × 17.8
cm, Collection of Allan Collier

Top right: Herta Gerz for BC Ceramics Ltd.,
Vancouver, BC, Bowl (#7087 Northern
Lights Décor), c. mid-1950s, ceramic, 9.0 ×
28.5 × 19.7 cm, Collection of Allan Collier

Right: Zoltan Kiss, Vase, 1957, ceramic, 23.2
× 12.3 (diameter) cm, Courtesy of the Artist

Robert Weghsteen, who arrived in Vancouver via Belgium, studied at the Central School of Arts and Crafts in London under Dora Billington and William Newland and began teaching at the VSA in 1957. Some of his late-1950s bowls feature abstract animals in the manner of his mentor Newland, who was also known for his Picasso-like decorations. Herta Gerz, the head designer at BC Ceramics Ltd., who gained training and production experience in Germany before WWII, also often applied abstract designs, including one called Northern Lights, to her mass-produced forms. Santo Mignosa, a sculptor from Sicily, arrived in Vancouver in 1957 and studied with the ceramicist Thomas Kakinuma at UBC. Mignosa's hand-built forms brought a novel approach to the BC pottery scene of the late 1950s, placing him in the vanguard of ceramic artists breaking away from wheel-thrown work.[26]

In addition to influences brought here by new Canadians, at least two well-known potters studied briefly outside the province in order to find inspiration and advance their skills. Mollie Carter studied with Edith Heath in San Francisco in 1947 and returned to Vancouver determined to improve pottery instruction in the city and advance the cause of modern design. Leonard Osborne studied at Pond Farm in Guerneville, California, with Bauhaus graduate Marguerite Wildenhain in the summers of 1956 and 1957. Wildenhain's influence can be seen in Osborne's footed vases with sgraffito markings.

Mollie Carter, Bowl, c. early 1950s (full view and detail), ceramic, 10.2 × 15.8 (diameter) cm, Collection of John David Lawrence

Santo Mignosa, Vase, c. 1958–59, ceramic,
59.4 × 27.0 × 21.2 cm, Collection of John
David Lawrence

POTTERY AND MODERNISM

By the mid-1950s it was clear that BC pottery was being judged by modernist standards that stressed, among other things, simple form and well-integrated decor. This was made clear in a review of the 6th Annual Potters' Exhibition shown in Victoria in 1954:

> Both the judges of the show and the makers of the objects have obviously been
> guided above all, by the considerations of form... Few artists have departed from
> the essential principles of simple and pleasing design.
> ...In most cases the potters have allowed the pure lines of the shapes to speak for
> themselves. What ornament one finds is integral to the design and is in many cases
> part of the surface texture.[27]

A variety of influences, both local and international, encouraged this modernist approach to ceramics production. Magazines such as *Ceramics Monthly* and *Canadian Art* covered innovations in craft practices, and the touring exhibition *Design in Scandinavia*, shown at the Vancouver Art Gallery in 1956, introduced local audiences to the work of some of the world's finest modernist ceramic artists. Among them were Rut Bryk, Stig Lindberg, Axel Salto and Kyllikki Salmenhaara, who would give a workshop at UBC in 1964.

In the context of these modernist sensibilities, local potters mainly produced utilitarian vessels—vases, bowls and casserole dishes—which doubled as decorative accents in the home. Throughout the 1950s, makers used both the potter's wheel, to create simple forms like cylinders and spheres, as well as moulds to make freeform shapes. Textured surfaces, made using techniques like sgraffito and incising, expressed the malleable quality of clay, and applied decoration, including wax resist, often referenced abstract art, although simple linear decorations were also common. Modernist potters used surface treatment, decoration and colour to enhance, rather than detract from, the forms they made.

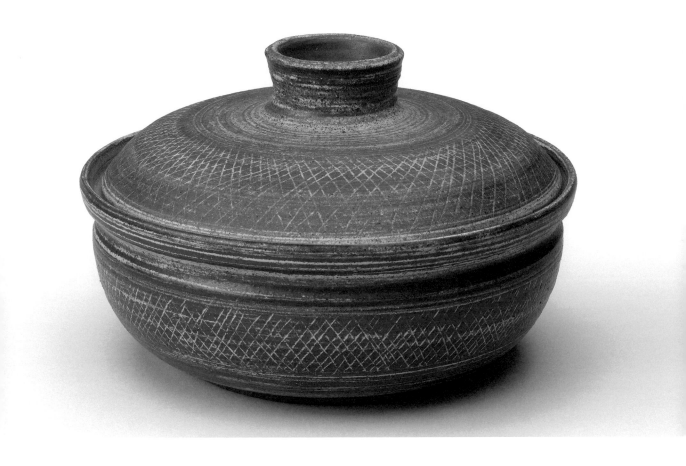

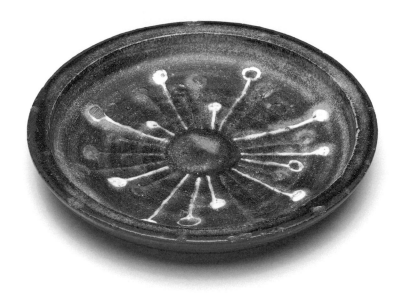

Hilda Ross, Casserole, c. mid-1950s,
ceramic, 15.0 × 23.5 (diameter) cm, Collec-
tion of Allan Collier

Avery Huyghe, Plate, c. 1955, ceramic, 2.3
× 15.5 (diameter) cm, Collection of Allan
Collier

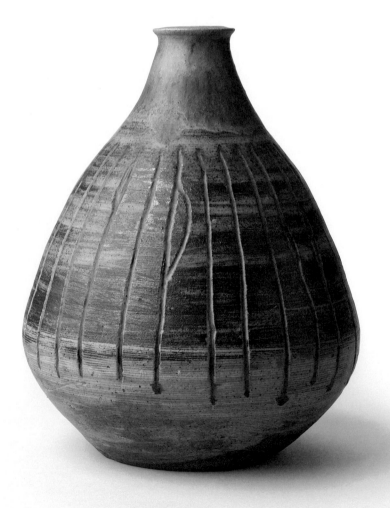

Top: Alice Bradbury, Casserole, 1959 (full view and details), ceramic, 15.2 × 22.0 (diameter) cm, Collection of the Vancouver Art Gallery, B.C. Industrial Design Committee Purchase Award, VAG 59.12 a-b

Bottom: Reginald Dixon, Vase, c. 1956, ceramic, 25.0 × 20.0 (diameter) cm, Collection of the Vancouver Art Gallery, Gift of the Vancouver Art Gallery Women's Auxiliary, VAG 56.11

Opposite top: Sasha Makovkin, Casserole, 1955 (full view and details), ceramic, 24.0 × 28.5 (diameter) cm, Collection of the Vancouver Art Gallery, B.C. Industrial Design Committee Purchase Award, VAG 55.16 a-b

Opposite bottom: Gordon Stewart, Dish, c. mid-1950s (full view and details), ceramic, 5.8 × 27.0 (diameter) cm, Collection of Jay Stewart

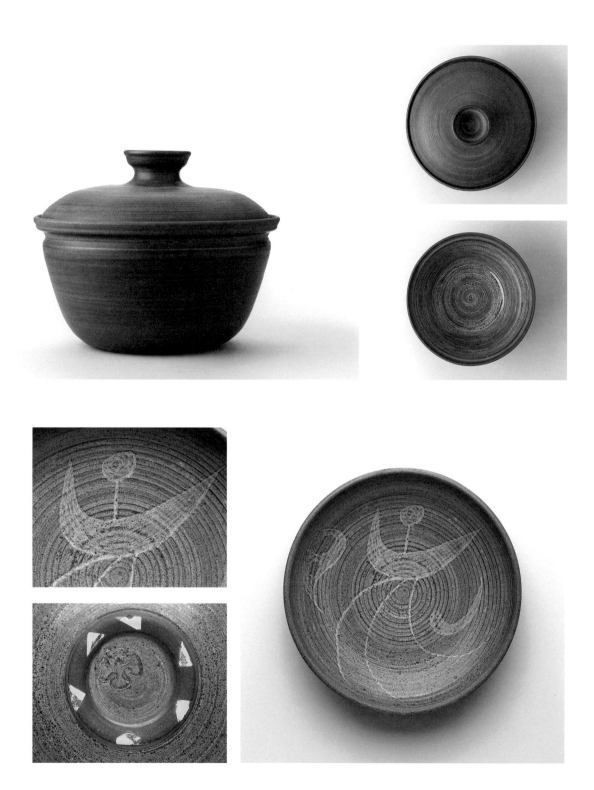

JEWELLERY IN THE 1950S

Much of the modernist jewellery produced in British Columbia in the 1950s referenced visual art, including aspects of Cubism, Surrealism and post-war abstraction. Jewellers of the period used plastic, wood and ceramics in addition to more traditional materials like gold, silver and diamonds, to appeal to a wider market. As a testament to the inventive work created in the region, BC designers Toni Cavelti and Bill Reid both received international recognition in the 1950s.[28]

Toni Cavelti came to Vancouver in 1954 after a rigorous jewellery apprenticeship in his native Switzerland, which included lessons in drawing and art history. In 1956, he set up shop with Karl Stittgen, a watchmaker who was just beginning to shift to jewellery design. As fate would have it, curator Alvin Balkind and architect Abraham Rogatnick had just opened the New Design Gallery—Vancouver's first independent gallery for modern art—upstairs from Cavelti's workspace. It was through the New Design Gallery that he would come to know many of the city's most prominent artists, including Gordon Smith, Toni Onley and Jack Shadbolt, whose abstract paintings would come to shape his designs. Cavelti became best known for his brooches and pendants featuring small diamonds mounted on delicate gold-wire frameworks of overlapping triangles, zigzag shapes and grids.

Bill Reid established a jewellery workshop in his basement and began selling his pieces to friends and specialty craft shops across the country in the early 1950s. His work recast the modern idioms he absorbed from magazines such as *California Arts and Architecture* and *Craft Horizons* in Haida design language. This notion of duality would inform his approach to jewellery design throughout his career. Reid's first modernist-inspired pieces were mainly geometric brooches in silver and silver wire, but his technique would change dramatically upon viewing a Haida totem pole from his maternal grandmother's village of T'aanuu llnagaay (Tanu) on display at the Royal Ontario Museum in Toronto. After this encounter, he began to rework Northwest Coast motifs into three-dimensional objects with semi-precious stones—a first in Haida jewellery making. Reid's sustained study of Haida carvings, particularly the work of Charles Edenshaw,[29] prompted further evolution in his work. His refined skills were able to marry complex European jewellery techniques, including repoussé and stone settings with traditional Haida materials and forms. The resulting works are sculptural, intricate and complex pieces that animate traditional forms with a modern spirit and vitality.

The largely self-taught jewellery maker Betty Clazie—together with her husband, John—began in the mid-1950s producing ceramic earrings and brooches with biomorphic shapes inspired by the three-dimensional sculptures of Jean Arp.[30] While John Clazie was also mostly self-taught, he did take a jewellery course in Chicago in the early 1950s while a business student in Illinois. Shortly after his arrival to Vancouver in 1954, he produced brooches and pendants featuring Picasso-inspired faces made of layered and faceted copper and silver sheets, likely influenced by the late-1940s designs of the New York–based jeweller Paul Lobel. From the mid-1950s to the 70s, John Clazie also produced pieces using silver, ebony, silver wire, plastic, pearls and rough-cast silver and bronze, which he sold through the Quest stores in Victoria and Banff and the Art Gallery of Ontario in Toronto.

Around 1953, Doris Shadbolt began making silver jewellery using simple forms inspired by African art. Artists of the early twentieth century were attracted to African sculpture's abstractions of the human form, a tactic also borrowed by Shadbolt for her brooches and pendants of fish and human figures—one of which won an award at the *Northwest Craftsmen's Exhibition* in Seattle in 1958. Her pieces use hollow construction to give them depth without the weight of solid material. Like others making jewellery at the time, Shadbolt considered jewellery to be little sculptures, remarking in 1961 at the time of her New Design Gallery exhibition that "sculpture is sculpture—even if it's jewelry."[31]

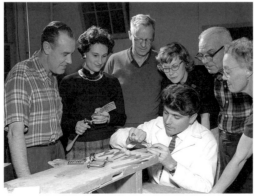

Above: Doris Shadbolt working, published in *Western Homes and Living*, January 1955

Bottom left: Toni Cavelti teaching at the University of British Columbia, Vancouver, BC, 1960

Bottom right: Bill Reid working, published in *Western Homes and Living*, January 1955

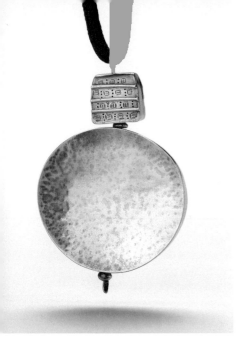

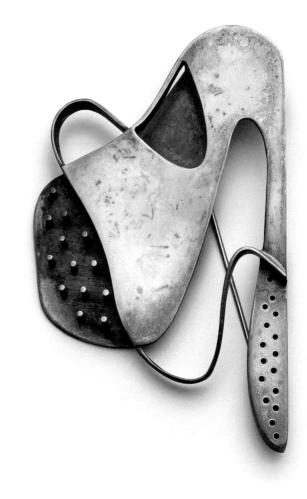

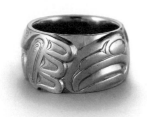

Top left: Doris Shadbolt, Circular Pendant, c. 1952–62, silver, 9.8 × 6.0 × 1.4 cm, Collection of Alice Philips

Top right: Doris Shadbolt, Brooch, c. 1952–62, silver, 9.8 × 5.8 × 1.5 cm, Collection of Alice Philips

Bottom upper left: Bill Reid, Gold Ring, c. 1970, gold, 1.4 × 2.0 (diameter) cm, Collection of the Vancouver Art Gallery, Gift of Takao Tanabe, VAG 2013.38.2

Bottom left: Bill Reid, Cufflinks, 1954, silver, 2.5 × 3.2 × 3.5 cm each, Courtesy of the Museum of Anthropology, The University of British Columbia, Vancouver, Canada, Elspeth McConnell Collection

Bottom right: Bill Reid, Lighter, n.d., silver, 5.7 × 5.6 × 1.1 cm, Courtesy of the Museum of Anthropology, The University of British Columbia, Vancouver, Canada, Elspeth McConnell Collection

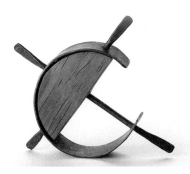

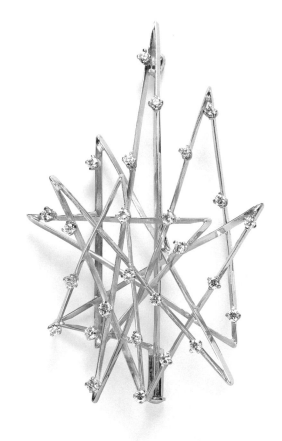

Top left: John Clazie, Earrings, c. mid-1950s, ebony, sterling silver, 5.7 × 2.0 × 0.5 cm each, Collection of the Clazie Family

Top lower left: John Clazie, Brooch, c. mid-1950s, teak, copper, 5.5 × 5.0 × 0.9 cm, Collection of the Clazie Family

Centre right: Toni Cavelti, Brooch, 1957, 18-carat yellow gold and white gold, diamonds, 8.0 × 4.0 × 3.0 cm, Private Collection

Bottom left: Toni Cavelti, Ring, c. 1970s, 18-carat rose gold and white gold, 1.2 (width) cm, Private Collection

Bottom right: Toni Cavelti, Brooch, 1957, 18-carat gold, pure gold dust, platinum, diamonds, rubies, sapphires, 3.7 × 3.7 × 2.0 cm, Private Collection

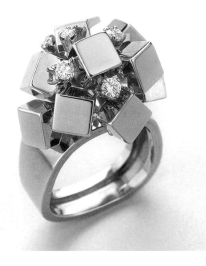

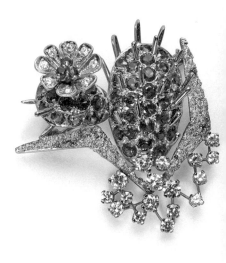

FASHION IN THE 1950S[32]

During this period, many Vancouver-based fashion designers began working out of domestic spaces. In 1945, Marjorie Hamilton began manufacturing lingerie with a hand-cranked sewing machine as a way to fill the time while her husband, a sergeant in the Royal Canadian Air Force, was away.[33] Within a decade, her small apartment business would grow into a large factory operation producing more than eighty styles of top-quality lingerie and loungewear. As with many Vancouver designers of the time, Hamilton made a name for herself with affordable, practical and versatile designs. She experimented with durable synthetic fabrics, which proved extremely popular among women looking for something glamorous yet wearable. By the 1950s, Hamilton's success landed her a position as one of only two women among the twenty-four members of the BC Needle Trades Association.[34]

Like other aspects of design, BC fashion of the period was deeply influenced by European trends. Couturiers displaced by the war began to arrive in Vancouver, often with little means but great ambition. Lore Maria Wiener, a Jewish Catholic refugee who completed formal fashion training in Austria, arrived from Shanghai to Vancouver in 1949. Here she applied her couture training to one-of-a-kind custom clothing that fit within the burgeoning ready-to-wear trends of West Coast fashion. From 1961 to 1990, she displayed her machine-made couture in her Arthur Erickson–designed shop in Vancouver's Kerrisdale neighbourhood. Julia "Madame" Visgak, Martha Wiens and Island Weavers Ltd. were among other talented BC-based designers and firms influenced by European styles and trends.[35]

From the 1940s to the 70s, Vera Ramsay applied her European and American design training to dressmaking and tailoring of both couture and ready-to-wear fashion. Her loungewear was available in department stores and became an overnight classic. Ramsay was well-known locally as an instructor of professional methods in dressmaking and tailoring at Vancouver's School of Beautiful Sewing—in a classroom named after her: the Vera Ramsay Sewing Room—also publishing the instructional book *Create Something Beautiful* in 1967. She often held public presentations and lectures at Eaton's department store, and, in addition to teaching at her own private school, Ramsay taught adult classes with the Vancouver School Board for nearly two decades.

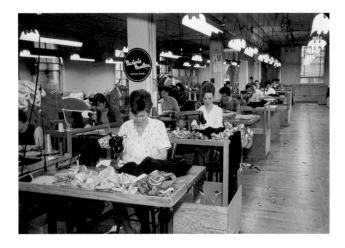

Interior of Marjorie Hamilton Ltd., Vancouver, BC, c. 1960–68

One of British Columbia's most recognizable exports of the period is the Cowichan sweater, a historically significant garment that gained regional acclaim throughout the early 1900s and international attention from the 50s onward. First made by the Cowichan Tribes—Coast Salish Peoples of the Cowichan Valley, located near Vancouver Island's southern tip—the sweater is an acculturated art form that combines European textile techniques with traditional Coast Salish spinning and weaving methods. The sweater's heavy, unprocessed, hand-spun wool forms geometric patterns that combine the Fair Isle technique with designs used in traditional Coast Salish blankets. Actively promoted by the federal government as an emblem of "Canadian identity," the Cowichan sweater became one of the best-known examples of Canadian fashion in the 1950s and their patterns were widely appropriated by non-Indigenous designers and manufacturers.

This page top: Interior of Island Weavers Ltd., Victoria, BC, 1946

This page bottom: Cowichan Sweaters, c. 1942

132–33: Unknown, Cowichan Sweater, c. 1938, wool fibre, plastic, dye, 72.0 × 143.0 cm, Courtesy of the Museum of Anthropology, The University of British Columbia, Vancouver, Canada

134: Lore Maria Wiener, Yellow Dress with Windowpane Black Checker, c. 1965–67, silk, wool crepe, 94.5 (length) cm, The Society for the Museum of Original Costume (SMOC)

135: Julia "Madame" Visgak, European Dressmaker and Tailoress, Vancouver, BC, Day Suit, 1949, wool gabardine, jacket: 80.5 (length) cm, blouse: 44.5 (length) cm, skirt: 93.0 (length) cm, Ivan Sayers Collection

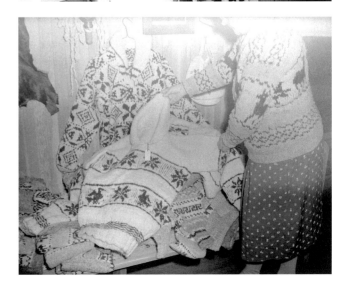

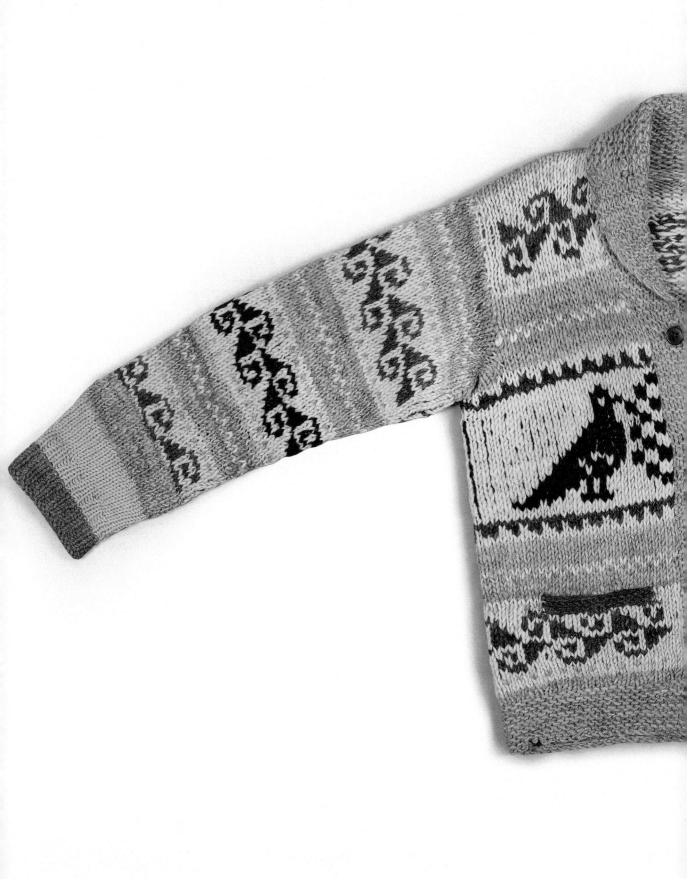

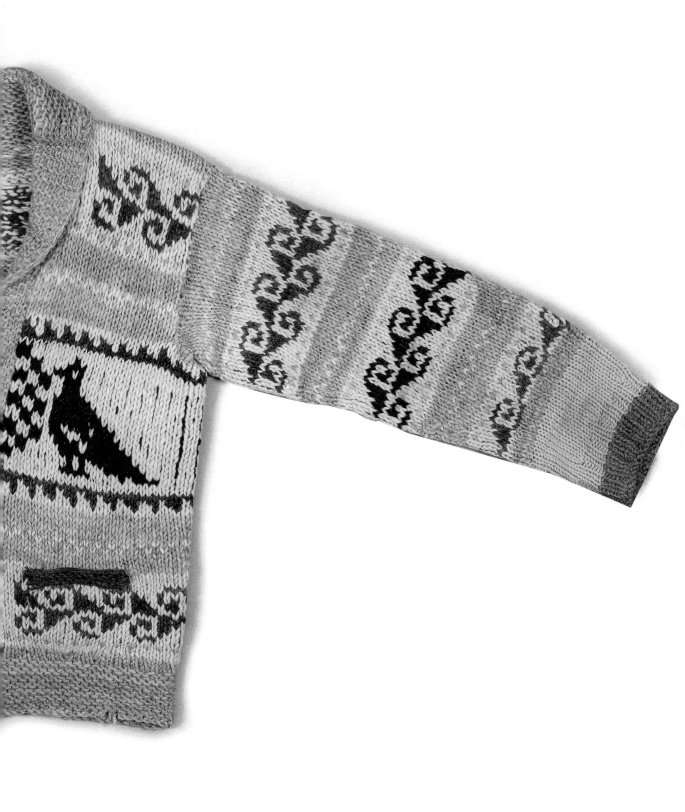

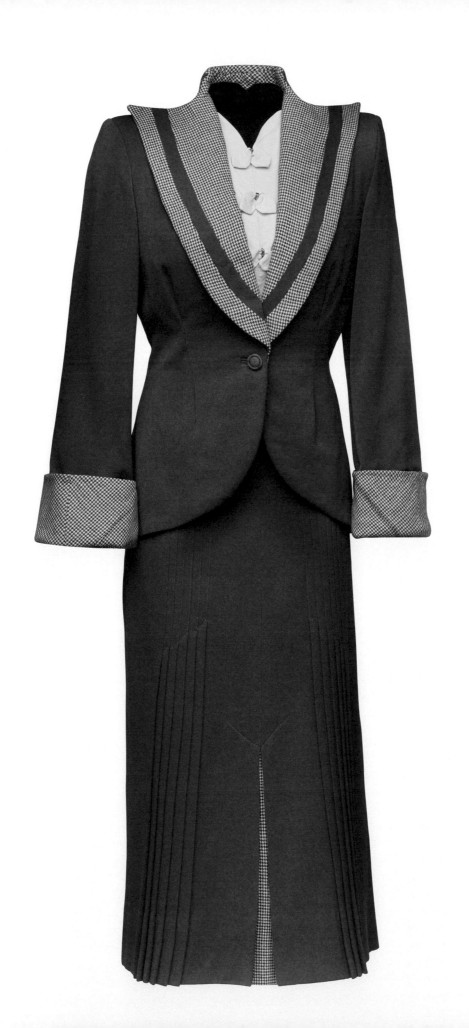

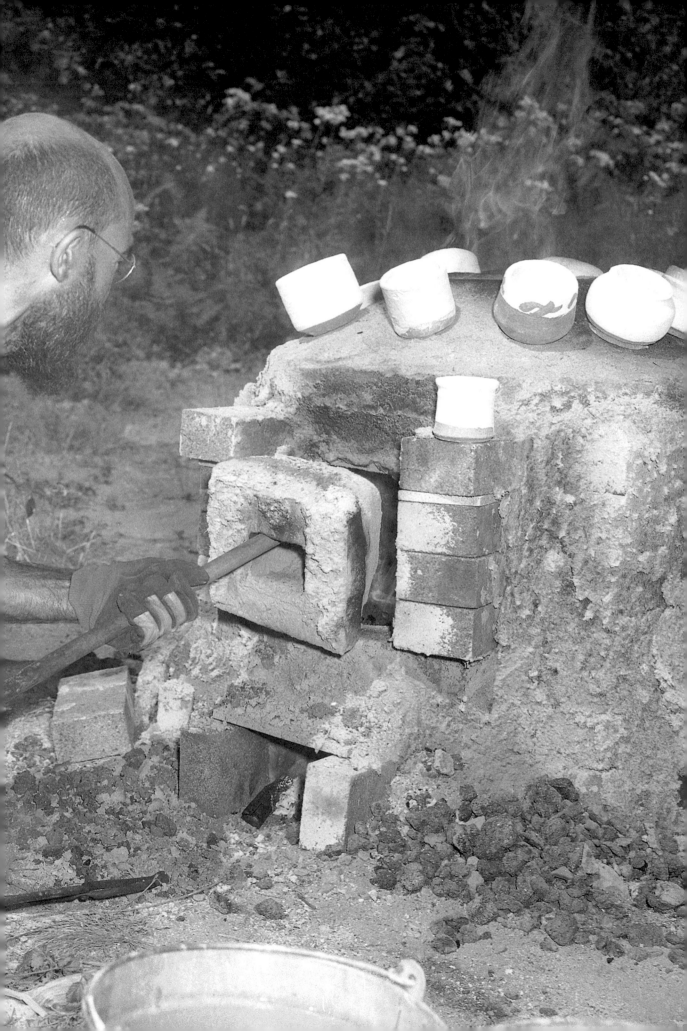

TOWARD MORE EXPRESSIVE FORMS
(1960S–70S)

While modernist ideas continued to percolate in the 1960s, the functionalism of the 1950s was largely abandoned in favour of more expressive and idiosyncratic materials and aesthetic forms. Building on the foundations of the previous decade, artists and designers challenged the traditionally accepted limits of their chosen media and embraced unconventional materials and production methods where individual expression was paramount.

By the start of the 1960s, public interest had shifted from design to craft, and there was a renewed appreciation of Arts and Crafts values that embraced the handmade as a way to counter the banality and standardization of mass consumerism. The Vancouver Art Gallery would go on to hold a wide range of craft exhibitions, and new opportunities for exhibiting and selling craft would emerge in Vancouver and Victoria over the next decade.[36] Canada's centennial in 1967 also provided opportunities for artists to show their work both nationally and internationally in large government-funded exhibitions.[37]

The predominant attitudes of individuals working in the crafts reflected a disenchantment with the soulless precision of machine-made goods, a strong urge to create products of personal meaning from durable traditional materials and a desire to achieve through handcraft a better sense of personal balance in a machine-made world. As an article in the December 1962 issue of *Western Homes and Living* proclaimed, "The hand-crafted look is coming back. Perhaps this is a reaction to the slick perfection and geometric regularity of mass production and the precise mechanical artforms of the industrial designer which have dominated our world for so long."[38] Penny Gouldstone, an associate professor of art at UBC, similarly believed it was "about time, in this age of cellophane packages that we begin again to think about making things with our hands,"[39] while the potter Avery Huyghe asserted, "In this age of mechanization, mass production, synthetics and plastics, people are attracted to a creative outlet which allows working with the basic elements of earth, fire and water."[40] These comments, all made in the 1960s, were part of an ongoing discussion—one that continues today—on the relevance of handcraft in the machine age.

By now, the university and vocational training programs in craft and design established in the immediate post-war period had produced their first graduates, introducing a generation of makers who were more interested in experimentation than their predecessors. This ethos was especially palpable in ceramic and fibre arts, where utilitarian and decorative objects began to give way to expressive, sculptural forms as well as site-specific installations in public and residential spaces. The sensibilities of the nascent counterculture and back-to-the-land movements of the 1960s and 70s also altered the direction of modernism in British Columbia, as craft practices were put into the service of alternative ways of life.

Previous spread: John Reeve with raku kiln at the University of British Columbia, Vancouver, BC, 1961

Right: Handcraft House, North Vancouver, BC, c. late 1960s–1970s

FURNITURE DESIGN IN THE 1960S AND 70S

The demand for locally designed modern furniture made of steel rod and angle iron had already started to wane by the mid-1950s. Consumers seeking modern residential furniture increasingly purchased Danish teak pieces—as well as the many copies of Scandinavian designs produced by Eastern Canadian manufacturers—featuring rich natural woods and fine-textured, colourful upholstery. With North American and imported furniture readily available in stores in the late 1950s and local production costs relatively high, BC designers and manufacturers began creating custom furnishings for architectural projects and producing furniture in small numbers for niche markets. In the 1960s, architects such as Ron Thom and Fred Hollingsworth often designed the furniture for their residential projects. Thom's couch with delicate wood joinery and leather upholstery made in 1963 for the Copp House in Vancouver reveals a strong Japanese influence that is also present in the projecting beams of the house. Chairs and metal lighting fixtures designed by Hollingsworth for his many architectural projects reflect his strong affinity with the philosophy of the American architect Frank Lloyd Wright, best known for designing the complete house, from stained glass to carpets.

Between 1965 and 1977, the German-trained furniture maker Helmut Krutz designed and made Scandinavian-style chairs, tables and fold-down sofas in his shop in Vancouver's South Granville neighbourhood. His chairs feature a basic contour shape that he developed through research. In his shop, he made the moulded-plywood seats, fabricated the metal legs—complete with wood accents—and applied the upholstery, which he often dyed himself to achieve colours unavailable on the market.

Also in Vancouver, Hans-Christian Behm made one-off art furniture that borders on the Postmodern. His chairs of brightly coloured cushions held together by panels of Plexiglas or aluminum echo the architect Le Corbusier's Grand Confort armchair (1928), which features loose cushions contained in a chrome frame. Behm exhibited his Vancouver Chair, with a Plexiglas frame, at the *Craft Dimensions Canada* exhibition held at the Royal Ontario Museum in Toronto in 1969.

Despite the reduced demand for local furniture in this period, one BC maker who achieved success designing for mass production was Niels Bendtsen. After apprenticing with his father and opening a store where he sold Scandinavian furniture, Bendtsen, who immigrated to Vancouver from Denmark as a child in 1951, returned to his homeland in 1971 to further refine his furniture-making skills. It was during this time that he designed his famous Ribbon Chair, which was produced in the thousands, sold worldwide through Kebe Møbler ApS, Copenhagen, and is now in the collection of MoMA in New York. Its softly curved, Scandinavian-inspired shape would prove to be a signature for Bendtsen.

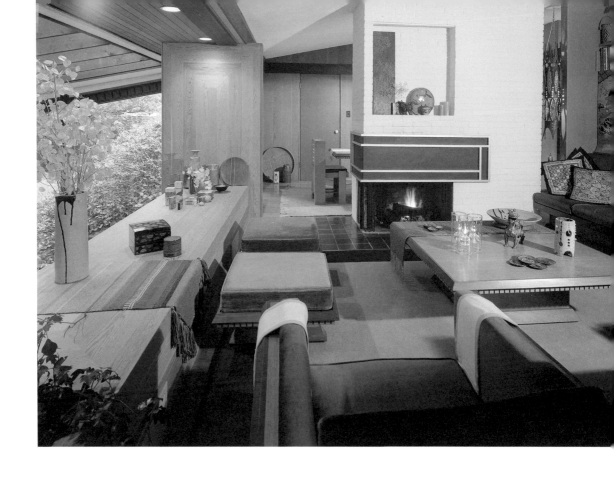

Interior of Hollingsworth House (Fred
Hollingsworth, architect, built 1946), North
Vancouver, BC, 1980

Fred Hollingsworth working, c. 1960

141

Fred Hollingsworth, Light Fixture, c. 1960s,
iron, 175.5 × 18.0 (diameter) cm, Collection
of the Hollingsworth Family

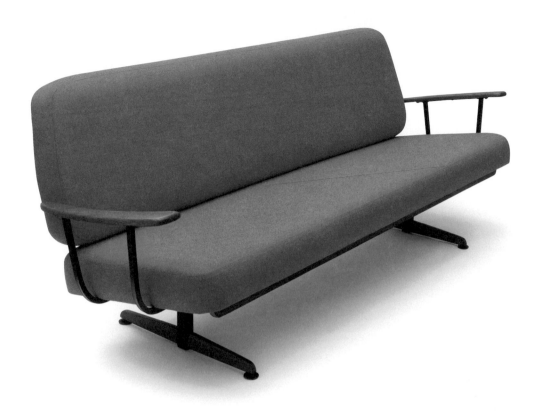

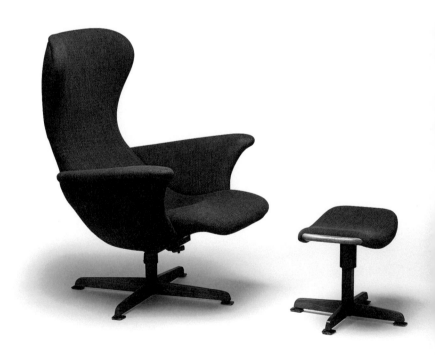

Helmut Krutz, Vancouver, BC, Fold Down
Couch, c. 1970, steel, plywood, teak, uphol-
stery, 82.0 x 214.0 x 65.0 cm, Collection of
Allan Collier

Helmut Krutz, Vancouver, BC, Chair with
Ottoman, 1966, moulded-plywood, steel,
teak, upholstery, chair: 104.0 x 96.0 x
84.0 cm, ottoman: 38.0 x 55.0 x 40.0 cm,
Collection of Bill Gilbert

Left: Ron Thom, Couch from Copp House,
1963 (detail), wood, upholstery, 75.0 × 84.0
× 203.0 cm, Courtesy of Jan Pidhirny and
Jim Ferguson

Below: Niels Bendtsen for Kebe Møbler
ApS, Copenhagen, Ribbon Chair, 1975,
tubular steel, cotton canvas, polyester fill,
69.9 × 71.1 × 71.1 cm, Courtesy of Nancy
and Niels Bendtsen

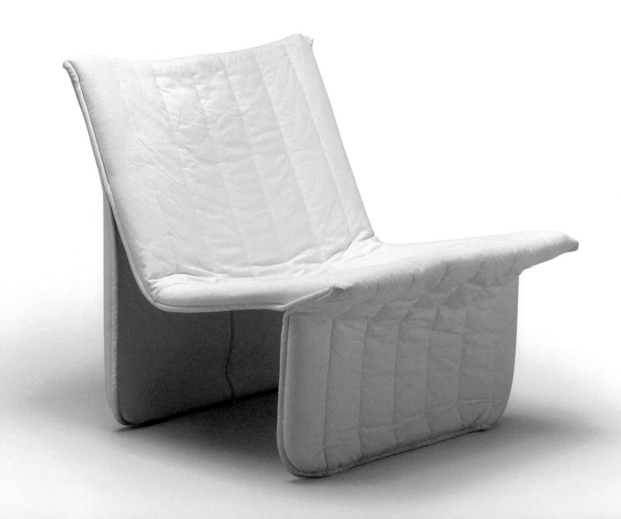

Above: Hans-Christian Behm, Vancouver
Chair, 1969, aluminum, textile, foam,
paint, braided rope, 76.5 × 92.3 × 92.3 cm,
Courtesy of the Artist

Right: Hans-Christian Behm, Vancouver
Table, 1969, aluminum, glass, 51.0 × 122.5
× 71.5 cm, Courtesy of the Artist

CERAMICS IN THE 1960S AND EARLY 70S

Most potters in this era continued to use the potter's wheel, with form, colour, materiality and surface treatment remaining central concerns. Several ceramic artists, however, now shifted their focus from the utilitarian to the expressive, and from pots to murals, blurring the lines between craft and art.

Exhibitions of work from elsewhere and local workshops conducted by international artists exposed the BC pottery community to new possibilities.[41] In the early 1960s, the centre of ceramic activity shifted from the UBC Extension Department (which would close in 1966) to the Vancouver School of Art and the privately operated Ross-Huyghe School of Pottery.

The search for new forms led several Vancouver potters to adopt an Asian aesthetic, largely introduced to the West by the British potter Bernard Leach. Leach's vision of the independent craftsperson making pottery from local clays and inspired by rural traditions and Asian forms proved popular among BC potters from the late 1940s through to the 70s. Particularly influential was Leach's incorporation of the Japanese mingei movement of the 1920s and 30s, which favoured using local natural materials to produce craft items for everyday use. Between 1958 and 1967, John Reeve, Glenn Lewis, Ian Steele and Mick Henry apprenticed with Leach in England, and all except Reeve returned to British Columbia to set up studios prior to 1975. Leach's influence on this group was varied: Steele's salt-glazed utilitarian pieces resembled Leach's more English-looking standard ware, while Lewis' work took on a loose, rustic Japanese look, and Charmian Johnson perfected the ancient celadon glazes on her simple but elegant forms. Beyond Leach's apprentices, Wayne Ngan and Heinz Laffin also began adopting Asian forms in the 1960s.[42]

Several ceramic artists turned to hand building, which allowed them to explore asymmetrical forms and new types of decoration. Santo Mignosa exhibited hand-built pieces in many exhibitions in the 1960s, including the 1962 *Ceramic National Exhibition* in Syracuse, New York, and *Canadian Ceramics 1961* at the Royal Ontario Museum in Toronto. Hand building also became central to the practice of Kathleen

Handbuilt Pottery Show, Handcraft House, North Vancouver, BC, 1968, printed exhibition announcement, 21.6 × 28.0 cm, Courtesy of the Vancouver Art Gallery Library

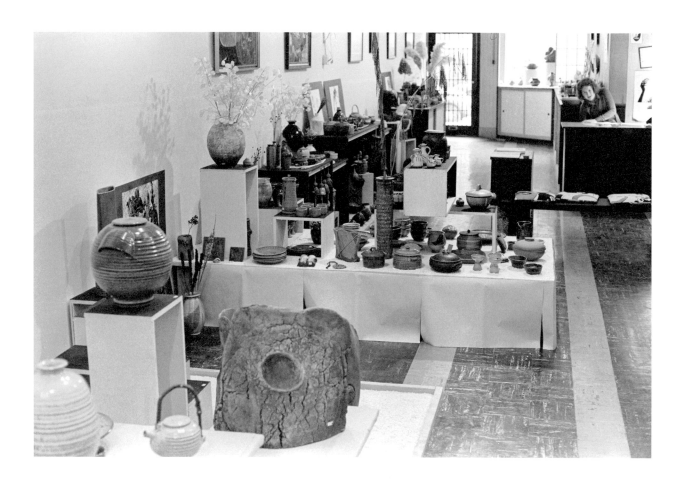

Above: House of Ceramics, Vancouver, BC, 1972

Right: Bernard Howell Leach, St. Ives, Cornwall, 1961

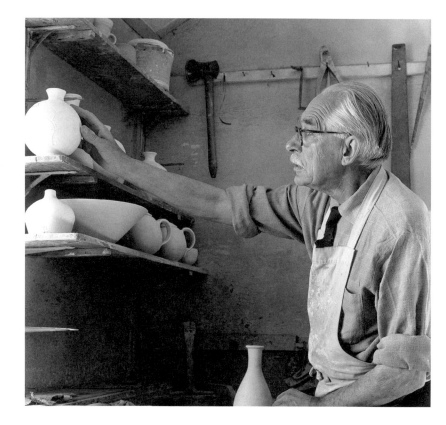

Hamilton, a painter who took up pottery in the late 1960s. The technique allowed her "to let loose those asymmetrical unique creations which pleases the artist's quest for form and aesthetic meaning."[43] The practice of reworking pots into free-form shapes by hand, as seen in vases by Tam Irving and Stan Clarke, also became common.

New techniques such as raku and reduction firing contributed to a spirit of innovation in the pottery-making process during the 1960s and 70s. Potters engaged in raku included John Reeve, Wayne Ngan, Francisca Hayman, Gillian Hodge, Walter Dexter and Zeljko Kujundzic. Raku—based on a process used to make tea bowls in Japan—was adapted to North American ceramic practice by the US potters Paul Soldner and Hal Riegger. As a teacher, Riegger found the raku process, which often involves using improvised kilns and local clays, a good way to demystify pottery making for his students. It also adds a spontaneous and unpredictable quality to the work. Between 1965 and 1975, he conducted many raku workshops throughout British Columbia, assisted on occasion by Gillian Hodge. Riegger's first BC workshop—in Nelson in 1965—helped establish that city as a raku centre, where instructors at the city's Kootenay School of Art, such as Santo Mignosa and Walter Dexter, gained useful skills that they applied to both their own work and teaching.

Reduction firing, which involves making stoneware in gas kilns where the amount of oxygen can be varied, was experimented with by potters like Stan Clarke. The technique often results in colours that change from one firing to the next, creating a sense of randomness sought by many BC potters in the 1960s and 70s.

Compared to ceramics in the 1950s, the work of the 60s and early 70s demonstrates a more refined use of surface treatment. Jan Grove brought his knowledge of solid-colour matte glazes—acquired during his seven-year apprenticeship in Germany in the 1950s—to his Victoria studio in 1966. Grove and others using colour were a minority in the BC pottery community, which mostly adopted a style of high-fired stoneware where deep saturated colour is impossible. Instead, these potters created an aesthetic based on muted colours and the natural browns and greys of the clay itself. Jean Marie Weakland and Gathie Falk left their pots mostly unglazed, revealing the natural texture of fine clay, with Falk leaving marks from the throwing process to accentuate her work's handmade quality. John Reeve often avoided decoration entirely, because he felt it distracted from line, proportion and strength of form.

Potters in the 1960s continued using sgraffito markings in different ways. Leonard Osborne scored very precise lines in the manner of Lucie Rie; Helga Grove scraped through the outer glaze to create her signature Fable Animal motifs; and Zeljko Kujundzic scribed through patches of glaze to create a geometric "brand," also seen in his graphics, jewellery and woodworking.

During this period at least two BC potters crossed a line that traditionally separated handcraft from mass production. In the mid-1960s, Heinz Laffin produced a series of Asian-inspired vases using moulds and slip he acquired from Canadian Potteries, a bathroom-fixture manufacturer in Vancouver. Around 1970, Tam Irving contracted Fairey and Company of Vancouver to hydraulically press ashtray blanks—formed from cast bronze dies he designed himself—which he then glazed and fired in his own kiln. Hundreds of these pieces were sold to the local office supply industry and later across Canada through Danica Imports.

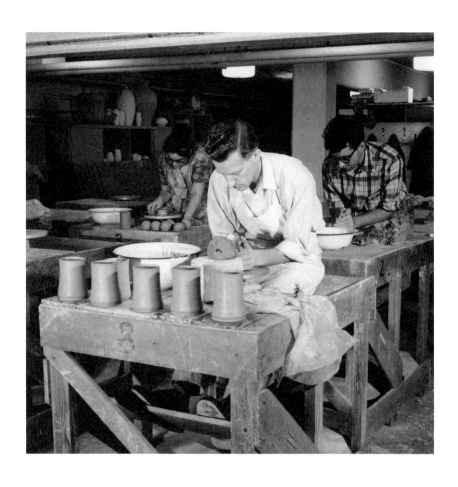

Above: Heinz Laffin in the ceramics studio at the Vancouver School of Art, BC, c. late 1950s–early 1960s

Right: Hal Riegger raku workshop at Hand-craft House, North Vancouver, BC, c. 1970

Several ceramic artists created modernist murals for the many new commercial and institutional buildings being erected around the province in the 1960s and 70s. Reg Dixon designed a mural for an Imperial Bank of Canada branch around 1960 and Robert Kingsmill undertook several in Victoria in the mid-70s, but it was Robert Weghsteen who produced the most significant body of work in this field. His works for architectural projects included walls in brick at the new Vancouver International Airport (1969), an exterior mural at the J.B. Macdonald Building at UBC (1971) and a mural called *Healing,* measuring ten feet by twenty-five feet and featuring scientific and medical symbols, for the Nanaimo Hospital (1963).

The growth of tourism in the 1960s, leading up to Canada's centennial in 1967, provided an ideal opportunity to define and promote provincial identities, and several BC artists—both Indigenous and non-Indigenous—produced ceramic items featuring First Nations motifs and forms destined for the ever-growing tourist and export markets. David Lambert, Herta Gerz and Ruth Meechan made and sold such items nationally, at a time when makers rarely stopped to consider the issue of appropriation. From the end of World War I, individuals like the anthropologist Harlan Smith, Alice Ravenhill of the Society for the Furtherance of BC Indian Arts and Crafts and the painter Jack Shadbolt advocated using such symbols on pottery and other consumer goods to create a sense of provincial identity and to distinguish BC products in the marketplace.[44] As part of an enterprise called Canadian Art Ceramics, started around 1965 by the Hungarian-born Gyula Mayer, Kwakwaka'wakw artist Henry Hunt made wood carvings that were used as moulds for ceramic masks, totem poles, chessmen and other items. The ceramic pieces were made at Lloyd-El Ceramics in Victoria, where Hunt's wife, Helen, finished the items prior to glazing. Mayer considered his venture the first attempt at establishing a craft industry based on Pacific Northwest Nations designs and anticipated selling the items at Expo 67 in Montréal.

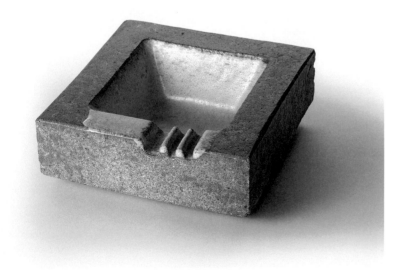

Tam Irving, Ashtray (Production Model), c. 1970, ceramic, 8.2 × 14.2 × 14.2 cm, Collection of Allan Collier

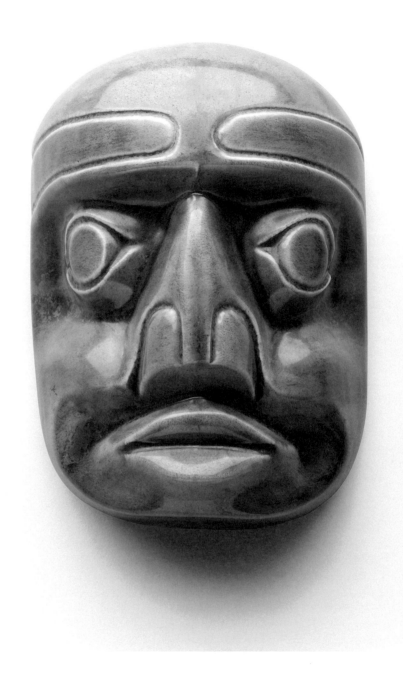

Henry Hunt for Lloyd-El Ceramics, Victoria,
BC, Green Mask, c. 1965, ceramic, 13.0 ×
10.0 × 7.0 cm, Collection of John David
Lawrence

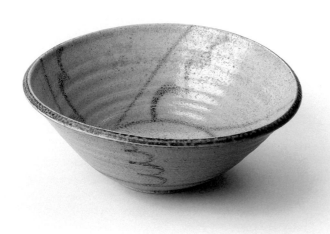

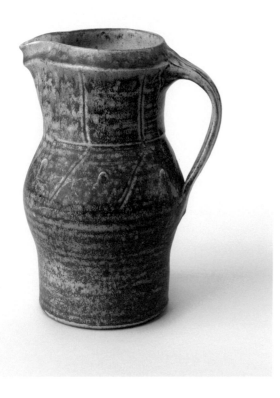

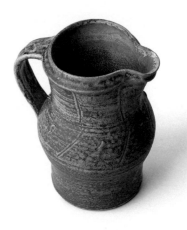

Top: Michael Henry, Bowl, c. 1970 (full view and detail), ceramic, 10.1 × 27.2 (diameter) cm, Collection of John David Lawrence

Bottom: Michael Henry, Pitcher, c. 1970, (front and top view), ceramic, 19.5 × 16.2 (diameter) cm, Collection of John David Lawrence

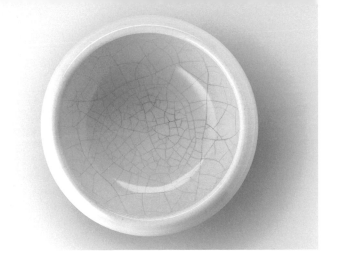

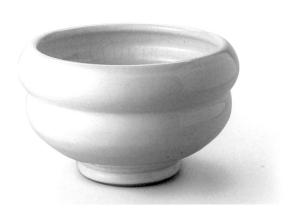

Charmian Johnson, Bowl, c. early 1970s (full view and details), ceramic, 11.7 × 20.3 (diameter) cm, Collection of John David Lawrence

Glenn Lewis, Vase, c. 1960s, (full view and detail), ceramic, 20.1 × 19.4 (diameter) cm, Collection of John David Lawrence

153

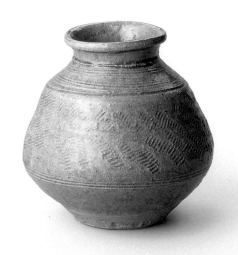

Top: Ian Steele, Pot, c. early 1970s, ceramic, 16.5 × 20.7 (diameter) cm, Purchased in Nanoose Bay, BC, 1974, by Margaret Sloan, then gifted to Debra Sloan

Bottom: John Reeve for Venema Pottery, Abbotsford, BC, Pitcher, c. 1972–73, ceramic, 27.3 x 14.7 (diamter) cm, Gifted to Don Hutchinson by John Reeve, 1973/74; Gifted to Debra Sloan by Don Hutchison, 2016

Right: Ian Steele, Pitcher, c. 1969–77, ceramic, 21.5 × 12.5 (diameter) cm, Collection of Allan Collier

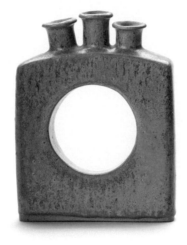
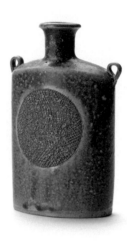

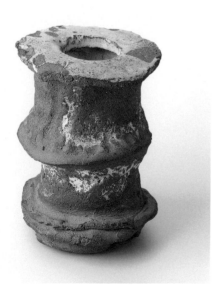
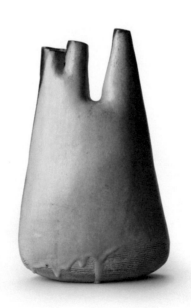
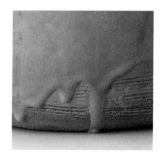

Top: Kathleen Hamilton, Three Vases,
c. 1969–76, ceramic, a: 31.0 × 9.4 (diame-
ter) cm, b: 18.5 × 14.6 cm, c: 16.5 × 10.5 ×
5.2 cm, Collection of John David Lawrence

Bottom left: Tam Irving, Hand-Built
Stoneware Vase, c. 1966, ceramic, 17.5 ×
13.0 (diameter) cm, Gift of Collective for
Advanced and Unified Studies in Visual
Arts, Collection of the West Vancouver Art
Museum, 2011.002.1

Bottom right: Stanley Clarke, Vase, c. 1960s
(full view and detail), ceramic, 42.0 × 20.0
(diameter) cm, Gift of A.H. and E. (Bessie)
Fitzgerald, University of Victoria Legacy
Art Galleries

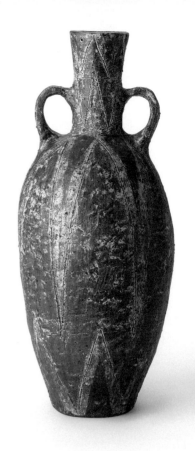

Top: Santo Mignosa, Vase, c. early 1960s
(full view and detail), ceramic, 46.1 ×
19.3 (diameter) cm, Collection of Andy
Kujundzic

Bottom: Thomas Kakinuma, Vase with
Handles, c. early 1970s (full view and
detail), ceramic, 40.9 × 17.3 × 14.7 cm,
Collection of the Kakinuma Family

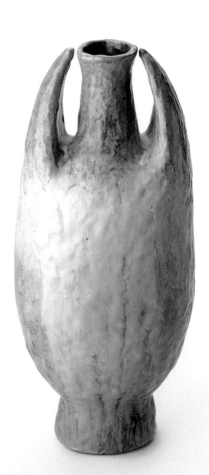

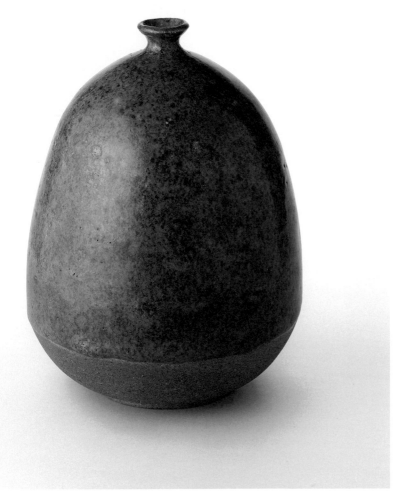

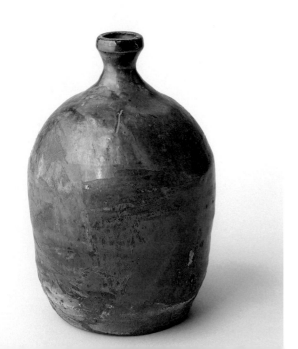

Top: Stanley Clarke, Vase, c. 1960s (full view and detail), ceramic, 23.0 × 53.0 (diameter) cm, Collection of Allan Collier

Bottom: Gillian Hodge, Raku Vase, c. 1960s, ceramic, 15.5 × 10.7 (diameter) cm, Collection of John David Lawrence

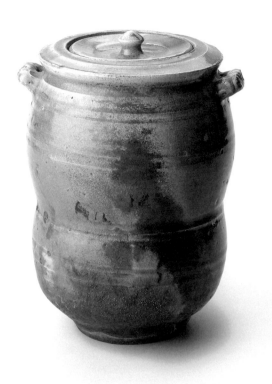

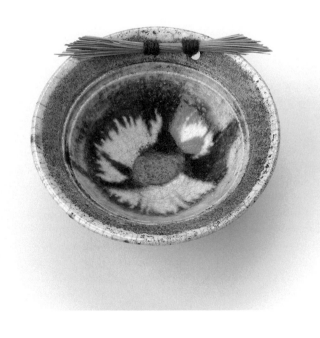

Top: Wayne Ngan, Raku Pot, c. 1970s (full view and detail), ceramic, 23.0 × 17.3 × 15.5 cm, Collection of John David Lawrence

Bottom: Francisca Hayman, Small Raku Dish, c. early 1970s, ceramic, plant material, 4.5 × 9.5 (diameter) cm, Courtesy of the Artist

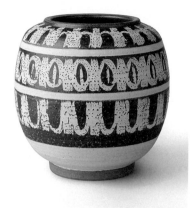

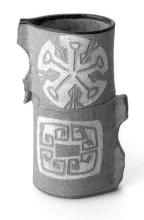

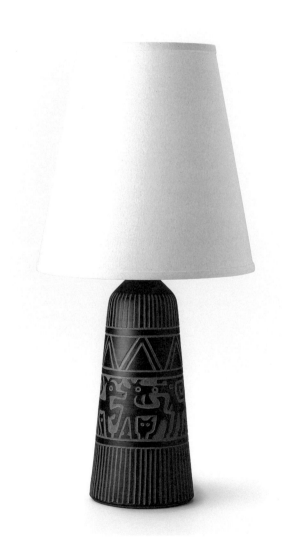

Top left: Janet MacLeod, Pot, c. 1969, ceramic, 19.6 × 20.0 (diameter) cm, Courtesy of the Artist

Top centre: Zeljko Kujundzic, Vase, 1966 (full view and detail), ceramic, 22.4 × 14.0 × 7.1 cm, Collection of Ann Kujundzic

Bottom: Jan Grove and Helga Grove, Lamp with Fable Animal Décor, 1966 (full view and detail), ceramic, 43.0 × 16.0 cm, Collection of Alexander Forrester

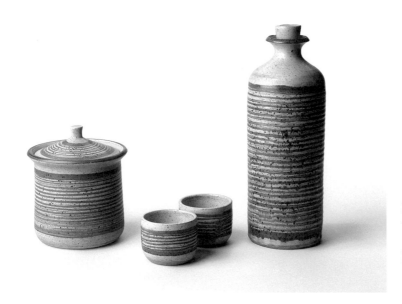

Above: Walter Dexter, Plate, c. 1963–67, ceramic, 1.6 × 12.2 × 12.4 cm, Collection of Allan Collier

Left: Walter Dexter, Liqueur Set with Two Cups and Lidded Pot, c. 1963–67, ceramic, bottle: 26.5 × 9.4 (diameter) cm, cups: 5.1 × 6.6 (diameter) cm each, pot: 14.4 × 13.0 (diameter), Collection of John David Lawrence

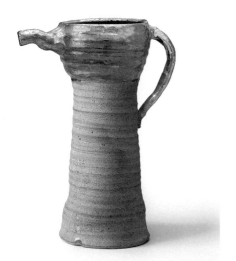

Above: Gathie Falk, Pitcher, c. 1966, ceramic, 32.0 × 13.5 × 24.0 cm, Courtesy of the Artist

Right: Olea Davis, Vase with Sgraffito, c. 1960s, ceramic, 26.2 × 17.5 (diameter) cm, Collection of John David Lawrence

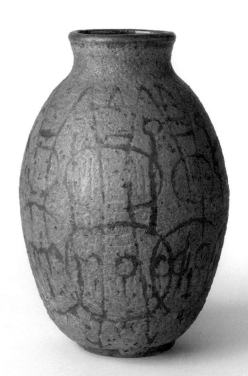

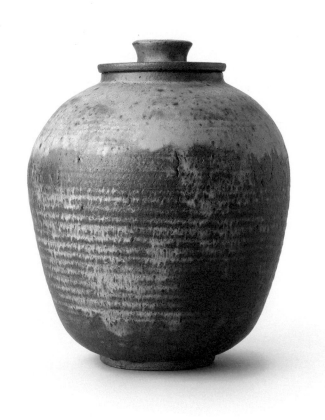

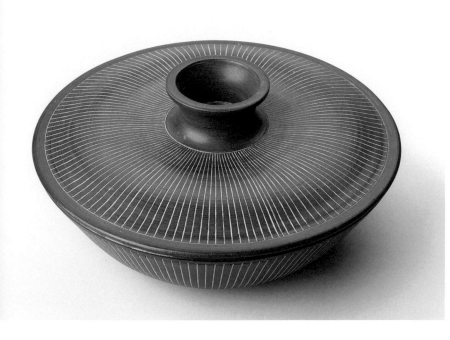

Top: Stanley Clarke, Lidded Pot, c. 1960s (full view and details), ceramic, 28.7 × 24.6 (diameter) cm, Collection of John David Lawrence

Bottom: Leonard F. Osborne, Casserole with Sgraffito, c. 1960s (full view and detail), ceramic, 12.5 × 27.1 (diameter) cm, Collection of John David Lawrence

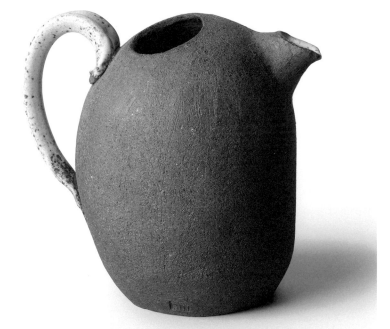

Top: Jean Marie Weakland, Pitcher, c. 1968 (full view and details), ceramic, 16.0 × 17.4 × 12.0 cm, Collection of John David Lawrence

Right: Wayne Ngan, Pot, c. 1965, ceramic, 21.5 × 17.5 (diameter) cm, Courtesy of Monte Clark, Vancouver

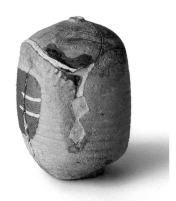

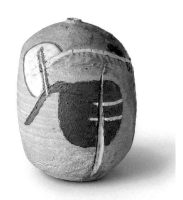

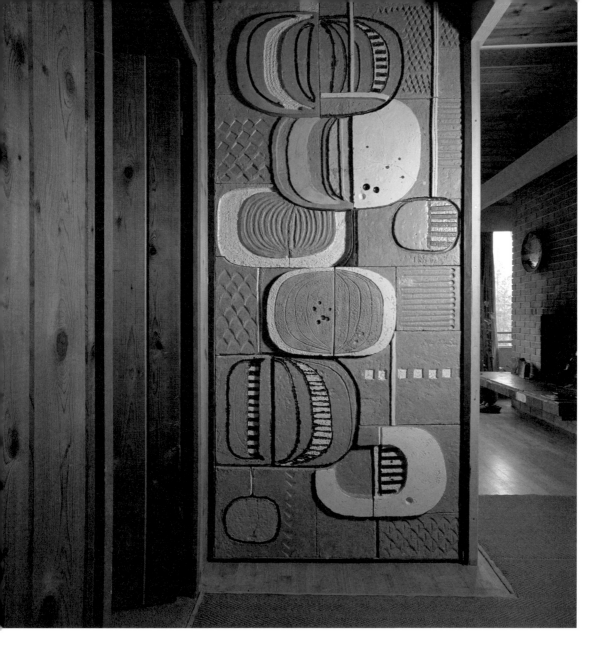

Top: Robert Weghsteen wall installation, c. 1960s

Bottom: Dentistry Building with Robert Weghsteen's *Untitled*, University of British Columbia, Vancouver, BC, c. 1970s

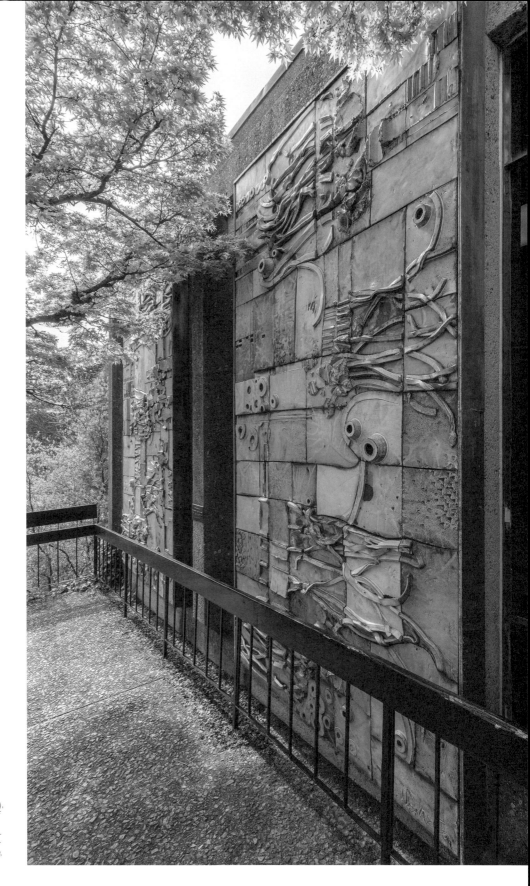

Robert Weghsteen, *Untitled*, 1971 (detail),
ceramic, 323.0 × 470.0 cm, Collection of
the Morris and Helen Belkin Art Gallery,
University of British Columbia. Commis-
sioned with support from the Vancouver
Alumni Chapter Alpha Omega Fraternity,
1971

JEWELLERY DESIGN IN THE 1960S AND 70S

Unlike the jewellery of the 1950s, which referenced modern art, jewellery from the 60s is more expressive and experimental in its use of materials. The work of Karl Stittgen and Idar Bergseth is often baroque and organic, comprising stones, pearls and roughly cast precious metals that together create irregular forms like those found in nature. In the 1960s, when gold and silver were relatively inexpensive, Bergseth would often melt gold and throw it into water to create expressive forms. When the price of gold rose, precious stones and diamonds became the new focus of his designs.

More formal approaches to jewellery design can be seen in Willy Van Yperen's chain necklaces and Robert Davidson's precisely detailed pieces utilizing traditional Haida motifs. Van Yperen, self-taught in Holland before immigrating to Canada in the late 1950s, exhibited his work nationally.[45] Davidson studied with Bill Reid for eighteen months in 1966–67 before attending the Vancouver School of Art, where he studied design, painting, pottery and sculpture. In his bracelets from the period, Davidson demonstrates great sophistication with the Haida artistic vocabulary, skillfully adapting the iconography to push formline design beyond traditional limits.

Zeljko Kujundzic's Mayor's Chain of Office, made in 1962 for the City of Nelson, is composed of a series of medallions made of metals mined in the region and marked with symbols depicting local industries. In 1960, Kujundzic helped found the Kootenay School of Art and served as its director until 1964. He envisioned the school as a place where young people could get the instruction they needed to transform local materials into well-made products. The Mayor's Chain is a manifestation of that vision.[46]

Consistent with developments in weaving and pottery in the 1960s that saw makers venture into site-specific art for new buildings, the jeweller Karl Stittgen produced the work *Rainforest* (1968) for the Hotel Vancouver and a large enamel mural for the Pan Am Building in New York (c. 1963).

Karl Stittgen, Enamelled Panel, Pan Am Building, New York, 1963

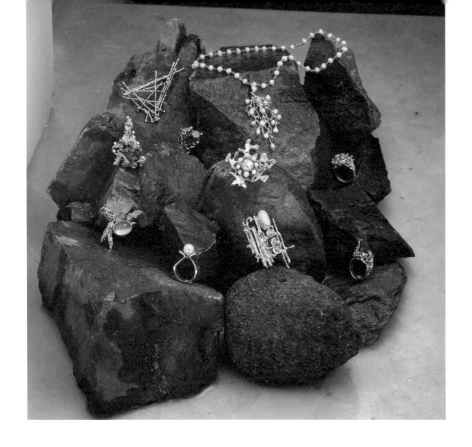

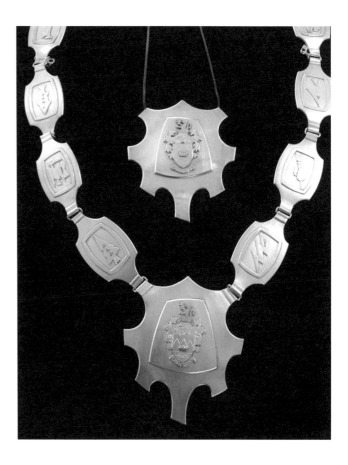

Above: Karl Stittgen jewellery display, 1964

Right: Zeljko Kujundzic, Mayor's Chain of
Office, 1962, hand-wrought sterling silver
with 22-carat gold inlay, chain: 111.8 cm,
pendant: 8.9 × 10.5 cm, Collection of the
City of Nelson

167

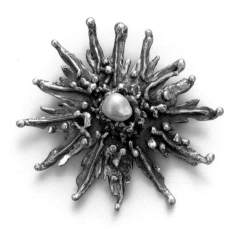

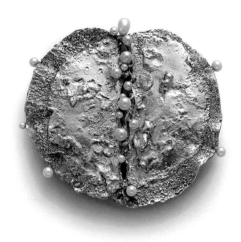

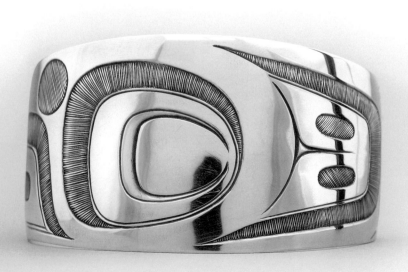

Top left: Idar Bergseth, Star Brooch, c. mid-1960s, sterling silver, 18-carat yellow gold, Japanese Akoya pearl, 7.0 × 6.0 × 2.5 cm, Courtesy of the Artist

Top right: Idar Bergseth, Brooch, c. mid-1960s, sterling silver, 18-carat yellow gold, Japanese Akoya pearls, 8.5 × 7.5 × 1.0 cm, Courtesy of the Artist

Left: Robert Davidson, *Xiigya* [Bracelet], 1972, silver, 3.8 × 6.5 × 5.5 cm, Courtesy of the Museum of Anthropology, The University of British Columbia, Vancouver, Canada

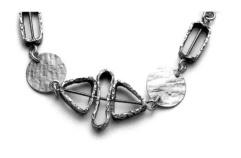

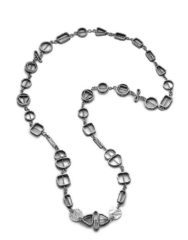

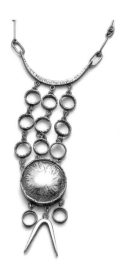

Top left and centre: Willy Van Yperen, Necklace, c. early 1970s (full view and detail), silver, 18-carat yellow gold, 81.3 (length) cm, Courtesy of Van Yperen Jewellers

Top right: Willy Van Yperen, Necklace, c. early 1970s (detail), silver, 14-carat yellow gold, 38.0 × 4.6 × 0.8 cm, Courtesy of Van Yperen Jewellers

Centre right: Karl Stittgen, *Fleur de Rocaille*, c. 1965, yellow gold, white gold, lapis lazuli gemstone, diamonds, rubies, pink sapphires, cultured pearls, 8.0 × 7.0 × 2.0 cm, Collection of Zera Karim

Below: Robert Davidson, Spoon, 1974, silver, 11.0 × 3.5 × 0.5 cm, Courtesy of the Museum of Anthropology, The University of British Columbia, Vancouver, Canada, Walter C. Koerner Collection

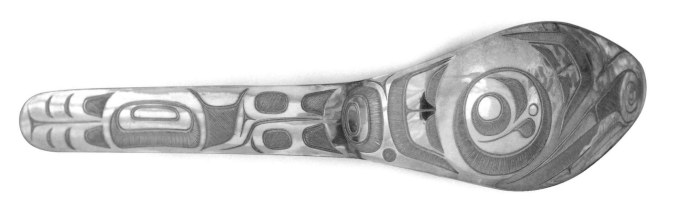

WEAVING AND TEXTILES IN THE 1960S AND 70S

The popularity of weaving increased dramatically in this period, leading to the opening of several schools that sold weaving supplies, offered instruction and held workshops and exhibitions. One such school, Handcraft House in North Vancouver (1967–77),[47] was also the most important craft supply and exhibition centre in the province. It sold clay, potters' wheels and fabric-printing supplies and exhibited contemporary pottery, weaving and other crafts by many leading artists from British Columbia and abroad. The weaving instruction there embraced both the traditional and the experimental, often expressed in tapestries and hangings made using innovative methods and unorthodox materials. Weavers of this period shifted their focus from making placemats, coverlets and upholstery material to rugs, hangings and large-scale custom works for architectural projects, using a wide range of natural and synthetic materials.[48]

Many weavers produced vibrant geometric abstractions, embracing motifs inspired by Scandinavian Pop and Op Art. Marion Smith and Chuck Yip produced hangings and rugs with brightly coloured abstract designs; Vee Elder, Joanna Staniszkis and Madeleine Chisholm made hangings that often featured geometric decoration; and in the 1970s all produced large architectural hangings for public spaces. These works of increased ambition and scale redefined the boundaries of textile work to include architectural art.[49]

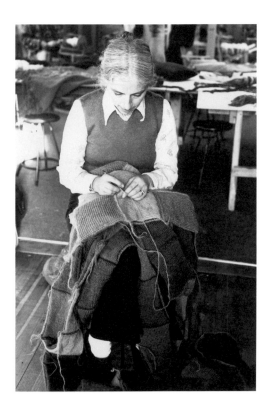

Madeleine Chisholm at Handcraft House, North Vancouver, BC, c. late 1960s–1970s

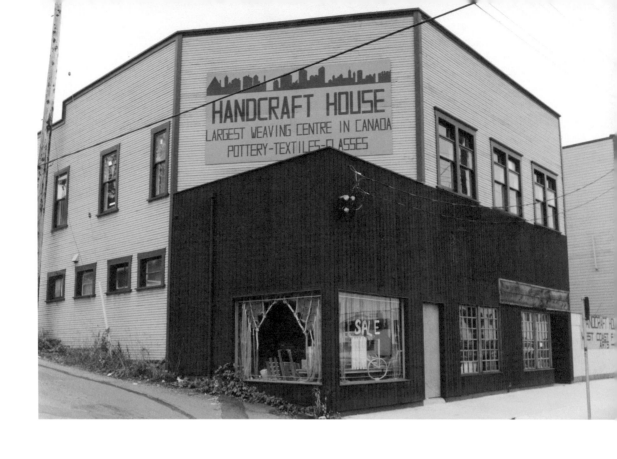

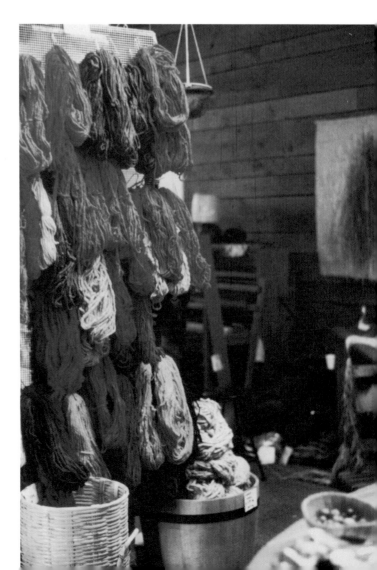

Handcraft House, North Vancouver, BC,
c. late 1960s–1970s

International wool available for sale at
Handcraft House, North Vancouver, BC,
c. late 1960s–1970s

171

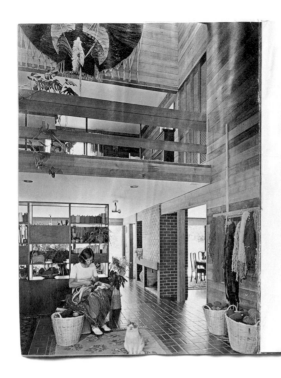

ONE HOUSE, TWO STUDIOS

Tom Staniszkis is an architect, one of the few who specialize in the design of homes rather than office buildings. His wife, Joanna, a teacher of design at UBC School of Home Economics, weaves giant tapestries of vibrant colors and textures that are very much in demand as works of art as well as craftsmanship.

As you might expect, their home reflects the talents of both of them. Designed by Tom to accommodates both Joanna's studio on the ground floor and Tom's office on a balcony above. The featureless character of the lot dictated the building's geometry, with roof slopes descending deeply at front and rear to bring about as gradual a transition as possible between the height of the two-storey house and the site. Instead of dormers pushing out from the roof to let light in to the upper storey, decks are cut into it, allowing the roof to sweep without interruption from peak to overhanging eaves.

Shut off from the neighbors at the sides and from the street (except for the studio) the house opens to the south through glass walls onto a paved patio and a garden where earth berms planted with groundcover and a fringe of poplars will ultimately provide privacy.

Inside, the house was kept as open as possible. A free-standing fireplace wall divides living room from dining room, which in turn is open to the kitchen across a serving counter. Open storage shelves define the limits of Joanna's studio without shutting her off from family activities. Tom's office at the end of the upstairs hall, overlooks Joanna's. "We share the same work space, but separated vertically", explains Tom. Of simple frame construction, the slab-on-grade house has heated quarry tile floors and is clad with cedar inside and out. Furnishings are simple and eclectic – a modern leather and chrome sofa and chair, wicker and rattan, Victorian dining furniture, baskets of all shapes and sizes, Russian ikons and giant houseplants. And against the plain cedar walls, Joanna's tapestries, woven on a simple frame with hand-spun and home-dyed yarns, spread pools of richly glowing color.

September 74 Western Living 31

Top: Living room with weaving studio far left, features a landscape tapestry. Floor is tile. Below: Dining room looks out to paved terrace and through to kitchen.

Architect: TOM STANISZKIS
Photographer: JACK BRYAN

Opposite page: Two-storey entrance hall gives feeling of space, provides a gallery for tapestry exhibit. Tom Staniszkis' study at end of upstairs hall overlooks Joanna's studio. Round weavings are "insects".

1 Living area
2 Weaving studio
3 Architecture studio

32 Western Living September 74

September 74 Western Living 33

Interior views of Joanna Staniszkis' home, published in *Western Living*, September 1974, magazine, 27.9 x 21.6 cm, Courtesy of Joanna Staniszkis

172

Cliff Robinson, Heather Maxey and Carole Sabiston also worked in an abstract style.[50] Robinson's blocky shapes, common in his early-1960s works, take their inspiration from the ruins the artist encountered on his many trips to Greece. Robinson got his start in batik with the abstract painter Marion Nicoll at the Alberta College of Art in Calgary in the early 1940s, and from the early 50s to the 70s he conducted batik workshops throughout British Columbia and elsewhere in North America. His major commissions include large batiks for the Dorothy Somerset Studio Theatre at UBC and for Simon Fraser University in Burnaby. Maxey, who trained in art and architecture in Britain, often produced work with nature themes, like *Florigorm*, which she exhibited at Expo 67. She also did ecclesiastical commissions, including a tapestry for Ryerson United Church in Vancouver.

Founded in 1971 and in operation for nearly two decades, the Salish Weavers Guild was a cooperative dedicated to the revitalization of traditional Salish loom weaving. The group, made up mainly of Stó:lō women from the Fraser Valley and lower Fraser Canyon area, studied traditional weaving practices and reworked them with contemporary techniques, patterns and dyes, often using fleeces purchased from local farmers. The collaborative approach to making embraced by the weavers allowed for specialization and experimentation with design, fibre processing and natural dyeing. Established at a time when the government was looking to support the development of local craft and design, the Salish Weavers Guild was able to qualify for federal funding due to its formal structure. More importantly, this structure allowed for continuity and the passing on and sharing of knowledge.[51]

Adeline Lorenzetto with a twill weaving, n.d.

Mary Peters with a weaving commissioned for the lobby of the Hotel Bonaventure, Montréal, QC, c. 1967

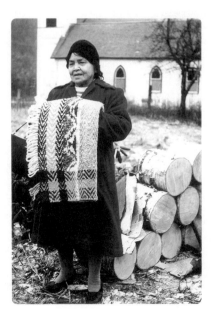

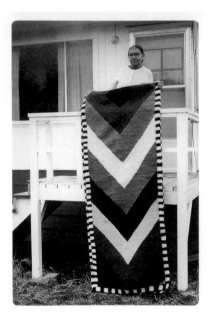

Top: Carole Sabiston, *Victoria by Jolly*, 1968, wool, velveteen, tulle, linen, satin, embroidery thread, 28.7 × 28.6 × 4.2 cm, Collection of the Clazie Family

Left: Heather Maxey, Stitchery and Appliqué (Stylized Plant Motif), c. 1966, thread, silk, 22.9 × 19.4 cm, Courtesy of R. Sloan

Right: Cliff Robinson, Hydra Batik, 1962, silk, 154.0 × 93.6 cm, Collection of Zoltan Kiss

Left: Chuck Yip, Rug, c. 1960s, wool,
139.9 × 68.0 cm, Collection of Roger Yip

Right: Marion Smith, Wall Hanging,
c. 1964, wool, linen, 188.0 × 102.0 cm,
Private Collection

Above: Madeleine Chisholm, *A Place for a Son*, 1972, rayon chenille, rayon, yarn, fishing line, wood, 105.0 × 124.0 × 4.5 cm, Courtesy of the Artist

Right: Joanna Staniszkis, *Untitled*, 1975, wool, cotton, feathers, 177.0 × 155.0 cm, Collection of the Vancouver Art Gallery, Gift of Audrey and Gerald Clarke, VAG 2012.32.1

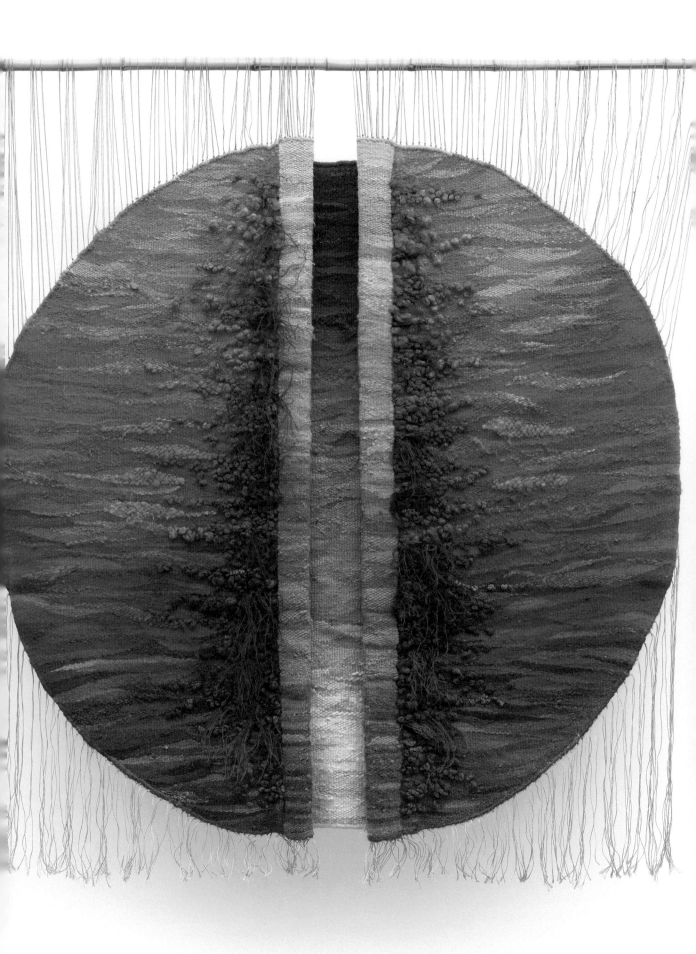

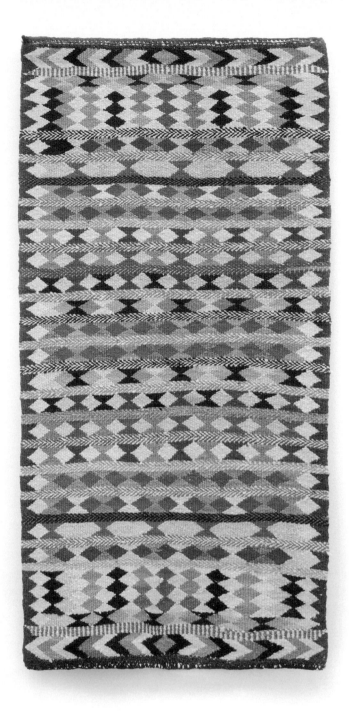

Mary Peters, Stó:lō Weaving, 1968, sheep
wool, coloured dyes, 170.0 × 81.0 cm,
Courtesy of the Chilliwack Museum and
Archives, 1987.031.001 a–b

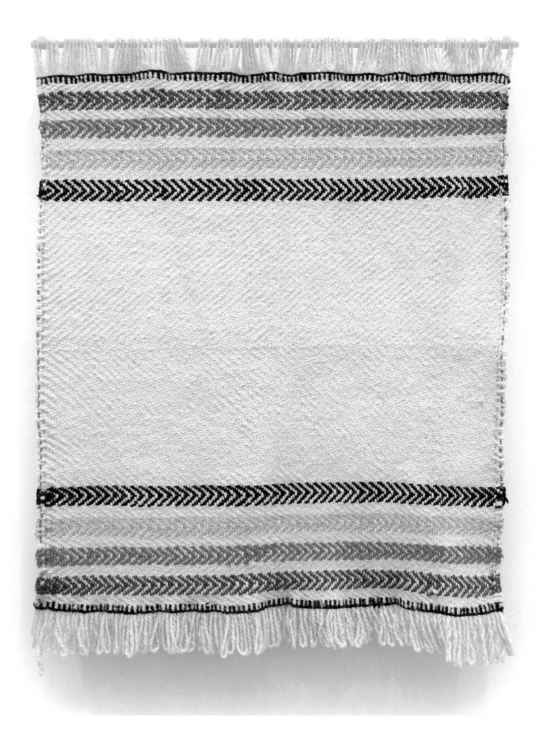

Adeline Lorenzetto, Untitled Hanging,
c. mid-1960s, goat hair, fibres, sheep wool,
coloured dyes, 117.0 × 94.0 cm, Courtesy
of the Chilliwack Museum and Archives,
2016.070.002

FASHION DESIGN IN THE 1960S AND 70S[52]

By the 1960s, fashion had become an important aspect of modern living on the West Coast. Designers and manufacturers proudly produced garments of exceptional quality, and the industry flourished, with total annual sales in excess of $10 million.[53] From casual sportswear to high-styled suits and coats, BC designers applied thoughtful styling and advanced craftsmanship to the garments they produced.

Couturier Mano Herendy came to Vancouver from Hungary in 1956. The former ski racer, law student, painter, structural designer and architectural draftsman first transitioned into fashion by designing ski sweaters in Switzerland.[54] From this outerwear experience, his design acumen developed to include ready-to-wear fashion for men and women. Herendy believed that quality was more important than quantity, both in business and as a consumer. He encouraged local women to consider a capsule wardrobe of five garments: a classic tweed suit for luncheons, streetwear and early afternoons; a little silk dress for cocktail parties and dinners; a simple sleeveless wool dress; a coat; and an understated evening dress. In 1967, Herendy purchased a house on Hornby Street in Vancouver and opened Mano Designs. Throughout the 1970s, he produced thousands of custom bat mitzvah, graduation and wedding dresses.

From the 1950s to the 70s, designer Mary Chang received many honours and awards for her coveted designs. She was part of a multigenerational Nanaimo family, and her father, Charles York, was a tailor who ran a menswear shop in the city for many years. Chang described herself as an average homemaker, caring for five children, husband and home. While she always had a passion for making clothing, she had no studio or desire to become a large-scale manufacturer.[55] Like Herendy, she believed that less is more, a philosophy she put into practice with her own thoughtful capsule wardrobes, featuring fabric appropriate for wear from early spring to late fall. The colours of Chang's designs were similarly flexible: they could travel and look stylish from morning to evening and represented a contemporary yet timeless mood. Chang, an extraordinary collaborator, worked with specialty textiles from local producers like Penny Gouldstone, also an associate professor in the UBC Faculty of Education, and international ones, like Marimekko and Vuokko of Finland.[56] However, perhaps her most famous collaboration was with Mrs. Charles of the Musqueam Nation. Together they developed a West Coast ski tunic made of familiar Cowichan grey-and-white wool in a slightly lighter weight. Chang blocked the pattern and Charles knitted the garment with wool sourced from Vancouver Island, and the tunic's carved bone buttons came from the Vancouver shop Talking Stick.[57]

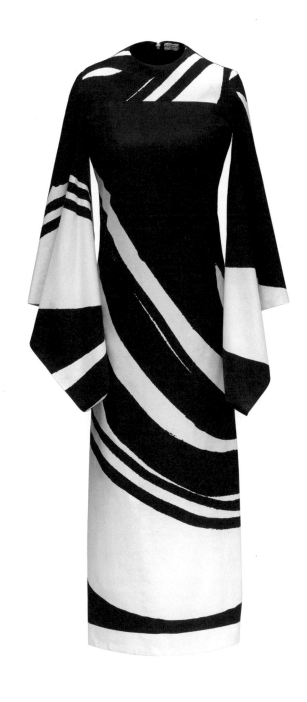

Above: Mano Herendy for Mano, Van-
couver, BC, Orange Print Caftan Dress,
c. 1969, polyester knit, plastic, metal,
151.0 (length) cm, Museum of Vancouver
(H2003.30.71)

Right: Mary Chang, Dress, 1963–68, cotton,
143.4 (length) cm, Ivan Sayers Collection

BLURRING BOUNDARIES (1968–75)

By the late 1960s, the counterculture and back-to-the-land movements—with their emphasis on individual expression and free creativity—began to have a significant influence on the direction of modernism in the region. During this period, British Columbia, and the Gulf Islands in particular, became a haven for artists, hippies, back-to-the-landers and US draft dodgers looking for a peaceful place to live and create. Artistic and craft practices were embraced as part of new ways of living in harmony with nature and a desire to use the earth's resources more efficiently and productively. There was widespread interest in rural self-sufficiency and holistic living. Many creative individuals, including Anne Ngan and Zonda Nellis, made shawls, scarves and other clothing from locally sourced wool that they carded, spun, dyed and wove themselves. These and other craft items such as pottery were sold at the craft fairs that rapidly proliferated throughout the province in the late 1960s.

THREE-DIMENSIONAL WEAVING

Textile art thrived during this period. Artists further explored weaving as a sculptural medium, working both on and off the loom to create works that operate at the intersection of craft and sculptural assemblage. One of the first weavers in British Columbia to make three-dimensional weavings was Sharon Butler,[58] who studied in San Francisco with Glen Black from 1963 to 1964. She presented this new art form as part of *Fabricart*, a children's exhibition dedicated to the exploration of colour, fabric and form.[59] Butler made her one-piece weavings using textured wool that she coloured with natural dyes and often supported with wire to separate one surface from another.[60]

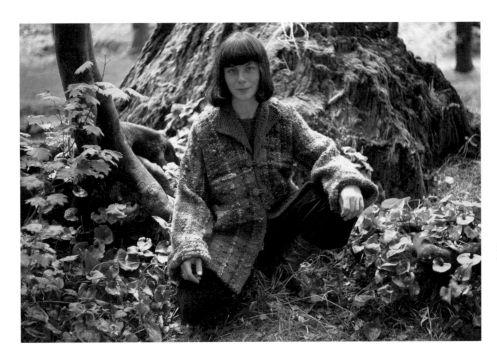

Zonda Nellis wearing a woven jacket, c. mid to late 1970s

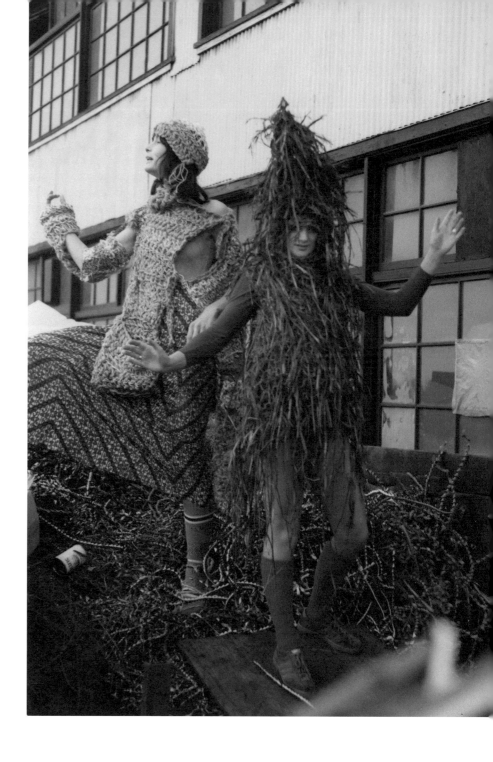

Students of Evelyn Roth outside Handcraft
House, North Vancouver, BC, c. 1970s

185

North Vancouver's Handcraft House became the epicentre for experimental weaving practices in the region.[61] Lynda Gammon, the daughter of founder Margery Powell, remembers: "It was a real hub for the counter-culture movement with long-haired hippies, (many recent draft dodgers from the U.S.) doing pottery, glass blowing, weaving and spinning etc. Crafts were very much a part of the 60's and 70's counter-culture movement in Vancouver… It was a totally amazing place."[62] While Handcraft House offered instruction on the conventional loom, that form of weaving is complex and often requires years of study and practice before satisfactory results can be achieved. Many young weavers in the late 1960s wanted to circumvent this training and get to the creative side of weaving as quickly as possible. To accommodate this new generation of artisans, Handcraft House taught methods that proved easier to use and more conducive to personal exploration of form, colour and texture, such as weighted warp weaving and other traditional methods that use simple, self-made frames. Rather than the fine fibres used in traditional weaving, the younger weavers used coarse wool and cord, often integrating found objects, grasses, seaweed and wood into their work.

It was within this creative environment that Handcraft House weaving instructor Lynda Gammon and painter-turned-weaver Setsuko Piroche developed three-dimensional weaving in the late 1960s. Using this medium, Piroche created animal and human forms composed of woven fabric panels that hang from the ceiling and small environments like *Dizzy Dome* (c. 1974) that invite viewer participation. For many of her works, Gammon experimented with unconventional materials, such as sisal, to produce works that assume a bodily form. For *Untitled* (1972), she extended the traditional Scandinavian rya rug technique, knotting rows of unspun sisal for the pile, followed by plain weaving with single-ply sisal for the backing. The work also employs non-loom techniques, such as wrapping to create its rope-like parts, some of which are knotted and joined.

Textile works like Piroche's and Gammon's were spotlighted in the early 1970s in local exhibitions, including at Vancouver's Mido Gallery, and nationally in *Textiles into 3-D*, an important exhibition featuring three-dimensional textile works by Canadian artists that toured Ontario in 1973.[63] Around 1974, Handcraft House also initiated a two-year Textile School offering instruction in design, soft sculpture, work on the loom, fabric dyeing and printing. This program eventually evolved into a textile arts program at Capilano College in North Vancouver.

Lynda Gammon (Powell), *Untitled*, 1972,
published in *Textile into 3D*, 1973, Courtesy
of the Vancouver Art Gallery Library

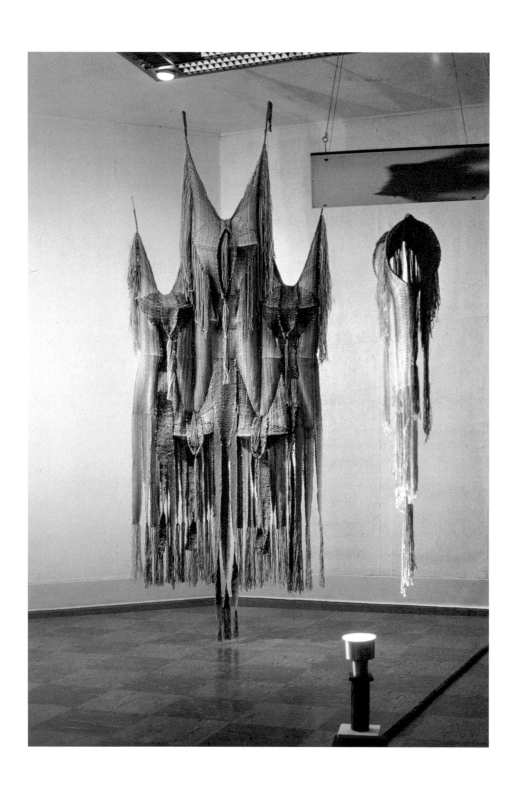

Installation view of Sharon Butler's
three-dimensional weavings, c. late 1960s

Woven sculptures hang like surrealist costumes from the high ceiling of Sharon Hassell's studio home in West Vancouver.

They hung their house on a hill

This low-cost studio home
was built on a problem lot
that everyone else passed up

By Harris Mitchell

8

Above: View of Sharon Butler's studio,
West Vancouver, BC, published in the
Calgary Herald, February 15, 1969

Right: Setsuko Piroche with her work *Dizzy
Dome*, c. 1974

189

INTERMEDIA

Other artists applied their interest in craft to radically new modes of production, participating in Vancouver's nascent experimental art scene of the late 1960s and early 70s. The distinction between "craft" and "fine art" became nebulous as artists turned their attention to embracing fluid approaches to production, exploring process-based concerns and transcending disciplinary boundaries. Gathie Falk and Glenn Lewis in particular combined craft methodologies, a Pop sensibility and aspects of Funk (non-functional) ceramics to develop entirely new ways of making. With her *Fruit Piles* (1967–70), Falk suggests a new understanding of the artistic potential of ceramics and questions its marginal status as craft. Similarly, Lewis' ceramics practice expanded into sculptural porcelain tableaux of domestic tableware. Misshapen by imperfections and cracks, these pieces make oblique reference to the body while revealing the many chance processes that occur when working with clay.

Poster advertising *Electrical Connection*, exhibition at the Vancouver Art Gallery, BC, 1969

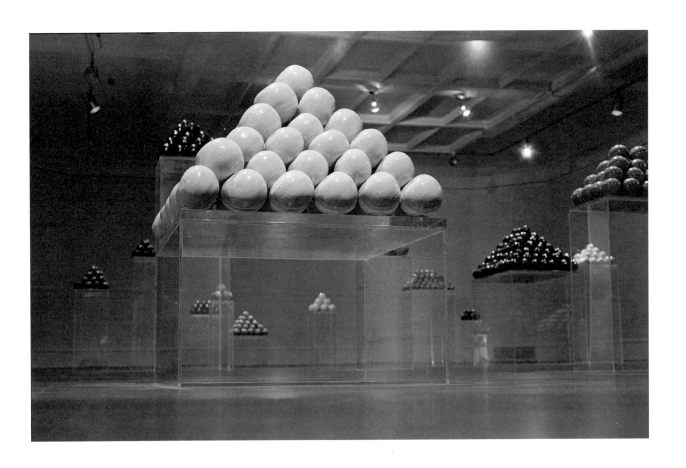

Installation view of *Gathie Falk Fruit Pieces*,
exhibition at the Vancouver Art Gallery,
BC, 1970

Evelyn Roth was a founding member of Intermedia (1967–72), a community of artists, musicians, filmmakers and dancers in Vancouver that had an experimental, interdisciplinary and collaborative approach to art production. Roth refused to distinguish between "art," "craft" and "performance," often creating works that combine elements of each. In the late 1960s and early 70s, she produced many works out of recycled videotape—including wearable pieces that she used in performances. At a time when environmentalism and recycling were novel interests, Roth began using knitting and crocheting as means to recycle both natural fibres and discarded film from local TV stations.

The works produced in British Columbia in this period represent the last vestiges of the modernist enterprise—created at a moment when the era's utopian impulse began to falter and the tenets of modern architecture and design were being challenged. As the optimism and promise of the post-war generation became marred by economic stagnation and political and cultural turmoil, the late 1970s witnessed the emergence of a Postmodern eclecticism that reflected this new cultural landscape. The self-sufficiency and environmentalism embraced by countercultural groups cast doubt on the culture of consumption that had precipitated this renaissance of craft and design. The promise that modern living was for everyone began to prove hollow, as racial, gender and class inequalities prevented many from participating in its grand visions of progress.

While many of the artists and designers who established careers during the modern period would continue to produce and exhibit in the decades that followed, this intense period of growth, innovation, community interest and institutional support was coming to an end. The creative community became increasingly fractured and fragmented, with stylistic, formal and material affinities less apparent. Beginning in the mid-1970s, the Vancouver Art Gallery ceased exhibiting design and craft and instead focused on the emergence of performance, video and interdisciplinary work.

In today's digital age, many of the aesthetic concerns, conceptual approaches and material investigations initiated during the modern period have a renewed relevance. As digital representation and rendering have been integrated into every crevice of cultural production and daily life, a deep interest in the material—and a reverence for the hand-made and for craft traditions—has emerged in contemporary art and design practice. All around us we see renewed interest in mid-century modern design and the importance of the handmade in our increasingly dematerialized world.

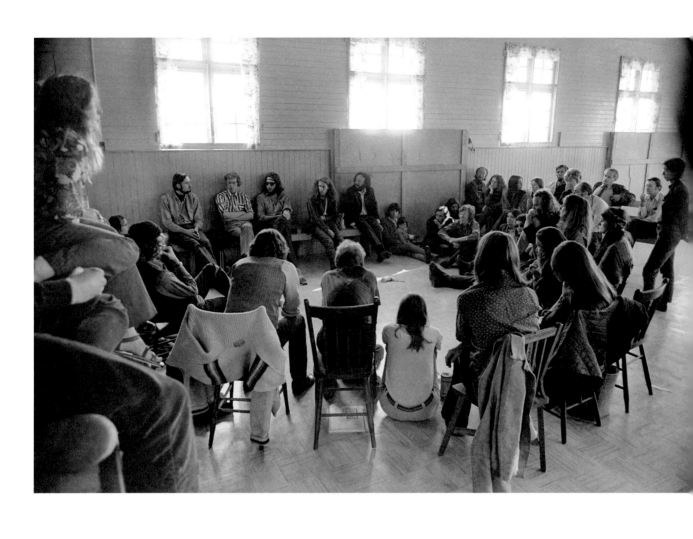

Above: Intermedia members' meeting,
Vancouver Art Gallery, BC, 1970

Right: Installation view of a Glenn Lewis
exhibition at Douglas Gallery, Vancouver,
BC, 1968

193

Above: Gathie Falk, *30 Grapefruit*, 1970, ceramic, glaze, 32.0 × 49.5 × 49.5 cm, Collection of the Vancouver Art Gallery, Endowment Fund, VAG 70.112

Right: Glenn Lewis, *Still Life*, c. 1968, ceramic, glaze, Plexiglas, acrylic sheet, 168.0 × 51.0 × 51.0 cm, Collection of the Vancouver Art Gallery, Gift of Ken and Lorraine Stephens, VAG 2013.23.3 a-b

Crocheted videotape "Car Cozy"

68

Evelyn Roth, *The Evelyn Roth Recycling Book*, 1975 (spread and cover), paperback book, 14.9 × 21.4 × 1.9 cm, Collection of Allan Collier

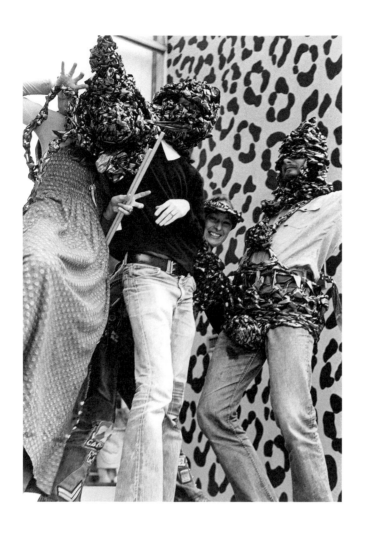

Above: Evelyn Roth's "Creative Recycling Workshop," during the exhibition *Pacific Vibrations*, Vancouver Art Gallery, BC, 1973

Right: Evelyn Roth, *Video Armour*, 1972 (detail), recycled videotape dress, hat, basket, mittens, boots, mannequin, dimensions variable, Collection of the Vancouver Art Gallery, Gift of the Artist, VAG 2015.15.3 a-e

NOTES

1 *Vancouver: Art and Artists*, 1931–1983 (Vancouver: Vancouver Art Gallery, 1983), 76.

2 Donald W. Buchanan, *Design for Use in Canadian Products* (Ottawa: National Gallery of Canada, 1947).

3 The Design Centre was replaced in the early 1960s with institutions in Toronto and Montréal operated by the Department of Trade. A parallel organization called the BC Industrial Design Committee sponsored NIDC exhibitions that toured to British Columbia and occasionally made awards to potters and others producing work they considered suitable for mass production.

4 The Sky Bungalow received cover-story treatment in *Canadian Homes and Gardens* in June 1950.

5 Mouldcraft Plywoods auctioned their equipment in 1950. *Province* (Vancouver), April 8, 1950, 34.

6 Carole Reid Burr and Roger Petersen, *Rose Marie Reid: An Extraordinary Life Story* (American Fork, UT: Covenant Communications, 1995), 34–35.

7 *Los Angeles Times*, May 8, 1956, 12.

8 The "Twelve Precepts" are: (1) Modern design should fulfill the practical needs of modern life; (2) Modern design should express the spirit of our times; (3) Modern design should benefit by contemporary advances in the fine arts and pure sciences; (4) Modern design should take advantage of new materials and techniques and develop familiar ones; (5) Modern design should develop the forms, textures and colours that spring from the direct fulfillment of requirements in appropriate materials and techniques; (6) Modern design should express the purpose of an object, never making it seem to be what it is not; (7) Modern design should express the qualities and beauties of the materials used, never making materials seem to be what they are not; (8) Modern design should express the methods used to make an object, not disguising mass production as handicraft or simulating a technique not used; (9) Modern design should blend the expression of utility, materials and process into a visually satisfactory whole; (10) Modern design should be simple, its structure evident in its appearance, avoiding extraneous enrichment; (11) Modern design should master the machine for the service of man; (12) Modern design should serve as wide a public as possible, considering modest means and limited costs no less challenging than the requirements of pomp and luxury. See Edgar Kaufmann Jr., *What Is Modern Design?* (New York: Museum of Modern Art, 1950).

9 *Vancouver Sun*, October 22, 1956, 23.

10 Compiled by Jenn Jackson from conversations with fashion historian Ivan Sayers.

11 *Western Homes and Living* ceased publication in 1966.

12 Vancouver architect Fred Hollingsworth also designed a chair using plywood, which appeared in several of his houses in the 1950s, based on a 1942 design by Richard Neutra.

13 *PM Magazine* 2, no. 1, 1952, 16.

14 Perpetua Furniture was located at 1512 West 14th Avenue in Vancouver. Cotton closed the business in 1954 and finished his architecture degree at UBC in 1955. Cotton's designs were sold in Eastern Canada at Morgan's department store.

15 Carl Ostermeier also designed modernist furniture that he exhibited alongside Cotton's at a local trade fair and at the Vancouver Art Gallery in 1952.

16 Many of Cotton's pieces were included in the Design Index and won NIDC Design Awards.

17 Earle Morrison, personal letter to Allan Collier, March 29, 1988.

18 Bush's design experience prior to 1950 consisted mainly of renovating a family-owned pub on Genoa Bay, north of Victoria, which he outfitted with chairs by Charles Eames, produced in the United States by Herman Miller Inc. Bush later became an agent for Herman Miller Inc. and president of its Canadian subsidiary in 1958.

19 Between 1950 and 1952, the furniture was made by Morrison's firm E.A. Morrison Ltd. which had thirty-five employees, many of them European-trained craftspeople who worked in the well-equipped Pacific Furniture factory, formerly operated by Standard Furniture, a large Victoria retailer where Morrison-Bush furniture was also sold. Despite monthly production volume of $100,000 and national sales through Eaton's and other retailers across the country, E.A. Morrison Ltd. had financial difficulties, which forced it to shift production to the Victoria-based Modern Metal Furniture Co. for about eight months, before eventually ceasing production in 1953.

20 In August 1948, an exhibition of McCrea McClain's work at the Vancouver Art Gallery displayed a selection of these items alongside her pottery, which often had matching motifs.

21 Enchantment was later chosen as a fabric for the new nurses' residence at the Vancouver General Hospital in 1951.

22 McCrea McClain also received commissions for architectural projects, including an entrance mural and hand-screened drapery fabric for architect Harold Semmens' residence in West Vancouver.

23 Yip later settled into a career in drawing and calligraphy but occasionally made rugs with abstract designs into the 1960s.

24 Following Mason's departure, Thomas Kakinuma headed the UBC Extension Department pottery program until 1960, and again between 1965 and 1966.

25 *Vancouver Sun*, August 24, 1956, 56. Modernist influences at UBC continued into the late 1950s with guest instructors Martha Middleton (1955), Konrad Sadowski (1956) and Marguerite Wildenhain (1959).

26 In 1959, Mignosa won a gold medal at the prestigious International Ceramics Exhibition in Ostend, Belgium. That same year he won an honourable mention at the *Northwest Craftsmen's Exhibition* in Seattle, where he was later acknowledged as being a ceramic artist who was moving pottery in new directions. He would go on to exhibit internationally and teach at the Kootenay School of Art in Nelson in the 1960s.

27 Gwladys Downes, *Daily Times* (Victoria), May 12, 1954, main edition, 25.

28 Cavelti was awarded a Diamonds International Award in 1957 and Reid was included in the Brussels World's Fair in 1958.

29 Charles Edenshaw was Reid's great-great-uncle.

30 These smooth organic forms were later adopted by Isamu Noguchi (furniture), Eva Zeisel (dinnerware), Henning Koppel (silverwork) and Gaétan Beaudin (pottery) in the late 1940s and early 50s.

31 Doris Shadbolt, quoted in Kathy Hassard, *Vancouver Sun*, December 7, 1961, 56.

32 Compiled by Jenn Jackson from conversations with fashion historian Ivan Sayers.

33 *Ottawa Citizen*, July 18, 1964, 76.

34 *Province* (Vancouver), August 30, 1952, 14.

35 Compiled by Jenn Jackson from conversations with fashion historian Ivan Sayers.

36 Craft exhibitions held at the Vancouver Art Gallery included tapestries by Québec weavers Micheline Beauchemin and Mariette Rousseau-Vermette (1960); pottery by Robert Weghsteen (1961), Thomas Kakinuma (1962) and Beatrice Wood (1966); jewellery by Jack Leyland, Willy Van Yperen and Karl Stittgen (1962); *German Arts and Crafts* (1965); and *BC Crafts* (1961) and *BC Craftsmen '64* (1964). Venues for selling craft in Vancouver included Handcraft House and the House of Ceramics, and in Victoria were the Potters' Wheel and Handloom.

37 Among potters exhibiting in the Canadian Pavilion at Expo 67 were Jan Grove, Olea Davis, Walter Dexter, Gathie Falk, Mick Henry, Avery Huyghe, Thomas Kakinuma, Glenn Lewis, Leonard Osborne and Hilda Ross. Rodney Maxwell-Muir designed and made lamps, plates and salt and pepper shakers with animal shapes in sgraffito (over one thousand pieces in all) for the restaurant La Toundra at Expo 67. Many of these same individuals exhibited in *Canadian Fine Crafts 1966/67* at the NGC.

38 *Western Homes and Living*, December 1962, 3.

39 *Nanaimo Daily News*, April 16, 1969, 10.

40 *Vancouver Sun*, October 17, 1969, 111.

41 Exhibitions at the Art Gallery of Greater Victoria included *Japanese Ceramics* (1960); *Picasso Ceramics and Posters* (1964); *Eight British Potters*, including pieces by John Reeve who was then working in Britain (1966); *Early Korean Ceramics* (1966); and *Pottery by Lucie Rie* (1970). Exhibitions at the Vancouver Art Gallery included pottery by the California artist Beatrice Wood (1966). The international potters who ran workshops included Harry Davis from Britain and Kyllikki Salmenhaara from Finland.

42 For a more in-depth exploration of Bernard Leach's influence on the development of studio pottery in British Columbia, see *Thrown: British Columbia's Apprentices of Bernard Leach and Their Contemporaries* (Vancouver: Morris and Helen Belkin Art Gallery and UBC Press, 2011).

43 *Richmond Review,* November 22, 1972, 17.

44 Ravenhill's book *A Corner Stone of Canadian Culture* (1944) would prove to be a valuable source of First Nations imagery for non-Indigenous artists in the 1950s.

45 Van Yperen exhibited in *Canadian Fine Crafts 1966/67* at the NGC and *Craft Dimensions Canada* at the Royal Ontario Museum in 1969.

46 The Mayor's Chain of Office was exhibited in *Canadian Fine Crafts* at Expo 67 in Montréal.

47 Handcraft House was founded by Margery Powell and Miriam McCarrell in 1967.

48 Exhibitions like *Textile Kostbarkeiten* and *Deliberate Entanglements*, held at the Vancouver Art Gallery in 1970 and 1972, respectively, broadened the horizons of local makers.

49 Around 1970, Elder produced a translucent screen of woven rectangular forms measuring approximately ten by forty feet for the cafeteria of the Technical Institute in Terrace. Starting in the 1970s, Staniszkis made several hangings for banks, offices and other buildings in Vancouver, including the Bank of Montreal (1973), Westcoast Transmission (1975) and Plaza International Hotel (1975). These were followed by scores of other commissions worldwide. One of Chisholm's first commissions was a large sisal macramé hanging for a law office in Vancouver's Bentall Centre (1972), soon followed by several others in the mid-70s. All three artists exhibited nationally and internationally.

50 Formerly an abstract painter, Sabiston exhibited a series of non-representational collages using found materials at Victoria's Print Gallery and the exhibition *Craft Dimensions Canada* at the Royal Ontario Museum, both in 1969.

51 Salish weaving achieved national prominence, with the guild receiving a number of commissions for architectural projects.

52 Compiled by Jenn Jackson from conversations with fashion historian Ivan Sayers.

53 *Vancouver Sun*, May 28, 1957, 66.

54 *Vancouver Sun*, August 21, 1963.

55 *Vancouver Sun*, February 16, 1967, other editions, 2.

56 *The Province* (Vancouver), October 17, 1968, main edition, 37; *The Province* (Vancouver), March 21, 1972, main edition, 27.

57 The design was featured in a travelling fashion show presented in New York, Montréal, Winnipeg, Edmonton, Calgary and Vancouver. *The Province* (Vancouver), November 19, 1964, 38.

58 During this period, Butler exhibited under the name Sharon Hassell.

59 *Fabricart* was held at the Vancouver Art Gallery in November 1966. It also included Marion Smith's rya rugs and Vee Elder's afghans.

60 Butler would later exhibit three-dimensional weavings at Weavers (Directions '68), Vancouver Art Gallery, 1968, and Perspective 67, Art Gallery of Ontario, 1967. She is reported to have made a large three-dimensional hanging for Expo 67.

61 Starting in the late 1960s, Handcraft House also held workshops by Joanna Staniszkis, tie-dye expert Penny Gouldstone, artist and recycler Evelyn Roth and Californian sculptor Barbara Shawcroft.

62 Lynda Gammon, interview by Nellie Lam, Women Artists PNW, spring 2016, http://women.pnwartists.ca/lynda-gammon.

63 British Columbia–based artists included in the exhibition were Lynda Gammon (as Lynda Powell), Setsuko Piroche, Joanna Staniszkis, Katherine Dickerson and Janina Jakobow.

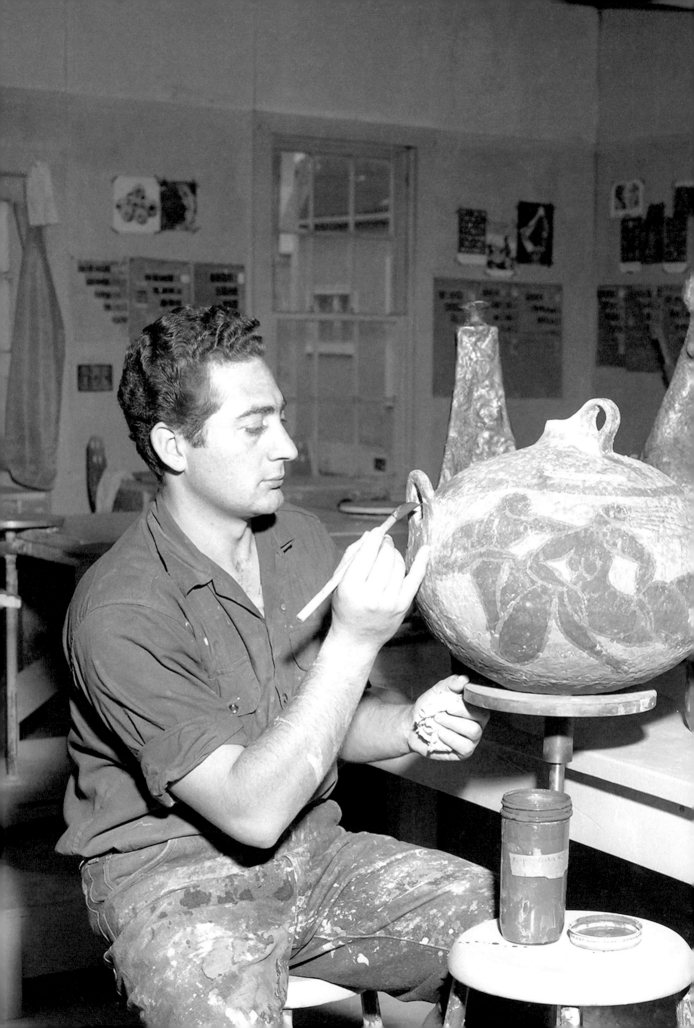

BIOGRAPHICAL SKETCHES

Compiled by Allan Collier
with contributions from Siobhan McCracken Nixon

Biographical information and select exhibition histories are limited to the time period covered in the *Modern in the Making* exhibition and do not reflect the entirety of an artist's life and career. Every reasonable effort has been made to confirm dates and details.

CRAFT EXHIBITIONS (SELECTED)

The following exhibitions are mentioned frequently in the biographical sketches:

· *BC Potters Annuals,* **1949–64.** Organized by the Federation of Canadian Artists (BC region) and held at the University of British Columbia's Art Centre (later called the UBC Fine Arts Gallery) in 1949–54; in 1955–64, organized by the BC Potters Guild and shown, alternate years, at the UBC Fine Arts Gallery and Vancouver Art Gallery, where it was renamed a craft exhibition in the years 1957, 1959, 1961, and 1963.

· *Ceramics, Textiles, and Furniture,* **1951–52.** The first of these was an opening exhibition at the remodelled Vancouver Art Gallery in 1951. Both featured craft and design from British Columbia.

· *Canadian Ceramics Biennial,* **1955–71.** Sponsored by the Canadian Handicrafts Guild (Montréal) and Canadian Guild of Potters (Toronto), and by additional provincial groups later. It was exhibited only at the Royal Ontario Museum

(Toronto) and the Museum of Fine Arts (Montréal) until 1961, when it also circulated across the country. It opened at the Vancouver Art Gallery in 1969.

· *BC Arts Today,* **1956.** Organized by the Art Gallery of Greater Victoria. Included painting, sculpture and craft from British Columbia's best-known artists.

· *First Canadian Fine Crafts,* **National Gallery of Canada, 1957.** Canada's first national craft exhibition. Fifty of the pieces shown were also exhibited at the Brussels World's Fair in 1958.

· *Centennial Crafts Caravan,* **1958.** Part of the 1958 BC Centennial celebrating the establishment of a mainland colony in 1858. Sponsored by the BC Centennial Committee, the Extension Department at the University of British Columbia and others. The exhibition consisted of over 110 Indigenous and non-Indigenous craft items and travelled by van to seventy-five communities in British Columbia, May 6–August 28.

· *Canadian Fine Crafts 1966/67.* Federally funded exhibition that celebrated craft during Canada's Centennial. Opened at the National Gallery of Canada in Ottawa in December 1966 and toured the country in two parts: one section travelled west; the other east.

· *Western Crafts 1967.* Organized by the Western Canada Art Circuit, funded through the Centennial Committee. The exhibition went to thirteen art centres in

four western provinces.

· *Craft Dimensions Canada,* **1969.** Organized by the Royal Ontario Museum (Toronto) and the Canadian Guild of Crafts (Ontario). Included work by fourteen BC artists.

· *British Columbia Craft,* **Simon Fraser University, 1972.** Organized by the craft liaison committee of the Community Arts Council of Vancouver and the Centre for Communications and the Arts at Simon Fraser University.

BARBARA BAANDERS (NÉE SCHOLZ)
b. 1926, Germany
d. 2016, Richmond, BC

Barbara Baanders was best known for her functional kitchenware and for her teaching, which stressed basic pottery skills. From 1943 to c. 1950, she studied pottery in Germany with Nanette Lehmann and Wilhelm Kagel under whose mentorship she became a "Fellow" in pottery. She also worked for Kagel for about a year. In 1951, she moved to Vancouver and, in the early 1950s, threw pottery part-time at Lambert Potteries on Fraser Street. In the 1960s, Baanders taught pottery at night school, the University of British Columbia Extension Department, and starting in 1966 also at the Ross-Huyghe School of Pottery. In 1970, she fulfilled a lifelong dream by opening her own well-equipped pottery school in the basement of her home in Richmond, BC (c. 1970–85), where she taught all skill levels.

HANS-CHRISTIAN BEHM
b. 1940, Gross Thurow, Holstein,
Germany; lives in Maple Ridge, BC

Hans-Christian Behm came to Canada in 1961. He studied general arts at the University of British Columbia, focusing on art and architectural design. His Vancouver Chair is built with four seat and three backrest polyfoam cushions, held together by an anodized aluminum frame and laced at the corners. It is part of a living room set consisting of two armchairs, a sofa and a glass table, which Behm exhibited at the Design Centre in Toronto in 1969. It remains the only copyrighted example in existence. The chair is similar to an earlier version

with a Plexiglas frame that Behm exhibited in *Craft Dimensions Canada* at the Royal Ontario Museum (1969). Behm states that the Bauhaus tenet "function is beautiful" strongly influenced his design.

NOTABLE EXHIBITIONS
· *Craft Dimensions Canada*, Royal Ontario Museum, Toronto, ON, 1969
· Design Centre, Toronto, ON, 1969

NIELS BENDTSEN
b. 1943, Copenhagen, Denmark;
lives in Vancouver, BC

Niels Bendtsen immigrated to Canada with his family in 1951. He had no formal design training and apprenticed under his cabinetmaker father who designed and built Scandinavian-influenced furniture in Canada. In 1958, Bendtsen sold his first design, a shelving unit, to a shop on Robson Street in Vancouver when he was fifteen years old. In 1963, Bendtsen opened a store called Danet Interiors at Park Royal in West Vancouver that sold his father's furniture as well as imported modern Scandinavian lines. While Bendtsen designed some small items for the store such as a cast-metal candlestick holder, it wasn't until he was in his thirties that he began designing furniture full-time. In 1972, Bendtsen sold his store and returned to Denmark where he studied design and began freelancing with various manufacturers including Eilersen, IKEA and Kebe. During this period, Bendtsen also started producing furniture under his own brand, 2B. Bendtsen eventually returned to Vancouver in the 1980s and bought back his old Gastown store and rebranded it Inform Interiors. In 1981, he founded Bensen, his manufacturing line.

NOTABLE EXHIBITIONS
· *Recent Acquisitions: Architecture and Design*, Museum of Modern Art, New York, NY, 1979

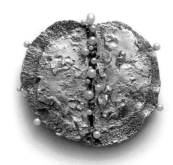

IDAR BERGSETH
b. 1945, Vancouver, BC;
lives on Pender Island, BC

From an early age, Idar Bergseth was interested in jewellery, rocks and gems. In 1962, he started an apprenticeship with Vancouver jeweller Bino Schratter, and from 1964 to 1973 worked with Karl Stittgen in West Vancouver and in Stittgen's studio in the Georgia Medical-Dental Building in downtown Vancouver. During the 1960s, he employed casting, fusing, water dropping and other experimental methods using silver and gold—then relatively inexpensive—to create jewellery with irregular forms and surfaces like those found in nature. His 1970s jewellery features shells, pearls and coral in simple settings. Bergseth opened his shop in Victoria in 1973. He won the De Beers Diamonds Today award in 1970.

PAUL LUDWIG BINKERT
b. 1908, Waldshut, Germany
d. 1995, Vancouver, BC

From 1924 to 1926, Paul Ludwig Binkert apprenticed as a tool and die maker in Ebingen, Germany. He came to Vancouver via Colombia in 1950 and made a living repairing office machines. In the late 1950s and early 60s, he took evening and summer courses in art and made art metal objects part-time. These included boxes, jewellery, bookends, candleholders and pokers. He also made woodenware including serving spoons and bowls. In 1967, he quit the repair business to work full-time as an artist, mainly making small metal sculptures.

· *BC Craftsmen '64*, Vancouver Art Gallery, Vancouver, BC, 1964
· *Canadian Fine Crafts 1966/67*, National Gallery of Canada, Ottawa, ON, 1966–67
· *Canadian Fine Crafts*, Expo 67, Montréal, QC, 1967
· *Western Crafts 1967*, Western Canada Art Circuit, 1967
· Department of External Affairs and the Canada Council, Ottawa, ON (touring, Europe), 1968–69

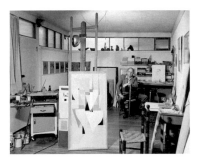

B.C. BINNING
b. 1909, Medicine Hat, AB
d. 1976, Vancouver, BC

B.C. Binning studied at the Vancouver School of Art (VSA) with Charles H. Scott, W.P. Weston, Jock Macdonald and Fred Varley. In 1933 he became an instructor at VSA where he taught until 1949. Binning was Assistant Professor at the School of Architecture at the University of British Columbia (UBC) from 1949 to 1955; and he founded the Department of Fine Arts at UBC in 1955 and taught there until his retirement in 1974. Binning's expansive and innovative practice importantly included architecture and non-traditional fine art forms such as ceramics and sculptural constructions. He designed his own ground-breaking, Bauhaus-influenced flat-roofed, post-and-beam home in West Vancouver (completed in 1941). It was one of the earliest modernist designed residences in Canada and shaped the region's domestic architectural landscape. While teaching architecture at UBC, Binning invited leading California modernist architect Richard Neutra to lecture in Vancouver in 1946 and 1953. He helped to found the Art in Living Group with Fred Amess in 1944 and was a supporter of the *Design for Living* exhibition at the Vancouver Art Gallery in 1949. Binning's interest in architecture lead to experiments in design and other art forms such as large public mosaics. His major art commissions in Vancouver included the mosaics for the former B.C. Hydro Building in Vancouver (1957); former Imperial Bank of Commerce (1958; now Shopper's Drug Mart); and CKWX Radio station (now dismantled). He was made Officer of the Order of Canada in 1971.

NOTABLE EXHIBITIONS
· Vancouver Art Gallery, Vancouver, BC, 1944, 1946, 1961, 1976
· Art Gallery of Toronto, Toronto, ON, 1946, 1951
· UBC Fine Arts Gallery, Vancouver, BC, 1950, 1973
· Venice Biennale, Venice, Italy, 1953

ALICE BRADBURY
b. 1905, Vancouver, BC
d. 1995, Vancouver, BC

Alice Bradbury first studied pottery through the University of British Columbia Extension Department in 1957, later graduating from the Vancouver School of Art (ceramics) in 1965.

NOTABLE EXHIBITIONS
· *1st Annual BC Crafts*, Vancouver Art Gallery, Vancouver, BC, 1957
· *Centennial Crafts Caravan* (touring), 1958
· *2nd Biennial Crafts Exhibition*, Vancouver Art Gallery, Vancouver, BC, 1959 (award)
· *Canadian Ceramics Biennial*, 1959, 1961
· *BC Crafts*, Vancouver Art Gallery, Vancouver, BC, 1961

ELAINE BULLY
b. Unknown
d. Unknown

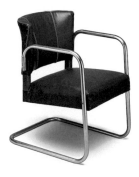

CYRIL G. BURCH
b. 1912, Surac, MB
d. 1968, Vancouver, BC

Cyril G. Burch started Cyril G. Burch Ltd. upholsterers with his brother James in 1947 at 165 West 4th Avenue, Vancouver. The Company manufactured contemporary furniture for offices, restaurants and hotels, including the Bayshore Inn (1961) and the Four Seasons Hotel (1976) in Vancouver. The company closed in 1984. The company's output mirrors the changes in public taste from the tubular metal furniture of the 1940s to the Scandinavian look of the 60s.

ROBIN BUSH
b. 1921, Vancouver, BC
d. 1982, Vancouver, BC

Robin Bush studied at the Vancouver School of Art in the late 1930s and served in the Royal Canadian Navy during World War II. In 1950, he teamed up with Earle A. Morrison in Victoria to design minimalist residential furniture made of wood and steel rod, forming the marketing company Morrison-Bush in 1952. In the early 1950s, the company had fourteen listings in the Design Index and received several NIDC Design Merit Awards in 1953 and 1954. Morrison-Bush furniture was publicized in Canadian home magazines and the British publication *Decorative Art: The Studio Yearbook*. A wooden dining table and occasional chair were exhibited at the Milan Triennial (1954). While the partnership with Morrison ended in 1953, Bush

continued to market these designs through his new Vancouver-based company, Robin Bush Associates (est. 1954). For the next three years, Bush developed designs for institutional furniture, principally the Hotel/Motel group (1954–55)—shown at the Milan Triennial (1957)—and the Prismasteel component office furniture system (c. 1957).

NOTABLE EXHIBITIONS
· Milan Triennial, Milan, Italy, 1954, 1957

SHARON BUTLER
b. 1942, Matsqui, BC;
lives in New Westminster, BC

Sharon Butler studied art and architecture at the University of British Columbia (BA, UNBC/Open Learning) and later with well-known weaver Glen Black in San Francisco, CA (1963–64). In 1966, she was awarded a Canada Council grant to explore three-dimensional weaving, exhibiting several new pieces at *Fabricart* (Vancouver Art Gallery, 1966) along with other local weavers. One of her pieces was displayed at an Arthur Erickson–designed unit in Habitat at Expo 67 (Montréal, QC) and later shown during the Venice Biennale in 1968 (Venice, Italy). She was inspired by weavers Lenore Tawney and Sheila Hicks to push the boundaries of two-dimensional weaving. She spun her own yarn from BC fleece and used natural dyes in response to the vibrant surroundings of the Pacific West Coast.

NOTABLE EXHIBITIONS
· *BC Craftsmen '64*, Vancouver Art Gallery, Vancouver, BC, 1964
· *Vancouver Art Gallery 34th Annual*, Vancouver Art Gallery, Vancouver, BC, 1965
· New Design Gallery, Vancouver, BC, 1965, 1966
· *Canadian Fine Crafts 1966/67*, National Gallery of Canada, Ottawa, ON, 1966–67
· *Fabricart*, Vancouver Art Gallery, Vancouver, BC, 1966
· *Perspective '67*, Art Gallery of Ontario, Toronto, ON, 1967
· *Directions '68 – Weavers*, Vancouver Art Gallery, Vancouver, BC, 1968 (with Guerite Fera, Charlotte Lindgren and Glen Black)
· Venice Biennale, Venice, Italy, 1968

ROBERT CALVERT
b. 1918, London, ON
d. 1993, Kingston, ON

Robert Calvert studied architecture at the University of Toronto (1945–49), later working for about two years with the Vancouver architectural firm Sharp and Thompson, Berwick, Pratt (STBP). While there, he designed a reading chair, an upholstered armchair and a circular coffee table for the "Peridot family" tableau in the *Design for Living* exhibition (Vancouver Art Gallery, 1949). While originally intended for mass production, the furniture was ideally suited to the do-it-yourself woodworker searching for stylish, inexpensive home furnishings. Plans were available through STBP and *Western Homes and Living* magazine. The reading chair could be made from one two-by-four-foot panel of plywood and some upholstery webbing for about ten dollars. Calvert returned to Toronto in 1951 and became a partner in the architectural firm of Fleury and Arthur. He also served as home planning consultant for *Canadian Homes and Gardens* magazine in the early 1950s.

NOTABLE EXHIBITIONS
· *Design for Living*, Vancouver Art Gallery, Vancouver, BC, 1949

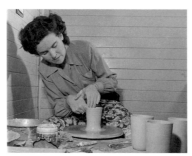

MOLLIE CARTER
b. 1918, unknown
d. 2002, Vancouver, BC

Mollie Carter is known today for her pioneering efforts to improve pottery instruction and promote modern design in Vancouver. She graduated from the Vancouver School of Art, 1939 (postgraduate year, 1940) and in the mid-1940s was active in the Art in Living Group. In the early summer of 1947, she studied for about five weeks with Edith Heath in San Francisco. In the late 1940s, she initiated and directed pottery instruction at both the Gordon Neighbourhood House in Vancouver's West End (fall 1947–49) and at the Art Centre workshop located in the basement of the University of British Columbia (UBC) Library (January 1949–52) where she was assisted by Hilda Ross. In 1949, she was instrumental in arranging an exhibition of pottery from the Association of San Francisco Potters shown at the UBC Imperial Order of the Daughters of the Empire Gallery and was on the organizing committee for the *Design for Living* exhibition (Vancouver Art Gallery, 1949). In 1951, she played a large role in bringing Edith Heath to teach at the UBC Extension Department summer workshops (1951, 1952), which focused on clay, glazes and wheel throwing. That same year she headed the selection committee for the *Ceramics, Textiles and Furniture* exhibition at the Vancouver Art Gallery. From the fall of 1950 to at least the late 1970s, she operated the shop Mollie Carter Contemporary Design in Vancouver's university district, where she sold Heath ware, Peter Cotton furniture, local craft and imported household goods. In the mid-1950s, Carter focused on her retail business.

NOTABLE EXHIBITIONS (POTTERY)
· Canadian National Exhibition, Toronto, ON, 1940
· Canadian Handicrafts Guild, Montréal, QC, 1940
· *The National Ceramics Exhibition* (touring), 1941
· BC Artists Annual Exhibitions, Vancouver Art Gallery, Vancouver, BC, 1943–49
· *34th Annual Exhibition: B.C. Society of Fine Arts*, Vancouver Art Gallery, Vancouver, BC, 1944

- *Design for Living*, Vancouver Art Gallery, Vancouver, BC, 1949
- *2nd Annual BC Ceramics, Textiles, and Furniture*, Vancouver Art Gallery, Vancouver, BC, 1952

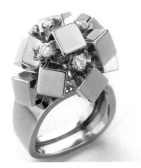

TONY CAVELTI
b. 1931, Ilanz, Switzerland;
lives in West Vancouver, BC

Toni Cavelti apprenticed with Richard Bolli in St. Gallen, Switzerland in 1946, which also included lessons in drawing and art history. Following his training, he set off to pursue a career at an atelier servicing the watch and jewellery trade in Geneva, Switzerland, in 1951. In 1954 Cavelti immigrated to Vancouver, BC. He soon befriended Karl Stittgen and set up a shop within Stittgen's watch store in West Vancouver. Upstairs from Cavelti's workspace, curator Alvin Balkind and architect Abraham Rogatnick had just opened the New Design Gallery—Vancouver's first independent gallery for modern art. The New Design Gallery was where Cavelti would encounter the emerging modern artists and architects of the period, including Gordon Smith, Toni Onley and Jack Shadbolt, whose work greatly influenced his approach to jewellery design. He was also shaped by his ongoing collaboration with jeweller and carver Bill Reid and the two briefly shared a studio space together in 1962. Reid encouraged Cavelti to pursue a more abstract and conceptual approach. After 1957 Cavelti moved his store from West Vancouver to various locations in downtown Vancouver including a Peter Cotton designed store on Seymour Street

(c. 1963) as well as a second branch in the Oakridge shopping centre in the 1970s. Cavelti was best known for his innovative abstract forms, often influenced by modernist art and architecture (such as architect Arthur Erickson's use of raw concrete, Erickson's Simon Fraser University buildings and the new Vancouver Public Library which opened in 1957 on Burrard St. close to Cavelti's salon) featuring small diamonds mounted on delicate gold-wire frameworks of overlapping triangles, zigzag shapes and grids. He received international recognition for his inventive work when he was awarded a Diamonds International Award in 1957.

NOTABLE EXHIBITIONS
- UBC Fine Arts Gallery, Vancouver, BC, 1957

MARY CHANG
b. 1927, Nanaimo, BC
d. 2015, Vancouver, BC

Mary Chang was a member of the Fashion Designers Association of BC (est. c. 1958), a designer's group, which held non-competitive fashion shows in conjunction with the Fashion Manufacturer's Association (also known as the BC Needle Trades Association). She was well-known for her capsule clothing, where one garment converted easily into two or more outfits—a practical design concept for the jet age. In 1965, Chang's clothing was included in a touring show highlighting Canadian-designed fashion that appeared in Nassau (Bahamas), New York and Canada. In 1968, Chang participated in *Artists in Fashion* at the Burnaby Art Gallery. This exhibition resulted from a Canada Council grant Chang received to produce clothes that turned a woman into an art object. She designed and produced the clothing and then asked well-known fabric artists to enrich them. In 1969 and 1972, Chang participated in two other Burnaby Art Gallery exhibitions featuring fashion as art: clothing made from Barbara Lambert's fabric (1969) and fashions made from the Finnish fabric manufacturers Marimekko

and Vuokko and shown in *Body and Soul* (1972).

NOTABLE EXHIBITIONS
- *Art in Fashion*, Burnaby Art Gallery, Burnaby, BC, 1968
- Burnaby Art Gallery, Burnaby, BC, 1969
- *Body and Soul*, Burnaby, BC, 1972

MADELEINE CHISHOLM
b. 1934, Halifax, NS;
lives in West Vancouver, BC

Madeleine Chisholm graduated from Dalhousie University with a BSc in science and mathematics. Between 1970 and 1974, she took courses in batik, dyeing and weaving at Handcraft House, North Vancouver, where she taught between 1974 and 1978 and later also elsewhere in British Columbia and Alberta. Her hangings feature geometric designs—knotted in sisal or woven or knitted in wool or rayon chenille—which are hand-dyed in bright colours. These designs, techniques and materials can be seen in some of her early Vancouver commissions: knotted sisal hangings for a law office in Bentall Centre (1972) and for the executive offices of Dominion Construction (c. 1975), and a knitted chenille hanging for BC Tel (1977). She won several awards, among them first prizes for ikat weaving at the *16th Exhibition of Canadian Handweaving* (1973) and in the North American weaving competition organized by *Woman's Day* magazine (1976). Her work is in the Chalmers Collection and at the Department of External Affairs in Ottawa.

NOTABLE EXHIBITIONS
- Community Arts Council, Vancouver, BC, 1972
- *British Columbia Craft*, Simon Fraser University, Burnaby, BC, 1972
- *Wool Gathering '73*, Canadian Guild of Crafts, Montréal, QC, 1973
- *Tapestry Canada*, Royal Centre Mall, Vancouver, BC, 1974
- *Tapestry 74*, Mido Gallery, Vancouver, BC, 1974
- *3-D Hangings*, Canadian Guild of Crafts, Montréal, QC, 1974

- *Faces of Canada*, Canadian Guild of Crafts, Montréal, QC, 1976 (award)
- *Metiers d'Art* 2, Canadian Cultural Centre, Paris, France, 1976
- Presentation House, North Vancouver, BC, 1976
- Spectrum Canada, Olympic Games, Montréal, QC, 1976
- *Fibre Works Americas and Japan*, Museum of Art, Kyoto, Japan, 1977; Tokyo, Japan, 1977–78

STAN & JEAN CLARKE
Stan Clarke:
b. 1914, Fort William, ON
d. 2010, Vancouver, BC
Jean Clarke (née McIntyre):
b. 1915, Nanton, AB
d. c. 1995, Vancouver, BC

Largely self-taught, Stan Clarke started making pottery around 1948 with his partner (and later wife), Jean McIntyre. They started using the name Reagh Studio in 1950. Between 1952 and 1956 they ran Reagh Studios, a store-workshop at 3529 West 41st Street in Vancouver, moving in late 1955 to a location at 1573 West 6th Avenue for about one year. Starting in late 1954, Reagh Studios also sold supplies (clay, kilns, enamelling supplies) to the growing hobby market. In 1956, the Clarkes sold their business to Ruth Meechan (RM Potteries). Reagh Studios produced slip-cast, hand-moulded and thrown work, often with figurative decoration by Jean. Around 1957, the couple moved to Surrey, with Stan fo-

cusing on pottery, including reduction-fired ware, and Jean on ceramic sculpture. Starting in the late 1950s, Stan Clarke taught pottery at the University of British Columbia for about eleven years, mostly through the Department of Education, and presented talks, demonstrations and seminars, including the Malaspina Ceramic Seminars in Nanaimo, BC (1971, 1974). In 1958, he was president of the BC Potters Guild and studied pottery in Britain, where he spent time with Bernard Leach. Clarke also did jewellery, enamel work, glass blowing and wood turning.

NOTABLE EXHIBITIONS (INCLUDES POTTERY BY REAGH STUDIOS; STAN CLARKE; *STAN CLARKE WITH JEAN CLARKE)
- Canadian National Exhibition, Toronto, ON, 1951
- *Ceramics, Textiles, and Furniture*, Vancouver Art Gallery, Vancouver, BC, 1951, 1952
- *Northwest Craftsmen's Exhibition*, Henry Art Gallery, Seattle, WA, 1952
- New Design Gallery, West Vancouver, BC, 1956
- *Canadian Ceramics Biennial*, 1957, 1959, 1961, 1963
- *Centennial Crafts Caravan* (touring), 1958
- Contemporary Ceramics (Ceramic International), Ostend, Belgium, 1959
- *2nd Biennial Crafts Exhibition*, Vancouver Art Gallery, Vancouver, BC, 1959
- *BC Crafts*, Vancouver Art Gallery, Vancouver, BC, 1961
- Canadian Guild of Potters, Toronto, ON, 1963*
- *Canadian Fine Crafts 1966/67*, National Gallery of Canada, Ottawa, ON, 1966–67
- Canadian Guild of Crafts, Montréal, QC, 1967
- *British Columbia Craft*, Simon Fraser University, Burnaby, BC, 1972

JOHN & BETTY CLAZIE
John Clazie:
b. 1928, Windsor, ON
d. 2019, Victoria, BC
Betty Clazie:
b. 1929, Windsor, ON
d. 2015, Victoria, BC

John and Betty Clazie moved to Vancouver from Windsor in 1954. Soon after arrival, they started producing biomorphic-shaped ceramic jewellery, using home-built equipment. To learn more about clays and glazes, Betty took courses at the University of British Columbia Ceramic Hut, with Thomas Kakinuma (evenings) and with Hilda Ross (summer of 1962). In the early 1950s, while a business student in Chicago, John also took a course in jewellery making. Starting in 1954, he began creating Picasso-inspired jewellery, which was illustrated in *Western Homes and Living* magazine in Dec/Jan 1954–55. From the mid-1950s to the 70s, John also produced jewellery in silver (sheet and wire), ebony, plastic, pearls and rough-cast silver and bronze, which he sold through the New Design Gallery and Charlotte Kennedy Interiors in West Vancouver, BC (in the 50s), the Quest in British Columbia and Alberta, and at the Art Gallery of Ontario in Toronto.

NOTABLE EXHIBITIONS
- *BC Arts Today*, Art Gallery of Greater Victoria, Victoria, BC, 1956
- New Design Gallery, West Vancouver, BC, 1956

- Jewellery, Print Gallery, Victoria, BC, 1969 (with stitchery by Carole Sabiston)
- Open Space, Victoria, BC, 1970

COLUMBIA FURNITURE
(c. 1940s–1948, Vancouver, BC)

Columbia Furniture was a small Vancouver firm making veneered tables with moulded-plywood legs in the late 1940s. Their factory, located at 212 East 17th Avenue, was damaged in a fire in December 1948 and never reopened.

PETER COTTON
b. 1918, Merritt, BC
d. 1978, Victoria, BC

Peter Cotton studied architecture—which included industrial design—at the University of British Columbia (UBC) between 1947 and 1955. Between 1948 and 1953, he designed modernist furniture using steel rod and angle iron, among the first of that type in Canada. In 1952, he took about a three-year break from studies to market his furniture through his own company, Perpetua Furniture Ltd., and through Mollie Carter Contemporary Design and Charlotte Kennedy Interiors (both in Vancouver) and Morgan's department store in Eastern Canada. As a result of his furniture being shown at the Design Centre in Ottawa, in 1953 his spring-back chairs were specified for the Wymilwood building at the University of Toronto.

Three of Cotton's designs won NIDC Design Awards in 1953: the Highback armchair, the Lowback settee and Lowback armchair—

the latter two in collaboration with Alfred Staples. Several designs were registered in the Design Index: round table (1950), desk (1952), storage unit (1952), Armchair No. A3 MK II (1953), Delhaye End Table (1953), spring-back dining chair (1951), glass-topped coffee table (1950–51) and Tripod Lamp (1950–51). Cotton's work was widely publicized in *Canadian Art, Western Homes and Living* and *Canadian Homes and Gardens* magazines in the early 1950s and was shown in Italy. Cotton also designed display fixtures for both the Vancouver Art Gallery and the UBC Fine Arts gallery in the 1950s, and store fixtures for the Quest stores in Banff, AB, and Victoria, BC, and for Toni Cavelti's Vancouver shop in the early 60s. Cotton was also an amateur potter who taught elementary pottery at Gordon Neighbourhood House in Vancouver's West End neighbourhood with Hilda Ross and Mollie Carter in 1949.

NOTABLE EXHIBITIONS
- *Ceramics, Textiles, and Furniture,* Vancouver Art Gallery, Vancouver, BC, 1951, 1952
- Design Centre, Ottawa, ON, c. 1953
- Milan Triennial, Milan, Italy, 1954

CRANE FURNITURE LTD.
1945–50, Vancouver, BC

Crane Furniture Ltd. was in existence between 1945 and 1950, with a woodworking plant located at 900 Odlum Drive in Vancouver. There they made moulded-plywood dinette suites, which were sold at the Hudson's Bay department store in 1947.

DOUG CRANMER (KESU')
b. 1927, 'Yalis, BC
d. 2006, 'Yalis, BC

Doug Cranmer was a Kwagu'ł artist who was initially self-taught. He began working in the fishing and logging industries at a time when the Potlatch ban made working full-time as a carver difficult. He received his first formal training in Victoria with famed master carver Chief Nakapankam (Mungo Martin) in the 1950s. Around this

time, he also met Bill Reid, who invited him to assist with the building of his Haida village project (1958–62) at the University of British Columbia's Museum of Anthropology. Together they also worked on the restoration of totem poles in Stanley Park in Vancouver. In 1962, along with A.J. Scow and Dick Bird, Cranmer founded the Talking Stick Gallery on Granville Street in Vancouver, one of the first commercial and retail galleries operated by Indigenous people and dedicated to Indigenous art. Though best known as an innovative carver, Cranmer was also a painter and printmaker. Alongside his artistic pursuits, Cranmer was an influential teacher. He taught design and carving at the Gitanmaax School of Northwest Coast Indian Art in 'Ksan, BC (1970), at the Vancouver Museum and at a studio in Alert Bay following his return in 1977. Cranmer was integral to the construction of the U'mista Cultural Centre and the Bighouse in Alert Bay.

NOTABLE EXHIBITIONS
- *Arts of the Raven*, Vancouver Art Gallery, Vancouver, BC, 1967
- BC Pavilion, Expo 70, Osaka, Japan, 1970

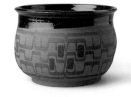

JUDITH CRANMER
b. 1935, Vancouver, BC
d. 2007, Vancouver, BC

Judy Cranmer trained at the Vancouver School of Art, graduating with honours in 1956. After graduating, she freelanced in silkscreen printing and fabric design for two years. From 1958 to 1961, Cranmer travelled around Europe, where she developed an interest in Northwest Coast Indigenous design after seeing work in European collections. Upon her return to Canada,

Cranmer met and married Kwakwaka'wakw artist Doug Cranmer, who was involved in the Vancouver art scene through his Talking Stick Gallery. Judy developed her own pottery and graphic design practice, which was heavily influenced by Northwest Coast design elements. Cranmer's work adapted traditional Northwest Coast designs taken from ceremonial feast dishes, bowls, bentwood boxes and blankets and used them as decorative elements on her pottery pieces.

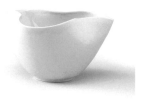

CROWN CERAMICS
1951–57, Vancouver, BC
Victor Fabri, operator:
b. 1910, Rome, Italy
d. 1975, Vancouver, BC

Crown Ceramics was located at 523 West 7th Avenue in Vancouver, where it produced slip-cast ceramic giftware for the retail market, which included Eaton's, Mc & Mc, and Ogilvy's. The company was operated by Victor Fabri, son of well-known Vancouver sculptor Alimando Fabri, who until the late 1940s produced "art ware" and architectural sculptures at Western Arts, located at 2300 Granville Street. Fabri likely learned casting from his father.

FLORENCE DWINNELL DANIELS
b. 1900, Fitchburg, MA
d. 1975, Victoria, BC

Florence Daniels studied weaving at the School of Applied Arts in Boston and at the Art Institute of Chicago. By the late 1940s, she was well-known in Chicago as a traditional weaver working in linen, cotton and wool. She made closely woven guest towels, placemats and table runners decorated with the Spanish stitch and was considered a foremost authority on coverlets. By the late 1940s, she had taught weaving at the Pine Mountain Settlement School, the Little Loomhouse and Berea College (all in Kentucky), the Oakdale women's reformatory (Dwight, IL) and the famed Hull House (Chicago). Daniels was on the jury of the *Contemporary Weavers of America* exhibition, which toured the United States in 1946. She came to Victoria in the early 1950s and established herself as an important weaving instructor, teaching night school at the Art Gallery of Greater Victoria and from her studio in Oak Bay, BC.

ROBERT DAVIDSON (GUUD SAN GLANS)
b. 1946, Hydaburg, AK;
lives in White Rock and Haida Gwaii

Robert Davidson is a Haida carver, sculptor, jeweller, printmaker and painter. He was born in Alaska but raised in Masset, Haida Gwaii. Davidson's great-grandfather was renowned Haida carver Charles Edenshaw and his grandmother was Florence Davidson, a respected basket weaver, button-blanket maker and important Haida language and culture consultant. Following in the family tradition, Davidson learned to carve at the age of thirteen from his father, Claude Davidson, and his grandfather Robert Davidson Sr. In 1965, he moved from Masset to Vancouver to attend high school. In Vancouver, Davidson studied great works of art from the Haida Nation through visits to the Vancouver Museum. In 1966, he gave a carving demonstration at Eaton's department store, where he met the artist Bill Reid. Reid would mentor Davidson as he worked in Reid's studio on his own projects over the course of eighteen months. In 1967, Davidson enrolled in the Vancouver School of Art (VSA), where he developed his drawing and screenprinting skills. In 1969, at the age of twenty-two, Davidson carved a forty-foot totem pole, the first to be raised in his hometown of Masset since the 1870s. The same year, Davidson attended an extension course in jewellery making at the VSA. Davidson received numerous commissions for totem poles and other works nationally and internationally including Montréal (1970), Dublin, Ireland (1970), and Tokyo, Japan (1980). In 1968, he taught carving at the Gitanmaax School of Northwest Coast Indian Art in 'Ksan, BC. He was the Canadian delegate to the World's Craft Council Convention in Dublin, Ireland, in 1970.

NOTABLE EXHIBITIONS
· *Arts of the Raven*, Vancouver Art Gallery, Vancouver, BC, 1967
· *Man and His World*, Montréal, QC, 1970
· Solo exhibition, Museum of Vancouver, Vancouver, BC, 1971
· *Legacy: Contemporary BC Indian Art* (touring), BC Provincial Museum, Victoria, BC, 1971

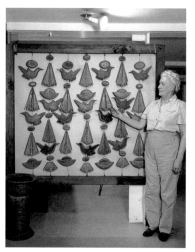

OLEA DAVIS
b. 1899, Buffalo, NY
d. 1977, Vancouver, BC

Olea Davis studied art at the Ontario College of Art in Toronto, L'École des Beaux-Arts in Montréal, Vancouver School of Art and University of British Columbia (UBC) in Vancouver. In the early 1950s, she was instrumental in establishing the pottery program at the Ceramic Hut at UBC, where she taught for more than a decade. She was one of the driving forces behind the

formation of the BC Potters Guild in 1955 and served as its first president, a position she would hold again in subsequent years. As western vice president of the Canadian Guild of Potters (1955–64), Davis promoted BC pottery and kept local potters aware of opportunities outside the province. Between 1955 and 1963, she regularly wrote a report on the activities of the BC Potters Guild for the trade journals *Clay Products News* and *Ceramic Record*. In 1951, she studied clays and glazes with Edith Heath during UBC's summer session and co-authored a report on BC clays with Hilda Ross in 1958.

NOTABLE EXHIBITIONS

· BC Potters Annuals, 1953–60
· Canadian Ceramics Biennial, 1955, 1957 (award), 1959, 1961, 1963, 1967
· *BC Arts Today*, Art Gallery of Greater Victoria, Victoria, BC, 1956
· *First National Fine Crafts*, National Gallery of Canada, Ottawa, ON, 1957
· Brussels World's Fair, Brussels, Belgium, 1958
· *Centennial Crafts Caravan* (touring), 1958
· *Fine Crafts Here and Now*, Canadian Handicrafts Guild, Montréal, QC, 1958 (award)
· Contemporary Ceramics (Ceramic International), Ostend, Belgium, 1959
· *Ceramic National Exhibition*, Syracuse, NY, 1960, 1962
· *BC Crafts*, Vancouver Art Gallery, Vancouver, BC, 1961
· *Eighth International Exhibition of Ceramic Art*, Smithsonian, Washington, DC, 1961
· *36th Annual Arts and Crafts*, Florence, Italy, 1962
· *BC Craftsmen '64*, Vancouver Art Gallery, Vancouver, BC, 1964
· *Canadian Fine Crafts 1966/67*, National Gallery of Canada, Ottawa, ON, 1966–67
· *Canadian Fine Crafts*, Expo 67, Montréal, QC, 1967

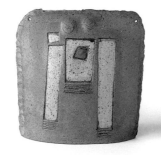

WALTER DEXTER
b. 1931, Calgary, AB
d. 2015, Victoria, BC

Walter Dexter graduated with a diploma in ceramics from the Provincial Institute of Technology and Art, Calgary, in 1954. He spent the next year at the Swedish School of Arts and Crafts, Stockholm, on a University of Manitoba scholarship, followed by a year of travel in Europe. He was a production potter at Lindoe Studios/Ceramic Arts in Calgary (1956–59), where he also experimented with raku; taught with the Visual Arts Branch (1959) and the Edmonton Potters' Guild (1959–60); and managed Sunburst Ceramics (early 1960s). Between 1963 and 1967, he operated a studio in Kelowna, BC, and taught at the Okanagan Summer School of the Arts in 1963 and 1964. In 1967, he started teaching at the Kootenay School of the Arts (KSA) in Nelson, BC, taking over from Santo Mignosa, who was on study leave in Europe. At KSA, Dexter headed the ceramics program (1967–73) and rediscovered raku through Hal Riegger's workshops at Wood Lake, BC (1969), and at Notre Dame University College, Nelson, BC (1970, 1972). In the mid-1970s, he taught pottery part-time at Langara College in Vancouver, set up his studio in Surrey, BC (c. 1974–78), and was president of the Craft Association of BC (1976–78). He moved to Victoria in 1978.

NOTABLE EXHIBITIONS

· Brussels World's Fair, Brussels, Belgium, 1958

· Canadian Ceramics Biennial, 1959, 1961 (award), 1963
· Contemporary Ceramics (Ceramic International), Ostend, Belgium, 1959 (award: silver medal)
· *Eighth International Exhibition of Ceramic Art*, Smithsonian, Washington, DC, 1961
· *Ceramic International*, Prague, Czechoslovakia, 1962 (award: silver medal)
· *Canadian Fine Crafts*, Expo 67, Montréal, QC, 1967
· *Craft Dimensions Canada*, Royal Ontario Museum, Toronto, ON, 1969
· Handcraft House, North Vancouver, BC, 1969
· International Competitions, Faenza, Italy, 1969, 1970
· *British Columbia Craft*, Simon Fraser University, Burnaby, BC, 1972
· *Ceramics International*, Calgary, AB, 1973
· House of Ceramics, Vancouver, BC, 1974, 1975

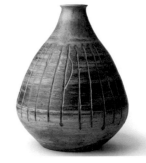

REGINALD LEONARD DIXON
b. 1911, Buenos Aires, Argentina
d. 1996, Mission, BC

Reg Dixon was known mainly as a pottery teacher. Mollie Carter mentioned that she had taken private lessons from him around 1940 and that he had studied with Bernard Leach. In 1951, he worked as a partner with David Lambert at Lambert Potteries. From 1952 to 1958, he was the pottery instructor at the Vancouver School of Art. In the summer of 1955, Dixon gave pottery demonstrations in the Okanagan, travelling in a station

wagon that carried a wheel, kiln, clay, glazes and samples of pottery made from clays he found along the way. In 1958, he was commissioned to make coloured clay pots, which were inserted into a wall of the Imperial Bank of Canada building located in Vancouver's Marpole district.

NOTABLE EXHIBITIONS
· *Ceramics, Textiles, and Furniture,* Vancouver Art Gallery, Vancouver, BC, 1951
· BC Potters Annuals, 1954, 1956 (award), 1957

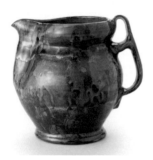

AXEL EBRING
b. 1874, Uppsala, Sweden
d. 1954, Vernon, BC

While wheel-thrown pottery was made by amateurs in Summerland and Victoria in 1923, Axel Ebring is acknowledged to be the first professional studio potter in British Columbia. In the late 1800s, Ebring had immigrated to North America and pursued logging, mining and railway work, bringing with him the pottery skills he learned in Sweden from his father and grandfather. He set up his first pottery near Notch Hill, BC, in the mid-1920s and ten years later, when clay ran out, moved to the Vernon area, purchasing an old brickyard property with a high-quality clay. There he established his second pottery, making functional earthenware on a kick wheel, which he glazed with local materials and fired in a wood-fired kiln. He sold these pieces directly to the many tourists who stopped at his workshop. Mollie Carter and other aspiring young potters from Vancouver are known to have

visited Ebring in the late 1940s before he stopped production around 1950. While he seldom exhibited his work, Ebring was featured in the *Canadian Geographical Journal* (Feb 1944).

NOTABLE EXHIBITIONS
· BC Pottery exhibition, Provincial Library, Victoria, BC, 1945
· Vernon-Okanagan Industrial Expositions, Vernon, BC, 1948, 1949

VEE ELDER
b. 1910, Crumpsall, England
d. 2001, North Vancouver, BC

Vee Elder enrolled in the London School of Weaving (1948) and later at the Hammersmith School of Building and Arts and Crafts (c. 1950). There she studied with Peter Collingwood, whose rug designs influenced her work. She was also influenced by the Swedish weaver Malin Selander, with whom she studied in Banff, AB. Prior to coming to Canada in 1962, Elder taught crafts in a New York rehabilitation hospital, won an award at the New York State Fair (Binghamton, NY, 1960) and exhibited her work in a travelling exhibition of American crafts. In Vancouver she exhibited locally, also giving weaving demonstrations and serving on juries. In 1970, she was commissioned by the BC Department of Public Works to weave a forty-by-twelve-foot tapestry for the new BC Vocational School in Terrace, BC. Geometrical in design, it was made in three-foot-wide sections of linen and wool, dyed by the weaver in purple, cerise and shades of yellow and orange with gold.

NOTABLE EXHIBITIONS
· New Design Gallery, Vancouver, BC, 1963
· *Canadian Fine Crafts 1966/67,* National Gallery of Canada, Ottawa, ON, 1966–67
· *Western Crafts 1967,* Western Canada Art Circuit, 1967

GATHIE FALK
b. 1928, Alexander, MB;
lives in Vancouver, BC

Between 1954 and 1965, Gathie Falk worked as an elementary school teacher in Burnaby, BC. During that time, she also developed an interest in painting, taking summer and evening courses in Victoria, at the University of British Columbia (UBC) and at the Vancouver School of Art, and began exhibiting her work locally. Starting in 1964, she studied ceramics with Glenn Lewis at the UBC Faculty of Education, and for the next few years produced pottery with Charmian Johnson and in her own studio equipped with a gas-fired kiln. In 1967, Falk exhibited about three hundred pieces of her work at the Canvas Shack Gallery in Vancouver. As reported in the *Province* (March 23, 1967), many of the pieces were partially glazed, leaving the clay partly exposed. Around the same time, she made a transition to ceramic sculpture, producing everyday objects in the manner of the Funk movement that emerged in the 1960s as a reaction to modernism. She would exhibit these at the Vancouver Art Gallery beginning in 1968.

NOTABLE EXHIBITIONS (POTTERY)
· Canadian Ceramics Biennial, 1967
· Canvas Shack Gallery, Vancouver, BC, 1967
· *Invitation I* (touring), Canadian Guild of Potters, Toronto, ON, 1968–69
· *Teapots,* Vancouver Art Gallery, Vancouver, BC, 1968

LYNDA GAMMON (NÉE POWELL)
b. 1949, Port Alberni, BC;
lives in Victoria, BC

Lynda Gammon studied in Vancouver at the Vancouver School of Art (c. 1968), Uni-

versity of British Columbia (c. early 70s) and graduated with her BA from Simon Fraser University (1978). She obtained her MFA from York University, Toronto (1982). Gammon began her artistic career in textile arts and taught at Handcraft House, North Vancouver, BC (1967–77), and at Fraser Valley College, Abbotsford, BC (1978–81). During these years, she exhibited frequently with potters and textile artists at Handcraft House and elsewhere. In 1982, Gammon's practice shifted to sculpture and photography. She was a professor of visual arts at University of Victoria for over thirty years and the recipient of numerous BC Arts and Canada Council grants, also exhibiting nationally and internationally.

NOTABLE EXHIBITIONS (TEXTILES)

· Community Arts Council Gallery, Vancouver, BC, c. early 1970s
· Festival of Canada, Robertson Art Centre, Binghamton, NY, c. early 1970s
· *British Columbia Craft*, Simon Fraser University, Burnaby, BC, 1972
· Mido Gallery, Vancouver, BC, 1972, 1973, 1974
· *Wool Gathering '73*, Canadian Guild of Crafts, Montréal, QC, 1973
· *Textiles into 3-D* (touring), Art Gallery of Ontario, Toronto, ON, 1973–74
· *Tapestry Canada*, Royal Centre, Vancouver, BC, 1974
· Presentation House, North Vancouver, BC, 1976

HILDE GERSON
b. 1913, Wuppertal-Elberfeld, Germany
d. 1998, Vancouver, BC
In the 1960s and 70s, Hilde Gerson developed an interest in weaving and often worked in collaboration with her husband, the West Vancouver architect Wolfgang Gerson, integrating her woven wall hangings and rugs into his architectural interiors. Typically he would provide a very rough sketch, which she would then transform into her woven designs. The Gerson home of 1958 featured several of her wall hangings, including woven drapes featuring an abstract sunset for a large window in the living room. Her pieces were of an abstracted design in the deep blues, orange, yellow and reds, also used elsewhere in the interior of the house. The second Gerson home of 1977 had a weaving studio as well as architectural settings designed specifically to display her colourful wall hangings: stair walls that showcased her tapestries, a focal fireplace that featured a wall hanging and movable wall partitions for which she made the woven panels.

NOTABLE EXHIBITIONS

· New Design Gallery, Vancouver, BC, 1963
· *Canadian Fine Crafts 1966/67*, National Gallery of Canada, Ottawa, ON, 1966–67
· Unitarian Church, Vancouver, BC, 1970

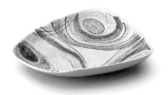

HERTA GERZ
b. 1913, Hanau, Germany
d. 2005, Vancouver, BC
Herta Gerz studied at the Städel Art Institute, Frankfurt (1930), and at the Keramische Fachschule near Colditz, Germany (1930–33), later working at several factories in Germany. She and her husband, Walter Gerz, a ceramic engineer, operated their own business in Gelnhausen, Germany, between 1946 and 1951. The couple was recruited in Germany to work at the newly formed BC Ceramics in Vancouver—Herta as art director, Walter as ceramic engineer—arriving there in the early 1950s. Herta Gerz's work at BC Ceramics included making cast animal figurines, vases and other giftware items in a variety of decors, including Indigenous motifs, local flora and abstract designs, often with matte glazes. She also produced wheel-thrown items and production ware with experimental glazes developed by Walter.

SOPHIE LOCKE GIBSON
b. unknown
d. unknown
Sophie Locke Gibson made handwoven items for sale in Vancouver craft stores in the 1950s. She was a member of the cooperative crafts store Creative Hands on Clyde Avenue in West Vancouver, which specialized in handmade items for sale.

PENNY GOULDSTONE
b. 1919, Manchester, England
d. 1997, Vancouver, BC
Penny Gouldstone studied at the Manchester Regional College of Art, Salford School of Art before coming to Canada in 1953. In 1965, she studied at Dartington in England with textile-printing specialist Susan Bosence. In the 1960s and 70s, Gouldstone taught in the art department of the Faculty of Education at the University of British Columbia and was considered an expert in tie-dye fabric printing. She often served on juries for craft exhibitions and fairs.

NOTABLE EXHIBITIONS

· *Batiks*, Canvas Shack Gallery, Vancouver, BC, 1966
· *Canadian Fine Crafts 1966/67*, National Gallery of Canada, Ottawa, ON, 1966–67
· *Canadian Fine Crafts*, Expo 67, Montréal, QC, 1967
· University of British Columbia Fine Arts Gallery, Vancouver, BC, 1969

JAN & HELGA GROVE

Jan Grove:
b. 1930 Hamburg, Germany
d. 2018, Victoria, BC
Helga Grove (Née Schmidt)**:**
b. 1927 Stettin, Germany
d. 2018, Victoria, BC

Jan Grove studied pottery and sculpture with his parents at the Grove studio in Lubeck, Germany (1948–51). To complete his seven-year training, he also worked at the Marschner and Gutenhalde ceramic studios in Germany prior to becoming a master potter in 1957. Between 1957 and 1960, he and Helga Grove ran his parents' studio, also exhibiting extensively in Northern Germany. Helga studied at the Grove studio (1946–49) and took drawing with former Bauhaus master Georg Muche at the School for Textile Design in Krefeld, Germany (1950–52). In the 1950s, she was a designer of decoration at the Marschner and Gutenhalde studios in Germany and worked with Jan in the late 1950s. From 1960 to 1965, Jan Grove was an instructor and later head of ceramics at the School of Applied Fine Arts in Istanbul, Turkey. In 1965, the couple immigrated to Canada and established their studio near Victoria, where they made functional ware, studio pottery and large ceramic sculptures (1966–2008). Jan specialized in throwing and glazes, while Helga produced items with sgraffito, incised surfaces and painted geometric designs. Between 1966 and 1968, Jan taught ceramics at the University of Victoria. He later taught at his studio, at the Malaspina

Ceramic Seminars (Nanaimo, BC) and with the Outreach program at the Emily Carr College of Art and Design (Vancouver, 1980–1994).

NOTABLE EXHIBITIONS

JAN AND HELGA GROVE

· *Jan and Helga Grove Pottery*, Art Gallery of Greater Victoria, Victoria, BC, 1966
· Bau-Xi Gallery, Vancouver, BC, 1969
· *British Columbia Craft*, Simon Fraser University, Burnaby, BC, 1972
· *Jan and Helga Grove: Canadian Guild of Potters,* Toronto, ON, 1972

JAN GROVE

· *Canadian Fine Crafts 1966/67*, National Gallery of Canada, Ottawa, ON, 1966–67
· Canadian Ceramics Biennial, 1967, 1969
· *Canadian Fine Crafts,* Expo 67, Montréal, QC, 1967
· *Western Crafts 1967,* Western Canada Art Circuit, 1967
· Department of External Affairs and the Canada Council, Ottawa, ON (touring, Europe), 1968–69
· *Craft Dimensions Canada,* Royal Ontario Museum, Toronto, ON, 1969

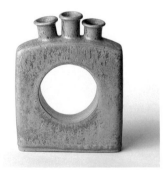

KATHLEEN HAMILTON
b. 1931, Vancouver, BC
d. 2014, Chilliwack, BC

Kathleen Hamilton graduated from the Vancouver School of Art (honours) in 1954. From c. 1955 to 1967, Hamilton was a prolific painter and printmaker showing work locally in public and private galleries, sometimes as a member of the Granville Group. At the beginning of her career, she

was included in the touring exhibition *Young Canadian Contemporaries* (London Art Gallery, ON, 1955). In the late 1960s, she began a career in pottery, studying with Kay Dodd and Barbara Baanders at the Ross-Huyghe School of Pottery, Vancouver. She specialized in hand-built work, which allowed her the freedom to explore diverse forms. During the 1970s, she taught pottery at the Burnaby Arts Centre and at Fraser Valley College, Abbotsford, BC.

NOTABLE EXHIBITIONS (POTTERY)

· Federation of Canadian Artists, Vancouver Centennial Museum, Vancouver, BC, 1969
· Community Arts Council, Vancouver, BC, 1971
· *British Columbia Craft*, Simon Fraser University, Burnaby, BC, 1972
· House of Ceramics, Vancouver, BC, 1972, 1973, 1974, 1977
· *BC Ceramics 75,* House of Ceramics, Vancouver, BC, 1975
· *Ceramics 76,* Centennial Museum, Vancouver, BC, 1976

MARJORIE HAMILTON
b. 1911
d. unknown

In 1945, with the help of her husband, William, Marjorie Hamilton started making lingerie as a hobby in her Vancouver apartment. By 1952, the company Marjorie Hamilton Ltd. had thirty-two employees with an annual payroll of $50,000. This kind of rapid growth in fashion manufacturing was not uncommon in Vancouver in the late 1940s. Two years later, Hamilton's company was considered one of the most important lingerie manufacturers in the country, also selling in Los Angeles. By 1964, the company had one hundred employees and had switched from lingerie to affordable casual wear.

HAMMOND FURNITURE CO. LTD.
1899–1951, Vancouver, BC

Hammond Furniture was founded in 1899 by E.W. Hammond. The company grew to be the largest furniture producer in the province, with about two hundred employees. It also had a plywood plant, logging operations and a mattress factory. From the late 1930s to 1951, the company manufactured bedroom suites consisting of dressers and chests of drawers with rounded fronts in the Waterfall Modern style, which it sold locally and in the Prairies. In 1945, the company opened a large three-storey Moderne factory located at Clarke Drive and Venables Street in Vancouver. It wasn't used for long, because the company ceased operations in 1951, largely on account of labour unrest, high wages and prohibitive shipping costs to eastern markets.

FRANCES HATFIELD
b. 1924, Kelowna, BC
d. 2014, Vernon, BC

Frances Hatfield attended the Ontario College of Art, Toronto, in the late 1940s, where she studied pottery and apprenticed with Kjeld and Erica Deichmann in New Brunswick. In the 1950s, she was a weaver, exhibiting in the *Centennial Crafts Caravan,* which toured British Columbia in 1958. In 1962, Hatfield graduated from the Vancouver School of Art in ceramics, and the following year was the only Canadian chosen to attend Shoji Hamada's summer workshop at San Jose State College in California. She moved to the Kelowna, BC, area in 1965 and to nearby Wood Lake, BC, around 1968. She attended the Paul Soldner raku workshop in Seattle, WA (1967), and hosted a Hal Riegger raku workshop at her

Wood Lake property (Aug 1969). She was well-known as a teacher: at the Paddock School of Fine Arts (Lake Okanagan, BC), Okanagan Summer School of the Arts (Penticton, BC), Notre Dame University College (Nelson, BC) and the Kootenay School of Art (Nelson, BC). In the late 1960s, Hatfield explored and taught raku. Hatfield served on the jury of *Ceramics 76* (Potters Guild of BC) at the Maritime Museum in Vancouver.

NOTABLE EXHIBITIONS (POTTERY)

· *BC Craftsmen '64,* Vancouver Art Gallery, Vancouver, BC, 1964
· *Canadian Fine Crafts 1966/67,* National Gallery of Canada, Ottawa, ON, 1966–67
· Canadian Ceramics Biennial, 1967, 1969, 1971
· *Western Crafts 1967,* Western Canada Art Circuit, 1967
· *BC Potters,* Canadian Guild of Potters, Toronto, ON, 1969
· House of Ceramics, Vancouver, BC, 1977 (with Janet MacLeod and Wayne Ngan)

FRANCISCA HAYMAN
b. 1938, Ommen, Netherlands;
lives in Victoria, BC

Francisca Hayman trained as a nurse prior to coming to Canada in 1960. In the early 1960s, she received pottery training in Victoria, with Louise Buck and Margarete Nehl-McLennan and later with Jan Grove at the University of Victoria (1967–68). She also received training in raku from Gillian Mackie. In the late 1960s and early 1970s, Hayman studied in Britain at Chelsea Pottery, Stanhope Institute, Oxford Polytechnic College and Berkshire College. In 1986, she was one of the founders of the Side Street Studio, Victoria, BC.

NOTABLE EXHIBITIONS

· Art Gallery of Greater Victoria, Victoria, BC, 1969, 1972
· Malaspina College, Nanaimo, BC, 1971
· The Potters' Wheel, Victoria, BC, 1973, 1976
· *National Ceramics Exhibition,* Glenbow Museum, Calgary, AB, 1976

MICHAEL HENRY
b. 1939, New Westminster, BC;
lives in Coquitlam, BC

Michael Henry attended the Vancouver School of Art (1957–61). While at VSA Henry studying under architect Ron Thom, Henry had his first experience with ceramics, designing and producing a ceramic mural as part of a project for the Faculty Club building at the University of British Columbia (UBC). After VSA he briefly produced prints, drawings and paintings while working as a delivery driver before leaving for England in 1963. In England Henry visited fellow art school alumni Glenn Lewis who at the time was working in Cornwall. At Leach Pottery in St. Ives, Cornwall (1963–65), Henry first worked as a clay mixer and later as an apprentice. While working at Leach Pottery Henry encountered many important potters including Michael Cardew and Gwyn Hanssen Pigott. On his return to Canada in 1965, Henry established a studio in Vancouver, BC, first in Glenn Lewis' space under the Granville Bridge on West 4th Avenue. In 1966 he bought a house on 13th Avenue with a large studio on the lane. Henry moved to Roberts Creek, BC, to set up Slug Pottery (1972–79), where he made pots and bowls in salt-glazed stoneware produced from local clays. Henry travelled in the mid-1970s working with potters in England, Denmark, Scotland and France. He also taught periodically at the Vancouver School of Art.

NOTABLE EXHIBITIONS

· Bau-Xi Gallery, Vancouver, BC, 1965
· *Canadian Fine Crafts 1966/67,* National Gallery of Canada, Ottawa, ON, 1966–67
· Canadian Ceramics Biennial, 1967, 1969 (award)

- *Canadian Fine Crafts*, Expo 67, Montréal, QC, 1967
- Canadian Guild of Potters, Toronto, ON, 1967
- Handcraft House, North Vancouver, BC, 1967, 1970
- *Western Crafts 1967*, Western Canada Art Circuit, 1967
- *Hemisfair 68*, San Antonio, TX, 1968

MANO HERENDY
b. 1923, Budapest, Hungary
d. 1978, Vancouver, BC

Mano Herendy, a Vancouver couturier, came to Canada in 1951 and started his practice in 1956. He was formerly a law student and competitive skier in Hungary and a designer of ski sweaters in Switzerland. In the late 1960s and early 70s, Herendy operated his business in a yellow Victorian house at 1380 Hornby Street near the Burrard Street Bridge in Vancouver. In 1970, he designed the hostess costumes for the BC Pavilion at Expo 70 in Osaka, Japan.

MARJORIE HILL
b. 1895, Guelph, ON
d. 1985, Victoria, BC

Marjorie Hill is well-known nationally as the second woman to graduate in architecture from a Canadian university (she was the first female architecture graduate at the University of Toronto in 1920). In Victoria, Hill was perhaps better known as a weaver and instructor with the Victoria Handweavers and Spinners Guild (1934), joining in the late 1930s. She helped establish the Victoria weaving schools instructed by the prominent American weaver Mary Meigs Atwater in 1939 and 1946. From the 1940s to the 60s, Hill gave many talks and weaving demonstrations around Victoria and was frequently in charge of the guild's standards committee. She also conducted a workshop in Regina as part of the Saskatchewan Festival of the Arts in 1962.

NOTABLE EXHIBITIONS
- Canadian National Exhibition, Toronto, ON, 1942 (award)

- Canadian Handicrafts Guild, Montréal, QC, 1950 (award)
- *Marjorie Hill*, Art Gallery of Greater Victoria, Victoria, BC, 1953
- *BC Arts Today*, Art Gallery of Greater Victoria, Victoria, BC, 1956
- *First National Fine Crafts*, National Gallery Canada, Ottawa, ON, 1957
- *Centennial Crafts Caravan* (touring), 1958

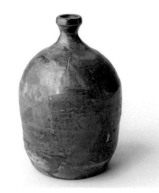

GILLIAN HODGE
b. 1928, unknown
d. 2001, Penn Valley, CA

Gillian Hodge studied art in India, in England and at the Vancouver School of Art in the mid-1960s. She taught many pottery workshops around the province including at the Okanagan Summer School of the Arts (raku, 1966; children's class, 1967), in Courtenay (1968), on Salt Spring Island (raku, 1969) and at Notre Dame University College in Nelson, BC. By the late 60s, she had ventured into raku, teaching it and also studying it with Hal Riegger. She later worked and exhibited with him in California, where she would live permanently, starting in the early 70s. In 1969, Hodge had an exhibition at the Mary Frazee Gallery, West Vancouver, where her raku was described by Charlotte Townsend (*Vancouver Sun*, Nov 19, 1969) as "free expressions of the way clay goes" and coloured in "vivid reds and ochres, an occasional surprising bright green." She was active in the BC Potters Guild as the editor of the group's newsletter, *The Western*

Potter (1969–71), and as a jury member for their exhibition *Ceramics 73* at the House of Ceramics, Vancouver.

NOTABLE EXHIBITIONS
- Canadian Ceramics Biennial, 1967, 1971
- *Teapots*, Vancouver Art Gallery, Vancouver, BC, 1968 (award)
- *BC Potters*, Canadian Guild of Potters, Toronto, ON, 1969
- Mary Frazee Gallery, Vancouver, BC, 1969
- Canadian Guild of Crafts, Canadian National Exhibition, Toronto, ON, 1971
- *28th Annual Exhibition of Ceramic Art*, Faenza, Italy, 1971 (award)
- *International Ceramics*, Victoria and Albert Museum, London, England, 1972
- *Gillian Hodge Recent Work,* House of Ceramics, Vancouver, BC, 1974

FRED HOLLINGSWORTH
b. 1917, Goldborne, England
d. 2015, Vancouver, BC

Vancouver architect Fred Hollingsworth often designed furniture, lighting and other accessories for his projects. In the early 1950s, he designed an indoor-outdoor plywood chair that appeared in several of his houses, including the Hill House (1953) and the Johnson House (c. 1953). It was similar to the Boomerang Chair designed by Richard Neutra for the Channel Heights Housing Project in Los Angeles (1942). Hollingsworth's later furniture was executed in an angular Arts and Crafts style, which reflected the aesthetics and spirit of Frank Lloyd Wright. A talented metal worker and welder, he also made light fixtures, candelabra and garden ornaments for many of his commissions. In the mid-50s, Hollingsworth also contributed designs for easy-to-make plywood projects for the home, which were published in a series of ten pamphlets for Sylvaply, the plywood division of the forest products company MacMillan Bloedel.

PHYLLIS HOLLINGSWORTH

(NÉE MONTGOMERY)

b. 1921, Wainwright, AB

d. 2018, North Vancouver, BC

Phyllis Hollingsworth moved to Ladner, BC, with her family in 1937. She worked at the Hudson's Bay department store, where she developed an interest in fashion design. She met Fred Hollingsworth in 1942 and they married in 1943. In 1946, they built a house together in North Vancouver, the design of which led to Fred's career in architecture. Phyllis was an important, if largely unseen, part of Fred's architectural practice. She was responsible for all record keeping and finances, and while she remained mainly behind the scenes of the design practice, Phyllis also produced weavings and other textile works as a hobby.

HOLLYWOOD FURNITURE MANUFACTURING CO. LTD.

c. 1946–60, Vancouver, BC

Hollywood Furniture was established around 1946 by Alfred Stern, who also designed its furniture. The company was first located at 1701 West 3rd Avenue in Vancouver and manufactured mainly dinette suites made in both chrome and iron rod, with plastic laminate tops. In 1957, the company moved to a new factory and showroom at 1375 East Pender Street, which was destroyed by fire in 1960. Three of the company's designs were included in the Design Index: a dining table in 1952 and an occasional chair and hostess wagon in 1956.

PHOEBE MARIE "HONEY" HOOSER

b. 1894, Summerfield, NB

d. 1984, White Rock, BC

Honey Hooser was entirely self-taught and began seriously weaving in 1935. In 1936 the Hooser family moved to Surrey, BC. The new home became an active centre for weaving, teaching and loom construction. The rural location also provided Hooser with a supply of fleeces from local sheep farmers and access to a stream to naturally clean the wool. Hooser's love of gardening and nature (particularly wildflowers) is reflected in her designs, use of colour and her interest in natural dyes. Hooser was a lifelong teacher, instructing local and international students in her home as well as teaching weaving as a form of rehabilitation therapy at local hospitals. She built an extensive weaving community, corresponding with weavers throughout Canada and around the world, providing instruction, exchanging patterns, ideas and samples. A handwoven skirt that she prepared to honour the birth of Princess Anne was presented to Queen Elizabeth II by the Hazelmere Women's Institute. She was on the jury with Vee Elder for the *12th Exhibition of Canadian Handweaving*, held in Vancouver in 1964.

NOTABLE EXHIBITIONS

· *Design for Living,* Vancouver Art Gallery, Vancouver, BC, 1949

· *Ceramics, Textiles, and Furniture,* Vancouver Art Gallery, Vancouver, BC, 1952

· *London District Weavers,* London, ON, 1953 (award)

· *First Canadian Fine Crafts,* National Gallery of Canada, Ottawa, ON, 1957

· Brussels World's Fair, Brussels, Belgium, 1958

HENRY HUNT (K'ULUT'A)

b. 1923, Tsaxis, BC

d. 1985, Victoria, BC

Henry Hunt was a Kwagu'ł carver from Fort Rupert on Vancouver Island. He went to Victoria in the early 1950s to assist his stepfather, the carver and Kwagu'ł Chief Nakapankam (Mungo Martin), who had been hired by the Royal BC Museum

(RBCM) as master carver at Thunderbird Park. Hunt studied under Martin and began his own carving practice, experimenting at home. Hunt succeeded Martin as RBCM's master carver following Martin's death in 1962. Hunt worked with and trained his sons, artists Richard, Tony and Stanley Hunt, over his twenty-year career as master carver with RBCM. With his sons often acting as his assistants, he produced numerous totem poles. Hunt and sons carved totem poles for Beacon Hill Park, Victoria; the marina at Shuswap Lake, BC; Expo 67, Montréal, QC; and Expo 70, Osaka, Japan. The Hunts were also commissioned by the BC government to make numerous smaller poles that were gifted to visiting heads of state and other VIPs including Lester B. Pearson, Lyndon B. Johnson and Queen Elizabeth II. Henry Hunt and Tony Hunt carved a memorial pole to Hunt's mentor Nakapankam at 'Yalis (Alert Bay, BC) in 1970–71.

NOTABLE EXHIBITIONS

· Expo 67, Montréal, QC, 1967

· BC Pavilion, Expo 70, Osaka, Japan, 1970

AVERY HUYGHE (NÉE MURIEL AVERY)

b. 1911, Alton, England

d. 1981, Vancouver, BC

Avery Huyghe came to Canada in 1949. During the 1950s, she studied pottery at the Ceramic Hut, part of the University of British Columbia's Extension Department, with Rex Mason, Thomas Kakinuma and Santo Mignosa and at summer workshops with F. Carlton Ball and Kyllikki Salmen-haara (1964). She also taught there in the early 1960s. Huyghe was also one of the first executives of the newly formed BC Potters Guild (1955). With the closing of the Ceramic Hut in 1966, Huyghe opened the Ross-Huyghe School of Pottery with Hilda Ross. By the late 1960s, Huyghe had moved into hand-building ceramic forms and deforming wheel-thrown pots.

NOTABLE EXHIBITIONS

· *BC Arts Today,* Art Gallery of Greater Victoria, Victoria, BC, 1956

- Canadian Ceramics Biennial, 1957, 1959, 1961, 1963, 1967, 1969
- *First National Fine Crafts,* National Gallery of Canada, Ottawa, ON, 1957
- *BC Potters 10th Annual Exhibition,* UBC Fine Arts Gallery, Vancouver, BC, 1958 (purchase award)
- *Centennial Crafts Caravan* (touring), 1958
- *2nd Biennial Crafts Exhibition,* Vancouver Art Gallery, Vancouver, BC, 1959 (honourable mention)
- *BC Crafts,* Vancouver Art Gallery, Vancouver, BC, 1961
- *Eighth International Exhibition of Ceramic Art,* Smithsonian, Washington, DC, 1961
- *Ceramic International,* Prague, Czechoslovakia, 1962 (award: silver medal)
- Exchange with Craftsman Potters of Great Britain, London, England, 1965
- *Canadian Fine Crafts 1966/67,* National Gallery of Canada, Ottawa, ON, 1966–67
- *Canadian Fine Crafts,* Expo 67, Montréal, QC, 1967
- *British Columbia Craft,* Simon Fraser University, Burnaby, BC, 1972 (award)
- *BC Ceramics 75,* House of Ceramics, Vancouver, BC, 1975

TAM IRVING
b. 1933, Bilbao, Spain;
lives in West Vancouver, BC

Tam Irving immigrated to Canada from Britain in 1956. He worked as a chemist with Shell Oil in Vancouver and Winnipeg, MB, where he also took evening courses in pottery at the Winnipeg School of Art. In 1964, he left his job with Shell Oil and attended the Haystack Mountain School of Crafts in Maine and later the Vancouver School of Art (1965) before establishing his own production pottery in West Vancouver in 1965. There, until the early 1970s, he made a wide range of functional stoneware pots. Inspired by the New Zealand potter Harry Davis, Irving began making glazes from local materials that he crushed and milled with his own equipment. Some of his work

from this period reflects a continent-wide interest in creating asymmetrical shapes through hand-forming and manipulating wheel-thrown pieces. In the late 1960s, he produced large numbers of wheel-thrown lamp bases. Fairey and Co. Ltd., a Vancouver supplier of industrial materials, began hydraulically pressing some of his ashtray designs, which he then glazed and fired in his own studio. These were sold to local office suppliers and nationally through Danica Imports. In the 1960s, Irving was president of the BC Potters Guild and editor of its newsletter, *The Western Potter.* In the 70s, he experimented with ceramic sculpture inspired by Henry Moore, Jean Arp and Isamu Noguchi. Between 1973 and 1996, he taught at the Vancouver School of Art, while continuing to operate his studio in collaboration with Ron Vallis.

NOTABLE EXHIBITIONS
- *Canadian Fine Crafts 1966/67,* National Gallery of Canada, Ottawa, ON, 1966–67
- New Design Gallery, Vancouver, BC, 1966
- *Western Crafts 1967,* Western Canada Art Circuit, 1967
- Canadian Ceramics Biennial, 1967, 1969
- *24th Ceramics National,* Syracuse, NY, 1967
- *Ceramics International,* Glenbow Museum, Calgary, AB, 1973
- House of Ceramics, Vancouver, BC, 1976

ISLAND WEAVERS
1932–74, Victoria, BC

Island Weavers was a Victoria-based producer of woollen material and clothing, established in Victoria by Enid Murray and her husband, Major R.G.H. Murray. On retirement from the British Army in India, the couple were looking for a business to supplement the major's military pension. Before opening their business, Enid studied weaving for about six months at the South of Scotland Technical College in Galashiels, Scotland, the centre of the tweed industry. They opened their first factory in the old Esquimalt High School in Victoria in 1932, later moving to Langley Street in downtown

Victoria. For the duration of their business, the Murrays used imported wool. By 1938, they had ten looms and retail outlets in Victoria and Vancouver. In the late 1930s, they established a weaving workshop in the Textile Tower in Seattle, WA, also selling to Frederick and Nelson, Marshall Field & Co. and other American firms. In the 50s, the Murrays had shops in Victoria (est. 1942) and in Vancouver at 818 Howe Street (1946–53) and the Park Royal (est. 1953) and Oakridge (1959–74) shopping centres. They sold readymade coats and suits at the Howe Street shop and made clothing at the Oakridge location. Along with the Cowichan sweater, Island Weavers woollen fabric was considered a uniquely British Columbian product. Albert Kaplan of Vancouver's National Dress Co. made coats from Island Weavers fabrics, and Island Weavers woven material was used in the Canadian Embassy in Washington, DC (1960s).

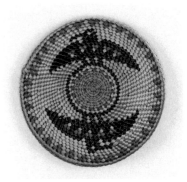

NELLIE JACOBSON
b. 1890, Ahousat, BC
d. 1969, Port Alberni, BC

Nellie Jacobson was a Nuu-chah-nulth weaver from Ahousat, BC. She was taught weaving by her grandmother and two great-aunts. By the age of seven, Jacobson helped her grandmother scrape bark from cedar trees and make mats and shawls for use by local fishermen. Her work is characterized by her incredibly fine, skillful weaving. Jacobson's weaving designs were traditional, employing Thunderbird, Eagle

and Whale motifs alongside abstract colour designs. In addition to baskets and mats, Jacobson wove non-traditional items such as zippered wallets and bags. Private collectors commissioned her to make work including woven buttons, indicating her status as a well-known weaver during this period. She was referred to as "one of our most famous basket makers" in a profile in the *Vancouver Sun* newspaper (November 20, 1954). Jacobson later taught basketry to women in Ahousat and was an important figure in the revitalization of Indigenous cultural practices in British Columbia.

CHARMIAN JOHNSON
b. 1939, Pouce Coupe, BC;
lives in Vancouver, BC

In the late 1960s, Charmian Johnson studied ceramics with Glenn Lewis at the University of British Columbia's Faculty of Education where she built her first kiln with fellow student Gathie Falk. From mid-1967 to early 1969, she was the editor of *The Western Potter,* the quarterly newsletter of the BC Potters Guild. Johnson travelled extensively during this period where she encountered important historical pottery collections including the Sir Percival David Foundation's collection of Chinese ceramics. She returned to Canada in 1969 and in August she conducted a pottery workshop at Williams Lake, BC, with Byron Johnstad. Johnson moved to Vancouver, BC in 1970 where she purchased Michael Henry's house, studio and kiln on East 13th Avenue. Johnson continually developed her pottery practice regularly teaching at UBC's studio program (1971–77), travelling and studying ceramic collections around the world. She met with Bernard Leach apprentice Gwyn Hanssen Pigott in France and briefly worked at Leach Pottery in St. Ives, England, cataloguing pottery in 1975. In 1977 she dedicated herself entirely to pottery production and returned to St. Ives to finish documenting Bernard Leach's pottery collection. Johnson then travelled to Morocco to work with master potter

Malem Ahmed Cherkaoui and developed her drawing skills. Johnson is known for her pure and simple forms, maverick glazes and utilitarian wares such as tea bowls, pots, porcelain boxes, vases and platters.

NOTABLE EXHIBITIONS
· *Canada Crafts '67,* Canadian Guild of Crafts, Montréal, QC, 1967
· *1 & 40,* Canadian Guild of Crafts, Montréal, QC, 1967
· *Teapots,* Vancouver Art Gallery, Vancouver, BC, 1968
· *BC Potters*, Canadian Guild of Potters, Toronto, ON, 1969

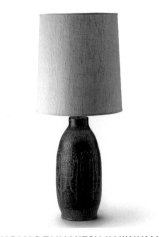

THOMAS TAKAMITSU KAKINUMA
b. 1908, Tanuma, Japan
d. 1982, Burnaby, BC

Thomas Kakinuma immigrated to Vancouver in 1937 and studied drawing and painting at the Ontario College of Art (OCA) in Toronto, graduating in 1947. He then studied painting at the Art Students League of New York (1948–50), followed by a year in ceramics at the OCA. In the early 1950s, he moved to Vancouver and studied ceramics at the University of British Columbia (UBC) with Rex Mason, Olea Davis, Hilda Ross and others at the Extension Department's Ceramic Hut. With the departure of Mason in the spring of 1956, Kakinuma was appointed instructor that fall, remaining until 1960. In 1960, he received a Canada Council Fellowship

and studied in Mexico and Japan. In 1965, Kakinuma resumed teaching ceramics at UBC. In 1958, one of his ceramic sculptures was purchased by the Department of External Affairs for the Canadian Embassy in Washington, DC.

NOTABLE EXHIBITIONS
· BC Potters Annuals, 1952 (award), 1953, 1954, 1955 (award), 1957, 1958, 1959 (award)
· *Pottery,* Canadian Handicrafts Guild, Montréal, QC, 1953 (award)
· *Northwest Craftsmen's Exhibition,* Henry Art Gallery, Seattle, WA, 1954, 1955, 1956
· Canadian Ceramics Biennial, 1955, 1957 (grand award), 1959, 1963, 1967
· *50th Anniversary Crafts,* Canadian Handicrafts Guild, Montréal, QC, 1956 (awards)
· *Thomas Kakinuma,* UBC Fine Arts Gallery, Vancouver, BC, 1956
· *First Canadian Fine Crafts,* National Gallery of Canada, Ottawa, ON, 1957
· Brussels World's Fair, Brussels, Belgium, 1958
· *Centennial Crafts Caravan* (touring), 1958
· *International Ceramics,* Ostend, Belgium, 1959
· *19th International Exhibition of Ceramic Art,* Faenza, Italy, 1959
· *Ceramics by Kakinuma,* Vancouver Art Gallery, Vancouver, BC, 1962
· *Ceramic International,* Prague, Czechoslovakia, 1962 (award: silver medal)
· *Ceramics by Thomas Kakinuma and Zoltan Kiss,* Art Gallery of Greater Victoria, Victoria, BC, 1963
· *BC Craftsmen '64,* Vancouver Art Gallery, Vancouver, BC, 1964
· *Ceramic National,* Syracuse, NY, 1964
· New Design Gallery, West Vancouver, BC, 1956; Vancouver, BC, 1965
· *Canadian Fine Crafts,* Expo 67, Montréal, QC, 1967

ZOLTAN KISS
b. 1924, Gyor, Hungary;
lives in West Vancouver, BC

Zoltan Kiss studied architecture at the Technical University in Budapest, Hungary, in the early 1940s. He fled wartime Hungary in 1944, spending five years in Denmark, where he worked at Knabstrup Keramik as an artist. After his arrival in Vancouver in 1950, he taught pottery for a short time with the Extension Department at the University of British Columbia (UBC) and completed his architecture degree at UBC (1951). In the early 1950s, Kiss was one of the few potters in British Columbia with training and experience and won at least two purchase prizes at the *BC Potters Annuals* (Fine Arts Gallery, UBC, 1958; Vancouver Art Gallery, 1959). He was featured in *Western Homes and Living* magazine in July 1961.

NOTABLE EXHIBITIONS

· *Ceramics, Textiles, and Furniture,* Vancouver Art Gallery, Vancouver, BC, 1951
· *BC Arts Today,* Art Gallery of Greater Victoria, Victoria, BC, 1956
· BC Potters Annuals, 1957, 1958 (award), 1959 (award)
· Canadian Ceramics Biennial, 1959 (award), 1961, 1963
· New Design Gallery, Vancouver, BC, 1960
· *Ceramics by Thomas Kakinuma and Zoltan Kiss,* Art Gallery of Greater Victoria, Victoria, BC, 1963

HELMUT KRUTZ
b. 1934, Germany
d. 2017, Campbell River, BC

Helmut Krutz had a family background in furniture making in Germany. Between 1962 and 1975, he designed and made upholstered chairs and couches, which he sold at his shop at 2229 Granville Street in Vancouver. These were of two basic types. One design had an upholstered armrest ending with a wooden ball, like the hand rest on the Papa Bear Chair by Danish designer Hans Wegner. Other designs were Jetsons-like, with simple forms supported on a metal pedestal base, accented in teak or walnut. These chairs had either open, metal-framed armrests finished in solid wood or curved upholstered armrests that flowed outward from the seat. The moulded-plywood seats for his pedestal chairs were made from one basic shape, which Krutz had determined through research. All aspects of the manufacturing—plywood moulding, metal fabrication, woodwork and upholstery—was done on site. His chairs were advertised in *Western Homes and Living* beginning in the fall of 1965.

ANN KUJUNDZIC (NÉE JOHNSON)
b. 1929, Dysart, Scotland;
lives in Victoria, BC

After her marriage in 1948 to the artist Zeljko Kujundzic, Ann Kujundzic soon took on the responsibility of raising a large family and supporting her husband's artistic career. After founding Nelson's Kootenay School of Art, where Zeljko was director (1960–64), the Kujundzics bought an old church in Kelowna, BC, which became the Kelowna Art Centre (1964–68). There Ann started making hand-stitched tapestries with burlap backing, which received notice in *Chatelaine* magazine (Oct 1965). In 1966, she took an intensive course in batik at the Instituto Allende in San Miguel de Allende, Mexico, later making batik hangings and clothing, which she sold at the Kelowna Art Centre boutique and elsewhere in the late 1960s and 70s.

ZELJKO KUJUNDZIC
b. 1920, Subotica, Yugoslavia
d. 2003, Osoyoos, BC

Zeljko Kujundzic's boundless creativity found expression in graphics, painting, sculpture, ceramics, woodcarving and jewellery, and he exhibited these extensively in British Columbia, the United States and Europe. Kujundzic studied art in Venice, Italy (1939–40), and at Budapest's Royal College of Art (1941–46). After the war, he relocated to Edinburgh, Scotland (1948–58), where he exhibited art and produced covers and illustrations for books by poet Ian Hamilton Finlay. In 1958, Kujundzic and his family immigrated to Canada, settling first in Cranbrook, BC, and moving to Nelson, BC, the following year. Dedicated to the

idea of creating an art institution in British Columbia's Interior region, he helped establish Nelson's Kootenay School of Art (KSA) and became its first director (1960–64). He was passionate about teaching using local materials: grinding pigments for paint and using local clay and local silver. In the early 1960s, ceramic artist Santo Mignosa joined him at the KSA and the two exhibited work together in Vancouver. From 1964 to 1968, Kujundzic lived with his family in Kelowna, BC, where he established the Kelowna Art Centre, which served as a studio, gallery and teaching space. He was a member of the Okanagan Five, along with artists Weldon Munden, Desmond Loan, LeRoy Jensen and Frank Poll, and George Ryga as their writer. Together in 1967 they established the Okanagan Summer Arts Festival. Between 1968 and 1982, Kujundzic ran the Art Department at the Pennsylvania State University (Fayette campus), returning to British Columbia in the summers.

NOTABLE EXHIBITIONS
· *Canadian Fine Crafts,* Expo 67, Montréal, QC, 1967

HEINZ LAFFIN
b. 1926, Stettin, Germany;
lives on Hornby Island, BC

Heinz Laffin immigrated to Canada from Germany in 1953. Between 1958 and 1963, Laffin attended the Vancouver School of Art (VSA) part-time, taking pottery courses only. In 1963, he took over pottery instruction part-time at the VSA, when Robert Weghsteen left on a Canada Council study grant. Laffin continued teaching there until 1965, alongside Wayne Ngan, who also taught part-time. In 1963–67, he shared a studio with Ngan in an old house in Vancouver at 59th Avenue and Main Street, where he made wheel-thrown studio pottery and a series of vases from moulds, using slip from the Canadian Potteries factory. Laffin moved to Hornby Island, BC, in 1967. He attended the raku workshop with Hal Riegger, hosted by Frances Hatfield at Woods Lake, BC (1967), as well as the Paul Soldner kiln-building workshop in Seattle, WA (1967).

NOTABLE EXHIBITIONS
· Gallery of BC Arts, Vancouver, BC, 1962–c. late 1960s
· *BC Crafts,* Vancouver Art Gallery, Vancouver, BC, 1961
· *BC Craftsmen '64,* Vancouver Art Gallery, Vancouver, BC, 1964
· New Design Gallery, Vancouver, BC, 1964
· *Canadian Fine Crafts 1966/67,* National Gallery of Canada, Ottawa, ON, 1966
· *Western Crafts 1967,* Western Canada Art Circuit, 1967
· Department External Affairs and the Canada Council, Ottawa (touring, Europe), 1968–69
· *Canadian Ceramics Biennial,* 1969

DAVID L. MARLON-LAMBERT
b. 1919, Sapperton, BC
d. 1985, Ryder Lake, BC

David Lambert opened Vancouver's first ceramic workshop at 4316 Fraser Street in 1945. By 1948, he was offering evening classes in art pottery, clay modelling and wheel throwing and soon after began selling ceramic supplies to amateur potters, schools and institutions. In 1951, the company hired Reg Dixon, who did the throwing, and a store manager, who ran a retail store at 2910 Broadway, selling Lambert's pottery and supplies. In 1953, Lambert moved his store to 866 Howe Street, where he also exhibited paintings by local artists (1954–55). In 1952–53, Lambert taught pottery with Dixon at the Vancouver School of Art. Around 1950, to make a distinctive BC product, Lambert started producing hand-thrown mugs and jiggered plates with West Coast First Nations designs, which he researched in libraries and museums, in consultation with Indigenous people. In the early 1950s, he used a red clay from Sumas Mountain in the Fraser Valley and later a white clay from Giscombe Narrows near Prince George, BC. The design motifs were hand-painted by Lambert and his assistants and fired with a clear, shiny glaze. In the mid-1960s, he produced bowls and platters with flowing Indigenous motifs that filled the surfaces and complemented the forms. Lambert is also known for a ceramic series called the Little Stick Family (who represent the simple life), which he first made in the early 1960s when he wanted to break away from his West Coast designs.

In 1951–52, Lambert was part of a group of Vancouver, Seattle and Portland potters interested in advancing their craft regionally through exhibitions and sharing of information. This set the stage for participation by several local potters in the *Northwest Craftsmen's Exhibitions* held in Seattle, WA, in the mid-50s. In 1954, Lambert was one of the artists involved in B-A Oil's national program to design interiors for its offices, producing wall tiles with Indigenous motifs for the company's new Vancouver building at 1101 West Pender Street.

NOTABLE EXHIBITIONS
· *Northwest Craftsmen's Exhibition,* Henry Art Gallery, Seattle, WA, 1950

EDWIN LARDEN
b. 1906, London, England
d. 1952, Vancouver, BC

Edwin Larden was an executive with the lighting manufacturer W. Freeman and

Son Ltd., located in Vancouver. In 1949, he designed a desk lamp that was included in the Design Index. Freeman and Son made many of the lamps that appeared in the *Design for Living* exhibition at the Vancouver Art Gallery in 1949.

NOTABLE EXHIBITIONS

· *Design for Living,* Vancouver Art Gallery, Vancouver, BC, 1949

GLENN LEWIS
b. 1935, Chemainus, BC;
lives in Vancouver, BC

Glenn Lewis graduated from the Vancouver School of Art in 1958. He later apprenticed at the Leach Pottery in St. Ives, Cornwall (1961–63) and helped establish Longlands Pottery with John Reeve and others in Devon, England (1963–64). Between 1964 and 1967, Lewis taught ceramics at the University of British Columbia (UBC) Faculty of Education. In 1967, he was awarded a Canada Council grant to research "the cut foot ring on the bottom of bowls and other pots in Japan." Around 1967, his focus changed from pottery to sculpture. At *Perspective '67,* Lewis exhibited *Rip Torn,* a sculpture composed of a torn cup and saucer made of porcelain sitting on a clear plastic column—his attempt to place the humble pot on an equal footing with art. Three years later, he created the ceramic mural *Artifact* for the Canadian Pavilion at Expo 70 in Osaka, Japan, which was not installed but is now in the Vancouver Art Gallery collection. Lewis was a visiting professor at New York College of Ceramics in Alfred, NY (1970–71), and taught in the Fine Arts Department at UBC (1971–73).

With six others, he established the artist collective Western Front in 1973. His commission *Science Library* was installed at the National Research Council Canada building in Ottawa in 1974.

NOTABLE EXHIBITIONS

· *Canadian Fine Crafts 1966/67,* National Gallery of Canada, Ottawa, ON, 1966–67
· *Canadian Fine Crafts,* Expo 67, Montréal, QC, 1967
· *Perspective '67,* Art Gallery of Ontario, Toronto, ON, 1967
· Douglas Gallery, Vancouver, BC, 1968

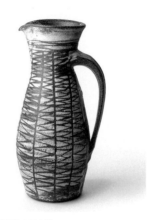

DESMOND LOAN
b. 1928, unknown
d. 2014, Summerland, BC

In the early 1960s, Desmond Loan took summer session pottery courses at the University of British Columbia with John Reeve and Stan Clarke. He exhibited his work with Zeljko Kujundzic at the Canvas Shack Gallery, Vancouver, in 1963. In 1966, he was a member of the Okanagan artist group known as the Group of Five (with Kujundzic, Weldon Munden, LeRoy Jensen and Frank Poll), which exhibited locally. In 1968, Loan built a studio in Peachland, BC, and exhibited with another Okanagan group called the Five Potters (with Gerald Tillapaugh, Poll, Bob Kingsmill and Frances Hatfield). He exhibited and sold work through the Exposition Gallery in Vancouver (1968) and at the Handloom in

Victoria (early 1970s).

NOTABLE EXHIBITIONS

· Exchange with The Craft Potters Association of Great Britain, London, England, 1965
· *Western Crafts 1967,* Western Canada Art Circuit, 1967
· Exposition Gallery, Vancouver, BC, 1968
· The Handloom, Victoria, BC, c. early 1970s

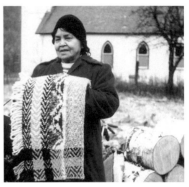

ADELINE LORENZETTO
b. 1894, Hope, BC
d. 1972, Laidlaw, BC

Adeline Lorenzetto was a Shxw'ōwhámél weaver. She was instrumental in the revitalization of Salish weaving practices in the 1960s and was one of the founding members of what would later become the Salish Weavers Guild. In 1963, Lorenzetto, known for spinning and processing her own wool for knitting, was brought a number of old Salish blankets made from wild mountain goat wool by Oliver Wells, a sheep farmer and amateur anthropologist from Sardis, BC. The Stó:lō Elders in possession of these blankets did not remember seeing how such blankets were made. Lorenzetto too had never seen the weaving of a goat-wool blanket and set about rediscovering these Salish weaving methods. She researched published accounts of Salish weaving techniques and patterns and studied the weave of old blankets. Together with Wells, she built a small lap-sized loom, measuring around twelve inches square. She began experimenting on this small

loom. Lorenzetto worked with the Salish weaver Mary Peters and others on a 1967 commission from the Hotel Bonaventure in Montréal, QC, for a six-panel, twenty-one-square-metre weaving.

NOTABLE EXHIBITIONS
· Canadian Handicrafts Guild, Montréal, QC, 1964 (award)
· Crafts Show, Chilliwack Arts Council, Chilliwack Secondary School, Chilliwack, BC, 1966 (award)

JANET (JAN) MACLEOD
b. 1941, Ladysmith, BC;
lives in Vancouver, BC

Janet MacLeod studied art and education at Victoria College and began teaching in Delta, BC, in 1961. In 1963, she settled in Terrace, BC, with her young son and husband, a newly hired teacher. Shortly after her arrival, she met a few members of the small but strong arts community, with whom she made pottery using a kick wheel and kiln located in the basement of the local high school, also learning from books borrowed from the Department of Education extension library in Victoria. At first, the group used blue clay dug from a slide area around nearby Lakelse Lake, BC. Because it was dense and difficult to throw on the wheel, they eventually opted for commercial clay, which resulted in more successful pots. With no knowledge of glazes, the group tried materials like water glass.

Workshops conducted by Walter Dexter in the mid-1960s and later by Frances Hatfield helped the group understand clay, master basic techniques and make glazes. MacLeod later took workshops with Leonard Osborne in Victoria (1968) and Hal Riegger in Ladysmith, BC (1970) and on kiln building in Vernon, BC (1971). Building a home studio with a wheel and kiln freed MacLeod from using the facilities at the high school, where she was now teaching evening pottery for adults. She worked with the Terrace Art Association to establish an annual arts and crafts exhibition, where she had no trouble selling work in the strong craft market of the late 1960s and 70s. She also exhibited and sold throughout British Columbia including Smithers, Prince Rupert, Kitimat, Prince George and Vancouver.

NOTABLE EXHIBITIONS
· House of Ceramics, Vancouver, BC, 1977
· *Retrospect Ceramics 80,* BC Potters Guild, Robson Square, Vancouver, BC, 1980

A.P. MADSEN LTD. / MADSEN MODERN
unknown–1954, Vancouver, BC
RESTMORE-MADSEN
1954–c. 1956, Vancouver, BC

In 1952, Swedish manufacturer DUX and designer Folke Ohlsson granted the rights to produce some of Ohlsson's designs to the Vancouver firm A.P. Madsen Ltd. At the time, the company was the largest manufacturer of upholstered furniture in Western Canada and had just moved into a modern manufacturing facility at 1122 Southwest Marine Drive. There it produced several different Ohlsson-designed upholstered chairs and sofas, which it marketed across Canada as Madsen Modern. All manufacturing, including upholstery, was done at the Vancouver factory, with only Ohlsson's ingenious knock-down hardware imported from Sweden. The furniture was very much a precursor to the IKEA low-cost furniture we know today. Several chairs in the Madsen Modern line were included in the Design Index in the early 1950s. In 1954, A.P. Madsen Ltd. amalgamated with Restmore Manufacturing Co. Ltd., a large Vancouver mattress and furniture company established in 1903, forming Restmore-Madsen. That company continued to produce Ohlsson's designs under the DUX Modern label until about 1956, when the production shifted to the United States.

SASHA MAKOVKIN
b. 1928, Vancouver, BC
d. 2003, Mendocino, CA

Sasha Makovkin started out studying architecture at the University of British Columbia and became interested in pottery through an Extension Department course at the Ceramic Hut, where he studied with Rex Mason. In 1954, Makovkin was invited to work for Heath Ceramics in Sausalito, CA, and moved to Mill Valley, CA. Eventually he became production manager. He left Heath Ceramics in 1960 to start his own studio in Mendocino, CA.

NOTABLE EXHIBITIONS
· Pottery exhibition, Canadian Handicrafts Guild, Montréal, QC, 1953 (award)
· BC Potters Annual, 1954 (award), 1955 (award: BC Industrial Design Committee)
· *Northwest Craftsmen's Exhibition,* Henry Art Gallery, Seattle, WA, 1954 (award)
· Northwest Potters, Portland, OR, 1954 (award)
· Association of San Francisco Potters, San Francisco, CA, 1956
· *BC Arts Today,* Art Gallery of Greater Victoria, Victoria, BC, 1956

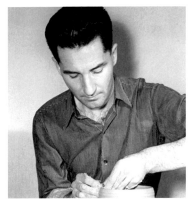

REX MASON
b. 1921, Madison, WI
d. 2014, Santa Fe, NM

Rex Mason was an experienced potter, teacher and exhibitor before coming to Vancouver to teach at the University of British Columbia (UBC) Extension Department (1952–56). He studied at the Layton School of Art, Milwaukee, WI, and, after serving in the marines, studied with F. Carlton Ball at the California School of Fine Arts in San Francisco, CA. He was an important member of the progressive San Francisco pottery community, which included Ball,

Edith Heath and Rudy Autio. In the late 1940s, Mason exhibited widely and won awards at the California State Fair (1946, 1947), de Young Museum (1946, 1947) and Pacific Coast Exhibitions (1948, 1949). He also exhibited at the Ceramic Nationals in Syracuse, NY (1948–50) and taught pottery at Mills College Oakland, CA (1948); in Ukiah, CA (1949); and in Montana (1950). He was president of the Association of San Francisco Potters in 1949. While at UBC, Mason taught many BC potters, including Hilda Ross, Olea Davis, Avery Huyghe, Thomas Kakinuma, Gordon Stewart, Sasha Makovkin, Dexter Pettigrew, Hal Fromhold and Leonard Osborne, and encouraged them to exhibit work across Canada and in Seattle, WA. He also gave pottery demonstrations in schools.

NOTABLE EXHIBITIONS

· *Ceramics, Textiles, and Furniture,* Vancouver Art Gallery, Vancouver, BC, 1952
· BC Potters Annuals, 1953–56 (awards)
· Canadian Handicrafts Guild, Montréal, QC, 1953 (award: best piece)
· *Northwest Craftsmen's Exhibition,* Henry Art Gallery, Seattle, WA, 1954, 1955 (award)
· *Canadian Ceramics Biennial,* 1955 (award)
· *12th Annual Exhibition of Ceramic Art,* Scripps College, Claremont, CA, 1955
· Association of San Francisco Potters, San Francisco, CA, 1956
· *BC Arts Today,* Art Gallery of Greater Victoria, Victoria, BC, 1956
· Craft exhibition, Canadian Handicrafts Guild, Montréal, QC, 1956 (award)

RUTH MATHERS
b. unknown
d. unknown

In the early 1950s, Ruth Mathers worked for Anne Fogarty in New York. In 1953, she opened her salon at 1773 Marine Drive in West Vancouver, where she made custom-designed dresses, suits and coats. In 1955, she won the annual fashion competition co-sponsored by the BC Needle Trades Association (Fashion Manufacturers of BC) and Alpha Omicron Pi sorority for a brown, black and white tweed ensemble for late-day party wear, with a coat. Her winning outfit was pictured in the *Vancouver Sun* (Sept 27, 1955). She was one of the first members of the Fashion Designers Association of BC (est. c. 1958), which held non-competitive fashion shows in conjunction with the annual fashion competitions.

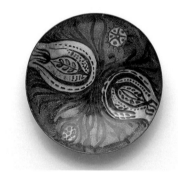

HEATHER MAXEY
b. 1926, Canterbury, England
d. 2017, Salt Spring Island, BC

Prior to immigrating to Canada from Britain in 1948, Heather Maxey studied architecture as well as stitchery and ecclesiastical embroidery in England at the Priory, Haywards Heath, and the Sidney Cooper School of Art, Canterbury. Her BC commissions include hangings for the Ryerson Memorial Church in Vancouver and the chapel of the Haney Correctional Institute in Haney, BC. In addition to embroidery, Maxey also produced enamelled bowls and, with her husband, operated a house design service in Vancouver.

NOTABLE EXHIBITIONS

· Embroiderers Guild, London, England, c. mid-1960s
· *Canadian Fine Crafts,* Expo 67, Montréal, QC, 1967

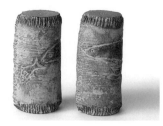

RODNEY MAXWELL-MUIR
b. 1931, Vancouver, BC;
lives in Chinook, WA

Rodney Maxwell-Muir graduated in art education from the College of Education, Western Washington State University, Bellingham, WA, in 1959. As an art teacher in Burnaby, BC, in the early 1960s, he took a course through the University of British Columbia's Extension Department with mentors Hilda Ross, Avery Huyghe and Olea Davis. At the suggestion of Ross, he sold work through the Gallery of BC Arts (near Stanley Park), where his work was seen by Rudy Kovach, who was then doing design work on the Canadian Pavilion at Expo 67 in Montréal. Kovach recommended Maxwell-Muir's dinnerware designs for La Toundra, a restaurant with a northern theme at the Canadian Pavilion. Maxwell-Muir completed the order of one thousand items in his basement studio in Burnaby, using mainly homemade equipment. The design was published in the Canadian government publication Design at Expo 67. Maxwell-Muir also completed a dinnerware commission for the Vancouver International Airport (1968). In 1979, he moved to Chinook, WA, where he re-established his studio.

NOTABLE EXHIBITIONS

· *BC Crafts,* Vancouver Art Gallery, Vancouver, BC, 1961
· *Canadian Ceramics Biennial,* 1961
· *BC Craftsmen '64,* Vancouver Art Gallery, Vancouver, BC, 1964
· *Craft Dimensions Canada,* Royal Ontario Museum, Toronto, ON, 1969

MARIAN McCREA McCLAIN
b. 1920, Edmonton, AB
d. 2008, Victoria, BC

Marian McCrea McClain studied painting, textile design and ceramics at the Vancouver School of Art (VSA, 1937–41). Between 1941 and 1946, she taught pottery and design with Doris Le Coq and Grace Melvin at the VSA and worked commercially in such diverse areas as medical illustration, murals and design (bathing suits, storefronts and fabric). In 1945, McCrea McClain studied ceramics and throwing on the wheel with F. Carlton Ball in San Francisco, CA. In the mid-1940s, she was active with Vancouver's Art in Living Group, for which she designed fabric, based on a painting by Lawren Harris, for one of the group's exhibitions. Starting in 1946, she spent almost two years in Britain on a scholarship, studying ceramics at the Camberwell School of Art and Crafts, with Bernard Leach in St. Ives and at the Wedgwood factory. Between 1951 and 1953, McCrea McClain operated shops in downtown Vancouver, selling her pottery and hand-printed fabrics under the trade name Marian. In the 1950s, she was active in the Federation of Canadian Artists as an organizer of the early pottery exhibitions at the University of British Columbia and later elsewhere. She was also one of the first executives of the BC Potters Guild (1955). In the late 1950s, she focused mainly on fabric design for various manufacturers, including Fewks, Riverdale and George Hees (Homemaker series). She moved to the United States around 1960 but returned to British Columbia in the 70s.

NOTABLE EXHIBITIONS
· *Marian McCrea*, Vancouver Art Gallery, Vancouver, BC, 1946
· *Marian McCrea Ceramics and Fabric*, Vancouver Art Gallery, Vancouver, BC, 1948
· *BC Artists*, Vancouver Art Gallery, Vancouver, BC, 1949
· *Ceramics, Textiles, and Furniture*, Vancouver Art Gallery, Vancouver, BC, 1952

DUNCAN MCNAB
b. 1917, Nanton, AB
d. 2007, Vancouver, BC

Duncan McNab was one of the architects involved in the *Design for Living* exhibition at the Vancouver Art Gallery in 1949. He designed the house and furniture for the fictitious McTavish family, including the versatile garden chair made of plywood, cord and upholstery and suitable for indoor-outdoor use.

NOTABLE EXHIBITIONS
· *Design for Living,* Vancouver Art Gallery, Vancouver, BC, 1949

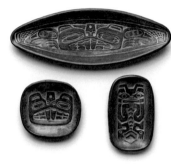

RUTH MEECHAN
b. 1914, Glenavon, SK
d. 2007, Vancouver, BC

Ruth Meechan started her pottery career in the mid-1950s with night school classes at the Vancouver School of Art, where she was taught by Reg Dixon. Around 1955, as a class assignment, she started making dishes that incorporated traditional Northwest Coast Indigenous designs. At Dixon's suggestion, she brushed manganese across the unfired glaze to accentuate the design and began selling these wares through a local shop and eventually across Canada. She continued making them until about 1963, when she sold her business to Gene Barker. In 1956, Meechan bought a pottery supply business from Stan and Jean Clarke (Reagh Studio), renaming it RM Potteries and moving the business to Hastings Street in Vancouver. She sold the business in 1960 and next set up a studio in Haney, BC. She was active in the BC Potters Guild from its

inception in 1955 and was editor of its newsletter, *The Western Potter,* in 1971 and 1974.

NOTABLE EXHIBITIONS
· Federation of Canadian Artists, Eaton's Department Store, Vancouver, BC, 1957
· *Centennial Crafts Caravan* (touring), 1958
· *2nd Biennial Crafts Exhibition,* Vancouver Art Gallery, Vancouver, BC, 1959
· New Westminster Public Library, New Westminster, BC, 1965 (with paintings by Gillian Hodge)
· Canadian Guild of Crafts, Montréal, QC, 1967
· House of Ceramics, Vancouver, BC, 1972, 1973
· *Ceramics 75,* House of Ceramics, Vancouver, BC, 1975

SANTO MIGNOSA
b. 1934, Siracusa, Italy;
lives in Aldergrove, BC

From an early age, Santo Mignosa had clay-working experience through his family's tile business in Sicily. He later graduated in painting from the Art Institute in Florence, Italy (1953), where he also did postgraduate studies in ceramic art (1954). He also taught for three years at the Art School in Siracusa, Italy. In 1957, he came to Vancouver, where he attended ceramic classes (1957–59) and taught pottery and sculpture at the University of British Columbia's Extension Department (1959–61). There he received support from potters Olea Davis and Thomas Kakinuma. From 1961 until 1967, Mignosa taught ceramics and sculpture at the Kootenay School of Art (KSA), in Nelson, BC, where he initiated the first Hal Riegger summer workshop, held at Notre Dame University College in Nelson in 1965. Mignosa took leave from the KSA to study porcelain work and bronze casting in Italy in 1967–68. Between 1969 and 1989, he taught ceramics, life drawing and sculpture at the University of Calgary, AB, and in 1972 completed his MFA at Alfred University, NY. In 1973, he organized the *Ceramics*

International exhibition held in Calgary. He was the featured artist in *Ceramics Monthly* magazine in February 1963.

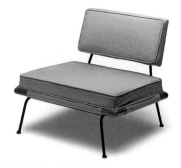

EARLE A. MORRISON
b. 1923, Vancouver, BC;
lives in Langley, BC

Earle A. Morrison studied aeronautical engineering at the California Institute of Technology, Pasadena, in the early 1940s and worked in the plywood components section of Hughes Aircraft of Los Angeles. Between 1950 and 1953, he partnered with Robin Bush in Victoria to design Minimalist coffee tables, settees, dining room sets and bedroom furniture in wood and steel rod. Between 1951 and 1953, the designs were manufactured by E.A. Morrison Ltd. in the Pacific Furniture factory, previously operated by the retailer Standard Furniture, which sold the furniture locally. Eaton's department store sold their designs nationally. A dozen of their designs were included in the Design Index, and three living room tables won NIDC Design Awards in 1953 and 1954. Other pieces were exhibited at the Design Centre in Ottawa and in the Trend House model home program sponsored by the BC forest industry in the early 1950s. Morrison-Bush furniture also received considerable notice in publications including *Western Homes and Living, Canadian Homes and Gardens* and *Decorative Art* (UK) in 1953–54 and in the Italian design journal *Domus* in 1954. A Morrison-Bush rush-seated occasional chair and dining table were included in the Canadian display at the Milan Triennial (1954).

After dissolution of the Morrison-Bush partnership in 1953, Morrison won design awards for a cast aluminum fire tender (NIDC Design Award, 1955), which also appeared in the exhibition *Good Design in Aluminum* (National Gallery of Canada/ NIDC, 1955), and for a carpet design for Harding Carpets (NIDC Design Award, 1959). He also designed the furniture for Victoria's Imperial Inn (designed by architect Fred Hollingsworth, 1961–62). In the 1960s, Morrison was in charge of renovating Canadian Pacific Hotels across Canada, including the interior design of the new Château Champlain in Montréal (1967).

MOULDCRAFT PLYWOODS
1946–c. 1950, North Vancouver, BC

Mouldcraft Plywoods was established in 1946 by R.B. McKenzie and J.E. White at 113 West Esplanade in North Vancouver. The company produced dining tables, side chairs and nesting tables, all with moulded-plywood legs, also making two upholstered chairs with one-piece moulded-plywood frames. One of these was a cantilevered armchair in the style of Alvar Aalto's Model 400 (1935–36) but with a more rectilinear form and flat, six-inch-wide armrests. The others resembled armchairs manufactured by Thonet in the early 1940s. The moulded parts were made in a press using local maple and other hardwood veneers, glued together with specially formulated Monsanto glues. Mouldcraft furniture appeared in architect Fred Hollingsworth's model home the Sky Bungalow (1949), built in a parking lot in downtown Vancouver, and in buildings designed by prominent local architects like Douglas Simpson and John Porter, reviews of which were published in the *Royal Architectural Institute of Canada Journal* in July 1947. Mouldcraft furniture also appeared in publications such as *Canadian Art* (Mar 1947) and *Canadian Homes and Gardens* (Jul 1950). In March 1949, the furniture was manufactured by Drake Industries, located at 683 East Hastings Street in Vancouver, but the company ceased production in early 1950.

· *Design in Industry,* National Gallery of Canada, Ottawa, ON, 1946–47; Vancouver Art Gallery, Vancouver, BC, 1947

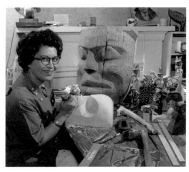

ELLEN NEEL (KAKASOLAS)
b. 1916, 'Yalis, BC
d. 1966, Vancouver, BC

Ellen Neel—Kwakwaka'wakw from 'Yalis (Alert Bay)—was trained as a carver by her grandfather Yakuglas, Charlie James, during the Potlatch ban, at a time when carvers were rarely women. In 1948, she set up a workshop and retail outlet called the Totem Arts Shop in Stanley Park and was made chief carver for the Parks Board, capitalizing on tourist interest in Northwest Coast Indigenous designs and motifs. She combined traditional practices with modern materials and new forms of creative expression. In addition to carving monumental public totem poles, Neel produced items for the tourist market including masks, jewellery, souvenir poles and other items such as screenprints, table runners, coasters, trays, skirts, scarves, bags and a series for Royal Albert China, all adorned with her signature designs. Neel received numerous commissions during her career, including five totem poles for Woodward's Department Store (1955), for a mall in Edmonton, AB (1955) and an eleven-foot pole commissioned by a Danish shipping company for a museum in Copenhagen, Denmark (1953). Neel made a smaller Wonderbird Pole (1953), which was topped with a white rooster in place of a Thunderbird for the local White Spot

restaurant chain. Its design was featured on the restaurant menus in the 1950s.

NOTABLE EXHIBITIONS

· Pacific National Exhibition, Vancouver, BC, 1952

ZONDA NELLIS
b. 1950, Woodstock, ON;
lives in West Vancouver, BC

Fashion designer Zonda Nellis studied for a year at the Vancouver School of Art (c. 1970), before moving briefly to Hornby Island where she found inspiration in its creative community and began her own spinning and dyeing. Nellis began by handweaving all the cloth for her own designs, working with silks, cashmere, suede and ribbons. As a result of her lack of formal education, Nellis approached fibre production in unconventional and experimental ways, resulting in highly unique and labour-intensive fabrics. Her textiles of the early 1970s are characterized by their loose weave, rough texture and elasticity, which is like that of a knit. Nellis' process often dictated the form of her early garments; her clothes from this period were composed in simple shapes, such as tunics, wrap coats, cardigans, capes and shawls. The simple forms contrasted with the vibrant colours and variable textures of Nellis' finished fabric. Nellis' initial foray into clothes making in the early 1970s produced around two hundred coats, each unique and hand-sewn by the artist. Her designs were considered wearable art and sometimes displayed in art galleries as wall hangings.

NOTABLE EXHIBITIONS

· Gallery 7, Vancouver, BC, 1970

ANNE NGAN (NÉE FEVEILE)
b. 1939, Sallanches, France;
lives on Hornby Island, BC

Anne Ngan was born in the French Alps and studied at the École des Beaux-Arts de Marseille before moving to Paris to study architecture. In Paris, Ngan developed an interest in costume, theatre design and modern dance. She moved to Vancouver

in 1966 and settled on Hornby Island in 1968, where she met her future husband, potter Wayne Ngan. On Hornby, Anne Ngan further pursued her interest in textiles, taking up weaving, spinning and dyeing wool in addition to gardening, painting, architecture, design and improvisational dance. Ngan's textile work included handmade clothes that she hand-dyed and produced from local and found materials. Her multidisciplinary practice is reflective of the ethos of the period, combining a connection with nature, sustainability and rural self-sufficiency with disparate craft practices such as weaving, painting and pottery. Ngan was also a performer with choreographer Helen Goodwin's improvisational dance company TheCo in the 1960s and 70s.

WAYNE NGAN
b. 1937, Guangzhou, China
d. 2020, Hornby Island, BC

Wayne Ngan was born in China and immigrated to Vancouver as a teenager in 1951. While he studied ceramics at the Vancouver School of Art (VSA), he largely considered himself to be self-taught. In 1963, Ngan graduated with honours from VSA, and for a period began teaching there as well as at the University of British Columbia. This period saw Ngan make a variety of experimental work in painting, sculpture, ceramics and drawing. In 1965, he showed such disparate works at Bau-Xi Gallery's inaugural exhibition in Vancouver. Ngan first made raku pottery around 1966. In 1967, Ngan moved to Hornby Island and built his own house and studio alongside a series of kilns on Downes Point (1969–75), all from found and natural materials. Ngan's practice was one of continual experimentation with pro-

cess, material and form. He studied painting, sculpture and architecture (Europe, 1968), bronze sculpture and marble carving (1974) and Sung and early Ming pottery and architecture (China, 1977). He worked with master potter Yoichi Murakami in Japan in 1978. Ngan taught (Shawnigan Summer School of Art, Victoria, 1975–77) and gave pottery workshops throughout his career, both locally and internationally including in Montréal (1977) and Taiwan (1983).

NOTABLE EXHIBITIONS

· BC Potters Annuals, 1962 (award: Vancouver Art Gallery purchase award)
· *BC Craftsmen '64,* Vancouver Art Gallery, Vancouver, BC, 1964
· *New Ceramic Presence,* UBC Fine Arts Gallery, Vancouver, BC, 1964
· Bau-Xi Gallery, Vancouver, BC, 1965
· Canadian Ceramics Biennial, 1965, 1969 (award), 1971 (award)
· *Canadian Fine Crafts 1966–67,* National Gallery of Canada, Ottawa, ON, 1966–67
· *Western Crafts 1967,* Western Art Circuit, 1967
· *Craft Dimensions Canada,* Royal Ontario Museum, Toronto, ON, 1969
· Handcraft House, North Vancouver, BC, 1969
· *The Recent Pottery of Wayne Ngan,* Art Gallery of Greater Victoria, Victoria, BC, 1970
· *British Columbia Craft,* Simon Fraser University, Burnaby, BC, 1972
· House of Ceramics, Vancouver, BC, 1973–1977
· *Pottery by Wayne Ngan,* Vancouver Art Gallery, Vancouver, BC, 1979

LEONARD FRANK OSBORNE
b. 1911, Coventry, England
d. 2004, Victoria, BC

Leonard Osborne came to Canada in 1937 and worked as an aircraft engineer until the mid-50s, when he took up pottery. He studied with Rex Mason, F. Carlton Ball and others at the University of British Columbia's Extension Department (1953–56), as well as with Bauhaus graduate Marguerite Wildenhain at Pond Farm in Guerneville, CA (summers of 1956 and 1957). Using a panel truck to cart his equipment around, Osborne taught pottery workshops—sponsored by Vancouver's Community Arts Council—at schools on Vancouver Island in 1959. He and his wife, Mary Osborne, also a potter, established studios in West Vancouver (1955) and later in Saanich, near Victoria (1960), where they also taught classes in the 1960s. The forms of Osborne's footed bowls often resemble Wildenhain's, and the sketchy sgraffito markings on some of his pieces are similar to those of Mason and Wildenhain. At other times, his forms are precise and linear, reflecting the influence of British potter Lucy Rie.

NOTABLE EXHIBITIONS

· BC Potters Annuals, 1954, 1955, 1956 (award), 1957 (award), 1958, 1959
· Canadian Ceramics Biennial, 1955, 1957, 1959 (grand award), 1961
· *BC Arts Today,* Art Gallery of Greater Victoria, Victoria, BC, 1956
· *First National Fine Crafts,* National Gallery of Canada, Ottawa, ON, 1957
· Brussels World's Fair, Brussels, Belgium, 1958
· *Centennial Crafts Caravan* (touring), 1958
· *Northwest Craftsmen's Exhibition,* Henry Art Gallery, Seattle, WA, 1958
· Contemporary Ceramics (Ceramic International), Ostend, Belgium, 1959
· *International Arts and Crafts,* Florence, Italy, 1962
· *Canadian Fine Crafts 1966/67,* National Gallery of Canada, Ottawa, ON, 1966–67 (with Mary Osborne)
· *Canadian Fine Crafts,* Expo 67, Montréal, QC, 1967

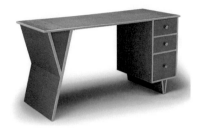

PACIFIC VENEER
est. 1938, Vancouver, BC

Pacific Veneer was started in 1938 by John G. Prentice and his brother-in-law L.L.G. "Poldi" Bentley. They relocated to Vancouver with their families after fleeing their native Austria under threat from Nazi Germany. Upon their arrival in Vancouver, they met two Hungarian brothers who were in the veneer-furniture business. After securing financing, together they formed the company Pacific Veneer, which initially started as a small furniture and panelling veneer company. After the outbreak of World War II in 1939, the company was contracted by the Royal Air Force to make aircraft plywood, and Pacific Veneer became their largest supplier. Through various acquisitions of pulp and sawdust mills and logging companies (including Canadian Forest Products, or Canfor), it was Prentice who sought a way to use forestry waste products and turn them into value-added products such as plywood board. By the 1940s, the company developed a twenty-five acre site in New Westminster, BC, which employed 850 workers and at the time was one of the world's largest plywood plants. The whole company was eventually renamed Canadian Forest Products Ltd. in 1947 and subsequently became Canfor, now one of the world's largest producers of sustainable lumber, pulp and paper.

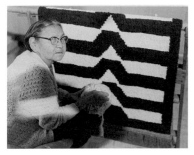

MARY PETERS
b. 1900, American Bar, BC
d. 1981, Harrison Mills, BC

Mary Peters was described as "one of the last traditional Salish weavers" before she and other Stó:lō women revived the art of Salish weaving beginning in the 1960s. Peters was a maker of fine coiled baskets, a skill passed down from the maternal side of her family. Her first foray into Salish weaving began in 1963 when she became interested in reproducing her grandmother's weavings. She constructed her own loom from memory and incorporated her family's traditional basket designs into her weaving work. She developed the Flying Goose motif that became her signature design, as well as the emblem of the Salish Weavers Guild.

Peters' rugs (along with a basket) were shown in a craft exhibition in Montréal in 1964 and were awarded the prize of best cotton rug and best basket. In 1967, Peters, working with Adeline Lorenzetto, was commissioned by the new Bonaventure Hotel in Montréal to make six large-scale weavings totalling 225 square feet for their lobby. The scale of the Bonaventure weaving project required 150 pounds of wool fleece and required the help and interest of other Stó:lō women to complete. From such collective effort and passing of knowledge, the Salish Weavers Guild would later formally emerge in 1971. In 1972, Peters made a five-by-seven-foot ceremonial blanket of her own original design for Prime Minister Pierre Trudeau's office foyer (accompanied by a weaving by Annabel Stewart).

NOTABLE EXHIBITIONS
· Canadian Handicrafts Guild, Montréal, QC, 1964 (awards)

· Crafts show, Chilliwack Arts Council, Chilliwack Secondary School, Chilliwack, BC, 1966 (awards)

DEXTER L. PETTIGREW
b. 1920, Kelowna, BC
d. 1999, Vancouver, BC

Dexter Pettigrew, an optometrist, studied pottery with Rex Mason and Thomas Kakinuma at the University of British Columbia's Ceramic Hut starting in 1954. His work was the first by a living ceramicist to enter the collection of the Art Gallery of Greater Victoria when it was acquired in 1958. He was featured with other potters in *Western Homes and Living* magazine in July 1961.

NOTABLE EXHIBITIONS
· *BC Potters 7th Annual,* Vancouver Art Gallery, Vancouver, BC, 1955
· Canadian Ceramics Biennial, 1955, 1957
· *First National Fine Crafts,* National Gallery of Canada, Ottawa, ON, 1957
· Brussels World's Fair, Brussels, Belgium, 1958

SETSUKO PIROCHE
b. 1932, Tokyo, Japan;
lives in Pitt Meadows, BC

Setsuko Piroche studied painting in Japan (1948–57) and exhibited there and in Australia before coming to Canada in 1968. Seeking a freer form of expression, she started studying textile art at Handcraft House in North Vancouver, exhibiting her first three-dimensional weavings at Vancouver's Mary Frazee Gallery in 1969. In the early 1970s, she developed these ideas further at Handcraft House, where she also exhibited and taught. Many exhibitions followed, including solo exhibitions at the Burnaby Art Gallery and the Vancouver Art Gallery where she exhibited three-dimensional weavings in macramé that invited viewer participation. Her belief in creating perishable "soft sculpture" using woven materials and wire rather than permanent works in wood, metal and stone was highlighted in her exhibitions at the Artists' Gallery, Vancouver (1977)

and her retrospective at the Surrey Art Centre (1978).

NOTABLE EXHIBITIONS (3D WEAVINGS):
· Mary Frazee Gallery, Vancouver, BC, 1969
· Handcraft House, North Vancouver, BC, 1971, 1972, 1974, 1976
· *British Columbia Craft,* Simon Fraser University, Burnaby, BC, 1972 (award: best in show)
· Burnaby Art Gallery, Burnaby, BC, 1973
· Mido Gallery, Vancouver, BC, 1973, 1974
· *Textiles into 3-D* (touring), Art Gallery of Ontario, Toronto, ON, 1973–74
· *Wool Gathering '73,* Canadian Guild of Crafts, Montréal, QC, 1973
· *Canadian Tapestry,* Royal Centre Mall, Vancouver, BC, 1974
· Vancouver Art Gallery, Vancouver, BC, 1974
· North Vancouver Civic Centre, North Vancouver, BC, 1975 (commissions)
· *Northwest Fibres,* Handcraft House, North Vancouver, BC, 1975
· House of Ceramics, Vancouver, BC, 1976
· Presentation House, North Vancouver, BC, 1976
· *Metamorphosis in Soft Sculpture,* Artists' Gallery, Vancouver, BC, 1977
· *Work from 1965 to 1978 by Setsuko Piroche,* Surrey Art Centre, Surrey, BC, 1978
· Canadian Cultural Centre, Paris, France, 1979

VERA RAMSAY
b. c. 1918, unknown
d. c. 2003

Vera Ramsay was a prominent local fashion designer and sewing instructor. She studied at Vancouver's Academy of Useful Arts in the late 1930s, also teaching there until about 1952. In 1945, she took a one-year break from teaching to attend the Frank Wiggins Trade School in Los Angeles, winning several prizes while she was there. In the late 1940s and early 50s, she designed women's loungewear, lingerie, rainwear and ski apparel independently and with

the Vancouver firm Smith Button Works. She also started teaching dressmaking in the Adult Education Department of the Vancouver School Board. In 1959–60, she worked mainly making lace for the London designer Norman Hartnell, dressmaker to Queen Elizabeth II. Ramsay's interest in education evolved into the publication *Create Something Beautiful* (1967, rev. ed. 1972) and the establishment of a sewing school in the late 1960s. In the mid-70s, she gave sewing workshops for men and women at Eaton's department store.

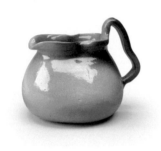

RAVINE POTTERY
1947–1949, Surrey/New Westminster, BC
Between 1947 and 1949, the company made giftware and tableware by hand (not wheel thrown) in Surrey, BC, at Scott Road and Victoria Road (now 99 Avenue). The pottery is sometimes marked as being made in New Westminster rather than Surrey.

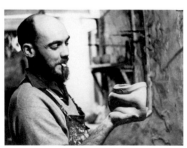

JOHN REEVE
b. 1929, Barrie, ON
d. 2012, Abiquiú, NM
In 1954, John Reeve studied drawing and painting for one year at the Vancouver School of Art, followed by one year studying

pottery with Reg Dixon. In the fall of 1956, Reeve opened a small pottery in Orillia, ON, called the Blue Mountain Craft Shop, which he ran for about a year. In early 1958, he went to England, working at the Carmelite monastery in Aylesford, Kent, which had a pottery run by Colin Pearson. Desiring to work for Bernard Leach, Reeve moved to Cornwall, where he worked for about one month at the Crowan Pottery run by Harry and May Davis. After several attempts, Reeve finally secured an apprenticeship with Leach, which commenced in November 1958 and lasted until early 1961, at which point he returned to Canada.

After his return to Vancouver in early 1961, Reeve taught pottery through the Extension Department at the University of British Columbia (UBC), which included giving workshops elsewhere in British Columbia, specifically Kitimat and Prince Rupert, in early 1962. Later that year, he returned to UBC to teach an advanced class during the 1962 summer session, for which he built and used a raku kiln. With architect Barry Downs and publisher Harris Mitchell, he helped organize an exhibition at the UBC Fine Arts Gallery entitled *Oriental Influences on Canadian Art,* which explored the relationship between Asian and Canadian architecture, visual arts, textiles, ceramics and landscape design.

On completing his teaching at UBC in early 1963, Reeve visited Warren MacKenzie's studio in Stillwater, MN, where he completed a commission for lamps and plates for architect Ron Thom's Massey College in Toronto. He again left for Britain where he stayed mostly until 1971. Between 1964 and 1970, Reeve and others including Glenn Lewis set up Longlands Pottery in Devon, where Reeve worked for about a year full-time, later teaching part-time in Farnham, England, for about five years. During this time he exhibited in Britain and his work was included in the book *Pottery in Britain Today* (1967). In 1970, Longlands was sold and Reeve returned to Vancouver in 1971, later teaching at the Vancouver School of

Art part-time in 1972. In November 1972, Reeve had a large solo exhibition at the Vancouver Art Gallery, followed by another at the House of Ceramics, Vancouver, in November 1973.

NOTABLE EXHIBITIONS

· *Ceramic International,* Prague, Czechoslovakia, 1962 (award: silver medal)
· New Design Gallery, Vancouver, BC, 1962, 1964
· *Eight British Potters,* Art Gallery of Greater Victoria, Victoria, BC, 1966
· *John Reeve: Ceramics,* Vancouver Art Gallery, Vancouver, BC, 1972
· House of Ceramics, Vancouver, BC, 1973

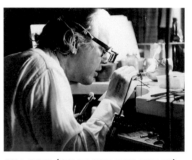

BILL REID (Q'ADASRU QIIRAWAAY)
b. 1920, Victoria, BC
d. 1998, Vancouver, BC
Bill Reid was born to William Ronald Reid, an American, and dressmaker and designer Sophie Gladstone Reid, who was from Kaadaas gaah Kiiguwaay. Reid's maternal grandfather was the carver and jewellery engraver Charles Gladstone, whom he only met later in life, during a trip to his mother's home village of Skidegate, Haida Gwaii, in 1943. Reid's great-great-uncle was renowned Haida artist Charles Edenshaw, who later became an inspirational figure for Reid's practice. Reid received no formal art training and had limited contact with Haida art during his childhood, except through the traditional jewellery his maternal aunts wore.

In 1948, Reid embarked on a career in radio broadcasting, working for the CBC in Toronto. While there, he enrolled in the new

Ryerson Institute of Technology to study European jewellery making. Following his course, he apprenticed at the Platinum Art Company in Toronto while still working for the CBC. Reid was essentially a self-taught carver, gaining experience through several restoration projects with the Royal BC Museum, Victoria, and the University of British Columbia's (UBC) Department of Anthropology. This included a stint working with Kwakwaka'wakw master carver Chief Nakapankam (Mungo Martin) in 1956. In 1958–62, Reid worked on his Haida village project at UBC, making five totem poles and two houses with the assistance of Doug Cranmer. In 1962, he briefly established a jewellery studio with Toni Cavelti in Vancouver. Reid went to London, England, in 1968 to study goldsmithing at the Central School of Design. While there, he produced his first ambitious gold necklace of purely contemporary design. In 1969 to 1973, Reid lived in Montréal and ran a jewellery workshop, returning to Vancouver in 1973.

NOTABLE EXHIBITIONS

· *Arts of the Raven,* Vancouver Art Gallery, Vancouver, BC, 1967
· Canadian Pavilion, Expo 67, Montréal, QC, 1967
· *Bill Reid: A Retrospective Exhibition,* Vancouver Art Gallery, Vancouver, BC, 1974

ROSE MARIE REID
b. 1912, Cardston, AB
d. 1978, Provo, UT

Rose Marie Reid was one of North America's most successful designer-manufacturers of swimsuits. In 1937, in response to the need of her swim coach husband, Jack C. Reid, for a more comfortable, fast-drying bathing suit, Reid started making men's suits from her kitchen. These were quickly sold at the Hudson's Bay department store, followed by an equally successful version for women. Between 1938 and 1946, production grew from $10,000 to $1.25 million and the number of employees from 12 to 178. In 1946, she made half of all bathing suits sold in Canada. To meet demand, Reid opened new factories in Vancouver and Los Angeles in 1947. By 1956, the company had five regional offices—in Los Angeles, New York, Chicago, Miami, and Dallas—and factories in the United States, Canada, Mexico, New Zealand and Brazil.

CLIFF ROBINSON
b. 1917, Bassano, AB
d. 1992, Calgary, AB

Cliff Robinson was a well-known painter and printmaker in Alberta before coming to teach at the Camouflage School at the University of British Columbia (UBC, c. 1942). He also taught at the Vancouver School of Art (1946–47) and in Banff, AB (1947), and exhibited paintings at the Vancouver Art Gallery (1943, 1945). Throughout the 1940s and 50s, he worked as an award-winning set designer. He taught art throughout British Columbia with the UBC Extension Department (1949–50, 1961) and served as its craft supervisor (1950–53), including teaching art and overseeing the development of the Ceramic Hut and pottery workshops with Edith Heath and Rex Mason in the early 1950s. In the mid-50s he was the first design director for Vancouver's CBUT television. Robinson was also a highly regarded batik specialist who learned the art from Marion Nicoll at Calgary's Provincial Institute of Technology and Art (c. 1940). In the early 1950s, he made batik lampshades for Peter Cotton's lamps and, in the 60s, large batiks for UBC's Dorothy Somerset Theatre; a student lounge at Simon Fraser University, Burnaby, BC; and Heath Ceramics in San Francisco, CA. He gave batik workshops in Vancouver (UBC Extension, 1952, 1953), at Hal Riegger's raku workshops in California (1966) and in Nelson, BC (1967, 1971), as well as elsewhere around the province. An itinerant artist, he exhibited his batiks in Europe, San Francisco and private galleries in Victoria (1963, 1970), Vancouver (1965, 1966, 1968) and Calgary (1970, 1971), as well as in a solo exhibition organized by the Western Art Circuit (1960–61).

NOTABLE EXHIBITIONS (FABRIC AND BATIKS):

· *Ceramics, Textiles, and Furniture,* Vancouver Art Gallery, Vancouver, BC, 1951, 1952
· *Paintings and Batiks,* Art Centre (later UBC Fine Arts Gallery), Vancouver, BC, 1951
· *Northwest Craftsmen's Exhibition,* Henry Art Gallery, Seattle, WA, 1954
· *2nd Biennial Crafts Exhibition,* Vancouver Art Gallery, Vancouver, BC, 1959
· *Cliff Robinson Batiks,* Western Art Circuit (touring), Vernon, BC, 1960; New Westminster, BC, 1960; Art Gallery of Greater Victoria, Victoria, BC, 1961
· *BC Crafts,* Vancouver Art Gallery, Vancouver, BC, 1961
· *BC Craftsmen '64,* Vancouver Art Gallery, Vancouver, BC, 1964

HILDA KATHERINE ROSS
b. 1902, Ottawa, ON;
d 1989, Vancouver, BC

Hilda Ross studied art at the Winnipeg School of Art, the BC College of Art and the Art Institute of Chicago. Ross was one of Vancouver's first studio potters, studying with Rex Mason and others at the University

of British Columbia (UBC) in the 1950s and one of the city's first pottery instructors. Starting in September 1948, Ross taught pottery with Mollie Carter for about two years at Gordon Neighbourhood House in Vancouver's West End. Between September 1949 and the summer of 1952, she also taught with Carter at the ceramics workshop located in the basement of the UBC library. When that facility moved to UBC's Ceramic Hut in 1952, Ross continued teaching and working there until it closed in 1966. Thereafter, she operated the Ross-Huyghe School of Pottery with Avery Huyghe until retirement in 1969. Ross studied clay and glazes with Edith Heath at the UBC Extension Department's summer school in 1952 and co-authored a study of BC clays with Olea Davis in 1958.

NOTABLE EXHIBITIONS

· *Design for Living,* Vancouver Art Gallery, Vancouver, BC, 1949
· *Ceramics, Textiles, and Furniture,* Vancouver Art Gallery, Vancouver, BC, 1951, 1952
· BC Potters Annuals, 1953 (award), 1955 (award), 1956 (award)
· *Northwest Craftsmen's Exhibition,* Henry Art Gallery, Seattle, WA, 1954
· Canadian Ceramics Biennial, 1955, 1957, 1959, 1961 (award), 1963, 1965, 1967
· Canadian Handicrafts Guild, Montréal, QC, 1955 (award)
· *First National Fine Crafts,* National Gallery of Canada, Ottawa, ON, 1957
· Brussels World's Fair, Brussels, Belgium, 1958
· *Centennial Crafts Caravan* (touring), 1958
· *BC Crafts,* Vancouver Art Gallery, Vancouver, BC, 1961
· *Ceramic International*, Prague, Czechoslovakia, 1962 (award: gold medal)
· *BC Craftsmen '64,* Vancouver Art Gallery, Vancouver, BC, 1964
· *Canadian Fine Crafts 1966/67,* National Gallery of Canada, Ottawa, ON, 1966–67
· *Canadian Fine Crafts,* Expo 67, Montréal, QC, 1967

EVELYN ROTH
b. 1936, Mundare, AB;
lives in Maslin Beach, Australia

Evelyn Roth is an experimental interdisciplinary artist. She moved to Edmonton, AB, in the 1950s and took a variety of classes in art, craft, dance, yoga and fencing, though she is primarily self-taught. In 1961, Roth moved to Vancouver and became a part of Intermedia in 1966. With this group, Roth was involved in happenings, wearable art, performance and video. She founded the Evelyn Roth Moving Sculpture Company in 1973, a group that explored sculpture and dance in the natural environment. Roth has been interested in recycling since the early 1970s and used her knitting and crocheting skills to recycle natural fibres, videotape and other materials into wearable artworks. These included wheatgrass capes, paper coats, knitted-fur pieces, moss costumes and a videotape car cozy. In 1972, she drove her car, covered in a videotape cozy, from Vancouver to St. Johns, NL, on her first Canada Council Arts grant. In 1973, she covered the Vancouver Art Gallery's entrance with a hundred feet of videotape and made a videotape canopy as artist-in-residence for the BC Pavilion at the Spokane Expo (1974). She published *The Evelyn Roth Recycling Book* (Talonbooks, 1975), which documents some of her recycling projects.

NOTABLE EXHIBITIONS

· *Birth and Rebirth of Objects,* University of British Columbia Art Gallery, Vancouver, BC, 1967
· *Bodycraft,* Portland Art Museum, Portland, OR, 1971
· *Costume Statements,* Museum of Contemporary Crafts, New York, NY, 1971
· *Recycled: The New Folk Art,* Simon Fraser Art Gallery, Burnaby, BC, 1971
· *Wearables: Sculpture in Movement,* Norman MacKenzie Art Gallery, Regina, SK, 1971
· *British Columbia Craft,* Simon Fraser Art Gallery, Burnaby, BC, 1972
· *Beelden in Beweging,* Stedelijk Museum, Amsterdam, Netherlands, 1973

· *Pacific Vibrations,* Vancouver Art Gallery, Vancouver, BC, 1973
· *Toward Costume,* Vancouver Art Gallery, Vancouver, BC, 1973
· Adelaide Festival Centre, Adelaide, Australia, 1974
· *Chairs,* Art Gallery of Ontario, Toronto, ON, 1974
· *Wrap Up,* Robert McLaughlin Gallery, Oshawa, ON, 1975
· *Evelyn Roth International Festival,* Burnaby Art Gallery, Burnaby, BC, 1979

CAROLE SABISTON
b. 1939, Harrow, England;
lives in Victoria, BC

Carole Sabiston studied art at Victoria College, the University of Victoria and the University of British Columbia between 1957 and 1967. Her self-taught textile techniques reflect her interests in painting and collage. She is well-known for her theatre and costume design (1973–87) and commissions for architectural projects, which include the reredos and altar frontal for Victoria's Christ Church Cathedral (1974 and 2002), tapestries at the Skyline Hotel (London, England, 1971), the Sunnybrook Extended Care Hospital (Toronto, 1974) and the BC Ministry of Health building (Victoria, 1976). Sabiston's work has been shown and collected internationally.

NOTABLE EXHIBITIONS

· *Stitcheries by Carole Sabiston,* Art Gallery of Greater Victoria, Victoria, BC, 1968
· *Craft Dimensions Canada,* Royal Ontario Museum, Toronto, ON, 1969
· Stitcheries, Print Gallery, Victoria, BC, 1969 (with jewellery by John Clazie)

- Stitchery, fabric collage and wall hangings, Print Gallery, Victoria, BC, 1971
- *British Columbia Craft,* Simon Fraser University, Burnaby, BC, 1972
- *Carole Sabiston: Wall Hangings,* Art Gallery of Greater Victoria, Victoria, BC, 1973
- *Wool Gathering '73,* Canadian Guild of Crafts, Montréal, QC, 1973
- *Canadian Tapestry,* Royal Centre Mall, Vancouver Art Gallery, Vancouver, BC, 1974
- Mido Gallery, Vancouver, BC, 1974
- *Toward Costume,* Vancouver Art Gallery, Vancouver, BC, 1974
- Zan Art Gallery, Victoria, BC, 1974
- *Form Function Fashion,* Vancouver Art Gallery, Vancouver, BC, 1975

J. SCALI WOODWORKING
c. 1960s, Vancouver, BC

J. Scali Woodworking was located at 1441 Parker Street in Vancouver. It manufactured and supplied furniture such as beds, tables and chairs in the 1960s. The company produced the bedroom sets and tables for rooms in the newly opened Blue Boy Motor Hotel in Vancouver in 1964.

ADOLPH & LOUISE SCHWENK
Adolph Schwenk:
b. 1898, Dresden, Germany
d. 1968, West Vancouver, BC
Louise Schwenk:
b. 1900, Sumas, WA
d. 1966, Devon, England

Louise Schwenk studied art at the University of Washington (1920–21). Adolph Schwenk, the son and grandson of artists, became a talented watercolour painter by watching his father at work in his Dresden studio. After their marriage, Adolph and Louise developed an orchard in Penticton, BC. In 1955, Louise attended Reg Dixon's pottery workshop in Penticton, also studying at the Vancouver School of Art (1955) during the winter session and at the University of British Columbia in the summer with sculptor Alexander Archipenko (1956)

and potter Charles Lakofsky (1957), and likely also with potter F. Carlton Ball (1958). The Schwenks established their studio in Penticton in the late 1950s, with Louise doing the throwing and Adolph the glazing and decorating. Their work was acclaimed across Canada and their studio was featured in the April 1961 edition of *Western Homes and Living.* The Schwenks were awarded a Canada Council grant to study European potteries in 1966.

NOTABLE EXHIBITIONS
- *Centennial Crafts Caravan* (touring), 1958
- BC Potters Annuals, 1958, 1959 (award), 1960
- Canadian Ceramics Biennial, 1959, 1961, 1963
- Stratford Festival Crafts, Stratford, ON, 1960
- *Canadian Fine Crafts 1966/67,* National Gallery of Canada, Ottawa, ON, 1966–67

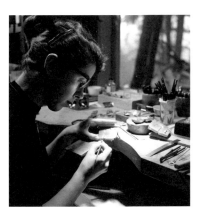

DORIS SHADBOLT
b. 1918, Preston, ON
d. 2003, Vancouver, BC

Doris Shadbolt graduated with a degree in Fine Art from the University of Toronto (1941). After marrying artist Jack Shadbolt, Doris moved to Vancouver and began contributing articles to *Canadian Art.* In 1948 Doris and Jack spent a year in New York where she worked in the catalogue department at the Metropolitan Museum of Art, studied metal work and attended a seminar held by noted art historian Meyer Schapiro.

She began her career working as an art educator at the Vancouver Art Gallery in 1950, a position she held until her appointment as curator in 1963. While she is recognized for her work as a curator, writer and art historian, her involvement in jewellery making, which she did in her Burnaby, BC, home from about 1953 to the early 60s, is less known. In her 1950s work, Shadbolt used simple forms inspired by African art, which she exhibited locally and in Seattle, WA. Her jewellery appeared in *Western Homes and Living* (Dec–Jan 1955–56).

NOTABLE EXHIBITIONS
- *Northwest Craftsmen's Exhibition,* Henry Art Gallery, Seattle, WA, 1956, 1958 (award)
- *Centennial Crafts Caravan* (touring), 1958
- New Design Gallery, Vancouver, BC, 1961, 1962

MARION SMITH (NÉE FLEMING)
b. 1918, New Westminster, BC
d. 2009, Vancouver, BC

Marion Smith graduated from the University of British Columbia in Social Work. In 1941, she married painter Gordon Smith, with whom she shared artistic interests. In the mid-1940s, she took an evening course in weaving, which proved to be the starting point for a career in textile art. Largely self-taught, Marion Smith studied traditional and contemporary weaving in books and from local Vancouver-area weavers who, in the 1950s, were interested in Scandinavian design and craft practice. She corresponded with the prominent Swedish weaver Malin Selander and hosted her in her Arthur Erickson–designed home. Smith's weavings, which served as rugs, coverlets and hangings, featured bold abstract patterns in the dark greens and grey-browns of the forest, blues of the water, and oranges and reds of the sunsets.

NOTABLE EXHIBITIONS
- New Design Gallery, Vancouver, BC, 1963 (with Karl Stittgen, Hilde Gerson, Robert Weghsteen, Vee Elder)

· *BC Craftsmen '64*, Vancouver Art Gallery, Vancouver, BC, 1964
· *Fabricart*, Vancouver Art Gallery, Vancouver, BC, 1966

SPIDER LOOM TIES
1935–72, Vancouver, BC

Danish immigrant Edgar Bollerup started his commercial weaving business Spider Looms Ltd. in 1935 on Kingsway Street in East Vancouver. Previously, he had worked part-time with the weaver Karen Bulow in Montréal, followed by a few handweaving courses in Copenhagen, Denmark. For the first two years in Vancouver he produced scarves, curtains, placemats, tablecloths and other items on two handlooms. As his work became known, he landed a contract with Birks making tablecloths that in turn led to the idea of making ties. To get into production, Bollerup joined up with his dressmaker wife, Dorothy, as well as several female employees and an accountant who also served as salesman. For over thirty years, Spider Loom Ties were distributed to men's shops throughout the province and to department stores nationally. The yarn used in the ties was custom dyed to the popular colours of the time, with designs left up to the individual weaver. To increase production, the company bought power looms in 1942, but because of wartime wool rationing, were unable to use them fully until after the war, when neckties regained popularity. Trends dictated the width of the ties: one inch (late 1950s to early 1960s); one to one-and-a-half inch (early 1960s); three inch (early 1970s).

ETHEL SQUIER
b. c. 1885, Buffalo, NY
d. Nanaimo, BC, 1962

Ethel Squier lived with her family in Mexico for many years, but with the onset of the Mexican Revolution, she and her family moved to Pasadena, CA, where Squier taught domestic science and dancing. As a young adult, she had studied art at Columbia University in New York, the University of California, Berkeley, and the Rudolph Schaeffer School of Design in San Francisco, CA. Around 1925, she and her mother, Lucy Squier (1865–1946), learned weaving at California's Santa Barbara State Normal School and later operated a successful weaving business in Pasadena. In 1928, the two moved to Cedar, BC, where they set up Squier Studio, making woven curtain material, blankets, hats and scarves. In 1939, Ethel studied with the American weaver Mary Meigs Atwater in Victoria. She exhibited locally at Spencer's department store in Nanaimo (1935) and in Victoria.

NOTABLE EXHIBITIONS

· Canadian Handicrafts Guild, Montréal, QC, 1935
· Women's Institute Weavers Guild, Victoria, BC, 1938, 1939
· Folk Festival, Hudson's Bay Company, Vancouver, BC, 1942
· London District Weavers, London, ON, 1953 (award)

JOANNA STANISZKIS
b. Częstochowa, Poland, 1944;
lives in Vancouver, BC

Joanna Staniszkis studied at the Fine Arts Academy, Warsaw, Poland (1962–64) and at the Universidad Católica, Lima, Peru (1965). Between 1964 and 1967, she studied at the Art Institute of Chicago with Else Regensteiner, who had connections to the Bauhaus through her teacher, Marli Ehrman. Staniszkis immigrated to Canada in 1967 and, soon after, taught weaving at Handcraft House, North Vancouver (1968). Between 1969 and 2006, she taught at the University of British Columbia, first at the School of Home Economics for over three decades, running courses in design fundamentals, textile design and history of costume, and later in the Landscape Architecture Program.

Throughout her career, Staniszkis has completed more than forty large-scale installations for architectural projects, public buildings and private residences, including the Mt. Pleasant Memorial Chapel, Toronto (1972); Bank of Montréal, Bentall III, Vancouver (1973); Laurel Medical Building, Vancouver (1975); Plaza International Hotel, Vancouver (1975); Yukon Territorial Building, Whitehorse, YT (1975); and West Coast Transmission Building, Vancouver (1975). Since the late 1970s, Staniszkis has exhibited in Eastern Canada, New York, Europe and Japan. She received the Saidye Bronfman Award for Crafts in 1981.

NOTABLE EXHIBITIONS

· Burnaby Art Gallery, Burnaby, BC, 1971
· *British Columbia Craft*, Simon Fraser University, Burnaby, BC, 1972
· Merton Gallery, Toronto, ON, 1972, 1974, 1976
· Mido Gallery, Vancouver, BC, 1972, 1973, 1974
· *Textiles into 3-D* (touring), Art Gallery of Ontario, Toronto, ON, 1973–74
· International Tapestry Triennial, Lodz, Poland, 1975, 1978
· International Tapestry Exhibition, Vevey, Switzerland, 1976

ALFRED STAPLES
b. 1920, Vancouver, BC
d. 2003, Victoria, BC

Alfred Staples was a graduate of the five-year Interior Architecture Program at the University of Oregon, Eugene (1945–50) and was Peter Cotton's partner in the Vancouver-based firm Perpetua Furniture in the early 1950s. He often produced the furniture, drawings and architectural renderings for the firm's interior designs. With Cotton, he designed a Lowback settee and Lowback armchair, which won NIDC Design Awards in 1953.

IAN STEELE
b. 1937, Biggar, SK
d. 2011, Devon, England

Ian Steele graduated from the Vancouver School of Art (VSA) in 1961, where he studied with Robert Weghsteen. He apprenticed for two years with Bernard Leach in St. Ives, Cornwall (1963–65), doing production work, using and firing the kiln and receiving instruction on the potter's wheel from Leach and his assistant Bill Marshall. Steele also spent many hours discussing aesthetics and looking at Leach's collection of pots. While there, he met Shoji Hamada, who was having an exhibition in England at the time, and Steele also saw other important English and Asian pottery in British collections. Between 1965 and 1967, Steele settled back in Canada, but later returned to England for eighteen months to do production work with Leach. In 1969, he worked for Weghsteen in Vancouver, taught at the VSA and

established his workshop in Nanoose Bay on Vancouver Island, BC (1969–77), where he became well known for using salt glazes. In 1977, he once again returned to England and set up a pottery in Devon.

NOTABLE EXHIBITIONS
· Crafts Centre of Great Britain, London, England, c. 1964
· *Canadian Ceramics Biennial*, 1967
· *Ian Steele Pottery,* Art Gallery of Greater Victoria, Victoria, BC, 1973, 1974

GORDON STEWART
b. 1910, Winnipeg, MB
d. c. 2002, North Vancouver, BC

Gordon Stewart and his wife, Fredl, lived in San Francisco, CA, from 1942 to 1947. During this time, he studied pottery, and the couple met Edith and Brian Heath. Working in the Financial District of San Francisco, Stewart often spent his lunch breaks throwing a few pots for Edith Heath at her studio on Clay Street, where she made hand-thrown dinnerware for sale at Gump's, a luxury home furnishings department store. After returning to Vancouver in 1947, Stewart continued his work in clay and studied with Rex Mason at the University of British Columbia's Ceramic Hut. He exhibited locally, nationally and internationally.

NOTABLE EXHIBITIONS
· *Ceramics, Textiles, and Furniture,* Vancouver Art Gallery, Vancouver, BC, 1952
· *BC Potters Annual,* 1954
· *Canadian Ceramics Biennial,* 1955
· *Northwest Craftsmen's Exhibition,* Henry Art Gallery, Seattle, WA, 1955

KARL STITTGEN
b. 1930, Ludwigshafen, Germany;
lives on Pender Island, BC

Karl Stittgen came to Canada in 1952. In 1954, he established a clock and watch repair business in West Vancouver, where he also made jewellery. In 1955, the New Design Gallery opened upstairs, and Stittgen became friendly with the owners, Alvin Balkind, an art critic, and Abraham

Rogatnick, an architect with whom Stittgen discussed his architectural interests, including his unrealized dream of training for that profession in post-war Germany. He also met some of Vancouver's most prominent artists, who introduced him to Abstract Expressionism, a term also applied to the rough expressive pottery of Peter Voulkos, which would inspire Stittgen's jewellery designs a few years later. From 1956 to 1957, Stittgen split his space with the Swiss-trained jeweller Toni Cavelti, who shared his knowledge about jewellery design and technique.

Around 1960, Stittgen closed his shop and visited Frank Lloyd Wright's Taliesin West, hoping to work there. When that didn't happen, he returned to Vancouver with a renewed interest in craft, learning enamelling from Shirley Legate. He set up his jewellery and enamel studio at home, producing enamel door panels for the Capilano Library in North Vancouver and a large mural for the Pan Am Building in New York. He also made some of his first baroque jewellery pieces, which were exhibited at the Vancouver Art Gallery (1962) and illustrated in *Western Homes and Living* (Dec 1962). Because of complaints from neighbours, he relocated his studio to a space in the Georgia Medical Dental Building in downtown Vancouver, where he had established a street-level shop in 1962.

From the 1960s to the mid-1970s, Stittgen became known for two jewellery styles—some with expressive forms, imitative of nature, others with refined geometric shapes—which he sold through his Gold and Silver stores in Vancouver, Calgary and San Francisco. In 1974, he sold his jewellery business to Brinkhaus and moved to Pender Island, BC. He later returned to jewellery in the 1980s and designed and built a Wright-inspired house on Pender (c. 1995).

NOTABLE EXHIBITIONS
· *Karl Stittgen,* Vancouver Art Gallery, Vancouver, BC, 1962

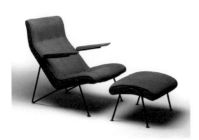

STRAHAN AND STURHAN
c. 1951–c. 1971, Vancouver, BC

Herb Sturhahn, an upholsterer, and John Strachan, an accountant, worked for other upholstery firms before forming the company Strahan and Sturhan at 3792 Commercial Drive, Vancouver, around 1951. In the early 1950s, they mostly made custom-upholstered sofas and sectional furniture, but by the late 50s they were mass-producing sofas that sold through the House of Modern in Vancouver and through the Hudson's Bay Company and Eaton's in British Columbia and Alberta. In 1953, the company produced a lounge chair based on Eero Saarinen's Grasshopper Chair, but using a steel-rod structure instead of plywood. They also produced a wooden version, which was featured in *Decorative Art: The Studio Yearbook, 1954–55,* published in the UK.

RON THOM
b. 1923, Penticton, BC
d. 1986, Toronto, ON

Ron Thom graduated from the Vancouver School of Art in 1947. From 1949 to 1957, he apprenticed with the Vancouver architectural firm of Sharp and Thompson, Berwick, Pratt. During this period, he designed several of the firm's best-known houses including the Copp House (1951), for which he also designed the furniture. Thom's interest in architecture as a "complete work of art" would find fuller expression in the University of Toronto's Massey College (1963), for which he designed furniture and light fixtures and commissioned specially made craft items like ashtrays, lamps and cutlery. Thom's interest in furniture can be traced back to 1949, when he helped make furniture for the *Design for Living* exhibition at the Vancouver Art Gallery.

NOTABLE EXHIBITIONS
· *Design for Living,* Vancouver Art Gallery, Vancouver, BC, 1949

JULIA "MADAME" VISGAK
b. c. 1899, Hungary
d. 1970, Vancouver, BC

Starting in 1938, Julia Visgak ran a dressmaking and tailoring shop from her home at 455 West Broadway and later from 1345 West Broadway in Vancouver. The name of her company varied over the years, sometimes featuring her name, Madame Visgak, and the words "European Dressmaker," "Tailor" or "Tailoress." Examples of her work in the 1940s indicate she made dresses that deliberately featured novelty and complexity in the use of materials and detailing—a style that was soon to be eclipsed by a cleaner, more minimal aesthetic advanced by Christian Dior and his circle.

JEAN MARIE WEAKLAND
b. 1931, unknown;
lives in Waldport, OR

Jean Weakland received her MFA in Indiana and was an innovative weaver and potter who exhibited mainly at Handcraft House in North Vancouver, BC, including her weaving (1967), woven structures (1968), hand-built pottery (1968) and pottery (1971). Her three-dimensional hangings were among the first in Vancouver. Weakland's pottery explored form and were mostly hand built. She was also an educator who taught ceramics in the Faculty of Education at the University of British Columbia (from c. 1967) and gave workshops at Handcraft House (primitive kilns, 1969), at the Malaspina Ceramic Seminars in Nanaimo, BC (1971, 1972) and at the Burnaby Art Centre (1975). She was also president of the BC Potters Guild (1970–72) and active in the formation of the Craftsmen's Association of BC in 1972.

NOTABLE EXHIBITIONS
· *Teapots,* Vancouver Art Gallery, Vancouver, BC, 1968
· *BC Potters,* Canadian Guild of Potters, Toronto, ON, 1969
· *Fibre and Clay,* Handcraft House, North Vancouver, BC, 1970

GERTRUDE WEBB (NÉE WEIR)
b. 1919, Vancouver, BC
d. 2000, Vancouver, BC

Gertrude Weir studied at the Vancouver School of Art (VSA), graduating in 1939. Between 1940 and 1955, she attended summer workshops in San Francisco, CA; Portland, OR; Seattle, WA; and London, England, as well as at the New York State School of Ceramics in Alfred. Weir's works range from figurines and tiles to free-form ashtrays and platters, which she exhibited at *Design for Living* in 1949 at the Vancouver Art Gallery. She taught at the VSA (1952) and her work was featured in *Canadian Geographical Journal* (Feb 1944) and *Western Homes and Living* (Dec–Jan 1952–53).

NOTABLE EXHIBITIONS
· *BC Artists,* Vancouver Art Gallery, Vancouver, BC, 1943, 1946, 1948, 1949
· *Ceramic National Exhibition,* Syracuse, NY, 1947
· *Design for Living,* Vancouver Art Gallery, BC, 1949
· *Ceramics, Textiles, and Furniture,* Vancouver Art Gallery, Vancouver, BC, 1951, 1952

ROBERT WEGHSTEEN
b. 1929, Bruges, Belgium
d. 2015, Vancouver, BC

From 1945 to 1949, Robert Weghsteen studied at the Sint-Lucas Institute in Ghent and the Académie des Beaux-Arts in Tournai, Belgium. From 1949 to 1951, he attended London's Central School of Arts and Crafts under Dora Billington and William Newland. He returned to Bruges in 1951 and worked as a potter until 1954. With wife and son, he moved to Vancouver in 1956, where he worked briefly at BC Ceramics Ltd. as an assistant to the firm's ceramic engineer, Walter Gerz, also setting up his home-based studio in West Vancouver in 1958. In 1957, Weghsteen started teaching part-time at the Vancouver School of Art and full-time starting in 1958.

His solo exhibition at the Vancouver Art Gallery in December 1961 included one hundred pieces, among them functional pottery, a fountain, a European-style fireplace made of moulded firebrick and a portion of his mural for the Nanaimo Hospital, which he was to complete in 1963. In 1964, he travelled to Europe on a Canada Council Fellowship, which afforded him the opportunity to study museum pottery collections. On his return to Vancouver in 1965, Weghsteen set up a studio in a barn in Langley, BC, where he produced many of the large mural commissions he received in the late 1960s and 70s: at the Vancouver Airport (brick mural for the arrivals level and tiles for a coffee shop, 1969); the Peace Arch Hospital, White Rock, BC (early 1970s); and the J.B. Macdonald Building at the University of British Columbia (1971), among others.

NOTABLE EXHIBITIONS

· New Design Gallery, West Vancouver, BC, 1956
· *Robert Weghsteen,* Vancouver Art Gallery, Vancouver, BC, 1961
· Ceramics, New Design Gallery, Vancouver, BC, 1963 (with Vee Elder weaving)
· BC Craftsmen '64, Vancouver Art Gallery, Vancouver, BC, 1964 (purchase award)

LORE MARIA WIENER
b. 1920, Hannover, Germany
d. 2019, Vancouver, BC

Lore Maria Wiener grew up in Bremen, Germany, and attended school until the age of sixteen, at which point she apprenticed with a local dressmaker for two years. In 1939, she was accepted at the Michelbeuern Modeschule (School of Fashion) in Vienna, Austria. She studied there until May 1940. By then, Wiener's father, Willy Frensdorff, who was Jewish, had left Germany for Shanghai to escape Nazi persecution. Wiener and her mother also left Europe to join him, travelling east on the Siberian Express. In Shanghai, Lore met her future husband, Walter Wiener, an economist and journalist at the *North China Daily News*. In October 1945, with his encouragement, she opened a fashion salon, which catered mainly to a European clientele. When the Communist Party gained power in China in 1949, Wiener, her husband and their newborn daughter were forced to leave, arriving in Vancouver in September 1949. Lore set up her first studio on West Boulevard in Vancouver's Kerrisdale neighbourhood. She made custom-designed fashions using European fabrics. In 1961, she moved to a shop on West 41st Avenue, which she commissioned Arthur Erickson to design. From the mid-1950s to the 60s, she was the sole West Coast representative of the Association of Canadian Couturiers which regularly publicized

its seasonal collections—including those by Wiener—through the national media. Over the course of her forty-year career, she became known for her elegant clothing with simple lines that was international in look yet practical.

MARTHA WIENS
b. c. 1925, unknown, BC
d. unknown

Between 1947 and 1952, Martha Wiens worked for Dorothy-Jeanne Sportswear and was listed in the 1952 City of Vancouver Directory as a designer with that firm. In the same year she was the winner in the sixth annual fashion competition co-sponsored by the Alpha Omicron Pi sorority and the BC Needle Trades Association (Fashion Manufacturers of BC). She won the prize for an afternoon dress of black and red ribbed silk, and she won the award again in 1953 for a gold cocktail frock. In the early 1960s, Wiens was an important member of the Fashion Designers Association of BC, which held fashion shows in conjunction with the Fashion Manufacturers of BC.

MONICA WILLIAMS
b. 1955, Chehalis, BC
d. 1995, Chilliwack, BC

Monica Williams was a Stó:lō weaver. Her grandmother was Mary Peters, the well-known Salish weaver and a founding member of the Salish Weavers Guild. Williams

was also a member of the Salish Weavers Guild, along with her mother Elizabeth Williams. Monica Williams started to weave in 1968 at the age of thirteen, and in 1973 her weaving was selected by the city of Chilliwack to be presented to the visiting Lord Mayor of London. Williams was later known for translating traditional Salish blankets and designs into larger, abstract twine wall hangings. She took the family's Flying Goose motif, a design originated by her grandmother Mary Peters, and altered it into a repeating geometric pattern.

NOTABLE EXHIBITIONS

· *Canadian Indian Art 74,* Royal Ontario Museum, Toronto, ON, 1974
· Century Plaza Hotel, Vancouver, BC, 1978 (award)
· Chilliwack Arts Council, Chilliwack Arts Centre, Chilliwack, BC, 1980 (award)

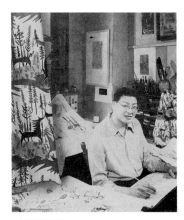

CHUCK YIP
b. 1923, Vancouver, BC
d. 2009, Vancouver, BC

Chuck Yip graduated from the Vancouver School of Art in 1950, studying design and textiles, followed by a year of postgraduate studies. In 1950 his Fantasia fabric design won third prize in the International Fabric Design Competition, sponsored by the Colonial Drapery and Curtain Corporation of New York. In 1954–55, Yip went to Britain, where he studied textile design, visited linen mills and worked briefly as a textile designer in Manchester. In the 1950s and 60s, he produced rugs with abstract designs.

He is best remembered for his drawings, paintings, linocut panels and calligraphy, especially the hand-scribed *Record of Service in the Second World War* (1955), which lists the names of two thousand University of British Columbia graduates and undergraduates who served in World War II. In the 1960s and 70s, Yip exhibited drawings and paintings at Vancouver's Danish Art Gallery and elsewhere.

NOTABLE EXHIBITIONS

· *Seventh Quarterly Group: Graphic: George Kuthan, Harry Webb, Jessie Webb, Chuck Yip,* Vancouver Art Gallery, Vancouver, BC, 1952
· *Textile Designs,* Pacific National Exhibition, Vancouver, BC, 1952
· *Chuck Yip Paintings and Hooked Rugs,* New Design Gallery, West Vancouver, BC, 1956

WILLY VAN YPEREN
b. 1925, Rotterdam, Netherlands; lives in Vancouver, BC

Willy Van Yperen was self-taught in the Netherlands before immigrating to Canada in 1957. Between 1957 and 1966, he worked at the Quest on Robson Street in Vancouver and made pieces for Karl Stittgen. He started Van Yperen Jewellers in 1967 on the south side of 10th Avenue, moving to 4425 West 10th in 1974. Although he retired in 1991, Van Yperen's son Rob continues the business at the same address. Van Yperen credits the great changes in the 1960s and 70s for stimulating his creativity. In 1966, his work was included in the permanent collection of the Canadian High Commissioner's Office in London, England, and ten of his pieces were displayed at Government House (Rideau Hall) in Ottawa. He has received four honourable mentions in the De Beers Diamonds Today competitions. His favoured materials include silver, gold, moonstones, lapis lazuli and pearls. Van Yperen's work was featured in a *Western Homes and Living* article titled "The Modern Revival of Custom-Made Jewelry" in December 1962.

NOTABLE EXHIBITIONS

· *BC Crafts,* Vancouver Art Gallery, Vancouver, BC, 1961
· *Willy Van Yperen Jewellery Exhibition,* Vancouver Art Gallery, Vancouver, BC, 1962
· *BC Craftsmen '64,* Vancouver Art Gallery, Vancouver, BC, 1964
· *Art in Action,* Vancouver Art Gallery, Vancouver, BC, 1965
· *Canadian Fine Crafts 1966/67,* National Gallery of Canada, Ottawa, ON, 1966
· *Six in Burnaby,* Burnaby Art Gallery, Burnaby, BC, 1967
· *Craft Dimensions Canada,* Royal Ontario Museum, Toronto, ON, 1969
· *British Columbia Craft,* Simon Fraser University, Burnaby, BC, 1972

CURATORS' ACKNOWLEDGEMENTS

An exhibition of this scale requires years of archival research, interviews, informal conversations and rigorous labour, all of which would not have been possible without the efforts of many individuals.

First and foremost, we are indebted to the numerous lenders to the exhibition who made their collections available to us. We extend our gratitude to our institutional colleagues for their essential loans: Art Gallery of Greater Victoria; Bill Reid Gallery of Northwest Coast Art, Vancouver; Canadian Museum of History, Gatineau; Chilliwack Museum and Archives; City of Nelson; Coqualeetza Cultural Education Centre; Equinox Gallery, Vancouver; Global Affairs Canada Visual Art Collection / Collection d'art visuel d'Affaires mondiales Canada; Metropolitan Home, Vancouver; Morris and Helen Belkin Art Gallery, Vancouver; Museum of Anthropology, Vancouver; Museum of Surrey; Museum of Vancouver; Royal BC Museum, Victoria; SMOC – Society for the Museum of Original Costume, Vancouver; UBC Library – Rare Books & Special Collections, Vancouver; University of Victoria Legacy Art Galleries; Vancouver Art Gallery; Vancouver Art Gallery Library; Victoria Handweavers and Spinners Guild; and West Vancouver Art Museum.

Our research also allowed us to access notable private collections that remain largely invisible to the public. We relied on the overwhelming generosity of a number of individuals who not only lent objects to the exhibition but spent countless hours with us sharing their expertise, knowledge and networks and unearthing rare treasures in their possession. They include Monte Clark, Alexander Forrester, Bill Gilbert, Jonathon Haddon and Louise Field, Francisca Hayman, Zera Karim, Dwight Koss, John David Lawrence, Peter Macnair and Jay Stewart, Alice Philips, Jan Pidhirny and Jim Ferguson, Michael Prokopow, Ivan Sayers, Debra Sloan, R. Sloan, Gordon Smith, Ian Wallace, Romilda Weiss and Anonymous Private Collections.

All exhibitions are collaborative efforts, and we are deeply appreciative of the tenacity and ingenuity of the Gallery staff. Independent Curator Jenn Jackson provided integral assistance during the exhibition's pivotal research stage. She compiled research material and tracked and documented hundreds of objects that helped us make the selections included in the exhibition. Assistant Curator Zoë Chan brought a sense of calm to an otherwise frenetic project; she managed every challenge with poise and diplomacy. Assistant Curator Siobhan McCracken Nixon provided essential research assistance that helped us meet our deadlines. We are grateful to Interim Chief Curator/Associate Director Diana Freundl and Manager of Curatorial Affairs Bruce Wiedrick for their support, guidance and advice throughout this unwieldy process. We thank our Curatorial colleagues Justina Bohach, Ashlee Conery, Lynn Chen, Bruce Grenville and Elaire Maund for their essential contributions throughout the development of this exhibition and publication. Jane Devine Mejia, Chief Librarian of the Vancouver Art Gallery Library, fielded our many research requests and sourced relevant material in the Gallery's archives. Our colleagues in the Education and Public Programs department, Melissa Lee and Stephanie Bokenfohr, thoughtfully planned a robust and compelling series of programs that greatly enriched the exhibition; while Susan Rome and Christina Jones produced engaging

family and school programs. The Development Department, especially work by Brynn Myers, Aryana Sye and Darren Staten was essential to our success.

Michael Lis and his team at Goodweather, Vancouver, brought a deep sensitivity of the material to their exhibition design, creating innovative modes of display that allowed the objects to take centre stage. They worked closely with our Preparation team, led by Steve Wood, Glen Flanderka and Dwight Koss, to realize our large ambitions for the project. The professionalism, broad knowledge and enthusiasm of our Preparators never ceases to amaze. We are indebted to our Design team, led by Martin Chester, who produced an immense number of graphics for the exhibition, handling our demanding requests with aplomb. Our Registrars Jenny Wilson and Amber McBride were undeterred by the volume of lenders in the exhibition and oversaw the shipping, photography and installation of more than three hundred objects, while the Conservators, led by Tara Fraser, cleaned every stain, polished each surface and repaired innumerable tears to ensure the objects were presented as their designers intended.

This publication is the result of a collaboration between the Vancouver Art Gallery and Figure 1 Publishing; we are grateful to Chris Labonté and Lara Smith for their interest in our project and for producing such an elegant catalogue. Michael Lis and Oliver Tomas contributed a thoughtful and stylish publication design; their appreciation for the material is discernable throughout. The Gallery's Photographers, Ian Lefebvre, Maegan Hill-Carroll and Trevor Mills, worked diligently on the image preparation for the book, and Danielle Currie, Rights and Reproductions Coordinator, assisted with our many reproduction requests. The time she spent in the Gallery's own photo archives added depth and complexity to our project. Our copyeditor, Jaclyn Arndt, refined the publication through her insightful edits and feedback.

The most rewarding aspect of the *Modern in the Making* exhibition was the opportunity to visit with many of the artists and designers whose works it features. Time spent in studios, living rooms and storage units enriched our understanding of craft and design in the post-war era. Visits, conversations and email exchanges with the following individuals were vital to the curatorial conception of our project: Hans-Christian Behm, Niels Bendtsen, Idar Bergseth, Toni Cavelti, Madeleine Chisholm, Robert Davidson, Gathie Falk, Lynda Gammon, Tam Irving, Charmian Johnson, Zoltan Kiss, Ann Kujundzic, Heinz Laffin, Glenn Lewis, Janet MacLeod, Santo Mignosa, Zonda Nellis, Anne Ngan, Wayne Ngan, Setsuko Piroche, Carole Sabiston, Joanna Staniszkis and Karl Stittgen.

We are also appreciative of the artists' many family members who met with us and shared their photo albums, memories and personal collections. They include Gary Baanders, Andrea Brauner, Carol Brauner, Natanis Christensen, Scott Clazie, Sean Clazie, Claudia Cornwall, the Gerson Family, the Hollingsworth Family, the Kakinuma Family, Andy Kujundzic, Judy Kujundzic, Jim Marlon-Lambert, Brad McClain, Elana Mignosa, Gailan Ngan, Goya Ngan, Pierre Piroche, Lorna Schwenk, Chris Small, Rob Van Yperen, Joanne Weghsteen and Roger Yip.

Other individuals, by sharing recollections, research, contact information and photos, also contributed immeasurably to our efforts. We thank the following people for their generosity, time and seemingly limitless patience for our barrage of questions: Allison Andrachuk, Martha Black, Alexandra Bourque, Adrienne Brown, Dr. Lolehawk Laura Buker (Stó:lō and Lake Babine Nations), Hank Bull, Liz Burnett, Beth Carter, Jamie Commodore, Teija Dedi, Chris Dikeakos, Karen Duffek, Barbara Duncan, Alan Elder, Jim Felter, Jim Fuller, Dr. Stelomethet Ethel Gardner (Stó:lō Nation), Marilyn Giles, Lance Glenn, Stephen Harrison, Karen Henry, Anna Irwin, Tamara Ivis, Catriona Jeffries, Sonya Jones, Elaine Karesa, Janni Kretlow, Hilary Letwin, Julie Malloway, Anthea Mallinson, Carol Mayer, Raine McKay, Peter McNair, Linda Montague, Darrin Morrison, Christine Purse, Martine Reid, Dr. Sue Rowley, Lynn Sabourin, Linda Sawchyn, Colleen Sharpe, Debra Sloan, Pierce Smith, Deirdre Spencer, Rochelle Steiner, Jay Stewart, Teresa Sudeyko, Susan Surette, Andy Sylvester, Stephen Topfer, Jon Tupper, Jana Tyner, Ron Vallis, Kristy Waller, Kiriko Watanabe, Mary Watson, Scott Watson, Siyameqwot Vivian Williams (Stó:lō Nation) and Erwin Wodarczak. In particular, we would like to acknowledge Michael Prokopow for his cogent advice and direction at a critical moment in the project's development.

Modern in the Making: Post-War Craft and Design in British Columbia would not have been possible without the financial contribution of our Lead Sponsor, Rogers Communications Inc.; and Supporting Sponsors, Coromandel Properties and KIMBO Design. We are also grateful for generous support from Gallery Board Member Phil Lind and additional support from the Poseley Family. The publication is supported by the Jack and Doris Shadbolt Foundation for the Visual Arts; the Richardson Family, the Gallery's Visionary Partner for Scholarship and Publications; and an anonymous donor. Many thanks to all.

It's been a great privilege and honour to work together in considering the creative output produced by British Columbians during the post-war period. A heartfelt thank-you to everyone who shared in some way on this journey.

–Daina Augaitis, Allan Collier and Stephanie Rebick

Adolph Schwenk and Louise Schwenk
working, Naramata, BC, 1961

241

PHOTO CREDITS AND COPYRIGHT NOTICES

Every reasonable effort has been made to acknowledge the ownership of copyright images included in this publication. Any errors that may have occurred are inadvertent and will be corrected in subsequent editions, provided notification is sent to the Vancouver Art Gallery.

Front Cover (from left to right, top to bottom): Peter Cotton for Perpetua Furniture, Vancouver, BC, Glass-Topped Coffee Table, 1950 (detail), steel rod, glass, 44.2 × 97.2 × 48.6 cm, Collection of Chris Small, Photo: Trevor Mills, Vancouver Art Gallery; Joanna Staniszkis, *Untitled*, 1975 (detail), wool, cotton, feathers, 177.0 × 155.0 cm, Collection of the Vancouver Art Gallery, Gift of Audrey and Gerald Clarke, VAG 2012.32.1, Photo: Ian Lefebvre, Vancouver Art Gallery; Stanley Clarke, Vase, c. 1960s (detail), ceramic, 42.0 × 20.0 (diameter) cm, Gift of A.H. and E. (Bessie) Fitzgerald, University of Victoria Legacy Art Galleries, Photo: Ian Lefebvre, Vancouver Art Gallery; Mary Chang, Dress, 1963–68 (detail), cotton, 143.4 cm (length) cm, Ivan Sayers Collection, Photo: Ian Lefebvre, Vancouver Art Gallery; Willy Van Yperen, Necklace, c. early 1970s (detail), silver, 18-carat yellow gold, 81.3 (length) cm, Courtesy of Van Yperen Jewellers, Photo: Ian Lefebvre, Vancouver Art Gallery; Unknown Nuučaańułʔatḥ (Nuu-chah-nulth) Weaver, Ucluelet Basket, 1944 (detail), grass, shell, glass, 16.8 × 12.0 (diameter) cm, Collection of John David Lawrence, Photo: Ian Lefebvre, Vancouver Art Gallery.

Front Interior Flap: Mouldcraft Plywoods, North Vancouver, BC, Armchair, 1946, moulded-plywood, upholstery, foam, 74.5 × 78.0 × 102.0 cm, Collection of Dwight Koss, Photo: Trevor Mills, Vancouver Art Gallery.

Rear Interior Flap: Mary Peters, Stó:lō Weaving, 1968 (detail), sheep wool, coloured dyes, 170.0 × 81.0 cm, Courtesy of the Chilliwack Museum and Archives, 1987.031.001 a–b, Photo: Rachel Topham Photography, Courtesy of the Morris and Helen Belkin Art Gallery, The University of British Columbia.

Back Cover: Doris Shadbolt working, published in *Western Homes and Living*, January 1955, Photo: Selwyn Pullan, Collection of West Vancouver Art Museum.

Body: 1: Ruth and Jack Southworth hand block fabric for display in Design for Living, exhibition at the Vancouver Art Gallery, BC, November 8 to November 27, 1949, Photo: Jack Long/Weekend Collection/Library and Archives Canada/ e002344009. **2:** Stanley Clarke, Vase, c. 1960s, ceramic, 42.0 × 20.0 (diameter) cm, Gift of A.H. and E. (Bessie) Fitzgerald, University of Victoria Legacy Art Galleries, Photo: Ian Lefebvre, Vancouver Art Gallery; **4–5:** Earle A. Morrison and Robin Bush chairs, c. early 1950s, Photo: Library and Archives Canada/PA-211054; **6–7:** Kathleen Hamilton, Vase, c. 1969–76 (detail), ceramic, 16.5 × 10.5 × 5.2 cm, Collection of John David Lawrence, Photo: Ian Lefebvre, Vancouver Art Gallery; **8–9:** Bill Reid, Beaver and Eagle Bracelet, 1970 (detail), 22-carat gold, 1.4 × 2.0 (diameter) cm, On loan from the Bill Reid Gallery of Northwest Coast Art Simon Fraser University Bill Reid Collection 2006.1.2.1 Gift of Anton and Hildegard Cavelti, Photo: Ian Lefebvre, Vancouver Art Gallery, Courtesy of the Estate of Bill Reid; **10–11:** Skeins of naturally dyed wool drying on a line, n.d., Courtesy of the Coqualeetza Cultural Education Centre; **12–13:** Walter Dexter, Liqueur Set with Two Cups, c. 1963–67 (detail), ceramic, 26.5 × 9.4 (diameter) cm, Collection of John David Lawrence, Photo: Ian

Lefebvre, Vancouver Art Gallery; **14–15, 80, 82–83, 88–89, 96–97, 103, 106–07, 110–11, 119 (top left and right), 123, 142–44, 155, 161 (bottom left), 194–95, 197 (bottom):** Trevor Mills, Vancouver Art Gallery; **17, 27, 72 (top), 190, 191, 193 (top), 197 (top):** Vancouver Art Gallery Photography Archives; **18–19:** Vancouver Art Gallery Photography Archives, Photo: Robert Keziere; **21:** National Film Board of Canada. Photothèque/Library and Archives Canada/PA- 211766; **23:** Jack Long/National Film Board of Canada/Weekend Collection/Library and Archives Canada/e002344007; **24:** University of British Columbia Archives [UBC 3.1/556-1]; **28:** City of Vancouver Archives, CVA 180-2361; **33, 37, 43, 45, 49–51, 86–87, 102, 107 (bottom), 112–15, 118, 119 (bottom), 120–21, 124–25, 128 (top left and right), 129, 134–35, 145, 150–54, 156–60, 161 (top and bottom right), 162–63, 168 (top), 169 (top and middle), 174–79, 183:** Photo: Ian Lefebvre, Vancouver Art Gallery; **35:** City of Vancouver Archives, AM54-S4-:In N46.1, Photo: Major Matthews James Skitt; **36 (top):** Image (H-03376) Courtesy of the Royal BC Museum and Archives; **36 (bottom):** University of British Columbia Archives [UBC 1.1/9256-6]; **40–41, 98 (bottom), 104–05:** © Graham Warrington; **46 (top):** Image (I-14433) Courtesy of the Royal BC Museum and Archives; **46 (bottom):** Image (I-28317) Courtesy of the Royal BC Museum and Archives; **48:** Tim Bonham, Vancouver Art Gallery; **54 (bottom), 101 (bottom), 109, 146, 172, 187, 196:** Maegan Hill-Carroll, Vancouver Art Gallery; **54 (top):** City of Vancouver Archives, AM1594-: MAP 197:1972-261.2; **57, 70–71, 72 (bottom), 90–91, 108 (bottom), 127 (top and bottom right), 141 (bottom), 164 (top), 166, 167 (top), 241:** Selwyn Pullan, Collection of West Vancouver Art Museum; **59:** George H. Van Anda © The Museum of Modern Art/Licensed by SCALA/Art Resource, NY; **61:** Jack Long/Weekend Collection/Library and Archives Canada/e002344008; **74:** © Country Life/Bridgeman Images; **75 (left):** BR50.90.B, Harvard Art Museums/Busch-Reisinger Museum, Gift of Walter Gropius. © Estate of Lucia Moholy/SOCAN (2020), Photo: © President and Fellows of Harvard College; **75 (right):** BRGA.21.55.A, Harvard Art Museums/Busch-Reisinger Museum, Gift of Ise Gropius, © Estate of Lucia Moholy/SOCAN (2020), Photo: © President and Fellows of Harvard College; **76:** Douglas C. Simpson Fonds, Canadian Centre for Architecture Canadian, Gift of Barry and Gregg Simpson, Photo: © Graham Warrington; **77 (left):** Jack Long/National Film Board of Canada Photothèque/Library and Archives Canada/PA-132031; **77 (right):** Jack Long/National Film Board of Canada Photothèque/Library and Archives Canada/PA-132037; **78 (left):** Jack Long/National Film Board of Canada Photothèque/Library and Archives Canada/PA-132046; **78 (right):** Jack Long/National Film Board of Canada Photothèque/Library and Archives Canada/PA-132038; **79 (top left):** National Film Board of Canada. Photothèque/Library and Archives Canada/PA-211766; **79 (top right):** National Film Board of Canada Photothèque/Library and Archives Canada/PA-160507; **79 (bottom left):** National Film Board of Canada. Photothèque/Library and Archives Canada/PA-151339; **79 (bottom right):** Library and Archives Canada/1972-143 NPC; **84:** Vernon Museum and Archives, photo no. 48; **85 (top):** City of Vancouver Archives, CVA 586-3545; **85 (bottom):** City of Vancouver Archives, CVA 586-3549; **93:** University of British Columbia Archives [UBC 1.1/9906]; **95 (top left):** Jack Long/Weekend Collection/Library and Archives Canada/e002344008; **95 (top centre):** Jack Long/Weekend Collection/Library and

Archives Canada/e002344014; **95 (top right):** Jack Long/Weekend Collection/Library and Archives Canada/e002344007; **95 (middle left):** Jack Long/Weekend Collection/Library and Archives Canada/e002344010; **95 (middle centre):** Jack Long/Weekend Collection/Library and Archives Canada/e002344011; **95 (middle right):** Jack Long/Weekend Collection/Library and Archives Canada/e002344014; **95 (bottom):** Jack Long/Weekend Collection/Library and Archives Canada/e002344014; **98 (top):** City of Vancouver Archives, CVA 180-2376; **101 (top):** National Film Board of Canada. Photothèque/Library and Archives Canada/PA-168137; **108 (top):** City of Vancouver Archives, CVA 180-5005; **117:** University of British Columbia Archives [UBC 3.1/1555]; **127 (bottom left):** University of British Columbia Archives [UBC 3.1/592-1]; **128 (bottom left lower and bottom right):** Courtesy of UBC Museum of Anthropology, Vancouver, Canada, Photo: Alina Ilyasova, Courtesy of the Estate of Bill Reid; **128 (bottom left upper):** Photo: Ian Lefebvre, Vancouver Art Gallery, Courtesy of the Estate of Bill Reid; **130:** City of Vancouver Archives, CVA 810-248; **131 (top):** Image (I-01314) Courtesy of the Royal BC Museum and Archives; **131 (bottom):** City of Vancouver Archives, CVA 586-838, Photo: Donn B.A. Williams; **132–33, 169 (bottom):** Courtesy of UBC, Museum of Anthropology, Vancouver, Canada, Photo: Derek Tan; **136–37:** University of British Columbia Archives [UBC 1.1/9944-2]; **139, 149** (bottom), **170–71, 185:** Courtesy of Marjorie Powell (deceased mother of Lynda Gammon); **141 (top):** John Fulker, Collection of West Vancouver Art Museum; **147 (top):** Vancouver Public Library 86180A, Photo: Noriko Hirota; **147 (bottom):** Photo: Ida Kar © National Portrait Gallery, London; **149 (top):** Courtesy of the Emily Carr University of Art + Design Archives; **154 (bottom):** Howard Ursuliak; **164 (bottom):** University of British Columbia Archives, Photo by Peter Holborne [UBC 1.1/12568-1]; **165:** Michael R. Barrick; **167:** Courtesy of Touchstones Nelson: Museum of Art and History, Photo: Jessie Demers; **168 (bottom):** Courtesy of UBC, Museum of Anthropology, Vancouver, Canada, Photo: Tim Bonham; **173 (left):** Courtesy of the Chilliwack Museum and Archives, 2004.052.1138; **173 (right):** Courtesy of the Chilliwack Museum and Archives, 2004.052.1136; **180–81:** Installation view, *Beginning with the Seventies: Collective Acts,* exhibition at the Morris and Helen Belkin Art Gallery, The University of British Columbia, September 4 to December 2, 2018, Photo: Rachel Topham Photography; **184:** Courtesy of Zonda Nellis; **188, 193 (bottom):** Artist File, Courtesy of the Vancouver Art Gallery Library; **189 (top):** Artist File, Courtesy of the Vancouver Art Gallery Library, Photo: Maegan Hill-Carroll, Vancouver Art Gallery; **189 (bottom):** Courtesy of Setsuko Piroche.

Biographical Sketches (starting from left column, top to bottom): 200: Santo Mignosa working at the University of British Columbia, Vancouver, BC, c. late 1950s–early 1960s, University of British Columbia Archives [UBC 3.1/545-3]; **202:** Barbara Baanders, Jar, c. 1970, ceramic, 9.0 × 10.5 (diameter) cm, Baanders Family Collection, Photo: Ian Lefebvre, Vancouver Art Gallery; Idar Bergseth, Brooch, c. mid-1960s, sterling silver, 18-carat yellow gold, Japanese Akoya pearls, 8.5 × 7.5 × 1.0 cm, Courtesy of the Artist, Photo: Ian Lefebvre, Vancouver Art Gallery; **203:** B.C. Binning in his studio, West Vancouver, BC, 1950s, Vancouver Art Gallery Photography Archives, Photo © Graham Warrington; Cyril G. Burch Ltd., Vancouver, BC, Cantilevered Lounge Chair in Tubular Metal, c. 1949, metal, upholstery, 74.0 × 51.5 ×

62.0 cm, Collection of Allan Collier, Photo: Trevor Mills, Vancouver Art Gallery; **204:** Mollie Carter working on ceramics for display in *Design for Living*, exhibition at the Vancouver Art Gallery, BC, November 8 to November 27, 1949, Photo: Jack Long/ Weekend Collection/Library and Archives Canada/e002344011; **205:** Toni Cavelti, Ring, c. 1970s, 18-carat rose gold and white gold, 1.8 (width) cm, Private Collection, Photo: Ian Lefebvre, Vancouver Art Gallery; **206:** Stanley Clarke and Jean McIntyre for Reagh Studios, Vancouver, BC, Salt and Pepper Shakers, c. early 1950s, ceramic, 17.3 × 4.2 (diameter) cm each, Collection of Allan Collier, Photo: Trevor Mills, Vancouver Art Gallery; John Clazie, Cubist Pendant, c. 1955, copper, 11.8 × 4.8 × 1.5 cm, Collection of the Clazie Family, Photo: Ian Lefebvre, Vancouver Art Gallery; **207:** Peter Cotton for Perpetua Furniture, Vancouver, BC, Armchair A3MKII, 1953, steel rod, plywood, teak, upholstery, 77.0 × 67.0 × 53.0 cm, Collection of Allan Collier, Photo: Trevor Mills, Vancouver Art Gallery; Judy Cranmer, Bowl, c. 1970–75, ceramic, 19.5 × 27.2 (diameter) cm, Collection of John David Lawrence, Photo: Ian Lefebvre, Vancouver Art Gallery; **208:** Attributed to Victor Fabri for Crown Ceramics, Vancouver, BC, Bowl (#804), c. mid-1950s, ceramic, 10.5 × 18.0 × 17.5 cm, Collection of Allan Collier, Photo: Trevor Mills, Vancouver Art Gallery; Olea Davis with ceramics display, University of British Columbia, Vancouver, BC, 1958, University of British Columbia Archives, [UBC 3.1/1487]; **209:** Walter Dexter, Weed Pot, c. 1967–73, ceramic, 25.8 × 26.2 × 10.9 cm, Collection of Jonathon Haddon and Louise Field, Photo: Ian Lefebvre, Vancouver Art Gallery; Reginald Dixon, Vase, c. 1956, ceramic, 25.0 × 20.0 (diameter) cm, Collection of the Vancouver Art Gallery, Gift of the Vancouver Art Gallery Women's Auxiliary, VAG 56.11, Photo: Ian Lefebvre, Vancouver Art Gallery; **210:** Axel Ebring, Pitcher, c. 1940s, ceramic, 18.0 × 19.5 × 15.3 cm, Collection of John David Lawrence, Photo: Ian Lefebvre, Vancouver Art Gallery; Gathie Falk, *30 Grapefruit*, 1970, ceramic, glaze, 32.0 × 49.5 × 49.5 cm, Collection of the Vancouver Art Gallery, Endowment Fund, VAG 70.112, Photo: Trevor Mills, Vancouver Art Gallery; **211:** Hilde Gerson, Rug, c. 1970s, wool, 197.0 × 100.0 × 3.0 cm, Courtesy of the Gerson Family, Photo: Ian Lefebvre, Vancouver Art Gallery; Herta Gerz for BC Ceramics Ltd., Vancouver, BC, Plate (#7088 Flamenco Décor), c. 1960, ceramic, 4.0 × 21.8 × 17.8 cm, Collection of Allan Collier, Photo: Trevor Mills, Vancouver Art Gallery; **212:** Jan Grove and Helga Grove, Floor Lamp, c. 1970 (detail), ceramic, 165.0 × 46.8 × 46.8 cm, Collection of Alexander Forrester, Photo: Trevor Mills, Vancouver Art Gallery; Kathleen Hamilton, Vase, c. 1969–76, ceramic, 18.5 × 14.6 cm, Collection of John David Lawrence, Photo: Ian Lefebvre, Vancouver Art Gallery, **213:** Exterior view of Hammond Furniture warehouse, Vancouver, BC, c. 1940–48, Photo: City of Vancouver Archives, CVA 1184-1988; Michael Henry, Bowl, c. 1970 (detail), ceramic, 10.1 × 27.2 (diameter) cm, Collection of John David Lawrence, Photo: Ian Lefebvre, Vancouver Art Gallery; **214:** Gillian Hodge, Raku Vase, c. 1960s, ceramic, 15.5 × 10.7 (diameter) cm, Collection of John David Lawrence, Photo: Ian Lefebvre, Vancouver Art Gallery; **215:** Honey Hooser, Placemat (Multicolour-Thread Flower Pattern), c. 1950s, wool, 27.0 × 39.2 cm, City of Surrey Heritage Services, Photo: Ian Lefebvre, Vancouver Art Gallery; **216:** Nellie Jacobson, Button, before 1950, swamp grass, paper, dye, 0.5 × 3.7 cm, Courtesy of the Museum of Anthropology, The University of British Columbia, Vancouver, Canada, Elspeth

McConnell Collection, Photo: Alina Ilyasova; **217:** Thomas Kakinuma, Lamp, c. 1960s, ceramic, 64.5 × 25.3 (diameter) cm, Collection of the Kakinuma Family, Photo: Ian Lefebvre, Vancouver Art Gallery; **218:** Zoltan Kiss, Vase, 1957, ceramic, 23.2 × 12.3 (diameter) cm, Courtesy of the Artist, Photo: Photo: Ian Lefebvre, Vancouver Art Gallery; Ann Kujundzic, Hanging, 1970, wool, wood, 89.5 × 63.5 × 0.5 cm, Courtesy of the Artist, Photo: Ian Lefebvre, Vancouver Art Gallery; Zeljko Kujundzic, *Family*, 1967, Ohio walnut wood, welded copper and bronze, left: 153.5 × 39.0 × 4.5 cm, centre: 149.0 × 39.0 × 5.0 cm, right: 152.0 × 39.0 × 4.3 cm, Collection of Natanis Christensen, Photo: Trevor Mills, Vancouver Art Gallery; **219:** Heinz Laffin, Plate, c. 1960s, ceramic, 5.1 × 21.7 × 21.9 cm, Courtesy of Joanne Weghsteen, Photo: Ian Lefebvre, Vancouver Art Gallery; Edwin Larden for William Freeman and Son Ltd., Vancouver, BC, Desk Lamp, 1949, anodized aluminum, plated steel, electrical fittings, 49.0 × 18.0 × 27.0 cm, Collection of Allan Collier, Photo: Trevor Mills, Vancouver Art Gallery; **220:** Glenn Lewis, Vase, c. 1960s, ceramic, 20.1 × 19.4 (diameter) cm, Collection of John David Lawrence, Photo: Ian Lefebvre, Vancouver Art Gallery; Des Loan, Pitcher with Wax-Resist Decoration, c. 1966, ceramic, 30.5 × 15.0 × 13.0 cm, Collection of John David Lawrence, Photo: Ian Lefebvre, Vancouver Art Gallery; Adeline Lorenzetto with a twill weaving, n.d., Courtesy of the Chilliwack Museum and Archives, 2004.052.1138; **221:** Rex Mason at the University of British Columbia, Vancouver, BC, 1953, University of British Columbia Archives, [UBC 1.1/9967-1]; **222:** Heather Maxey, Bowl, c. 1960s, enamelled copper, 3.2 × 15.6 (diameter) cm, Collection of Allan Collier, Photo: Ian Lefebvre, Vancouver Art Gallery; Rodney Maxwell-Muir, Salt and Pepper Shakers, c. 1967, ceramic, salt: 14.9 × 8.1 (diameter) cm, pepper: 15.3 × 7.3 (diameter) cm, Collection Romilda Weiss, Brigham, Québec, Photo: Ian Lefebvre, Vancouver Art Gallery; **223:** Ruth Meechan, Three Dishes, 1953–63, ceramic, a: 2.4 × 11.0 × 11.0 cm, b: 2.1 × 8.4 × 14.4 cm, c: 2.2 × 10.9 × 28.4 cm; Collection of John David Lawrence, Photo: Ian Lefebvre, Vancouver Art Gallery; **224:** Earle A. Morrison and Robin Bush for Earle A. Morrison Ltd., Victoria, BC, Airfoam Lounge Chair (#141), 1951, steel rod, plywood, walnut, upholstery, 71.7 × 76.2 × 73.0 cm, Collection of Allan Collier, Photo: Ian Lefebvre, Vancouver Art Gallery; **225:** Ellen Neel in her studio, 1958, Photo: Gar Lunney/ Library and Archives Canada/National Film Board Fonds/e011176933; Wayne Ngan's ceramic mark, 1976, Vancouver Art Gallery Photography Archives, Photo: Robert Keziere; **226:** Unknown (from plans published by Canadian Forest Products Ltd., Pacific Veneer and Plywood Division), Modern Shadow Wood Desk, c. early 1950s, Shadow Wood plywood, plywood, solid wood, 80.8 × 163.3 × 62.7 cm, Collection of Allan Collier, Photo: Trevor Mills, Vancouver Art Gallery; **227:** Mary Peters, n.d, Courtesy of the Coqualeetza Cultural Education Centre; **228:** Ravine Pottery, New Westminster, BC, Pitcher, c. 1948, ceramic, 16.3 × 20.7 × 16.7 cm, Collection of Allan Collier, Photo: Trevor Mills, Vancouver Art Gallery; John Reeve, c. 1950s, Artist File, Courtesy of Vancouver Art Gallery Library; Bill Reid working, c. 1970s, Artist File, Courtesy of Vancouver Art Gallery Library; **229:** Rose Marie Reid, 1945, Photo: City of Vancouver Archives, CVA 586-8905; Hilda Ross, Vase, c. 1960s, ceramic, 24.3 × 26.6 × 12.5 cm, Collection of John David Lawrence, Photo: Ian Lefebvre, Vancouver Art Gallery; **230:** Carole Sabiston, *Victoria by Jolly*, 1968, wool, velveteen, tulle, linen, satin, embroidery thread, 28.7 × 28.6 × 4.2 cm, Collection of the Clazie Family, Photo: Ian Lefebvre, Vancouver Art Gallery; **231:** Doris Shadbolt working, published

in *Western Homes and Living*, January 1955, Photo: Selwyn Pullan, Collection of West Vancouver Art Museum; **232:** Spider Looms, Vancouver, BC, Woven Ties, c. late 1950s–early 1970s, wool, dimensions variable, Collection of Michael Prokopow, Photo: Ian Lefebvre, Vancouver Art Gallery; Joanna Staniszkis, *Untitled*, 1975, wool, cotton, feathers, 177.0 × 155.0 cm, Collection of the Vancouver Art Gallery, Gift of Audrey and Gerald Clarke, VAG 2012.32.1, Photo: Ian Lefebvre, Vancouver Art Gallery; **233:** Alfred Staples, Firewood Rack, c. 1953, steel rod, steel mesh, 58.5 × 45.0 × 40.0 cm, Collection of Allan Collier, Photo: Trevor Mills, Vancouver Art Gallery; **234:** Attributed to Herbert Sturhahn for Strahan and Sturhan Upholsterers, Vancouver, BC, Contour Chair with Foot Stool, c. 1953, steel rod, upholstery, wood, chair: 83.0 × 67.0 × 79.0 cm, stool: 36.0 × 58.0 × 47.0 cm, Collection of Allan Collier, Photo: Trevor Mills, Vancouver Art Gallery; Ron Thom, Couch from Copp House, 1963 (detail), wood, upholstery, 75.0 × 84.0 × 203.0 cm, Courtesy of Jan Pidhirny and Jim Ferguson, Photo: Trevor Mills, Vancouver Art Gallery; **235:** Lore Maria Wiener, Yellow Dress with Windowpane Black Checker, c. 1965–67, silk, wool crepe, 94.5 (length) cm, The Society for the Museum of Original Costume (SMOC), Photo: Ian Lefebvre, Vancouver Art Gallery; Monica Williams with one of her weavings, n.d., Courtesy of the Coqualeetza Cultural Education Centre; **236:** Chuck Yip working, published in *Western Homes and Living*, October 1953, Collection of Roger Yip; **237:** Gathie Falk's house, Vancouver, BC, c. 1970s, Vancouver Art Gallery Photography Archives; **241:** Adolph Schwenk and Louise Schwenk working, Naramata, BC, published in *Western Homes and Living,* April 1961, Photo: Selwyn Pullan, Collection of West Vancouver Art Museum; **250–51:** Ellen Neel, West Wind Mask, c. 1946–65 (detail), cedar, 27.4 × 18.4 × 10.5 cm, Courtesy of Equinox Gallery, Photo: Ian Lefebvre, Vancouver Art Gallery; **252:** Evelyn Roth in her *Video Armour*, 1972, outside of the Vancouver Art Gallery, during the exhibition *Pacific Vibrations*, 1973, Vancouver Art Gallery Photography Archives.

COLOPHON

Published in conjunction with the exhibition *Modern in the Making: Post-War Craft and Design in British Columbia* organized by the Vancouver Art Gallery, curated by Daina Augaitis, Interim Director; Allan Collier, Guest Curator; and Stephanie Rebick, Associate Curator; and presented from July 18, 2020, to January 3, 2021.

EDITOR
Stephanie Rebick

ASSISTANT CURATORS
Zoë Chan and Siobhan McCracken Nixon

COPYEDITING
Jaclyn Arndt

PROOFREADING
Alison Strobel

DESIGN
Goodweather Studio

PUBLICATION COORDINATION
Stephanie Rebick

PHOTOGRAPHY AND DIGITAL IMAGE PREPARATION
Ian Lefebvre and Maegan Hill-Carroll

RIGHTS AND REPRODUCTIONS
Zoë Chan and Siobhan McCracken Nixon

Printed and bound in Canada by Hemlock

© 2020 Vancouver Art Gallery

ISBN 978-1-927656-51-8
ISBN 978-1-77327-122-4

Cataloguing data available from Library and Archives Canada. All rights reserved. No part of this book may be reproduced, stored in a retrieval system or transmitted, in any form or by any means, without the prior written consent of the publisher.

PUBLICATION SUPPORT

Visionary Partner for Scholarship and Publications:
The Richardson Family

Support for the publication is also provided by the **Jack and Doris Shadbolt Endowment for Research and Publications**, and a generous **anonymous donor**.

EXHIBITION SUPPORT

LEAD SPONSOR:

SUPPORTING SPONSORS:

Generously supported by **Phil Lind**
Additional support from **The Poseley Family**

The Vancouver Art Gallery is a not-for-profit organization supported by its members, individual donors, corporate funders, foundations, the City of Vancouver, the Province of British Columbia through the British Columbia Arts Council, and the Canada Council for the Arts.

Vancouver
Artgallery

Figure 1
Vancouver / Berkeley

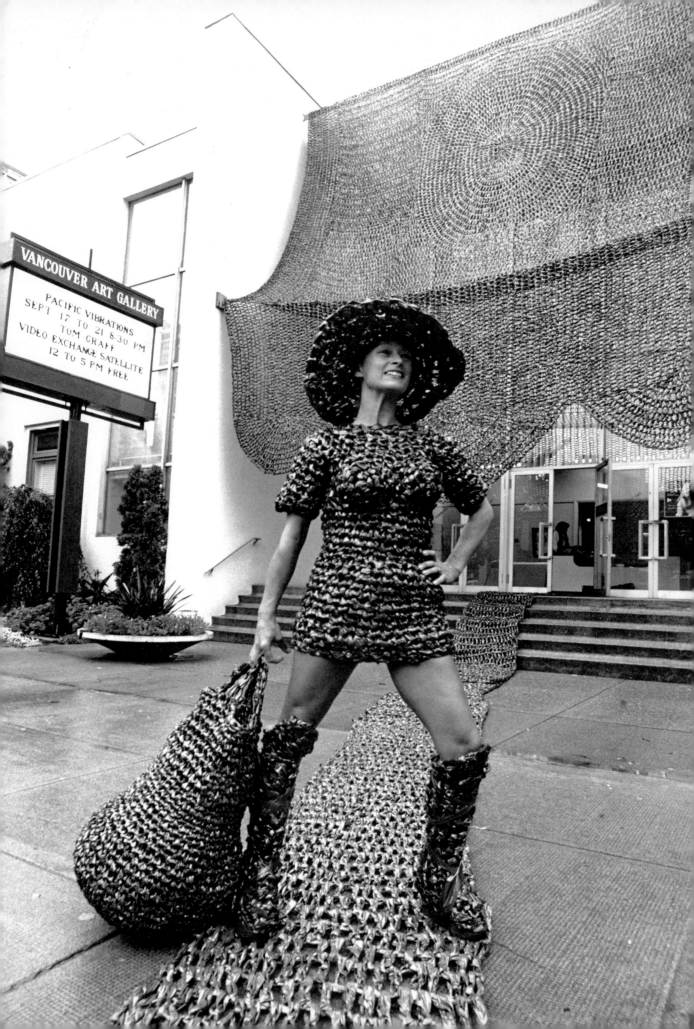